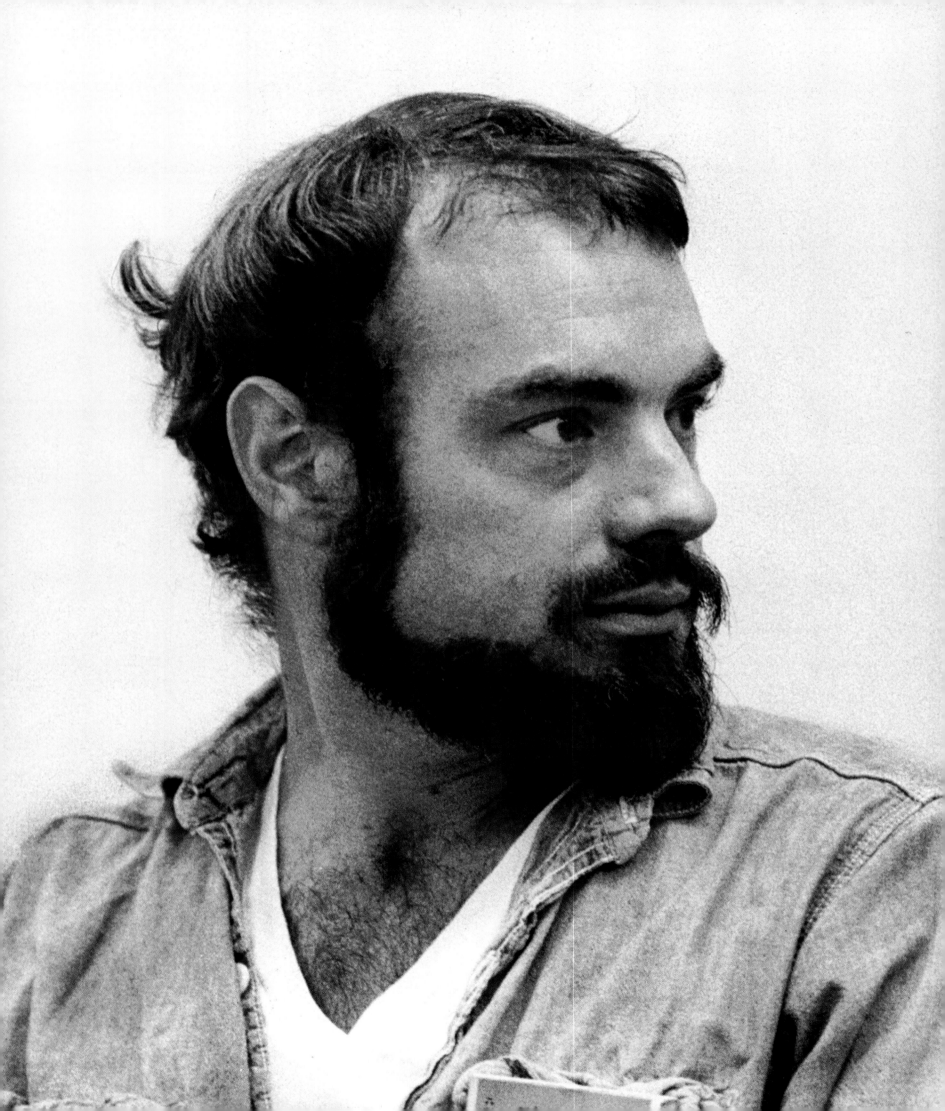

SCULPTURE BY Bruce Beasley

A 45-Year Retrospective

Oakland Museum of California

April 16–July 31, 2005

This book was published on the occasion of the exhibition
Sculpture by Bruce Beasley: A 45-Year Retrospective
Oakland Museum of California
April 16–July 31, 2005

The Oakland Museum of California gratefully acknowledges
the Oakland Museum Women's Board, the Bernard Osher Foundation,
Eileen and Joel Birnbaum, John and Jill Freidenrich, Lynn and Donald A. Glaser,
and the Helen Forster Novy Fund for their significant gifts in support of the
exhibition and Beverly Brooks Floe for her generous support of this publication.

ISBN 1-882140-35-4

Oakland Museum of California
Art Department
1000 Oak Street
Oakland, California 94607-4892

Photography: M. Lee Fatherree: Plates 1–3, 6, 7, 9, 10, 12, 14, 17, 18, 20, 23,
25, 27, 39, 41, 47, 49, 55, 65–68, 109–11, 115–44, 146–64, 175–89, 193;
Ron Finne: Figure 39; Leo Holub: Figure 12; Joanne Leonard: Figures 1–3,
7–10, 14, 15, 30, 33, 34, 77–98; Lita Ramos: Figure 46; Nick Zurek: Plate 77.

Frontispiece: Photograph of Bruce Beasley by Ron Finne.

Produced by Wilsted & Taylor Publishing Services
Production management: Christine Taylor
Copyediting: Rachel Bernstein
Design and composition: Jeff Clark
Printing and binding in Hong Kong by
Regal Printing Ltd. through Stacy Quinn of
QuinnEssentials Books and Printing, Inc.

CONTENTS

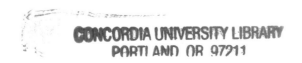

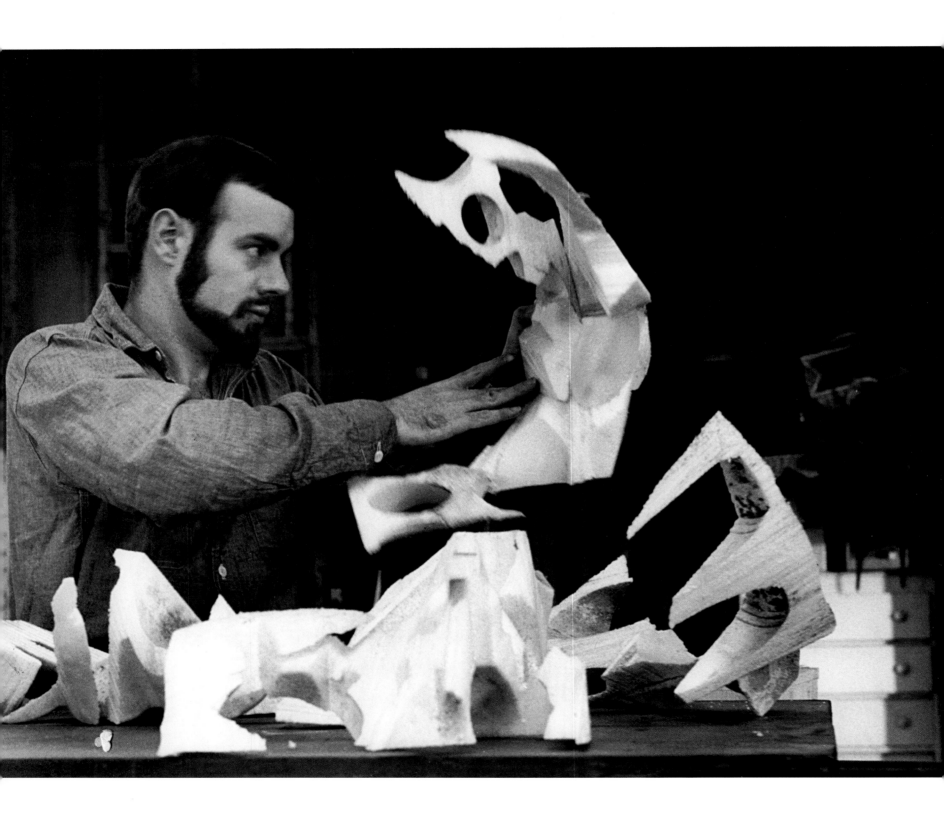

The life and art of sculptor Bruce Beasley suggest a new model for public perception of what an artist is and does. The long-held image of a sculptor—Vulcan at his forge, an inarticulate and simply intuitive builder of form—is replaced by Beasley's example as a thoughtful, analytical, and multifaceted creator of expressive form.

California-born and -raised, Beasley discovered his talents at an early age but sought the grounding of a liberal arts education at New England's Dartmouth College. Upon completing his studies there, he moved on to the "right place at the right time": University of California, Berkeley, art department. U.C. Berkeley in the late 1950s was the epicenter of revival in sculpture, and Beasley was exposed to a distinguished group of veteran sculptors including Jacques Schnier, Richard O'Hanlon, Wilfred Zogbaum, Sidney Gordin, Harold Paris, and, most importantly, Peter Voulkos. As a student, Beasley joined Voulkos, Paris, and foundryman Donald Haskin to build the Garbanzo Works in a corrugated-tin-exterior

Fig. 1 [facing] Bruce Beasley assembling Styrofoam shapes, original Lewis Street studio, 1966.

industrial building adjoining the railroad tracks in West Berkeley. Here, Voulkos, Paris, visiting sculptor Julius Schmidt, and students, including Beasley, began creating major works in cast bronze and aluminum in their handbuilt foundry.

Beasley's early works, in cast aluminum and welded cast-iron, met with early critical success, extending the visibility of his work in major international exhibitions and leading to acquisitions by the Museum of Modern Art; the Musée d'Art Moderne, Paris; the Solomon R. Guggenheim Museum; and prominent private collections. His subsequent travel opportunities allowed Beasley to meet many of the artists he admired, including Willem de Kooning, David Smith, Isamu Noguchi, Gio Pomodoro, and Eduardo Chillida, with whom he formed and nurtured lasting friendships. Intellectual curiosity drove him to explore the possibility of cast, clear acrylic sculpture, an untried medium posing daunting technical hazards. With the material support of the DuPont Corporation but also with the doubts of DuPont scientists, Beasley explored and experimented with the material, ultimately succeeding brilliantly. His technological breakthroughs enabled him to create a thirteen-thousand-pound cast-acrylic commissioned sculpture for the State of California and, most significantly, to create the process by which transparent bathyspheres could be built for underwater exploration. For this innovation and its resulting successes, he was awarded a commendation from the National Aeronautics and Space Administration (NASA) and was the subject of a nationally aired television program produced by the Smithsonian Institution.

More than a decade's prolific production of cast-acrylic sculptures gave way to explorations of new forms; large-scale stainless steel works and smaller works in maple evolved, exhibiting influences of Beasley's growing, eclectic collection of source materials including animal skulls, ethnographic art, mineral samples, and nineteenth-century machinery. These, in turn, evolved to a still-expanding series of cast-bronze, fabricated bronze, marble, and granite sculptures in both human and monumental scale. Beasley experimented with models composed of geometric modules cut from foam-core, moving and adjusting forms to satisfy his analytical eye. When this

proved too time-consuming, he embarked on another exploration, this time in the field of computer science. Rigorous research and learning provided some answers, leading to the creation of a three-dimensional computer modeling system that allows spontaneous changes and visualization of complex geometric models. Now, after the sculptor achieves a satisfying composition, he can create a printout of each of the many complex shapes involved; this pattern allows the timely formation of a maquette in foam-core, which can be cast and/or scaled up for fabrication as required.

This publication, accompanying the exhibition *Sculpture by Bruce Beasley: A 45-Year Retrospective*, serves as a personal document of his work and the process by which it is achieved. In his interview with art critic Peter Frank, Beasley describes himself as "a responder." He explains how he achieves his sculptures through an investigation of form. He also discusses, in his statement "The Language of Sculpture," his commitment to the language of three-dimensional art and the power of its emotional content. Beasley's work of the past forty-five years and his involvement in all aspects of the exhibition and this publication attest to the varied nature of his abilities; his intellectual rigor, technical skill, emotional sensitivity, and powerful determination are all evident here.

I want to thank Bruce Beasley for his gracious and patient cooperation during every phase of this project. Thanks go also to Dr. Dennis M. Power, Executive Director of the Oakland Museum of California; Mark Medeiros, Deputy Director for Curatorial Affairs; Jan Berckefeldt, Director of Development; and Linda Larkin, Senior Major Gifts Manager, for their enthusiastic support and professional contributions to the project. Sincere thanks also go to members of the art department staff, including Kathy Borgogno, Arthur Monroe, Karen Nelson, David Ruddell, and Joy Tahan, for their work on all phases of the exhibition, catalogue, and public programs. I also extend my appreciation to Peter Frank for his principal essay and interview of the artist, to the family of Dr. Albert Elsen for permitting the publication of Dr. Elsen's essay, and to M. Lee

Fatherree for his outstanding photography of Bruce Beasley's sculptures.

On behalf of the Oakland Museum of California I want to express my appreciation and gratitude to the Oakland Museum Women's Board, the Bernard Osher Foundation, Eileen and Joel Birnbaum, John and Jill Freidenrich, Lynn and Donald A. Glaser, and the Helen Forster Novy Fund for their significant gifts in support of the exhibition; to Beverly Brooks Floe for her generous support of this publication; and to Christine Taylor, of Wilsted and Taylor Publishing Services, for the design and production of this catalogue. Thanks go also to the lenders, both private collectors and major institutions, for generously allowing examples from their collections to be included in the exhibition, the first retrospective view of the extraordinary artistic accomplishments of sculptor Bruce Beasley.

Philip E. Linhares Chief Curator of Art
Oakland Museum of California

SCULPTURE BY BRUCE BEASLEY

THE LANGUAGE OF SCULPTURE

The language of sculpture is mute and silent.

The vocabulary of sculpture is shape and emptiness. It has a unique syntax and grammar that explores the limits of the physical world and the limits of our imagination. It is a language that can speak of the mystery as well as the reality of the physical world. It is the only language that can speak of our emotional relationship to the physical world. It can speak of the mystery of the border of the sky and the sea. It can speak of the alliance of the mountain, the plain, and ourselves.

This visual language has been deep within us from the beginning of our species. It is a part of our collective memory. It is a language that anyone who wants to can understand. But it is not a language that can speak of everything in our world or our experience. It is a language that is rich but not precise. It is emotional, not rational, and the truths it can speak cannot be subjected to analysis or rational verification.

It is not a fragile language, but it can be drowned out by words that distract the visual-emotional receptors of the brain and annoy the consciousness into the necessity to listen to the syntax, grammar, and vocabulary of the written or spoken word. These written or spoken words can carry very real and important truths of their own, but they cannot carry the truths that the language of sculpture can. If we teach people to hear words when they see sculpture, then they will become deaf to this singular language, and that is a loss to them because it is a unique language that has spoken to mankind for so long, and so richly.

BRUCE BEASLEY

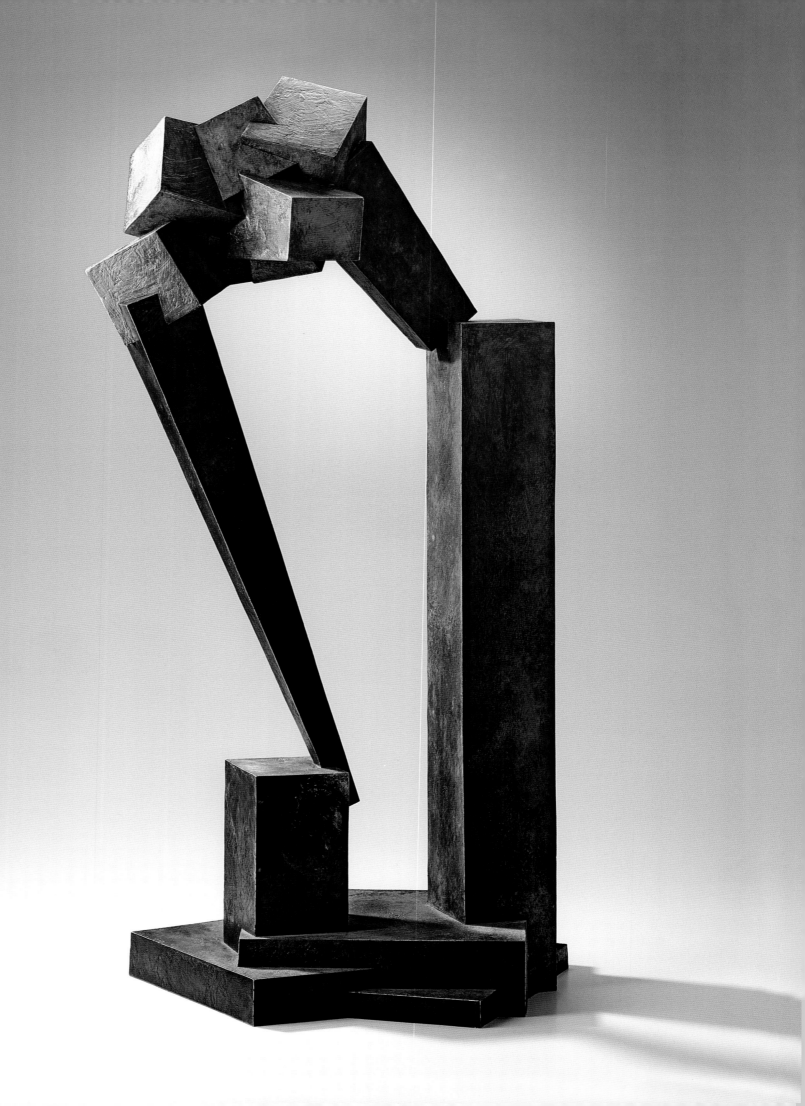

BRUCE BEASLEY: IN FORM PETER FRANK

Plate 1 [facing]. *Harbinger*, 2001. Cast bronze, 53 × 28 × 19 in. Hood Museum of Art, Dartmouth College, Hanover, New Hampshire.

The modernist era is not yet over. Postmodernism and, now, neomodernism are simply chapters in the history of our civilization's mind-set. The digital era may mark the true end of the modernist epoch, but even the advent of the cyberculture bears earmarks of modernist thought and practice. Modernism is going slowly, but not gently, into that good night.

At the lip, then, of the cybernetic age, the modernist spirit makes one last declaration of its values and achievements. In some discourses this declaration takes the form of neomodernism, a reconsideration and reavowal of modernist attitudes tempered by the anti-ideological skepticism of postmodernism. In other discourses, however, modernism itself recurs. Many creative individuals still maintain their faith in perceptions and practices identified with modernism per se—and many of those individuals exercise that faith with skill and conviction sufficient to sustain the persuasiveness of modernist practice.

This may sound in fact like a romantic notion, a stance of defiance, a rearguard action against the old modernist bugaboos of philistinism, pedantry, and vacuousness. The stance assumed by today's unreconstructed modernists (and, for that matter, reconstructed neomodernists), however, is not *against* anything, it is *for* a way of thinking and working, a self-possessed and self-justifying praxis that puts individual vision in dialectical relationship with communal perception and builds on the dynamics as well as—perhaps even more than—the resolution of that dialectic. Harmony is thus posed as the logical ordering of dissonances; experiment yields failures that are as revelatory as successes; knowledge grows with every challenge. Modernism is the most fluid of orthodoxies.

Bruce Beasley, for one, still professes fealty to this modernist steady state, the prevailing mode of discourse in his formative years. This attachment of Beasley's to the aesthetic of his youth is not ideologically (much less nostalgically) impelled. Rather, the aesthetic itself impels Beasley's larger worldview. His loyalty to modernist practice springs entirely from personal need. The man simply must fashion form, for its own sake. Shape, to him, is a universe of experience.

Beasley keeps practicing his modernism, finely wrought over four decades, out of an abiding curiosity as to where such practice takes him. The trajectory he has determined for himself within the modernist galaxy continues to provide him intellectual and experiential, even sensual, adventure. He justifies his modernist approach not through its implications, but through its results—that is, his sculpture stands for (and as) nothing but itself, and it must succeed as formal experience. In this, Beasley hews to modernism's formalist position, the art-for-art's-sake strain that has constituted the bedrock of modernist practice for a century and a half. The non- (or anti-) formalist position, proposing modernism as an ideology of progress, simply does not apply to Beasley's work—and not because the evolution of culture has robbed modernism of its progressive model. The teleological reading of artistic change dominated the discourse of Beasley's youth, and, along with so many artists of the time—especially on the West Coast —Beasley chafed at the imposition of such a deterministic criticism. It seemed inappropriate to his approach, that of his

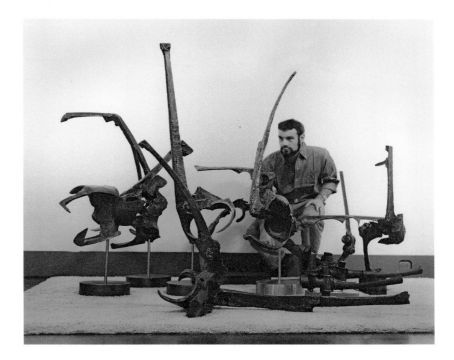

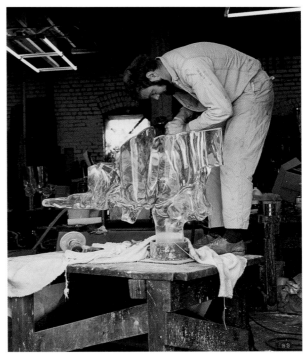

Plate 2 [facing]. *Tree House*, 1960. Welded cast iron, 24 x 15 in. Private collection. (See also plate 25.)
Fig. 2 [top]. Bruce Beasley installing show at Hansen Gallery, San Francisco, 1965.
Fig. 3 [bottom]. Bruce Beasley polishing acrylic sculpture, original Lewis Street studio, 1968.

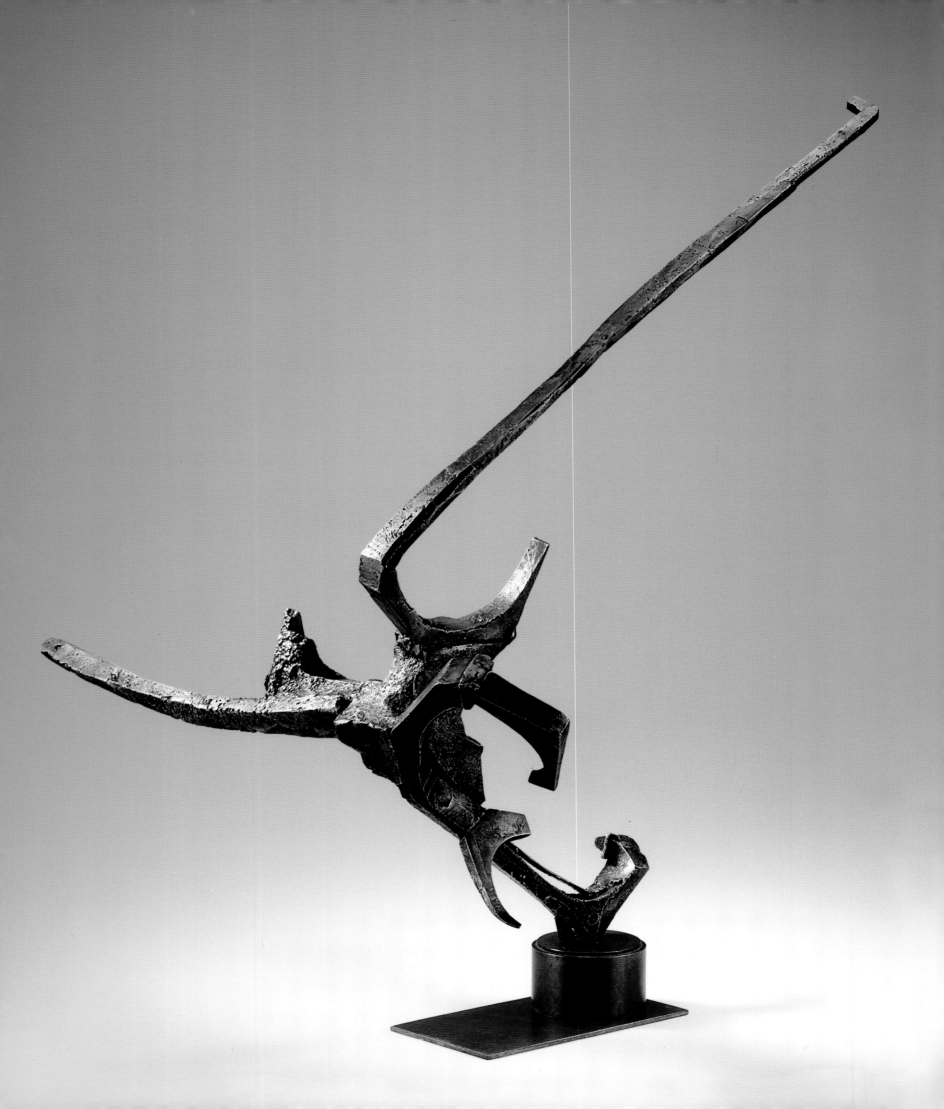

peers, and even that of his teachers. Beasley is no futurist (the occasionally apparent influence of Boccioni notwithstanding); he is, you might say, a presentist, interested primarily in the affective *presence* of a sculpture.

Being a good modernist, however, Beasley has always been engaged in and influenced by innovation—not novelty but true inventiveness, his own and that of the individuals and forces around him. In early-1960s California, for instance, innovations in both heavy industry and popular culture were shaping a new discourse of process among artists. Many of them had fashioned hot rods or surfboards in their adolescence, and many (and/or their friends and family members) had worked with new materials such as fiberglass and polyurethane. Such "form-giving" with new substances not only became accepted in the making of fine art but also weighed heavily on the kind of art being made. In southern California, this industrial innovation prompted the emergence of high-tech, high-craft artistic modes such as finish/fetish sculpture and light-and-space installation. Beasley had customized his share of cars as a teenager, and he was as responsive to and comfortable with the postwar milieu of new materials as today's adolescents are to the universe of computers.

Although a native of Los Angeles, Beasley realized his artistic leanings elsewhere: first back east, and then in the San Francisco Bay Area. He self-identified as an artist—indeed, as a sculptor—during his early college years at Dartmouth. The discovery of this inclination was profound, prompting him to leave the Ivy League and return to California, where he could participate in the sculpture classes and facilities offered at the University of California, Berkeley. Close contact with the improvisational pedagogy-by-example of Peter Voulkos, tempered with the more sober instruction of other teachers, most notably Sidney Gordin, immersed Beasley in a veritable theater of inspiration and fabrication, at once as free-form as a frat house party and as directed and goal-oriented as a baroque artist's atelier. When he and his classmates identified needs, artistic or technical, they fulfilled those needs themselves with brio and bricolage—for example, by initiating and building Cal Berkeley's first metal-casting foundry. Similarly, when looking for inspiration for work, Beasley was wont to scavenge junkyards, discovering provocative form in the discards of the late machine age. What had been cast out, he now recast.

In itself, of course, this impulse to assemblage was not innovative in the modernist context. Indeed, the late 1950s and early sixties saw a surge of such activity on both coasts, activity of which Beasley was certainly aware. California sculptors such as Bruce Conner and George Herms were cobbling together elaborate structures out of varied discards. And on the East Coast, Richard Stankiewicz, Mary Follett, Mark di Suvero, John Chamberlain, and others were working in manners even closer to Beasley's, welding and casting from discarded metal and other materials. What distinguished the work of the young Beasley—still an undergraduate—from that of these slightly older artists was its relatively straightforward and, in some ways, traditional methodology. For one thing, he was equally interested in welding and casting, while the other sculptors relied more or less entirely on welding. For another, while most other metal assemblagists, influenced by abstract expressionism, tended to combine disparate shapes and materials into coherent but open, essentially centrifugal structures, Beasley welded together closely packed, and closely related, shapes and materials. Indeed, typical early sculptures fuse shards of a single broken object (most often a length of industrial pipe) back together in an entirely nonfunctional composition—a dense, poised, and rhythmic structure unlike the expansive formations of the New York sculptors. Other metal assemblagists at the time worked, as Beasley did, with clustered shapes derived from a single source—for example, Jason Seley's sculptures were fashioned entirely from automobile bumpers—but, while he soon came to know and admire their work, Beasley initiated his assemblage series on his own.

Beasley's exposure to his fellow metal assemblagists' work was due heavily to his own early success and the opportunities he began receiving, even before he had received his BA, to exhibit with them on the national and even international stage. Curator William Seitz's inclusion of *Tree House* (plate 2) in the seminal 1961–62 Museum of Modern Art (MOMA) exhibition The Art of Assemblage placed Beasley's work in a

Plate 3 [facing]. *Icarus*, 1963. Cast aluminum, 36 x 36 in. National Museum of Modern Art, Pompidou Center, Paris, France. (See also plate 41.)

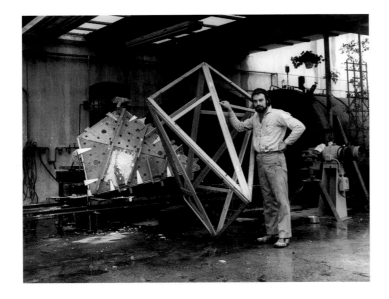

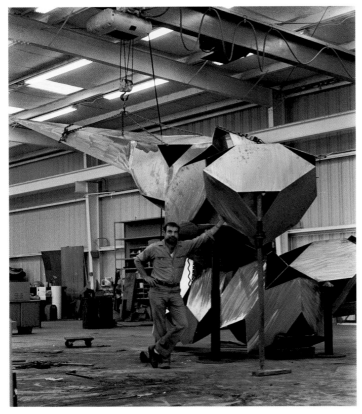

Fig. 4 [top]. Bruce Beasley with stick model and mold
for *Tragamon*, original Lewis Street studio, 1972.
Fig. 5 [bottom]. Bruce Beasley with stainless steel
sculpture in progress, new Lewis Street studio, 1983.
Plate 4 [facing]. *Stamper's Lighthouse*, 1967. Cast
acrylic, 29 × 23 × 16 in. Collection of the artist.

historical context even before it had acquired its own history,
and MOMA's subsequent acquisition of *Chorus* (plate 13)
made Beasley the youngest artist until then to have been
brought into that august collection. That all came about
through MOMA's influential curator Dorothy Miller, who first
saw Beasley's work as juror for a competition at San Francisco's
own modern museum, then found it again at Everett Ellin's
prestigious gallery in Los Angeles (where Beasley enjoyed his
first one-man gallery exhibition in 1963). Miller clearly recog-
nized Beasley's distinctive contribution to the new mode of
"junk sculpture," which she held in particular esteem (her sur-
veys of current American art in 1959 and 1963 included the
work of Stankiewicz, Seley, Lee Bontecou, and others), and
she recommended it to Seitz on her return.

Beasley's youthful work continued to receive significant
recognition. He was one of eleven sculptors associated with
Cal Berkeley to be featured in the 1963 Biennale de Paris—
and he received the Purchase Prize, given at each biennial by
the French minister of culture, who at the time happened to
be the world-renowned writer and philosopher André Mal-
raux. The work thus acquired for the *Musée Nationale d'Art
Moderne*, *Icarus*, was not a welded-pipe piece but a piece cast
in aluminum from found-Styrofoam forms, an approach Beas-
ley began exploring in 1962. The earlier cast-aluminum (or, if
you would, lost-Styrofoam) sculptures resembled the welded-
iron works in their clustering of discrete forms into basically
rectilinear dispositions. But even by late 1962 Beasley had bro-
ken out of this centripetal formula; the cast-aluminum works
would subsequently follow a very different schema, markedly
centrifugal, in fact highly animated and emphatically linear,
although always fashioned around a distinct mass. While the
welded-iron works never gave up their semblance of machin-
ery, the cast-aluminum sculptures, with their extended limbs,
exuberant poses, and bone-like segments, frequently con-
jured the human body—in extravagant motion. They com-
manded an anthropomorphic sense of kinesis, the same
contorted, dance-like abandonment that energizes many of
Auguste Rodin's later small figure studies—a relationship that
could not have been lost on Malraux.

Beasley professes Rodin's influence—he was aware of it

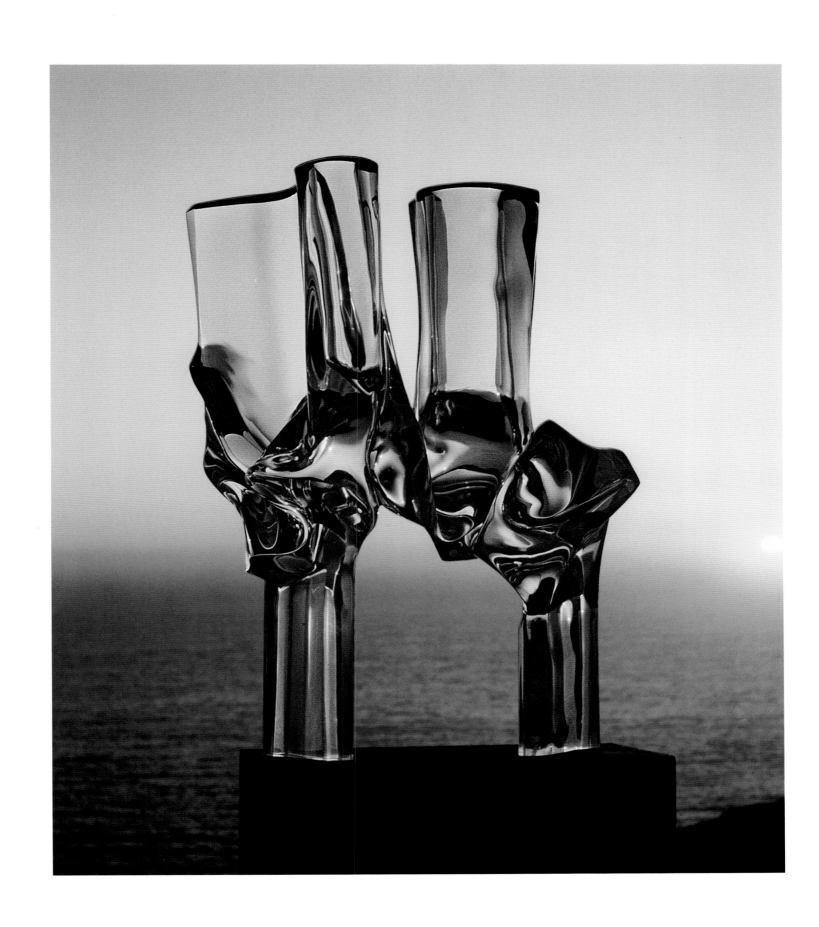

Fig. 6. Bruce Beasley with mold for cast-iron sculpture, Siempelkamp foundry, Krefeld, Germany, 1999.

almost from the moment he became aware of his own proclivities for sculpture—and it clearly bore on these cast-aluminum works. But from the first, what interested Beasley in Rodin's works was their abstract quality rather than their figural presence—Rodin's "stretching toward pure form," in Beasley's words (see page 44 of this catalogue). This "pure form" was Beasley's own grail from the moment he took up sculpture and remains so to this day. Many of his objects can suggest the human figure, as well as animals, architecture, topography, even the weather; and, up to a point, Beasley does not discourage such associative apprehension of his art. But he goes to great pains to clarify his own intentions—he does not seek to suggest such imagery—and to assign responsibility for such apperception to the viewer. "What I want to do is evoke feelings," Beasley cautions, "not evoke images. It is not about resemblance. Resemblance is just the skin of the truth" (see page 53 of this catalogue).

From the modernist standpoint Rodin's ultimate depen-

dence on the human form can be seen as a circumstance of time and place, a circumstance that prevented the sculptor from abandoning the figure entirely. Similarly, Constantin Brancusi's more tenuous adherence to figural reference a generation later marked the Romanian sculptor as a product of his time. By Beasley's era, reliance on exterior reference had become entirely elective. Pop artists and others reacting against the proscriptions of their abstract-expressionist and constructivist teachers brought the figure back in a variety of ways, but other artists emergent in the postwar era chose to maintain and, at best, exploit and extend the idiom(s) of pure abstraction. Obviously, Beasley counts himself among the latter; not as obviously, Beasley chooses to adhere to modernist abstraction as much through intellectual reasoning—grounded in his awareness of not only art history but all human history—as through personal preference. Beasley's impulse is to "pure form," but he supports his impulse with intellected argument rather than with defensive self-indulgence.

In doing so, Beasley quite deliberately gives the lie to the popular image of the sculptor as an inarticulate, macho fool, a gifted ape unable to explain even to himself his reasons for making what he makes. Indeed, Beasley's own interests range far and wide—and, notably, most of them bear at least indirectly on his art-making. His fascination with physics, biology, archaeology, and anthropology, as well as with the histories of these and related human investigations, has prompted him to amass collections of non-Western artifacture, animal skulls, and early-modern scientific illustrations related to, among other things, anatomy, botany, and crystallography. The forms of plants, bones, masks, and minerals that thus festoon Beasley's Oakland residence recur uncannily in the objects of his own invention, new and old, that occupy his studios next door.

Further underscoring the sculptor's potentially crucial role in the world, Beasley has repaid his debt to science with the invention of a process central to recent oceanographic research as well as to industrial construction and fabrication generally. In this, Beasley also fed back to the "California tradition" of material innovation that nurtured him as a boy and steered him toward sculpture. Not surprisingly, this invention

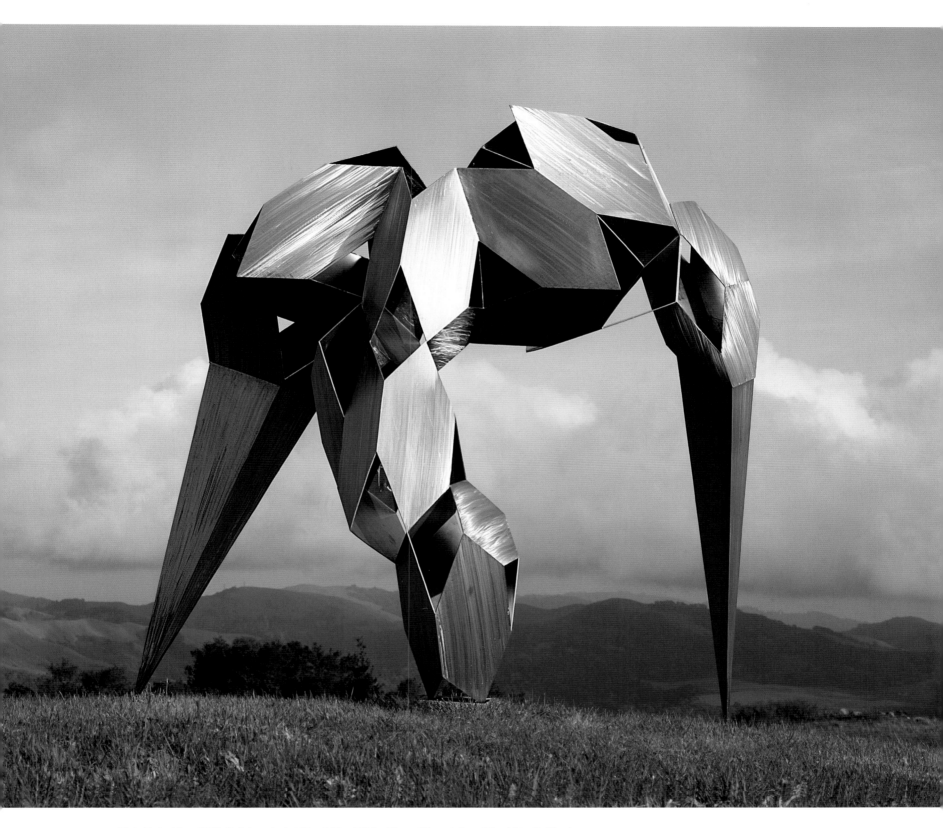

Plate 5. *Arristus*, 1981. Stainless steel, 148 × 168 × 132 in. Djerassi Foundation, Woodside, California.

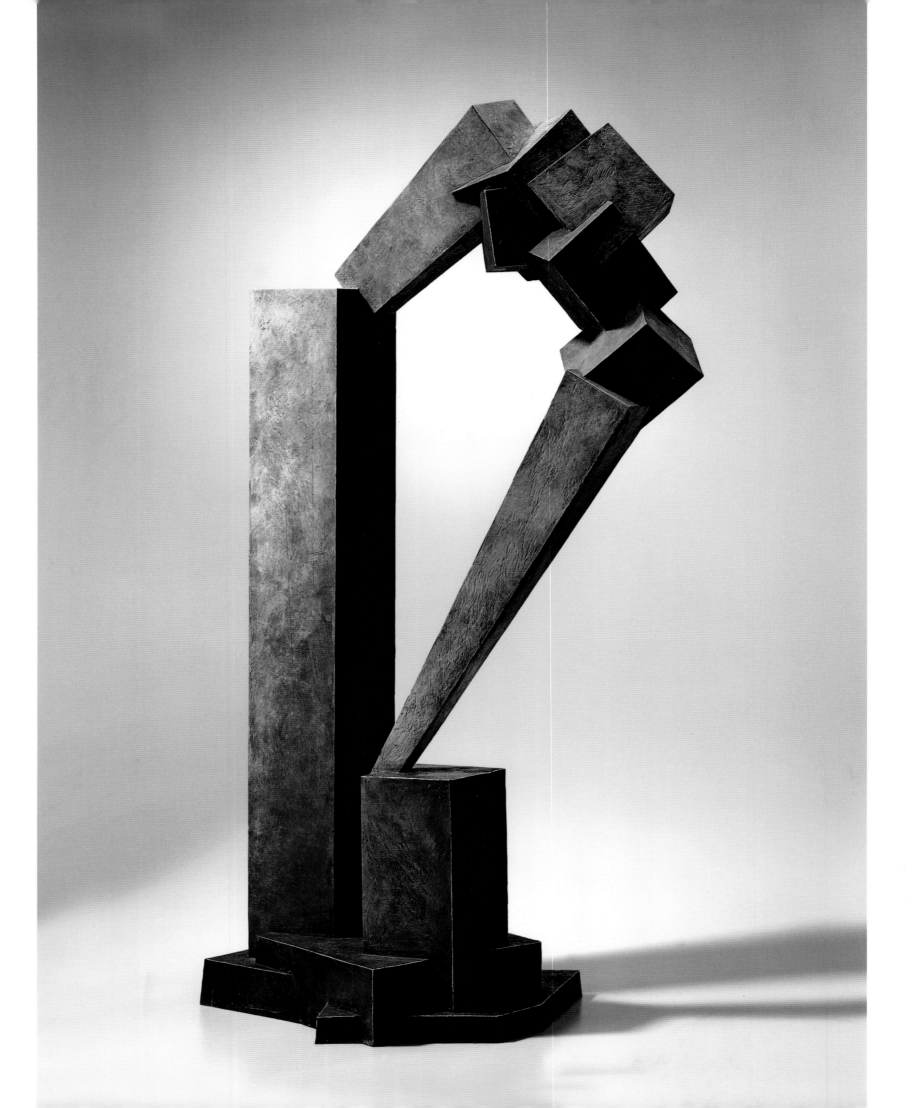

resulted from Beasley's growth, formally and intellectually, as a sculptor. By 1968, he felt he had exhausted the formal and evocative possibilities of the cast-aluminum works. Op art, video art, the "psychedelic revolution," and other new, often technologically driven, methods of creating sensation had resulted in a broad dissatisfaction among artists. New shapes were no longer enough to change conventional perception; the times demanded more thorough methods of providing optical, and haptic, stimuli. In this atmosphere of profound perceptual change, it could be said that Beasley proceeded cautiously; after all, he did not resort to motorization, lights, or other electronically driven modes of spectacle, as so many other sculptors did. But he did "break on through to the other side"—quite literally.

"I started imagining sculptures where the eye would not know where to stop," Beasley recalls. "The idea was of the eye being drawn into, through, and past the sculpture so that you would see things that are behind the sculpture, in the sculpture, not as reflections but seeing them in it. I wanted them to act as lenses, where you would see through to whatever was behind but distorted and changed, bringing color and light into the sculpture" (see page 52 of this catalogue). To achieve this effect, Beasley turned to solid acrylic polymer resin. But he was faced with what technicians identified as an insurmountable problem: acrylic could supposedly not be cast more than four inches thick. Leave it to an artist, working out of vision and necessity (specifically, a fabrication deadline), to solve that problem. Having won the competition for the California state capitol plaza commission with a proposal for a transparent sculpture, Beasley determined a way to cast acrylic resin at virtually any thickness. After experimenting for a year and a half with an autoclave pressure oven and liquid Lucite given him by DuPont Corporation, he was able to fabricate the six-ton object entirely out of acrylic.

Beasley had defied the conventional perceptions not only of the art audience but of the industrial chemists, and he realized he was sitting on a process that could have important applications in the "real" world. And indeed it did. His technique for mass-casting acrylic has come in especially handy in the realm of marine exploration, given the material's near-absolute imperviousness and resistance to exterior pressure. It has permitted the construction of much larger and sturdier aquarium windows and has brought about the virtual reinvention of the bathysphere (a reinvention in which Beasley was involved), which in turn has led to far deeper oceanic probes. Given the variety of life found at the bottom of the sea's deepest trenches over the last three decades, Beasley is probably being too modest when he claims that his transparent bathysphere has led to the discovery of "more than a thousand new species of fish" (see page 52 of this catalogue).

Beasley himself worked entirely in transparent acrylic from about 1968 (his first sculptures in this medium were realized the previous year) to 1980. He continued to employ cast acrylic through much of the 1980s, but he also worked in metal and wood during that decade. Although they do not (and could not) feature the same hyperextended limbs and sharply articulated segments as the cast-aluminum works, the earlier acrylic sculptures reiterate the aluminum pieces' organic fluidity and intricately modeled surfaces. This muscular, and almost aqueous, quality refracts the light shining through the sculptures to the extent that the light seems to become part of the objects' mass. While attractive, however, this effect still allowed the eye "to stop," so Beasley sought a format that allowed his acrylic yet more transparency.

In 1970 Beasley produced a series of more geometric works, essentially crystalline forms studded with large, circular concavities and convexities. Light and image appear far more distinctly in these sculptures' facets and curves. Here, then, were the distorting and mutating "lenses" Beasley had sought to create. By 1972 he had absorbed these sharply described facets and evenly formed bubbles back into more irregular, supple compositions, objects that once again rippled with almost animal energy. But Beasley could now hold onto the pellucidity he had sought, infusing these otherwise inert lumps of plastic with interior light and the changing drama of their surroundings as well as with the complexity of their own surfaces.

In 1980, faced with a glut of commissions that seemed to demand a different kind of work than that fashioned of acrylic resin, Beasley posed himself another challenge. He did not

stop making the acrylic sculptures until mid-decade, but he began simultaneously to explore a markedly different approach. Having conquered a limitation others set for him in the realization of his own goal, Beasley now set himself limitations and, almost as if playing a game, explored where those limitations led him. The rules of the game were simple: work in metal (normally stainless steel) or wood with a single module, a flat hexagon, two facing sides of which were longer than the other four. The formations fashioned from this rhomboid could be supported by non-rhomboidal extensions (usually very elongated three-sided pyramids that taper away from the rhomboid clusters), but the rhomboids would comprise the core of each work.

The results were at once surprising and characteristic. Beasley put the rhomboids together in ways that left pronounced gaps among and between them, giving them a somewhat honeycombed appearance. As intricately as he could design the interplay of modules, Beasley could not divest them entirely of their mechanical flavor. Nor did he really want to. He used that mechanistic stiffness as a foil against the often startling choreography he was able to effect with the pyramidal extensions. Aiming them every which way, Beasley was able to coax the extensions into suggestions of legs, arms, and antennae. Building on the biomorphism of his cast-aluminum works, he infused these mechanical concatenations with a sometimes graceful, sometimes comical voluptuousness. It was in these modular sculptures that Beasley hewed closest to science fiction, inventing giant mechanical insects and choreographing them into circus acts of irresistible charm.

By the time he gave up acrylic for good in 1986, Beasley had also tired of the modular approach. He had "won" both the battle for transparency and the game of hexagons. A foray into Cor-Ten steel, a slight modification of the modular formula (closing the gaps, changing the modules themselves to cubes), and the engagement of the computer as a drawing and designing tool all combined with a renewed interest in bronze casting to instigate the series of sculptures that has continued until today. The basic formula this series involves essentially schematizes Beasley's career-long approach to composing sculptures. He coheres disparate parts into a convincing whole but never allows the parts to mesh seamlessly; their articulation within the mass of the whole gives the whole its dynamic. The whole is in fact a sum of parts—what Albert Elsen called "eccentric union" (see page 26 of this catalogue) —and every part is distinguishable from every other, but the whole would dissipate were even one part removed, and, isolated thus, that part would be meaningless as a shape of any consequence. Unity in Beasley's work is a matter of coherent arrangement as opposed to the surrender of identity to fusion; every shape is an actor in the drama of the sculpture.

The temptation here would be to extend the choreographic metaphor and call every shape a dancer in the sculpture's dance. But the physical kinesis the sculpture conveys demands that it *not* be subject to such closely allusive reading, lest the sculpture's physicality be perceived entirely as "choreography." The metaphor of the theater is more oblique, allowing the sculpture its abstracted self-possession. Given Beasley's modernist ethos and the modernist aesthetic evident throughout the beautifully but plainly wrought cubistic formations he has fashioned over the last two decades, such self-possession and emotional reliance on "pure form" must be the focus of our attention.

The sculptures Beasley has been producing elucidate the relation of plane to volume. Although contour remains significant, even striking, Beasley now emphasizes the volumetric aspect of his shapes. The attention he continues to pay to line draws attention away from the silhouette and toward the line that plays *within* the sculpture, the moments of joining or fracture where the discrete segments meet and fall into one another.

More than one commentator has identified these relationships as "tectonic," and in their elementality—and their almost audible sense of impact—they do seem geologically dramatic, to the point of cataclysm. At the same time, and despite their craggy angularity, they maintain that animal elegance that has given Beasley's work a subtler level of intensity since the cast-aluminum pieces of the sixties. Despite their delicate patinas, they do not appear handmade, nor do they appear as if they themselves have hands. But even the most stolid, architectonic among them effervesce with a simmering energy,

a promise that, despite the seeming permanence of their material, they will not maintain this particular conformation forever.

The majority of these plane-to-volume sculptures have been cast in bronze, but Beasley has called them "materially neutral." Unlike most of his previous series, the formal vocabulary of this one does not technically or aesthetically require the employment of one particular substance. Beasley has also fabricated plane-to-volume pieces in wood and in several different kinds of granite (traveling to India, Portugal, and China to quarry and fashion the works). Likewise, he has employed a number of differently colored and textured patinas on his bronzes, changing the mood and presence of a work simply by darkening its surface or giving it a bluish tint.

The plane-to-volume sculptures are the least radical works in Bruce Beasley's forty-plus-year oeuvre—and yet they provide him with the richest vein of form and material he has so far mined. They confirm him as a dedicated modernist—not a neomodernist but a direct inheritor of modernism per se, a student of its students, a bearer of its flame. Beasley's technical innovations, his evolving formal vocabularies, the continuity of his sensibility, and his overt dedication to form as content all mark him as an unregenerate, and unapologetic, modernist. They embody his faith in the self-sufficiency of the art object and the ability of that object, in its self-sufficiency, to affect human perception. Beasley's dedication to modernism has also meant that he has soldiered through the vicissitudes of the artist's life with stoic determination as well as unbridled joy. He has always lived to make art. But what makes Beasley the artist he is, is the integrity of the art he makes.

Los Angeles September 2004

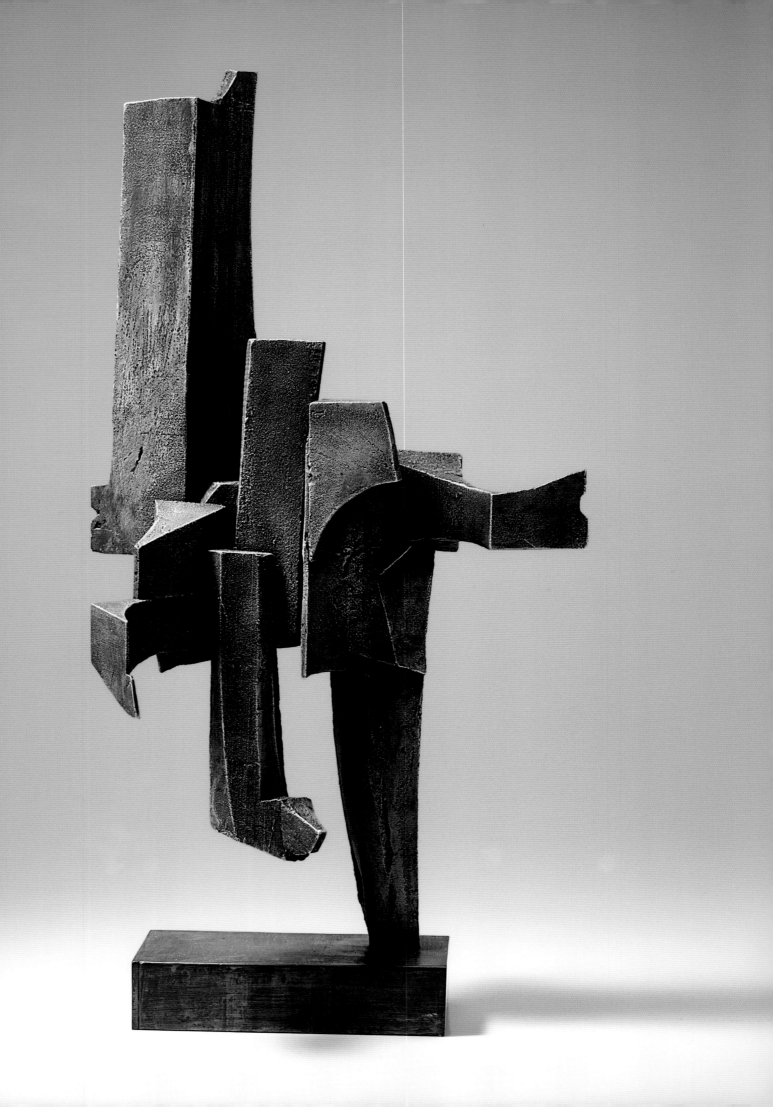

BRUCE BEASLEY'S PERSONAL "CUBISM":

1987–1990 ALBERT ELSEN

WHAT THESE SCULPTURES ARE ABOUT

They are about the beauty of formal structures invented by the artist and inspired by nature. From the considerable culture he brings to art, Beasley has drawn his inspiration from natural structures, rather than the built environment. Science and the microscope have changed the modern artist's understanding of nature as shown by Beasley's explanation: "The major source materials for me are what I call the building blocks of nature. People tend to think about natural forms as tree bark, waves, the bodies of animals, or people, but much more basic forms of nature are crystalline structures, molecular building blocks, and bones. I'm very interested in the way nature refines things down to very simple forms, and how it puts things together."

All quotations are from the author's interviews with the sculptor in 1987 and 1990.

Plate 7 [facing]. *Prometheus*, 1962. Cast aluminum, 38 × 18 × 15 in. Private collection.

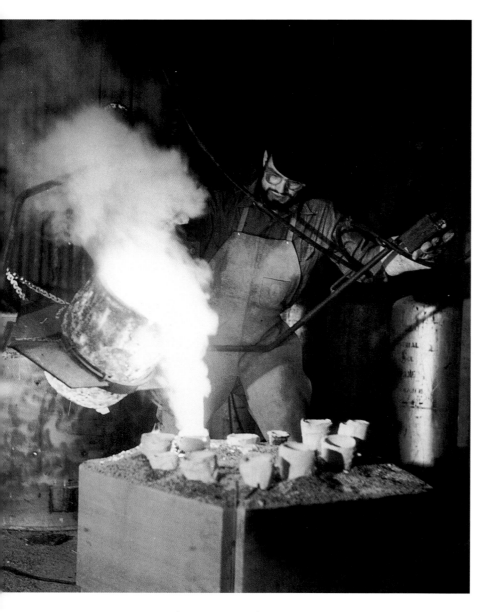

Fig. 7 [above]. Bruce Beasley pouring
bronze, Cypress Street studio, 1963.
Plate 8 [facing]. *Lemures*, 1961. Welded cast iron,
19 × 15 in. Private collection. (See also plate 27.)

In the past learned artists manifested their erudition by illustrating literature, history, myth and the Bible. In modern art the absence of the human figure and narrative have not prevented a well-educated artist such as Beasley from putting his learning at the service of the technical, formal and thematic aspects of his sculpture. "Information for me is freedom: freedom to make more choices." An instance is Beasley's long research on plastics years ago that led him to invent a technique that allowed large-scale, controlled castings of acrylic; another is his study in the UC Berkeley Geology library that resulted in consultations with scientists about his models. Particularly admired by Beasley are 19th-century German books on crystallography with beautiful hand drawn pen and ink illustrations. Filling shelves in one of his studios are skulls and bones from humans and animals. It is these hard armatures, not flesh or fur, tissue and muscle that navigate his voyages of curiosity. Among his living contemporaries that work which comes closest to Beasley's in inspiration and focus, though not in appearance, is the open form art of steel spars and cables by his friend Kenneth Snelson, who has been interested in the way natural structures are held in continuous tension. In the modernist tradition, Beasley does not see sculpture's purpose as providing the viewer with things the mind already knows. The sculptor's vision is to see what could be. His sculpture adds to, rather than confirms, our knowledge of what structures can look like that perform no practical function, such as do an architect's building—or chemist's molecular-models. Beasley's forms are dictated by a purely intellectual and aesthetic inquiry. (The modest dimensions of the recent works invite the thought that they are models for future enlargement, but this is not the case, as size and scale are intended to be one.) His purpose and personal reward are, as he puts it, that "I want to be able to take someone to a place he is not able to get to on his own." That "place" is not social wisdom but "emotional territory." Never are the sculptures intended as political metaphors or social symbols that offer a veiled commentary on a tragic human condition. There is no underlying theme of the sculpture except that it is perhaps form itself. They do not deliberately invite free-association, but as with certain types of music that demand strict attention to a sequence of sounds,

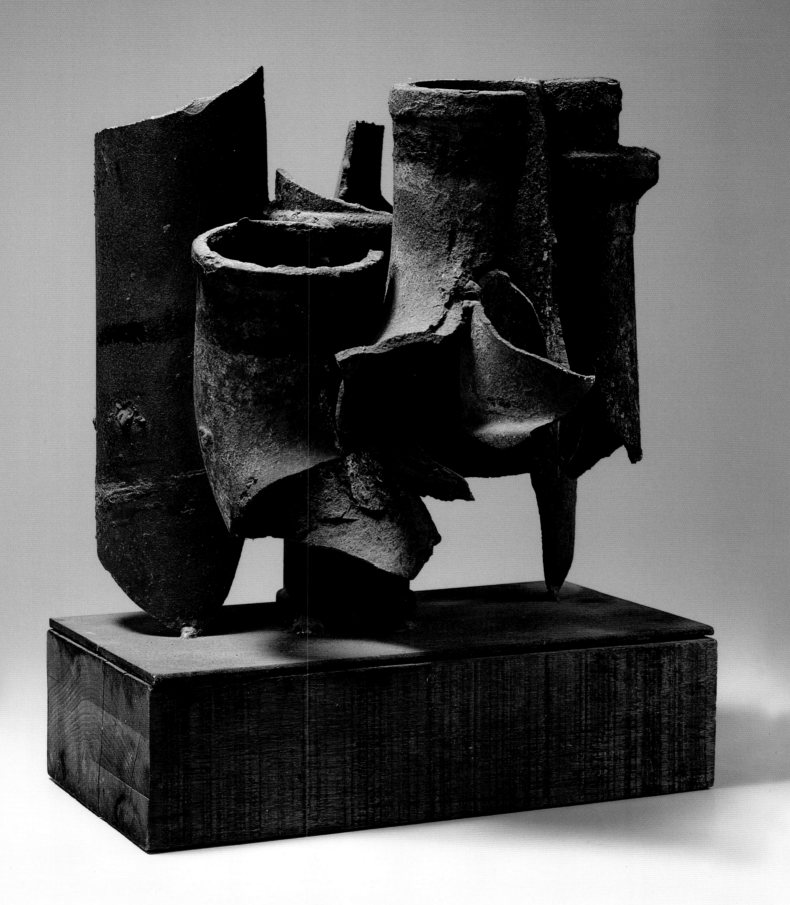

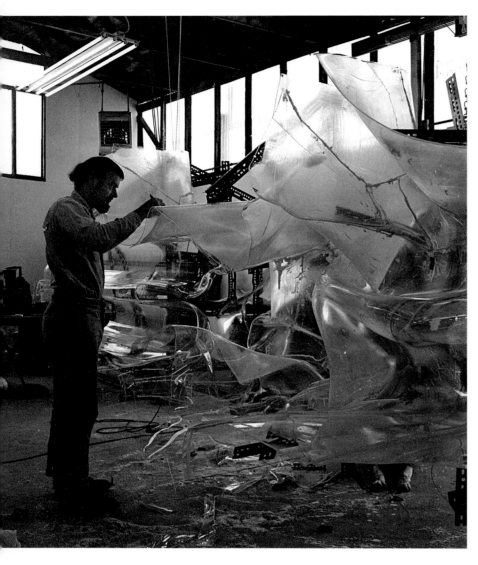

Fig. 8 [above]. Bruce Beasley making the mold for
Apolymon, original Lewis Street studio, 1969.
Plate 9 [facing]. *Hephaistos*, 1963. Cast aluminum,
45 × 36 in. Private collection. (See also plate 47.)

Beasley's constructions require that attention be paid to a series of sights that overall reveal the intelligence and beauty of their form. In the artist's words, "When you join a group of shapes that alone had no significance, and they sing when they're together, that is the best feeling there is." Not for the first time in modern art's history, it is the artist affirming that this is what his art and specifically sculpture alone can do with tangible forms in light and space.

A SCULPTOR'S CURSE: THE PERILS OF SOLVING PROBLEMS TOO WELL

It is a given that sculptors have special aptitudes for forming and joining three-dimensional shapes. They have an affinity for tools, endless patience, and because of demands on ingenuity and time, a love/hate relation with the sculptural process. With Beasley these attributes go back to youthful experiences of building racing cars. When we met in 1963 it was in a foundry he had built that allowed 200 pounds of molten metal to be poured by him alone, a feat that would have amazed and delighted Cellini.

Beasley was later to win international fame with his optically illusory lucite sculptures for which he, and not Dupont, had to solve the problems of controlled casting of acrylic in big sizes. Within the limits of his needs, the sculptor has taught himself: mathematics, geometry, trigonometry, chemistry, physics, and engineering.

When modern sculpture expanded beyond modeling and carving stone, wood and bronze, artists were confronted with new possibilities and technical challenges. As a result, and unlike the case with painting, the public and many critics have been more obsessed with how sculpture is made than with what the sculptor wants to show. (This essay recognizes such curiosity.) The curse visited upon the sculptor such as Beasley who is especially gifted in solving major practical problems is that some will see his audacities with the sculptural process as outdistancing his formal venturesomeness. Overlooked is the fact that for Beasley, vision determines process, not the reverse. Unlike those of science, his artistic problems are

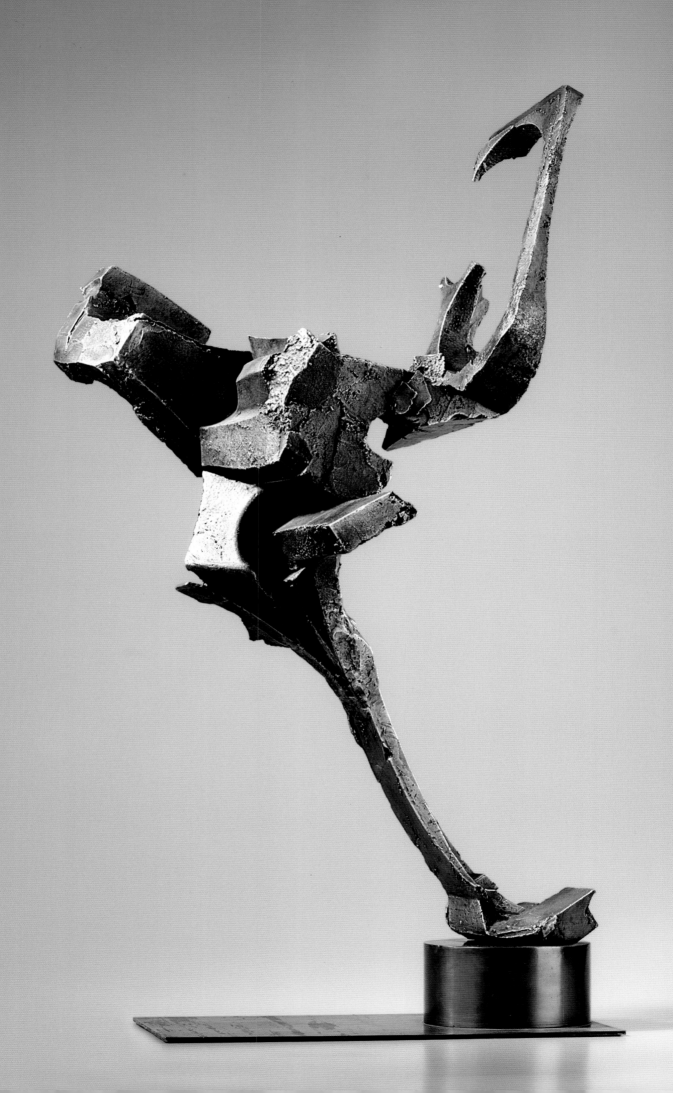

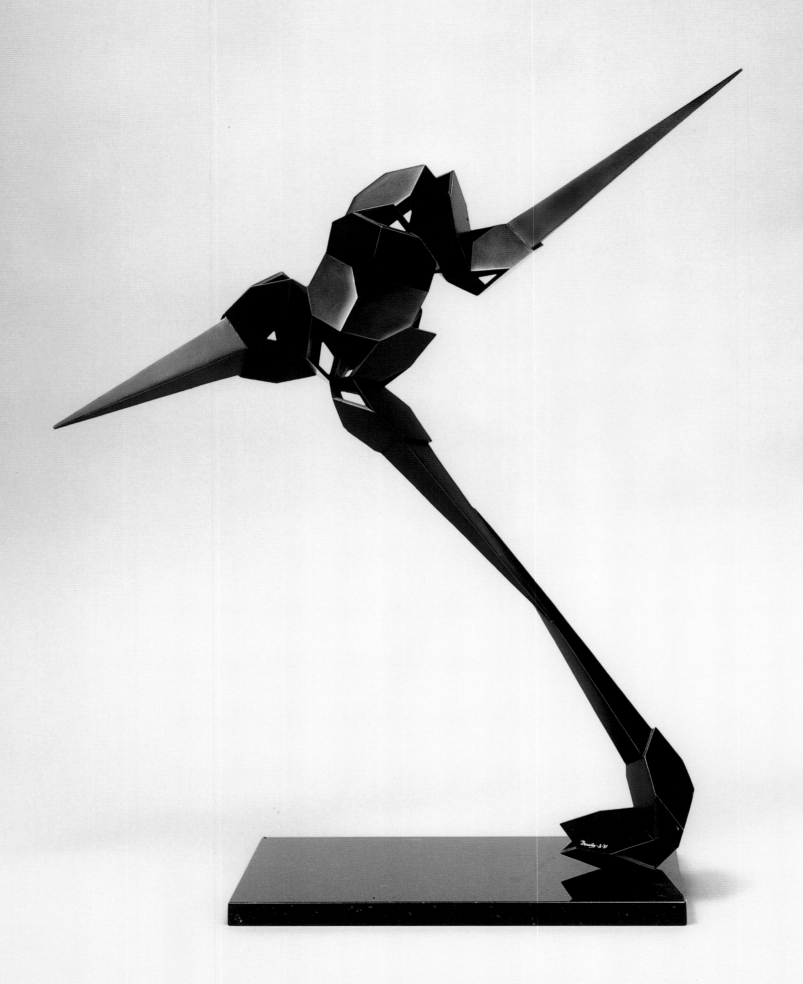

personal in origin and if he doesn't solve them nobody else may care or try. Example: his revolutionizing of certain sculptural procedures was at the service of his ideas and questions, which created initially such problems as, how do you get light and space inside a sculpture? In 1988 it was: how do you move people emotionally by the complex intersection of simple geometric forms?

A corollary to the judgment that the technically astute artist is prisoner of his processes is that there is an absence of artistic growth and risk-taking in his art. The inappropriateness of such a critique being applied to Beasley can be shown by the way he has drastically changed his art in successive decades: in the Sixties he worked in welded iron and aluminum casts of assembled industrial discards; in the Seventies he developed variations on various polyhedrons in cast acrylic; in the Eighties he built his hexagonally based open structures in steel. Left by each change were not only disappointed collectors and dealers, but Beasley has entire studios stocked with the extensive and expensive tools that each process required. (So much for no risk-taking.) Beasley's has been a genuine intellectual evolution, not an evasion of formal invention by substituting one material for another, as these were decided changes in imagery to which the material was inexorably linked. Explaining motives for his most recent change the artist recalls, "The images still had a psychological charge for me, the process of finding new ones didn't . . . I felt I had plowed the field." The connectives in these transformations were Beasley's style, consistent excellence of their fabrication, and conscious striving for quality, all of which mirror his mentality.

IN QUEST OF QUALITY

Like obscenity and pornography, quality is defined in the dictionary, but it is still such an elusive concept to discuss and apply that one identifies with the Supreme Court Justice who said that while he couldn't define pornography he could sure recognize it when he saw it. In our consumer society quality has been usually identified with how well goods are made, but now we associate it with certain kinds of time spent with

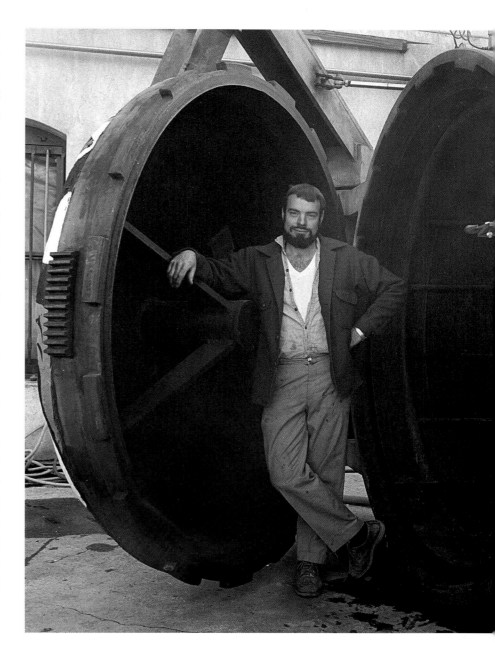

Fig. 9 [above]. Bruce Beasley in the door of the autoclave used to cure the acrylic sculptures, 1970. Plate 10 [facing]. *Terina*, 1981. Cast bronze, 32 × 21 in. Private collection. (See also plate 112.)

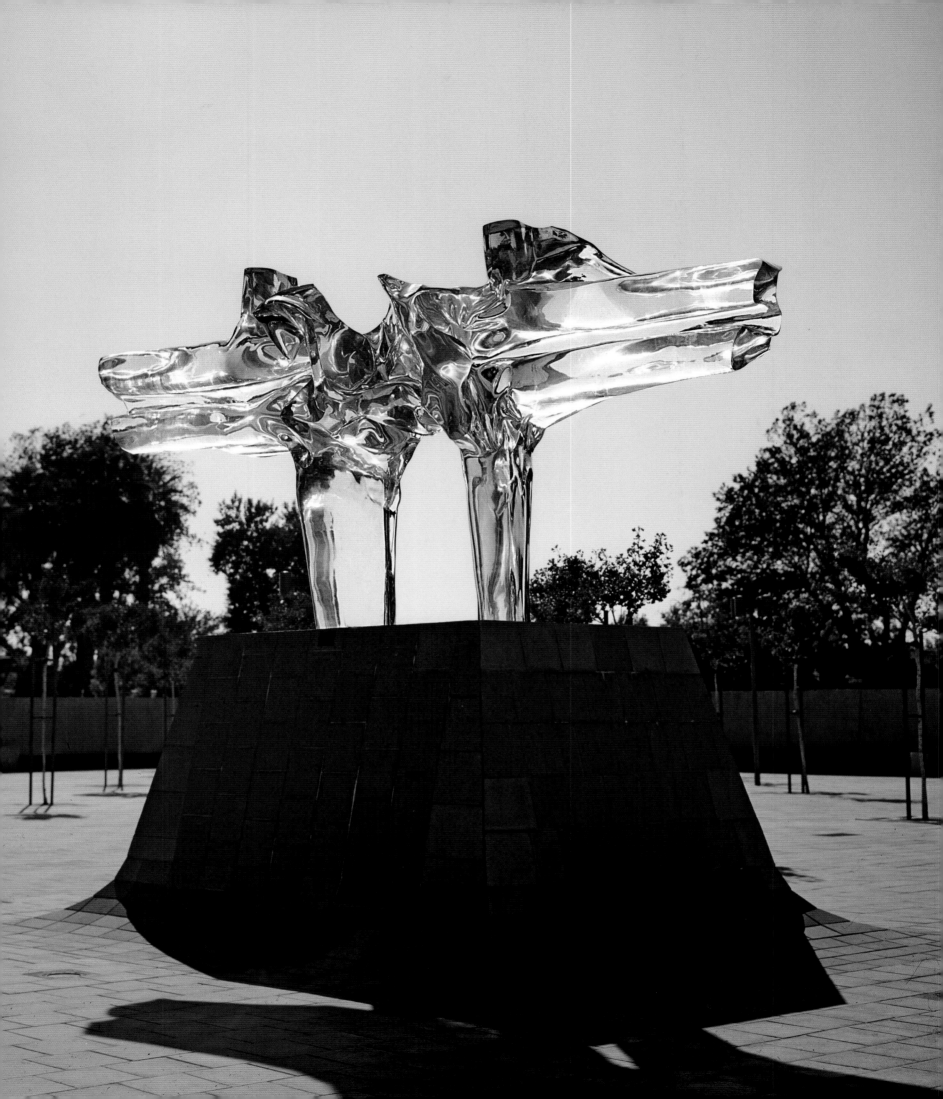

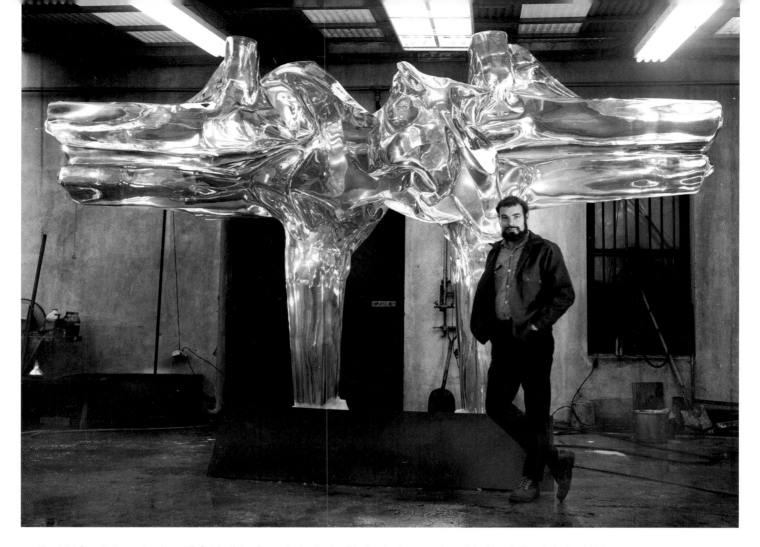

Fig. 10 [above]. Bruce Beasley with finished *Apolymon* just prior to shipping to Sacramento, original Lewis Street studio, 1970.

Plate 11 [facing]. *Apolymon*, 1970. Cast acrylic, 108 × 180 × 72 in. State of California, Sacramento, California. (See also plate 71.)

others. For Minimalists in the Sixties, quality was something associated with European art, and with forms of subjectivity such as taste, and was therefore to be shunned. Robert Morris had a certified public accountant witness a document in which the artist proclaimed that there was no quality in his work. As the Minimalists were artists who, for the most part, drew simple designs on paper for sculpture to be made by craftsmen they were not giving up any personal professional investment. Fortunately for us and for art, not all artists who engage in an art of simple forms are indifferent to quality. For Beasley quality includes but means more than the well-made. In fact, he doesn't want to divert the viewer's concentration by the excellence of his technique. The personal standards by which he evaluates his own sculpture comprise the quality of thought as expressed in the final composition and the coordination of all the components that include material, color and

the relation to the space the work occupies. Does the sculpture reflect his mind when it is most awake? Above all for the serious artist, whether or not we can define it in words, quality means esthetic durability, a sculpture not wearing out its intellectual and emotional welcome.

THE MORE THINGS CHANGE . . .

At this stage in his career Beasley has not re-invented his basic vocabulary but changed his grammar, and found that his visual language "is much more materially neutral," meaning that it can be expressed in many materials, including stone as well as metals, but not acrylics. As with nature's "building blocks," he relies still upon an art formed from known simple geometric shapes that are then joined in complex relation-

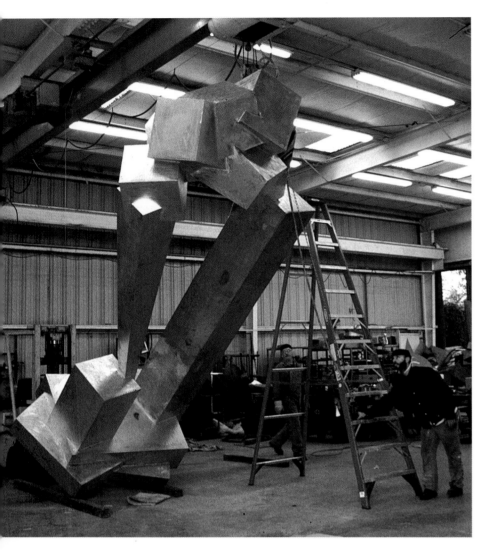

Fig. 11. Turning over *Quest* with Dan Dykes and
Albert Dicruttalo, new Lewis Street studio, 2001.

ships. With the Seventies acrylic pieces, Beasley opened an optically rich inner life to the transparent cube. The appeal of the transparent image "was the visual ambiguity that occurred when the eye was not sure where the surfaces were." Recently the constant is the conjugation of several closed cubes by bringing them together in unpredictable conjunctions such that they seem to lose their original identity and become complex and often surprising polyhedrons. "I don't want these to be visually ambiguous. I want the viewer to know where the shapes are." In all this is a playful use of geometry for serious artistic purposes.

Though not inspired by the classical Cubism of Picasso and Braque, Beasley's cubism, with a small c, shares with this older art the principle of fragmentation, such that no shape is totally self-sufficient or completely independent of those it adjoins. In American abstract sculpture the art of simple forms based on geometric-like volumes in eccentric union that was developed by David Smith, Tony Smith, James Rosati and others, provides Beasley's art with an impressive and nourishing background. The originality of Beasley's personal cubism and recent contribution to the constructivist tradition lies in what he chooses to emphasize: a new means of integrating simple shapes, not by their addition to or contiguity with each other, but rather their mutual interpenetration. As will be shown, the inspiration for this grammar and the resulting fragmentation principle owes much not to the history of modern art, but also to that of technology.

Within the evolution of his own sculpture, and in the last three years, Beasley has moved from thin hexagonal sheets to cubes, to closed volumes rather than flat planes that surround and divide space. Weight wins over lightness. Continued is the art of plain flat-faced forms in unpredictable union, these perform similar sculptural gestures to those found earlier in the cast aluminum and steel pieces, for example. Such configurations include cantilevering into space, a rugged, seemingly precarious arching, and the whole form springing usually from a stance of multiple points. A continued and calculated paradox is that Beasley wants his formal structures to have a sense of dynamism, to seem animated, as if perilously poised, and having the implication of movement, something not normally associated with cubes. Not unlike Arp's biomorphic and baseless *Conceptions*, Beasley's structures are susceptible to various orientations, sometimes including inversion.

In structures like *Bateleur* and *Keystone* (plates 141 and 117), a paradox perhaps inherited from David Smith is at work: the utmost calculation is at the service of giving the look of the unarranged or casually assembled, in bronze! The artist is playing with a co-existence of contraries, a precise kind of geometry used in what seems a casual way. These recent structures are less predictable in the round than before partly because no sides line up so that they touch a common plane.

They display new curved profiles as he begins to re-engage his polyhedral forms with a sphere. (In the cast acrylic sculptures hemispherical cavities were introduced into the polyhedrons.) And then there is the use of patina. The application of acid to raw bronze offers Beasley what had been for his art a missing dimension: surface nuance of inconstant color and texture. A suggestion of sensuousness counters the touch-repelling severe rectilinearity of the shapes. All these changes add up to a more overt appeal to feeling in order to balance an art with a strong address to the mind and our inclinations to look for the measurable and resolutions of threats to balance, or to see gravity confirmed or defied.

AGING AND SCULPTURE ARE NOT FOR COWARDS

None know better than sculptors that growing old is not for sissies. Talking with older sculptors about their injuries and ailments is like listening to a retired professional line backer recount his medical history. Unlike professional athletes, sculptors don't retire, but both learn early to "play with pain." As wise sculptors age they learn to do more with less. The difficult is not avoided, but made easier. The physical toll of having worked with heavy materials and tools, at times reflected on by Beasley in a hospital bed, makes this imperative. The body of a fifty-year-old man was not made for weeks of working all night grinding metal surfaces. To avoid becoming captive of his past art while preserving his artistic identity Beasley has shown repeatedly a brave willingness to take chances. He covers his bets with an avidity for technical know-how and the discipline of research to renew his sculpture at less physical cost. In so doing he has recently solved other serious problems that restricted his freedom as an artist.

The conventional wisdom has it that modern sculpture flourished because it was free from the demands of commissioners. Forgotten is that many of the pioneering sculptors craved commissions that would have allowed them to work on a big size in public, but usually such were not forthcoming. We should have learned from older art that often it has been the imagination of the client with regard to a site that has inspired the artist. As exemplified by Calder in his late years, senior sculptors learn to be open to and welcome new challenges offered by clients as a way of reinvigorating their art and thought. Recently given a commission by a San Francisco bank, but never having previously made relief sculpture, Beasley found a wall that he visualized his sculpture might come out of. A new commission by the California city of Antioch offers him a big hill whose complex curvature inspires its use as part of the sculpture. This would not be Beasley's first site-specific work as he has done hanging pieces for two airports, but gives him a chance to relate his sculpture to the earth in a new way.

FREEDOM'S NEW TOOL

The sculptor's equivalent of a painter's doodling is not necessarily mindless drawing, but it often takes the form of "noodling" shapes together with scrap material. This Beasley did for years with left over cardboard as he sought to provoke ideas and spontaneously give form to the promptings of imagination or intuition. When a likely form thus emerged it took countless hours to be transformed into a true working model. The precise nature by which shapes were made and fitted precluded improvisation during the cumbersome "making" process. The time of execution thus substantially preempted that of creation.

In 1987 Beasley was invited to the International Steel Sculpture Symposium in Krefeld, Germany. He was given the opportunity of having for the first time one of his new volumetric models enlarged in Cor-Ten steel to nine feet in height. A team of skilled German steel workers and hundreds of man-hours supplied by the Symposium had to be thrown into the solving of the problem of calculating all of the angles where the cubes conjoined before the steel sheets could be cut. The result was the fabricating of *Titiopoli's Arch* (plate 114), a descendant of *Vanguard* (plate 107) on the Stanford University campus. (A private homage, *Titiopoli's Arch* is named after the Greek who in the third century A.D. was the first to study

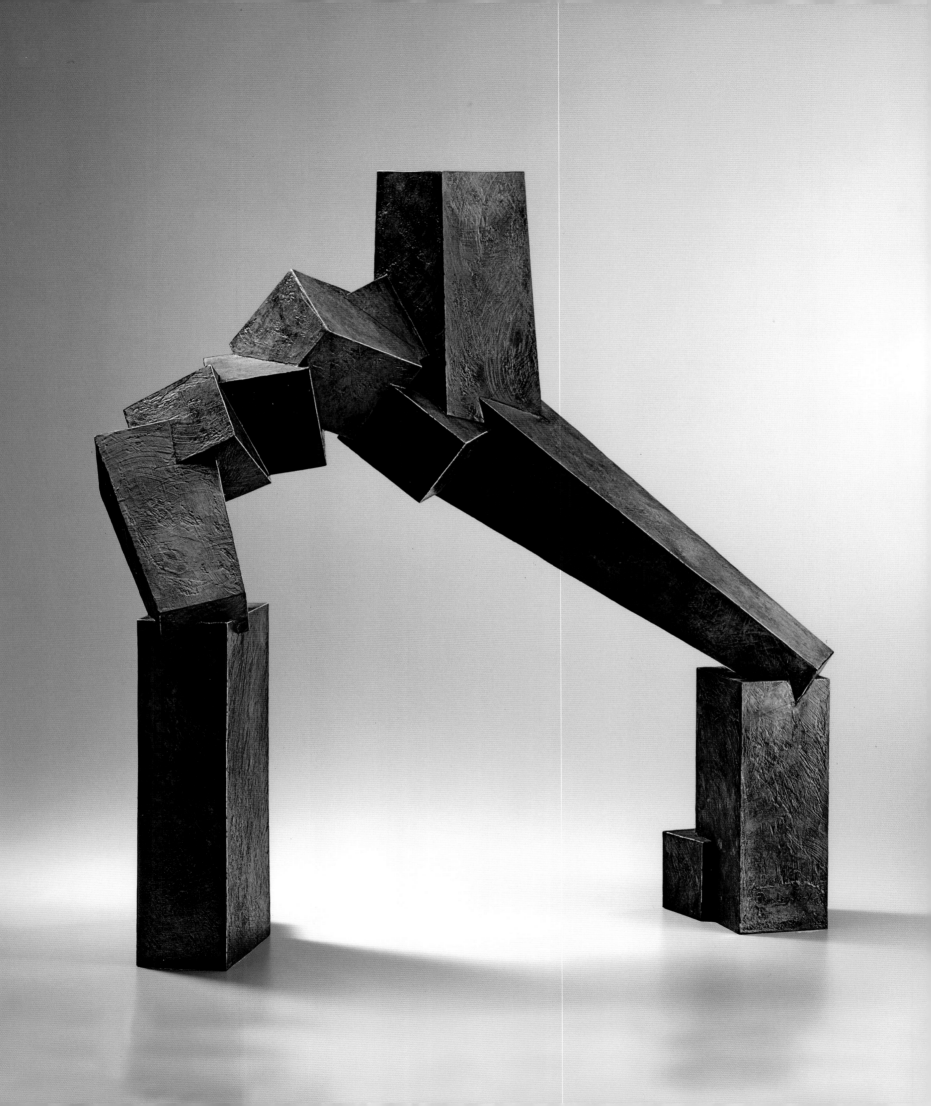

the order and logic of crystals.) Lacking such human resources as were available at the Symposium, Beasley realized that he needed a dramatically different tool.

Crucial to liberation from the tedious labors of making his constructions by hand and trial and error was Beasley's turning to the use in 1988 of a computer and program that allows him to visualize from any angle the complicated cubic conjunctions that he proposes. This required eight months of research and finding a high-end solids modeling program that was developed for aerospace engineering and molecular modeling by scientists. "It lets me do something that I want to do very gracefully."

Throughout his career his sculpture has not depended upon preliminary drawings. Not surprisingly his sculpture has never had the look of the hand-made. Some have equated this absence with an impersonal art. Beasley has wanted his sculpture to refract his mental rather than his manual dexterity. As his style after the cast aluminum pieces was formed largely by the straight lines of his narrow sculptural geometry, Beasley now finds it appropriate and easier to draw with the computer using it as basically a "three-dimensional drawing pad." Unlike a modeller's in clay, his configurations are linear and susceptible to being transformed into digital information.

These computer-assisted drawings are an exciting process of discovery for Beasley, who definitely wants things to happen that he is not anticipating. Cubes of varying dimension and proportion, and usually tilted, do not just abut but are made to intersect one another. "That's where the surprises come. New shapes appear as a result of the intersection that are not known to me, or that I might not have come up with just out of my imagination. The part of a cube that is penetrating out of another one is no longer a cube." That is when the extremely difficult computation of the angles of joints becomes appropriate for the computer. The artist is not only allowed but encouraged by his new tool to treat very spontaneously with a level of geometric complexity invited by the cube. This incentive to make changes owes to the fact that adjustments come in seconds, not days. Beasley had come to feel too restricted by the limited possibilities for rearrangement of

the previous flat shapes of the steel pieces. Another radical change encouraged by the computer is to liberate the sculptor from the tendency to work on a sculpture in terms of its primary view. "When I am working on the computer, there is no front view; I'm working on it completely in the round at all times."

This new tool that allows more time to be creative also permits the most precise drawing of the parts of his new sculptures, whose print-outs can then be used to construct in a new type of board the form that will actually be cast from. (Along with giving their angles and dimensions, the computer can give as well the indications of the cost of making each shape in bronze.) Beasley recognized that gallery-size sculptures could not be fabricated in steel, as small structures would not permit welding inside them. Exterior welding would not give the clean edges he wanted. The solution was to bronze cast when possible the whole sculpture in one piece.

In order to solve the problem of maintaining the precision that his new imagery requires, "the foundry and I had to work out a casting technique that was a variation on the traditional one." Instead of the traditional wax models used for bronze casting, Beasley now employs a "foam core" which is a polystyrene foam panel with KRAFT paper laminated on each side and used for architects' models that can be cut, glued and precisely shaped. The patterns are plotted directly on the foam panel and cut by hand. Over a period of days The Art Works Foundry in Berkeley burns out the foam core in the mold. The bronze is then poured into the resulting cavity. Where big wax surfaces would buckle or bow and require extensive retouching before casting, the "foam core" assures the sculptor that it will hold the plane and a precise edge. With bronze Beasley gains not only editions, strength and durability, but he can introduce more varied color in his art by means of the patinas. Consistent with his preference for not painting his sculpture, Beasley accepts patinas because the color becomes an integral part of the material and is not an applied surface. The irony is not lost on the artist that he is using space age technology to create sculpture in one of the oldest materials and shapes.

Plate 12 [facing]. *Arpeggio*, 2002. Cast bronze, 32 × 31 × 11 in. Private collection.

BEAUTY AND BLIGHT

An illuminating contradiction is that this severely handsome art is born in studios located in one of the most run down neighborhoods of Oakland that could symbolize urban blight in any city. Almost every day in the 300 block of Lewis Street there occurs simultaneously two strenuous and very noisy procedures that characterize our society: construction and destruction—for money. Opposite Beasley's workshops, where new metal forms are being put together for their artistic and financial value, helmeted welders work in a junk yard cutting to pieces, for their worth as scrap metal, old metallic objects that sometimes include originally expensive electronic equipment. Early in his career, reflecting the ethos of sculpture at the time, but particularly the work of Richard Stankiewicz, Beasley did make welded sculpture from junk. He scavenges now among this urban and technological detritus for salvageable often highly sophisticated equipment, not as before for his sculpture's form, but for that which will help him with the process of making his art, such as the hydraulic clamps he found that hold firmly big sheets of metal in order that they be precisely cut.

ART AND CITIZENSHIP

It is as a constructive member of the community, not as a sculptor, that Beasley manifests his anger about poverty and other forms of wastefulness. Most people become composers, poets and sculptors because they like to put together sounds or shapes, not to change the world. Beasley is out to reform sculpture, not society. In 1987 he offered the thought that, "The only reason that I'm an artist is that exhilaration of discovering that I can manipulate new forms."

Such an attitude is fully within the modern constructivist tradition, to which Beasley believes he belongs, and that began with Russian sculptors after the first world war. For constructivists, then, since and now, their reason for being is not to mimic the failings and tragedies of modern society that so many experience daily and know far better than they. When the terrible northern California earthquake of October 17, 1989, destroyed a large section of elevated freeway near Beasley's studios, within minutes he and his 14 year old son were there with those removing the dead and dying from the carnage. How could Beasley experience the horror of the collapse of Highway 880 without changing his art? Was his humanity reserved for what he did at the scene of an unspeakable disaster?

> For the first time in my career I felt I wanted to address through sculpture a particular event and my feelings about it . . . They went further than grief for the people killed and injured . . . I was very affected by the tremendous sense of energy and passion that motivated the efforts of my West Oakland neighbors. What struck me as we worked amongst massive broken concrete and steel columns was that the materials of the freeway had certainly failed in the earthquake, but there was no failure on the part of the people. I wanted to express these feelings some way through my work, and I fixed on the idea of reusing material that had failed in order to pay homage to the people in my neighborhood who had stood tall. When the freeway was being demolished, I explained my intent to the foreman in charge of loading the scrap metal and he gave me permission to take a few hundred pounds of steel reinforcing bar . . . It was crucial to the idea of the sculpture to give new form to the actual material from the freeway. The owners of Micro Metals in Richmond were sympathetic to the idea and were willing to melt and pour the steel at no charge into a mold that I had made. The sculpture is called *Pillars of Cypress*, with reference to the steel and concrete pillars that collapsed, and the human pillars that did not. It is not surprising that the sculpture has a vertical tapered column with tumbled and fragmented forms at the top and bottom. I hoped to achieve the feeling that the vertical column is enhanced in its strength by the fragmented chaos of the other elements.

Pillars of Cypress (plate 118) is the artist's personal memorial and tribute to the failings and heroism of others. It is also about how Beasley accommodated his experience of a terrible tragedy on his own artistic terms. In large part he was here treating a failed engineering structure and also investing his geometry with human associations. This event may not bode

a radical change in Beasley's art towards responding to human events, however. In his maturity and from history Beasley has learned that each must do professionally what he or she does best. The rest is for other forms of good citizenship. An artist's humanity is evidenced not just by what he doesn't do, but in all that he does. Although it may not always be their conscious intent, through their invented, austere and abstract harmonies, artists like Gabo, Mondrian, David Smith and Beasley reassure us of the constructive potential of the human mind. They have created tangible poetic analogies to the diverse balances in life that each of us seeks in our own way.

THE READER'S FINAL EXAMINATION

For those skeptics who believe that art such as Beasley's is without any significant meaning or relation to the time and place of its origin, and as an alternative way for readers to interpret personally the sculpture they have been reading about, consider the following question as an intellectual challenge. Know first that Beasley's home is filled with striking examples of tribal art. The American Indian masks, blanket and boat, and the Oceanic masks are valued not because of deep study by their owner but because they effect him strongly and take him into "emotional territory" he can't get to on his own. An imaginative if not scholarly collector, he knows generally that they served to give tangible form to collective beliefs in styles that were like the mother tongues of their respective cultures. Secondly, remember that the interpretation and misinterpretation of ethnic art has long been an academic industry. I now invite the academic audiences for this exhibition to imagine Beasley's new sculptures a hundred years from now in the homes of say hypothetical Oceanians who are art collectors and cultural anthropologists. What might these bronze configurations say to intelligent and perceptive outsiders of American culture about our achievements and values at the end of the 20th century?

Stanford University 1990

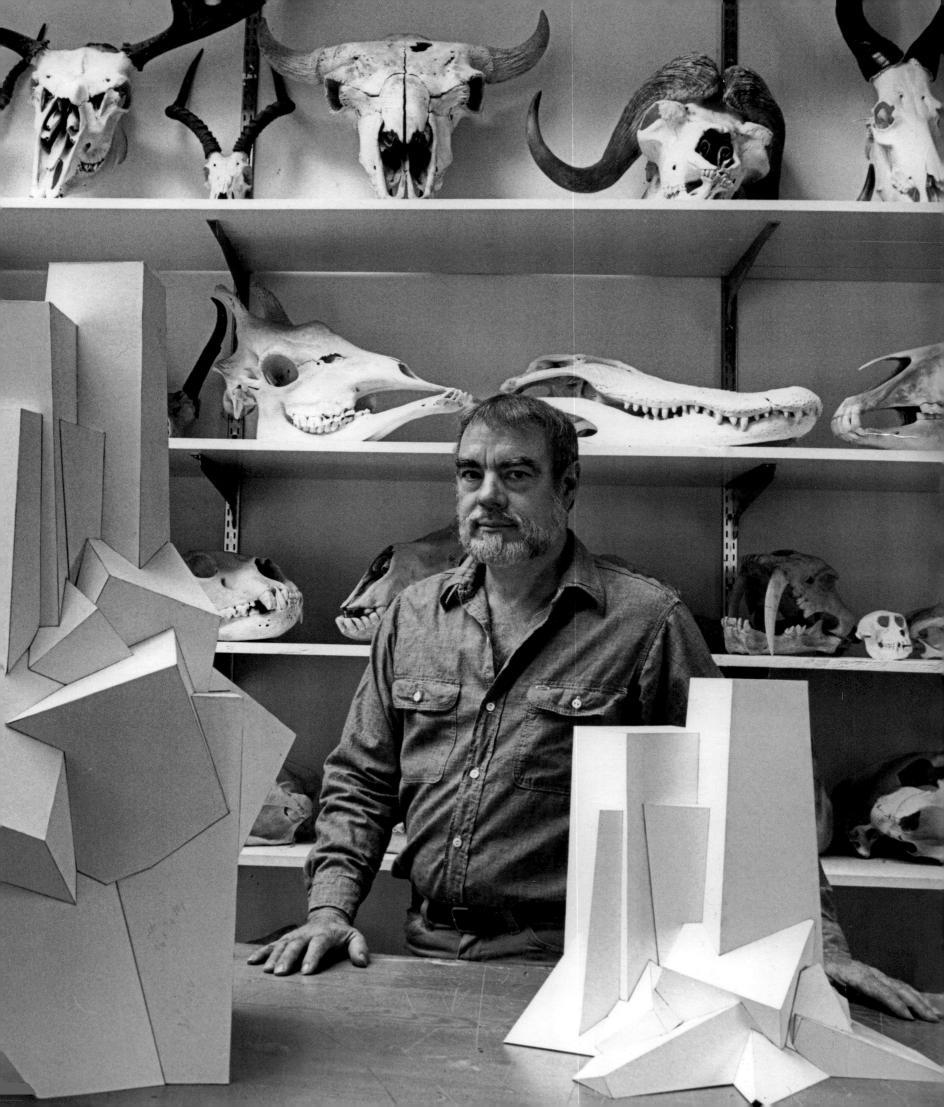

PF: Bruce, your car's license plate would seem to say it all: 4ME3D. Or, "for me, 3D." That sums up your commitment to sculpture. But there's also, and equally, your commitment to a modernist vocabulary of form. Indeed, your vocabulary *of* form, *about* form.

BB: You're right. For some reason, form as a language in itself has made sense to me from the very beginning. I've never felt it's about the abstraction *of* something. Form and shape to me are, themselves, a human language.

PF: Do you find that the forms generate themselves, that they spring fully formed from your mind, or do they take off from things that are seen in the natural world?

BB: I don't see finished sculptures in my head at all. I'm a responder. The sculpture comes out of an investigation of form. I play with shapes to get a dialogue started. For instance, if you confronted me with just a block of stone and a hammer and a chisel, I really wouldn't know what to do. But give me three blocks of stone, and then I'll start to arrange them together. My impulse is essentially that of a constructive builder: respond, and then change. The welded, broken cast-iron pieces, the ones shown in The Art of Assemblage show at the Museum of Modern Art, came out of that impulse.

My sculpture comes out of a lot of "What if?" questions:

What if I put this shape together with that? What if I add this? What if I change that? And very often the answer is: it's boring. Nothing is happening. Then some little thing happens, and that starts the direction that the sculpture is going to go. But I don't know what's going to happen when I start.

PF: When we were looking at the piece called *Storm* (plate 140) early in the current series, you pointed out formal equivalents to the conditions of the sky in a storm. Now I understand that that parallel image, that kind of physical metaphor, is not what you had in mind when you began the work, but it emerged as you formulated it.

BB: Yes, I think it's like that. I feel that when it starts going right, the sculpture is talking back to me. When it's not going right it's not a sculpture yet, it's just an experiment, but when it starts talking back to me, it comes alive. I'm involved with it, but it now has an existence independent of me. Officially I "create" the sculptures, but I've always felt it's more that I *discover* them.

PF: In that respect, the blocks of stone you were talking about—we expect Michelangelo to chip away until he finds the form—does have a direct relationship to you. It's just that you make your discoveries by putting blocks of stone together.

Fig. 12 [facing]. Bruce Beasley with models and skulls, original Lewis Street studio, 1994.

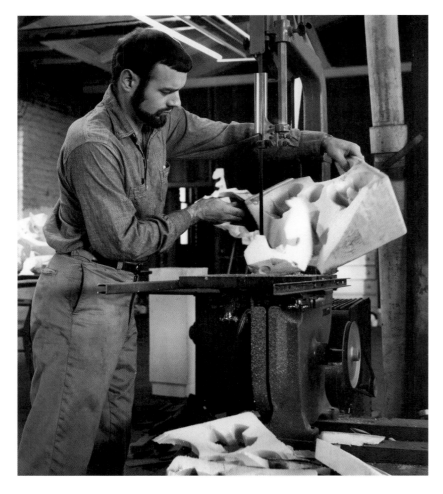

Fig. 13 [above]. Bruce Beasley cutting Styrofoam,
original Lewis Street studio, 1966.
Plate 13 [facing]. *Chorus*, 1961. Welded cast iron,
14 × 24 in. Museum of Modern Art, New York, New York.

BB: And changing my mind. [*laughs*] I love to change my mind, you see. That's the problem with direct carving.

PF: Do you change your mind, or does the work change your mind?

BB: Sometimes it's both, because sometimes a sculpture says, "I want to go this way," but other times, when I'm not discovering anything, I have to see if I can find that vein of gold somewhere else.

PF: It sounds like you're almost in a kind of improvisatory dialogue with the object you're working on.

BB: Yes, it's actually sort of a collaboration between me and the sculpture.

PF: Between you and the materials?

BB: The collaboration is with the shape, not the material as much. However, with the acrylic work, the material *was* a core issue. But part of what I'm enjoying so much about the newer work is that it's very independent of material. It's really a dialogue of form and shape, period. The material later becomes a vehicle for that dialogue, but it is simply carrying it. The material is not a core issue.

PF: What about the aluminum pieces?

BB: Using aluminum was just a practical way to make the work. They were made from assembling cut pieces of Styrofoam. The problem was that, because of the varying thicknesses of the shapes, it was almost impossible to cast them hollow. If I cast them solid, in bronze, they would be too heavy, but it worked to cast them solid in aluminum. So the aluminum was just a very practical solution to a technical problem. The impulse of the shapes was not material-driven.

PF: And the cast-acrylic work?

BB: That was the one instance where the material was central to the aesthetic question. I actually set myself a formal challenge. I wanted to see if I could make transparency, combined with shape, an aesthetic issue. I felt that had not been done before. And so I set that as a question to myself, and I think I answered it.

PF: I'd like to talk here about what you've said, and written, about abstraction in sculpture—especially as it differs from abstract painting.

BB: Abstract sculpture is different from abstract painting in that it is perhaps more natural to us. Sculpture and painting exist in separate perceptual spaces. Sculpture exists in the same experiential and perceptual space that we exist in. Painting, on the other hand, exists in a visual space that is not our perceptual or experiential space. We live in a world of shape and form, and we have physical and emotional reactions to them. It is inherent to us as humans: the path up a mountain, the cliff in front of us, the view over a precipice, the presence of someone standing near us, a crowded room versus an empty room, the majestic space of the horizon. Our fingers anticipate the roughness of tree bark and the softness of a child's skin. All this experiential, visual, emotional physicality

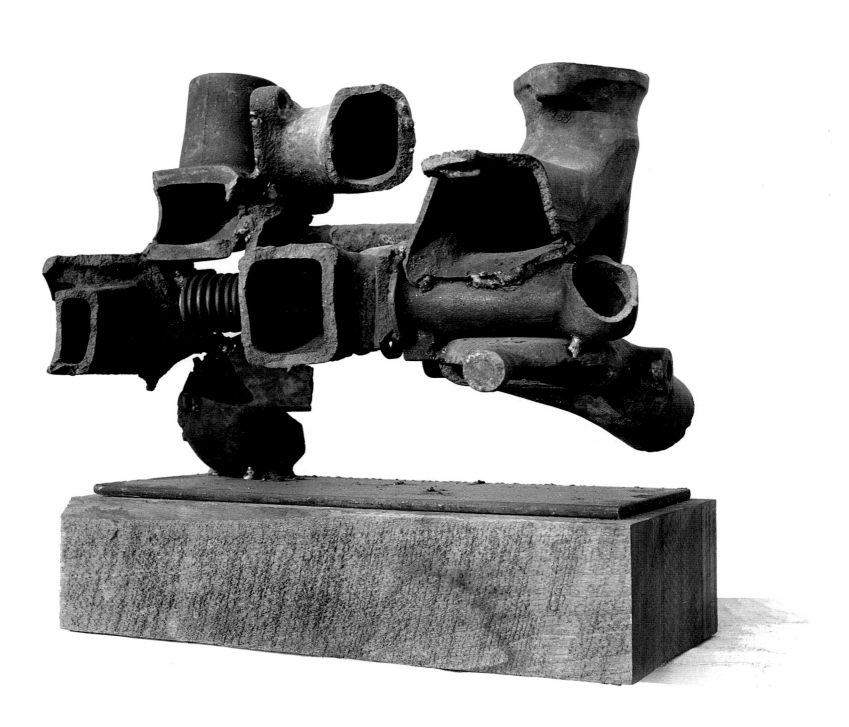

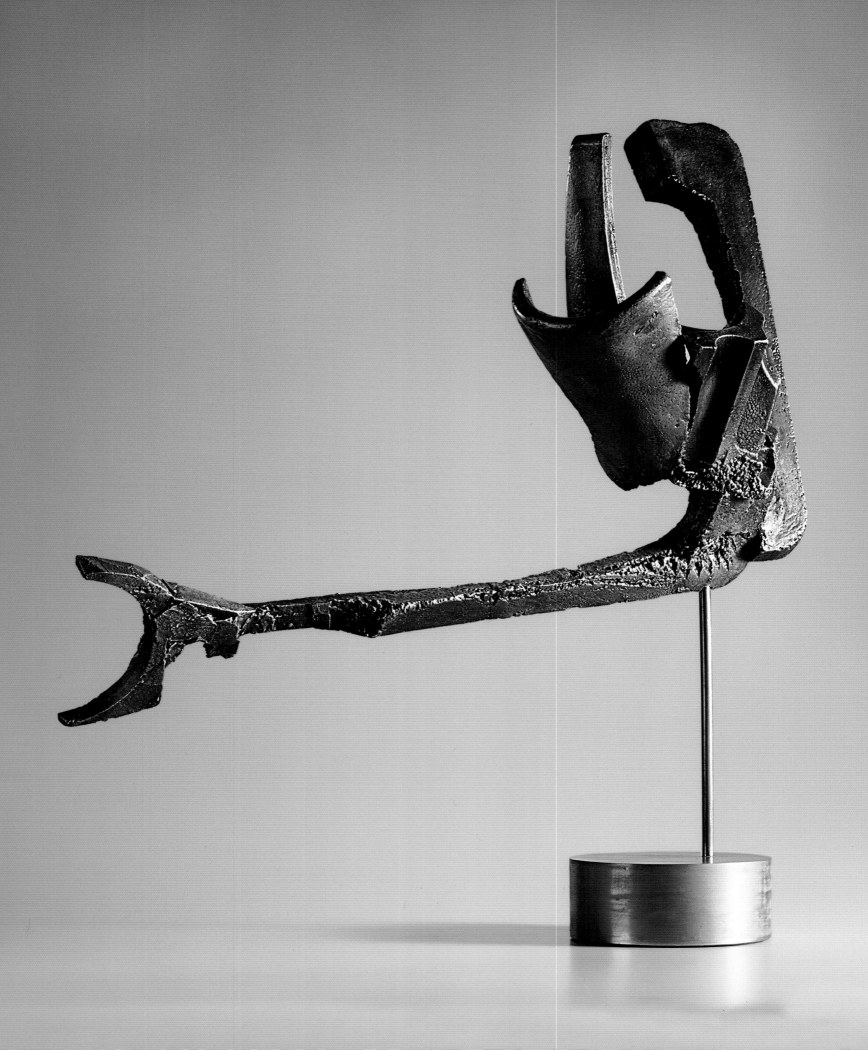

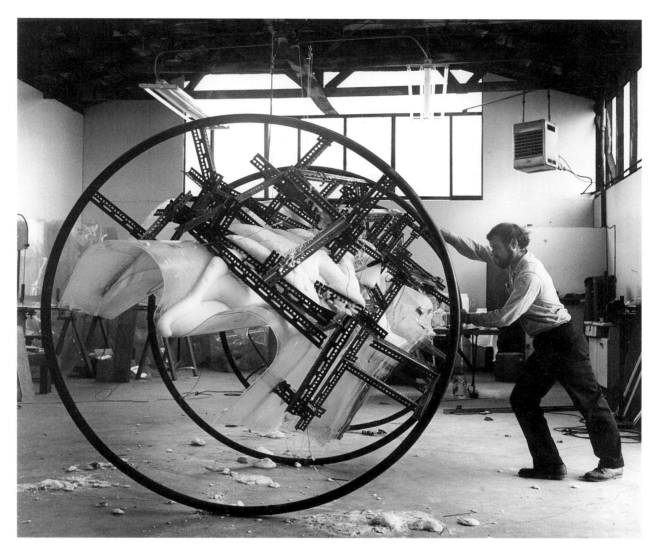

Plate 14 [facing]. *Damon*, 1964. Cast aluminum, 37 × 33 in. Private collection. (See also plate 49.)

Fig. 14 [above]. Bruce Beasley rolling over the mold for *Apolymon*, 1969.

is a part of the language of sculpture. This language is natural to us. It is a language we know from our own experience. This is why abstract sculpture is really not an "abstraction"; it is natural.

PF: It's concrete.

BB: That's right. It isn't an abstraction *of* something. It *is* something. We live and move and operate in a world of form. Abstract sculpture is a part of that same world. So, in a way, it's natural. It's not abstraction.

PF: In which case, by your argument, painting may make more intellectual sense to us than sculpture does, but sculp-

ture insists on bringing us back to the haptic sense of the world, the way the world is felt by the skin.

BB: Absolutely. The physicality of sculpture is central to it. That is one of the things you realize when you look back and see who became sculptors. We are attracted by both the physicality of making it and the physicality of its existence. It's very funny to read da Vinci's treatise, "On the Superiority of Painting over Sculpture." It's really a thinly camouflaged attack on Michelangelo. It says that the sculptor lives in a house full of dust and dirt, and the sweat from his brow mingles with the dust from the stone to make a mud that dribbles down his

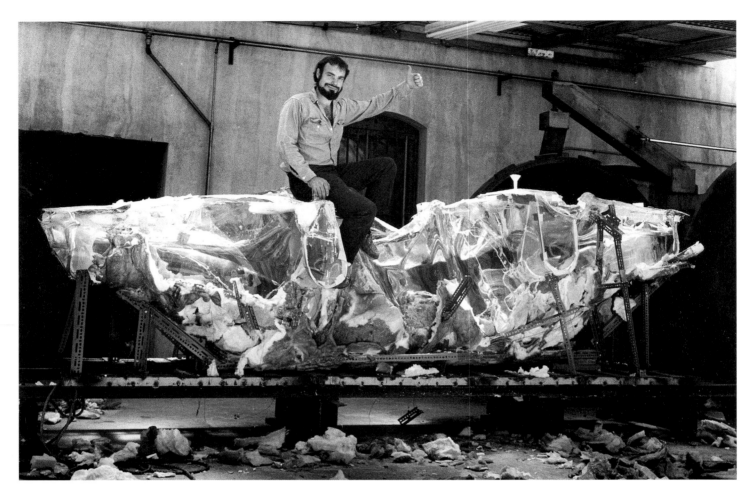

Fig. 15 [above]. Bruce Beasley celebrating the bubble-free acrylic casting of *Apolymon*
after three weeks of controlled cooling, original Lewis Street studio, 1969.
Plate 15 [facing]. *Prometheus II*, 1963. Cast aluminum, 48 × 18 in.
Solomon R. Guggenheim Museum, New York, New York. (See also plate 44.)

back, while the painter listens to boys play on lutes, dresses in fine clothes, and lives an elegant life. I've read the treatise to groups of sculptors, and they laugh and cheer. It's not a criticism to us. It is that physical engagement that attracts us. We don't think that that diminishes us. That's one of the reasons it's diffcult to talk about sculpture and painting in the same context. Sculpture is in the world that we are in. It's simply a different expression than painting.

PF: To be fair, there's a lot of painting that has struggled to be (and, to my mind, at least, has largely succeeded in being) painting that is physically present.

BB: I'm also not trying to say that sculpture is superior to painting. But it is different. I see the question with painting as being, Is it a window into an image? Is it a window through which you step into another world? Or is it something that you encompass into the world we occupy? I don't think that's ever really fully clear. At least it isn't to me. Sculpture has that in-your-face, I'm-here, you-bump-into-me-and-you'll-bruise-yourself presence.

PF: Yes. It occurs to me, in fact, that you can redouble this emphasis on the real by contrasting sculpture, particularly the sculpture you do with digital work, with video art, with work that exists not simply on a canvas but in fact behind a video screen, work that is entirely dematerialized.

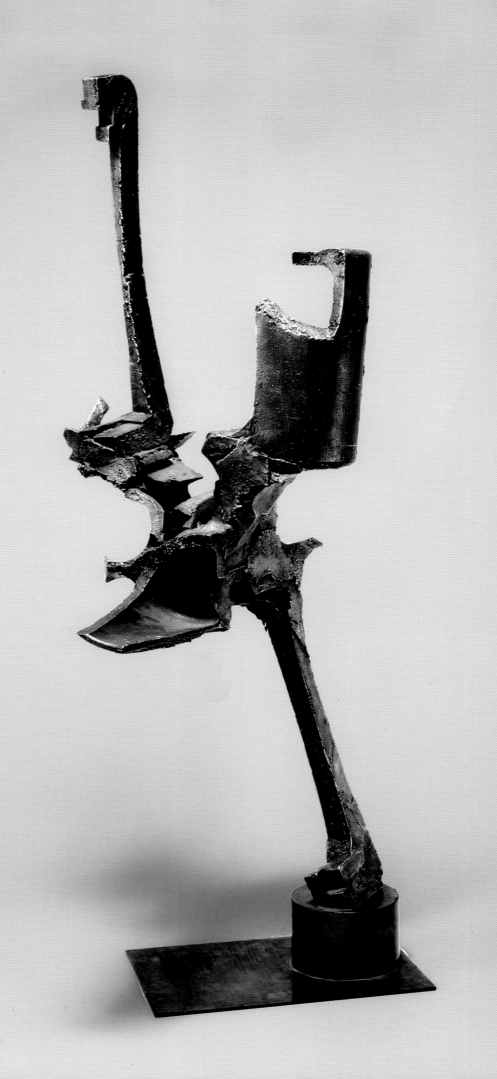

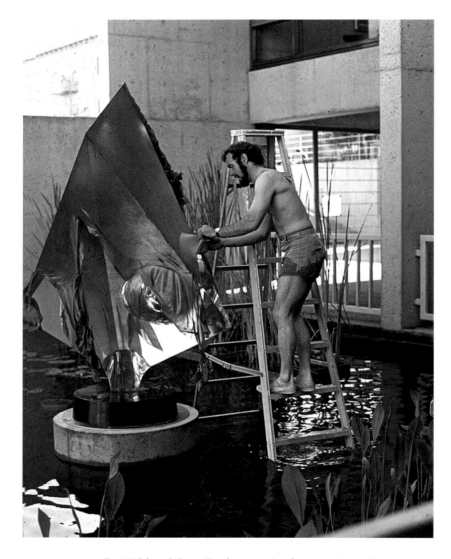

Fig. 16 [above]. Bruce Beasley removing the protective coating from *Tragamon* during installation at The Oakland Museum, 1973. Plate 16 [facing]. *Scalar Gyration*, 1972. Cast acrylic, 19 × 24 × 13 in. National Museum of American Art, Washington, D.C.

BB: The space between you and a distant mountain is real space, and the magic is that you're feeling that space. It's not the silhouette of the mountains on the horizon that is important. It is the space between you and the physicality of the mountain. Sculpture is about *space*, the space between things as well as the space of things. The space that the sculpture does *not* occupy is as important as the space it does occupy.

PF: To clarify this further: a sculpture *is* space. The practice of sculpture is thus about space. But, although your work relates crucially to architecture and has architectural elements in it, you've never thought of your work as architectural or even had an impulse to want to make buildings.

BB: Actually, I would love to make sculptures that people lived in. But my sculpture is not architectural per se. I'm not trying to have them evoke imaginary buildings.

PF: Even so, quite often one sees buildings in the group of works you've been working on for the last decade and a half or so.

BB: Well, I think that's because some people may have only an urban reference to form. I think the association is more by imaginary default than by any actual intention to evoke building spaces. My sculptures don't come out of my responses to architectural space; they come out of my feelings for natural space. It's more about canyons, cliffs, mountains, canopies of trees, and bones than it is about architecture.

PF: In that regard, when you take on a commission, how much more do you have to respond to the eventual site?

BB: It depends on the site. With some, there's more leeway than others. But I don't ever try to make the sculpture be a direct stylistic reflection of any nearby building. I think that would lead to very weak sculpture.

PF: I think your style is too forceful, too well defined for that to be able to happen.

BB: I just wouldn't want to do that. I think that's how you get design, not art. I think the best collaboration between sculpture and architecture is not when they reflect each other stylistically but when they work together qualitatively and when the sculpture has the proper space for its own expression.

PF: Is there an ideal space for your work?

BB: It certainly would be fun to try to define an ideal space for a sculpture. When I say that the subject of my sculpture is nature, that doesn't mean I necessarily think that the sculpture should be *in* nature. For instance, when I see a beautiful field or an expanse in the desert, my response is not that it needs sculpture in it. In many cases I think sculpture would be an intrusion into nature. But as an artist, I can talk about mankind's emotional relationship *to* nature. The sculptures aren't trying to be just a piece of nature brought into the urban

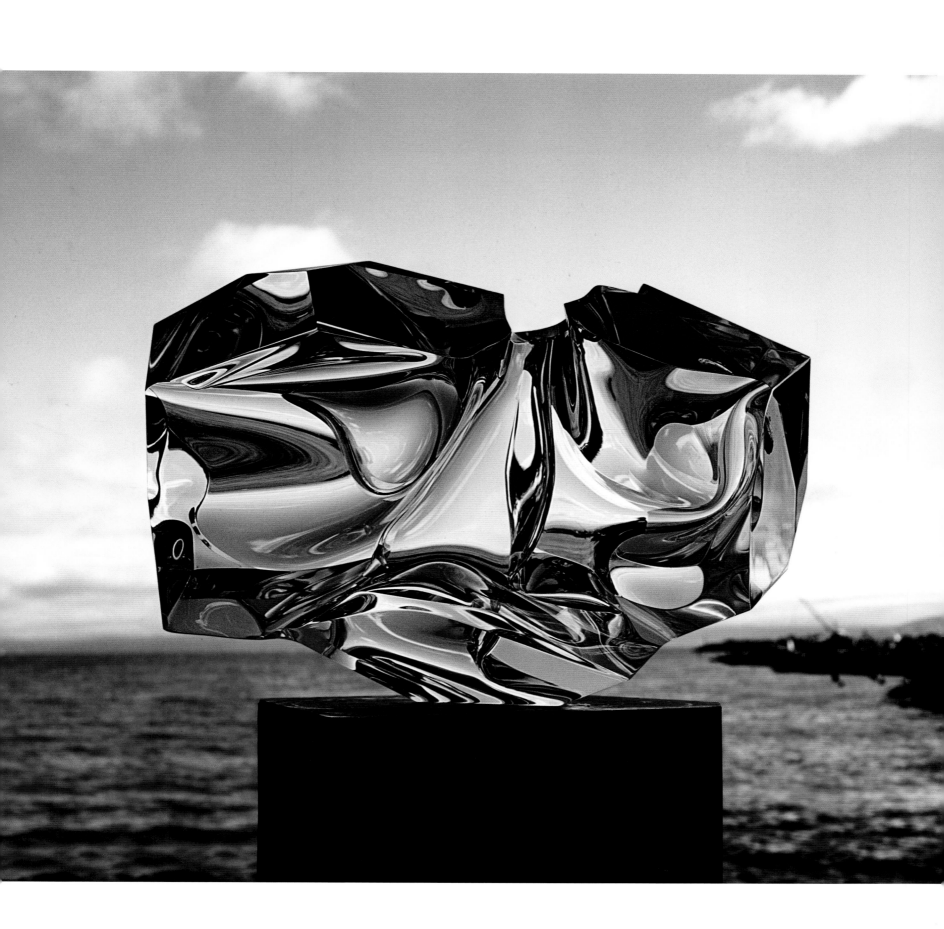

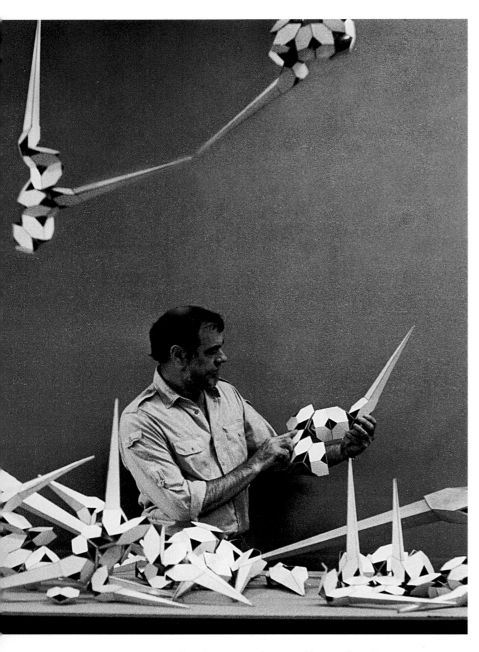

Fig. 17 [above]. Bruce Beasley assembling cardboard
models, original Lewis Street studio, 1985.
Plate 17 [facing]. *Small Dorion*, 1980. Maple
construction, 39 × 59 × 20 in. Private collection.

setting to remind us of what's not there; it's much more com-
plicated than that. Were I to want to do that, then the sculp-
ture would lose, because it cannot ever be as good as nature.
A beautiful rock *is* nature. However, a beautiful rock cannot
be *about* mankind's relationship to nature. My sculpture is
about our relationship to nature. It is not trying to be the rock.

PF: It's actually trying to be the beauty in the rock.

BB: Yes, but not in an imitative sense. It's trying to grab
the beauty of the rock and talk to *you* about the beauty of the
rock. Art is a human activity. It is a human expression, and we
are its audience. For me, nature is the subject matter, and
geometry is the vocabulary, but the overall dialogue is a hu-
man one in a completely human context. The subject matter
is our relationship to nature. That relationship is about space
and form, and it speaks to us emotionally, not intellectually.

PF: Talk more about what impels your work—conceptu-
ally and personally, as opposed to materially.

BB: What impels my work is the excitement of exploration
and discovery. It is the feeling that I can make something with
my own hands that is *new*, something that didn't exist before,
and the sense that it has meaning on some human level.

PF: Do you find that your approach has changed overall
from what it used to be?

BB: Over time you gain experience. You know more about
what you are doing, and you learn what doesn't work for you.
But I'm not sure that the work actually gets better. The visual
input also gets more efficient with time. I know better what is
important to see and to experience than I did earlier. I know
sooner which directions not to follow, which doors not to go
through.

PF: You know sooner whether to leave, when to leave,
and how to leave.

BB: Yes, that's right. I think that really is what experience
provides. I don't know if we become basically better artists.
This touches that difficult issue of quality, and I don't know
how well any of us can judge ourselves no matter how hard
we try. I don't know if the quality gets better, but I think we
hone ourselves better.

PF: Do you remember back when you were emerging, in

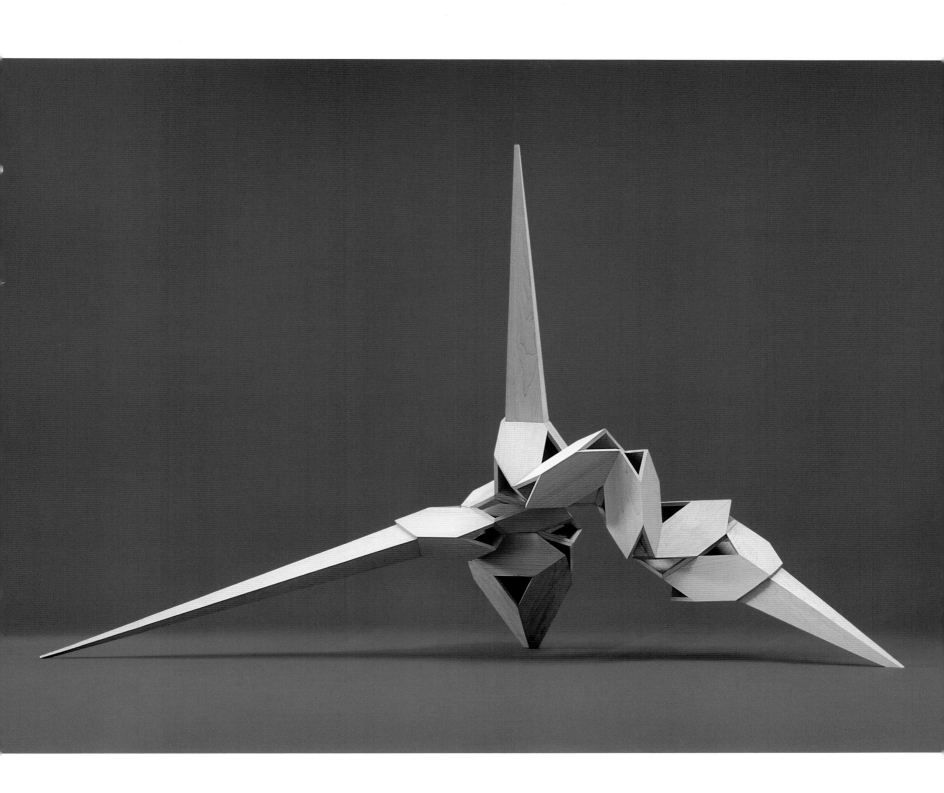

the early sixties, was there a great pressure to perform as an artist? In producing work, were you expected to make work that was interesting or were you expected to make "Bruce Beasleys" right off the bat?

BB: Young artists feel great pressure to find a personal style. And I think that that's one of the most difficult issues for a young artist. If I were teaching, I would try to relieve my students of that pressure, because looking for a style is like looking for a shadow with a flashlight. By shining the light on it you destroy what you are looking for. What we call a "style" should be a result or a consequence; it cannot be a goal. You cannot look for it. It is a result of trying many things, rejecting some, and focusing on others. It becomes a summary of what the artist responds more deeply to.

There was an expected way to act when I was a young sculptor in the late fifties and early sixties. It was a variation of the grunt-and-groan school. We were expected to be physical but not articulate.

PF: Double Y chromosome.

BB: Yes. It was kind of fun, but it was also a little bit stupid because we *were* articulate and we did have ideas that could be talked about. But the prevailing posture was "I don't know nuthin' about art, I just make it."

PF: "The work speaks for itself."

BB: Yes. It was a bit of a contrivance, and I think we set a trap for ourselves that was sprung on us when conceptualism came along. Abstraction and modernism had great spokesmen. People like Greenberg and Rosenberg and all were great spokesmen for us. We didn't have to justify ourselves or explain our intentions or motives. Then the conceptualists came along with all kinds of clever words. There are many people in the art world who do not respond visually. They only get the verbal ideas, the intellectual content. The conceptualists were clever with words, and they left us feeling undefended. "Where are our advocates? Where are our spokesmen?" we asked ourselves. We should have been able to speak for ourselves. And it wasn't simply a matter of taking over words. It was an assault on the legitimacy of visual expression. It was a matter of trying to take over a *visual* language and replacing it with a *verbal* language. Their art ideas were word ideas, not visual ideas. Of course that made it easier for others to write about since it was already about words.

PF: I would imagine that David Smith was a model for you?

BB: Yes. David Smith was *the* big influence on my generation of American sculptors; he was a tremendous presence. I was a very young artist when I met him, but I did have the privilege of knowing him. To be honest with you, Smith's influence on me was as much approach as it was actually stylistic. The directness, the "do it right now" approach, had a tremendous impact on me. However, I think Smith was more interested in silhouette and less in volume than I am. He talked a lot about drawing in space, and I don't feel that way. I am more interested in grappling with space.

PF: Was Noguchi an influence on you?

BB: Yes, but not directly. I definitely consider Noguchi one of the great sculptors who helped define the whole language of sculpture.

PF: And especially sculpture as a response to nature.

BB: Noguchi's influence on me wasn't so much stylistic as it was his incredible sense of completion, and the presence of the work.

PF: Which artists whom you consider influences do you feel address space the way you do?

BB: Eduardo Chillida, for sure. He is the sculptor I admire above all others. I was very fortunate to have had a long friendship with him. I think Chillida uses space as well as any sculptor ever has. His work uses space so robustly and demandingly and is so spatially aware and articulate that it just amazes me that he could get those drawings and woodcuts so right in two dimensions. I know of no other sculptor whose two-dimensional work is as successful as Chillida's. It refers to his sculpture but does not emulate it.

PF: Which other artists—not just sculptors but artists generally—do you consider profoundly influential on you?

BB: Rodin. I've never been drawn to work with the figure myself, but I think Rodin is one of the great sculptors. Rodin is very interesting because if you look at his work across the span of time, you see him stretching toward pure form. I consider Rodin the first abstract sculptor, although officially that title

usually goes to Brancusi. But I think Rodin was trying to put the figure in positions where it couldn't really be, and he was basically looking for pure form and practically breaking the models in half to put them in positions that the figure didn't want to assume. So you see him just on the edge of saying, "Oh, the hell with the figure; I'll just make shapes."

PF: Other influences?

BB: Brancusi, certainly, Some of Giacometti, although not so much his surrealist work. Julio Gonzales, Henry Moore, Anthony Caro, Fritz Wotruba, also Gio Pomodoro. I saw a fabulous show of his in the early sixties. He was using surface in a way I'd never seen a metal sculptor do. Later we became great friends.

A lot of my influences have been European sculptors. I feel that in many ways I come out of a certain European aspect, although I'm very Californian in the do-it-yourself, weld-it-yourself, figure-out-the-processes-yourself sense.

PF: California method and European aesthetic.

BB: Yes, so I really haven't quite fit into an easy category. Another sculptor I admired very early is Richard Hunt, also John Chamberlain, and Kenneth Snelson. Also some sculptors who are not as well known now: Edward F. Higgins, Jean Ipousteguy, the Swiss sculptor Robert Mueller, Gabriel Kohn, Lee Bontecou (who is being rediscovered). I love Ed Kienholz, but I can't really say he was an influence.

Painting has influenced me less directly, but I respond strongly to it. I think if I could have my choice of five paintings from the modernist period they would be by Gauguin, Franz Kline, Richard Lindner, Wayne Thiebaud, and Richard Diebenkorn.

PF: Of course, there are so many artists from back then worth reexamining, sculptors not least. Higgins and Kohn were East Coast sculptors, as is Bontecou, but there were several on the West Coast as well. Who were the ones you were in contact with in Berkeley?

BB: Sidney Gordin and Peter Voulkos were the primary influences on me as a student, both of them very strong and good artists, with very different teaching styles. Pete taught by example. He worked with us; he didn't really conduct formal classes. Pete was like a river you jumped into and were

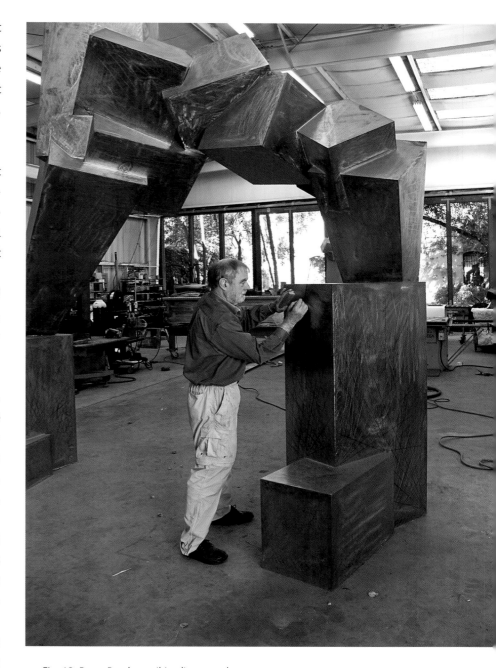

Fig. 18. Bruce Beasley scribing lines on a bronze sculpture, new Lewis Street studio, 2004.

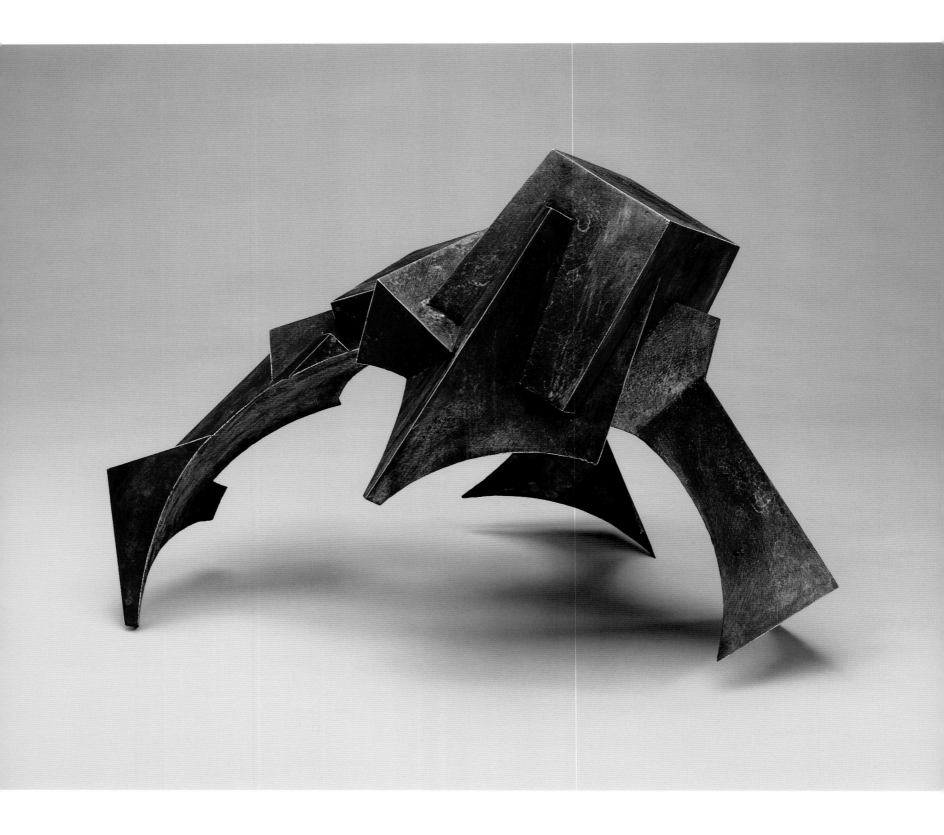

carried on his current. Sid was more contemplative and helped us more directly reach into ourselves. It was good to have a balance of the two.

In 1961, I worked on Pete's first show of bronze sculpture at the David Stuart Gallery in Los Angeles. It was a very interesting experience. A group of students, including Steven De Staebler and myself, wanted desperately to do metal casting, and we handbuilt the first foundry there in 1961. Pete was interested also, and he provided some seed money, a twenty-dollar bill here and there, for a blower and a garbage can to make a furnace out of. So we built the first foundry, and that led to an explosion of cast work, including Voulkos's. He had clay instincts, and it was interesting to see him bring those to bronze. He didn't want to replicate the ceramics in bronze; he wanted to work directly in the wax, and that led to a different look than clay. The wax came in blocks, and he was breaking them into shapes. It was very direct, and they fractured into shapes with beautiful broken edges. Then he would cast the broken wax shapes.

Pete had this important show scheduled in Los Angeles, and I was helping him with the casting. We weren't casting complete sculptures, we were just casting pieces of bronze that would be welded together later. All of us who were working for Pete were convinced he had all the sculptures visualized in his head. So we loaded the truck, and I drove it down to L.A. It was five days before the show, and there had been a lot of hype—"Peter Voulkos Does Bronze at David Stuart Gallery," that kind of thing. There was a parking area behind the gallery where we were going to assemble the sculptures. So there I am in welding leathers and hood, ready to weld, and I say, "Okay, Pete, what goes where?" Again, I'm thinking he's got all the sculptures in his head. Then he picked up one of the pieces of bronze and held it next to another one and said, "Well, let's try this," and, "Well, that looks pretty good," or "No, that's terrible, take it apart." That's when I realized that all the castings we had done were only a vocabulary of shapes, and that Pete was just then actually starting to decide what form the sculptures would take. That whole show was made in four days, from just a bunch of shapes we had spent six months casting.

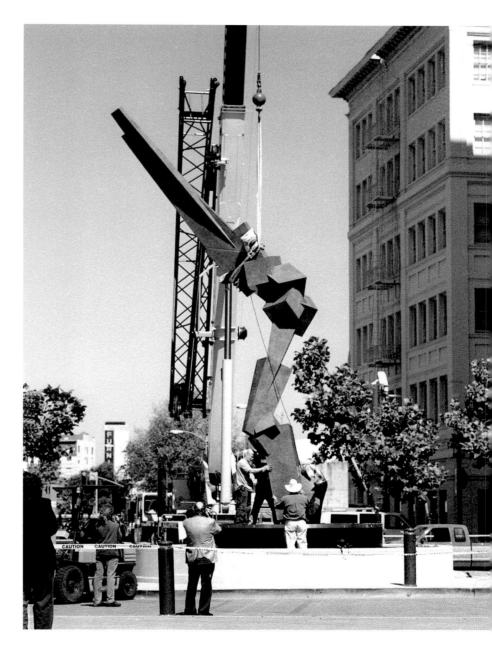

Plate 18 [facing]. *Raptor*, 1990. Cast bronze, 19 × 24 × 22 in. Private collection. (See also plate 147.)
Fig. 19 [above]. Installation of thirty-foot bronze sculpture *Vitality*, Oakland City Hall Plaza, 2002.

Plate 19 [facing]. *Intersections*, 1987. Cast bronze, 24 × 33 × 12 in. Private collection. (See also plate 127.)

PF: What year was this?

BB: This was 1962. I learned something very important from that experience. I learned that Pete's working method was not for me. Pete worked great under pressure; he was a quick decider. It was a wonderful show, terrific work. Pete was a great sculptor, but that was not the way I wanted to work. I don't create well under pressure. I wanted to try things, and then try them again. I learned a lot from Pete, and part of what I learned was that I wasn't him.

PF: Has anybody else had that impact or that ability to teach by example on you?

BB: Not the same. Sid Gordin taught more formally. He was a teacher, but he was also a very productive artist. He was always creating, always having shows. He was a very regular artist who didn't work in spurts. Making art was something he did all the time. That's more the way I am. I want the continuity. The joy of the creation of the new shapes is basically what drives me, so I don't want to cram all of that into one cataclysmic week or month. I like a much more steady exploration. So Sid was an influence on me in that he showed me the benefit of just going into the studio every day and making something.

PF: So you got your vision from Pete and your work habits from Sid.

BB: There was also vision from Sid, though he was less volcanic than Pete. Sid was steadier, but he was no less dedicated and committed an artist. Sid taught responsibility and commitment to art. He also taught me that to make good art you will also have to make bad art—that when things go badly you have to continue working. So what you do in response to making bad art is make more bad art. You don't stop and wait for the muse to come around again. The only way good art appears is out of the process of just making art, and there will be times when it's not good, but you don't stop. The only way you find those new ideas is by continuing to work through those terribly painful, difficult, awkward times when every part of you is saying, "This is awful. It hurts. It's horrible. Stop. Don't do it anymore." It is unfortunate that more students are not taught this, because if they are not prepared for this grind they can be really thrown. I think that a lot of teachers don't

talk about it because they don't want to admit that they go through dry periods. That's silly; it happens to all artists. It isn't that you just hope it won't happen; it will happen. What matters is what you do when it does happen. I learned a lot from Sid about the dedication to the long-term process and your own responsibility as an artist.

Being an artist is a life commitment, a total way of life, but there are many forms it can take. Pete was the prototypical movie version of an artist with all the drama. Sid was less pyrotechnic, but still very, very dedicated. My own way has been to create my own world of sculpture—where I create it, work on it, and live with it. I am surrounded by sculpture. I live at the studio, and the sculpture garden lets me live with the pieces after they are made. If I have an idea at 3 a.m., the studio is only fifty feet away. I don't want to have a regular time when I get in the car to drive to the studio. Everything is right here all the time. The whole focus of my life is built around sculpture.

PF: Do I understand that you've never taught?

BB: I have never taught. It was expected, but I didn't follow that path. My generation of artists got degrees at places like Berkeley and went out and became the young, and then the tenured, professors all over the country. I was being groomed for that. But I simply wanted to be a sculptor. I didn't want to be a professor. I didn't want to end up being forty and in school since I was five years old. If I did teach, I wanted it to be something that I would come back to from real experience. I didn't want to go from being the hotshot undergraduate to the promising graduate student to the young tenure-track professor and all of that.

PF: You wanted to apply what you learned.

BB: It looked to me that being a sculptor demanded full-time attention, and I didn't want to be one of those teachers who hold back from the students to concentrate on their own work, nor did I want to be one of those who sacrifice their own work for the students' sake. I didn't want to have that moral dilemma. I wanted to give full-time attention and energy to the sculpture. And so I did, and every year I didn't have to go and work at another job was just one more year that I got by, and now I'm sixty-five still doing the same thing.

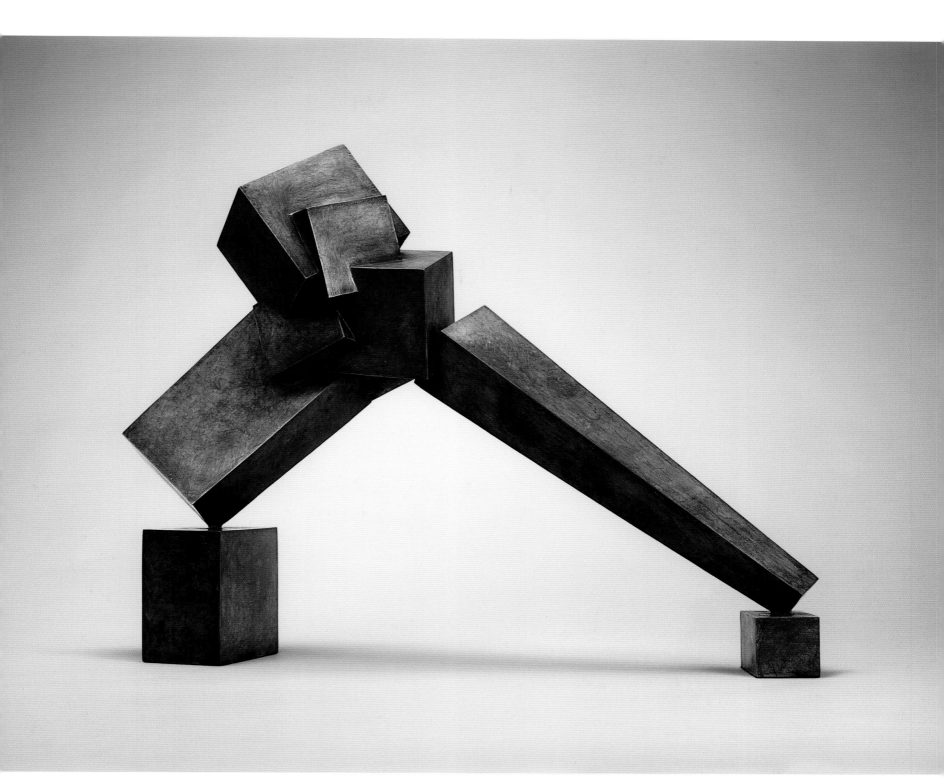

PF: So sculpture *is* your day job.

BB: And my night job. It's the only job I have. And from the first I've been willing to pay the price for it. My friends were getting jobs at schools around the country as young professors. They were buying houses and cars and had a regular life. I was willing to live very modestly. Financially, the first years were really very meager, but it allowed me to put all of my energy into the sculpture. I didn't kid myself that I could have it both ways. I didn't expect I could live a comfortable life and be a full-time sculptor. It was clear to me that making sculpture was so much better than anything else that I would pay whatever price that took. And I still would.

PF: And you never wavered from that.

BB: Yes. Later on, I got offered extremely attractive jobs, even as head of departments and such, at very nice salaries. I just didn't want to do it. There were other financial opportunities that I turned down, too. When I invented the process for massive acrylic casting, I had the very real option of becoming a wealthy industrialist. I remember the formal decision when I said to myself, "Okay, what would I do with that money? Well, if it means I don't have the time or energy to make sculpture, if it doesn't mean a better studio, if it doesn't mean better tools, then I don't want it." I had no illusions that I could run an industrial company and be a sculptor. I'd seen other colleagues try to run businesses and be sculptors on the side. You can't do it. Life doesn't let you give full time and attention to more than one thing. So I simply asked myself, "What would I do with all that money?" And I realized that all the things I wanted to do with it had to do with making more sculpture. Then it was an easy decision. It's always been the sculpture that came first. If I won the lottery tomorrow, I wouldn't buy a country house or a yacht. I'd get a new forklift, I'd get a second bridge crane, I'd buy more tools.

PF: Would you buy some land to create a setting for the work?

BB: Sure, I'd do that kind of thing, and I'd fund some scholarships for young sculptors, but it would all be about *sculpture*. I don't want the things that wealth means to a lot of people—except maybe for the ability to buy art by other artists.

PF: What's your involvement with the International Sculpture Center currently?

BB: I've been on the Board of Directors for ten years, or more. This is the organization that started the sculpture conferences in the early sixties. The International Sculpture Center wants to be a worldwide center for information about and support for sculpture. I think it's very important to have a place that's sort of a home base for sculpture. That's what the ISC is trying to be, and I believe in it. Sculpture is a lonely discipline.

PF: Lonelier than other artistic disciplines?

BB: I think more than most. The creative process for all the solo disciplines is fundamentally lonely. That solo moment of connection any artist has with their work when they're making the important decisions—I think that's the same for all of us. But there's so much process in sculpture, the grinding, the welding, the mold-making. There are so many hours devoted just to noncreative work that I think sculptors tend to spend even more time than other artists in their studios. Imagine if stretching canvases and making frames was a forty-hour-a-week job.

PF: Or mixing pigments.

BB: Yes, that's right. For painters, at least nowadays, there isn't as much process that's not direct creation. Sculpture is so process-oriented that we spend a lot of time just doing stuff that's not really creative. It means we tend to become hermits in our studios. I like other sculptors, and I like the camaraderie. Only a sculptor knows what another sculptor goes through. Whenever painters hear about the ISC they're amazed, because this organization encompasses all of the styles of sculpture and all of the disciplines. There's no issue between abstraction and figuration, or traditional and contemporary. The painters' reaction is "Well, how do you guys all get along?" We get along because we all have in common the fact that sculpture is heavy and difficult and galleries don't like to show it and it's hard to ship and it needs to be mounted. We have in common the attraction to physicality that made us sculptors in the first place. Regardless of stylistic differences, that attraction to physical engagement gives us something that we have in common. So sculptors have a camaraderie that I don't know of an equivalent to in the other visual arts. It goes back

to Leonardo's attack on sculpture. I meet sculptors all over the world, and it is as though we metaphorically wipe that mud off our brows and shake hands. We recognize each other.

P F : You achieved some recognition rather early on in your career. You were still an undergraduate when you were showing internationally.

B B : I had a very fortunate beginning. In 1960, while I was still a student at Berkeley, I won a prize in an annual show put on by the San Francisco Museum of Modern Art. The juror was Dorothy Miller, who was the Curator of Painting and Sculpture at the Museum of Modern Art in New York. She gave me a prize for one of the welded broken sewer-pipe pieces. She went to L.A. on her way back to New York and saw some more of my work at the Everett Ellin Gallery and notified William Seitz, who was at that time putting together the big The Art of Assemblage show for the Modern. I wound up included in that exhibition, and then the Modern acquired a piece for their collection. For a long time I was the youngest artist ever included in the permanent collection.

And then that next year, the United States entries to the Biennale de Paris were eleven sculptors who had been associated with the U.C. Berkeley art department. André Malraux, the French Minister of Culture, was the juror. He gave me the Purchase Prize and bought my sculpture *Icarus* (plate 3) for the French National Collection. That year the Guggenheim Museum and the L.A. County Museum of Art also acquired pieces, so it was a nice beginning.

P F : The Everett Ellin Gallery was a pretty important gallery at the time. It was one of the few places showing new international art of stature in Los Angeles. How did they alight upon you?

B B : Well, I was just brash as hell. I was basically just a kid, and I walked into the gallery one day with a few very bad pictures of some sculptures and told him I would like to show him my work, and he agreed to exhibit it.

P F : These were the broken-pipe pieces?

B B : We started together with the broken-pipe pieces.

P F : How did the broken-pipe pieces themselves come about?

B B : I saw a big pile of broken cast iron in a scrap metal

yard. Unlike steel, cast iron is brittle and will fracture. I had never looked at rusty, broken iron before. I was fascinated by the dialogue between the ragged, random broken shapes and the more controlled cast shapes, so I bought a pile of this scrap and took it home and started welding it together.

P F : Did all these things happen while you were still in school?

B B : Not quite. My show with Everett Ellin happened the first year I got out of school, and the Paris Biennale followed that. Henry Seldis gave me a terrific review in the *Los Angeles Times*. The header was "Young Sculptor Shows Rare, Precocious Talent."

P F : When you went on to aluminum, how did that relate to the welded cast-iron sculptures?

B B : Even the later cast-aluminum work was related to assemblage. I would begin by cutting up Styrofoam packing cases to make a big pile of Styrofoam shapes—I was making Styrofoam scrap, if you will—and then I would start assembling them, and then later I cast them in aluminum. What I was really doing was making my own junk pile. It has been a

Fig. 20. Granite sculpture being carved, Chongwu, China, 2004.

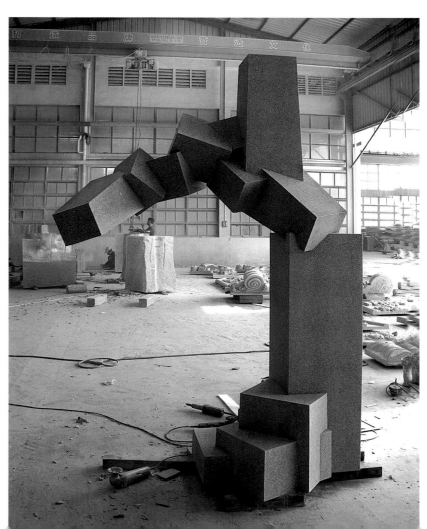

method of working that I have always been comfortable with from the beginning and, except for the acrylic work, has continued to now. Basically what I do now is make a bunch of rhomboids, and then I start assembling them. So there really has been continuity in the basic approach.

PF: You're still assembling.

BB: That's right, I'm still assembling. My working method is one of response rather than visualization of a finished sculpture. I don't see a finished piece in my head. My way of working is to start taking some shapes that by themselves aren't interesting and begin combining them until they speak to me. Except for the acrylic work, that has been my method basically my whole career.

PF: When did the acrylic pieces start? How did it occur to you that you wanted to make them and not what you had been making?

BB: I literally started having dreams and fantasies of transparent sculpture. I started imagining sculptures where the eye would not know where to stop. Normally the eye stops on the surface of a sculpture. The idea was of the eye being drawn into, through, and past the sculpture so that you would see things that are behind the sculpture, in the sculpture, not as reflections but seeing them in it. I wanted them to act as lenses, where you would see through to whatever was behind but distorted and changed, bringing color and light into the sculpture. At first I investigated glass, but the weight and cooling times made it impossible, and then I went to the plastic people, and they kept telling me that the only plastic material that is as clear as I wanted is acrylic, but you can't cast it more than four inches thick. So I finally decided I would just have to invent a way to cast it thicker.

I had just started experimenting with acrylic when the invitational competition for the state capitol sculpture came along. It would be the first sculpture that the state of California had ever commissioned, and I had been invited to compete on the basis of my cast-aluminum sculpture. It was really a dilemma, because I didn't want to go back to the aluminum. I really wanted to pursue transparency, but I didn't know how to cast a large piece in acrylic. I was facing a real turning point: go back to safer work that I was less interested in, or pursue a new material that I wasn't sure would work. I screwed up my courage, made a model out of cast acrylic the best I could at that time, and with that, I won the competition. Fortunately, once I got the commission I was able to figure out a new way to cast acrylic, and the big transparent sculpture turned out fine.

PF: How hard was it to come up with that?

BB: It was very hard. I thought I wasn't going to make it. But I finally had a major breakthrough, and I was able to cast the big sculpture at thirteen thousand pounds.

PF: And the acrylic has remained stable ever since.

BB: Yes.

PF: And usable well beyond the realm of sculpture.

BB: Yes. My process has been used to make all of the big aquarium windows around the world.

PF: And the new generation of bathyspheres.

BB: Yes. I took a year off and cast the first all-transparent bathyspheres ever made. When the space shuttle *Challenger* exploded in 1986, it was one of my bathyspheres that searched the floor of the seabed and found the crew compartment so the remains of the astronauts could be retrieved. The bathyspheres are used all the time for undersea research. Marine biologists have discovered more than a thousand new species of fish using them, and they're still making those discoveries, now at three and four thousand feet below the surface. I am very proud to have made that contribution to oceanography.

PF: You've managed to support yourself as a sculptor without compromising what you do with the kind of sculpture you make.

BB: I made a decision that I was going to make the sculpture I wanted to make without thinking about salability. But once I had made the sculpture that I believed in, I would then try to be as professional and practical as I could to do those things that would help them sell. I would try to show them well, photograph them well, etc., but the choice of the work would always be strictly what I believed in and wanted to make. The acrylic work sold very well, and when I quit doing them I had some galleries drop me. They didn't want to show

the new work. I just had to live with that. I didn't stop making acrylic sculptures because I was dissatisfied with them, and it certainly wasn't because they weren't selling. It was because the excitement of doing them had diminished, because I had basically answered the aesthetic question I had posed to myself. I wanted to explore something new. However, I did pay a price for giving up a successful style.

PF: And the next series was . . . ?

BB: I never put a name on the next series, but it was based on a particular geometric module. The large pieces were made in stainless steel. In a way they were an interim step. I'm very proud of those pieces, but it was a limited vocabulary. It was a rich vein but not a deep one. I learned that I wanted to work with a geometric vocabulary with which I could make more subtle changes. The modular pieces could change only in certain formal ways.

PF: You were locked into the basic unit.

BB: That's right, and that finally became a limitation that was not acceptable. The newer question I posed for myself was, Can I tell stories out of a vocabulary that is based on simple shapes intersecting each other in complex ways? And can the arrangements and intersections of those shapes, which by themselves are without emotional impact, create something that speaks to us as humans? It's analogous to musical composition. The composer doesn't make any new sounds or any new notes. They're all there on the piano keyboard. It's the repetition, rhythm, and spacing of the notes that make the difference between something that's just noise and something that's profound and moving. It's the same with my current work. Conceptually you can imagine a table full of simple blocks and cubes that alone carry no emotional response. Then imagine them starting to move into each other. It's the arrangement of those blocks and the new shapes that are created as they intersect and pass through each other that starts making something that speaks to us.

PF: And with each little shift it says something different.

BB: That's right. What I have realized is that we are very, very responsive to small changes in shapes and angles. Just as we hear extremely small changes both in tone and in interval between musical notes, we see very small changes in geome-

try. We see and respond to differences of less than a half of one degree of angle, so there is a huge emotional range in this vocabulary from something that is shouting to something that's whispering, through just a small change in angle.

PF: Or in music, from a diminished third that is not dissonant to a second that is dissonant.

BB: That's right. Or rhythm. Just a small change in the interval between two notes is a big impact on how we respond to that music.

PF: Rhythm is also an integral part of your compositional method.

BB: Rhythm is an important part of balance and a part of implied motion; this imagery allows me a very broad expression of rhythm. So I found this vocabulary to be a very deep and rich vein. The reason I have stayed with this series longer than the others is that it provides such a robust vocabulary. I can be funny, I can be ominous, I can be aloof, I can be elegant, and I can be funky or awkward with it.

PF: In certain ways, it's your most traditional body of work. It's mostly cast bronze. It's the most directly metaphorical. Even so, you have insisted that it is still not objective, it's clearly a geometric vocabulary—

BB: But geometry is not the subject matter.

PF: No, but there's a subject matter there. It's not simply composition. And it's not a geometric subject. It's not a metaphorical subject matter. I don't get a feeling that we're supposed to look at *Storm* (plate 140) and necessarily see the storm clouds and the shaft of sunlight that inspired it.

BB: What I want to do is evoke feelings, not evoke images. It is not about resemblance. Resemblance is just the skin of the truth.

PF: This despite the fact that the work actually is quite imagistic; it's just not imagistic in the way a picture of its source would be. It's a presence.

BB: Yes. In some ways I'm making imaginary creatures. When I say "creatures," I don't mean actual animals. I say "creatures" because one of the things that I strive for in my work is the completeness any living thing has. In the animal kingdom the range of shapes is amazing. But there isn't any animal whose shape is "wrong." They're each right in

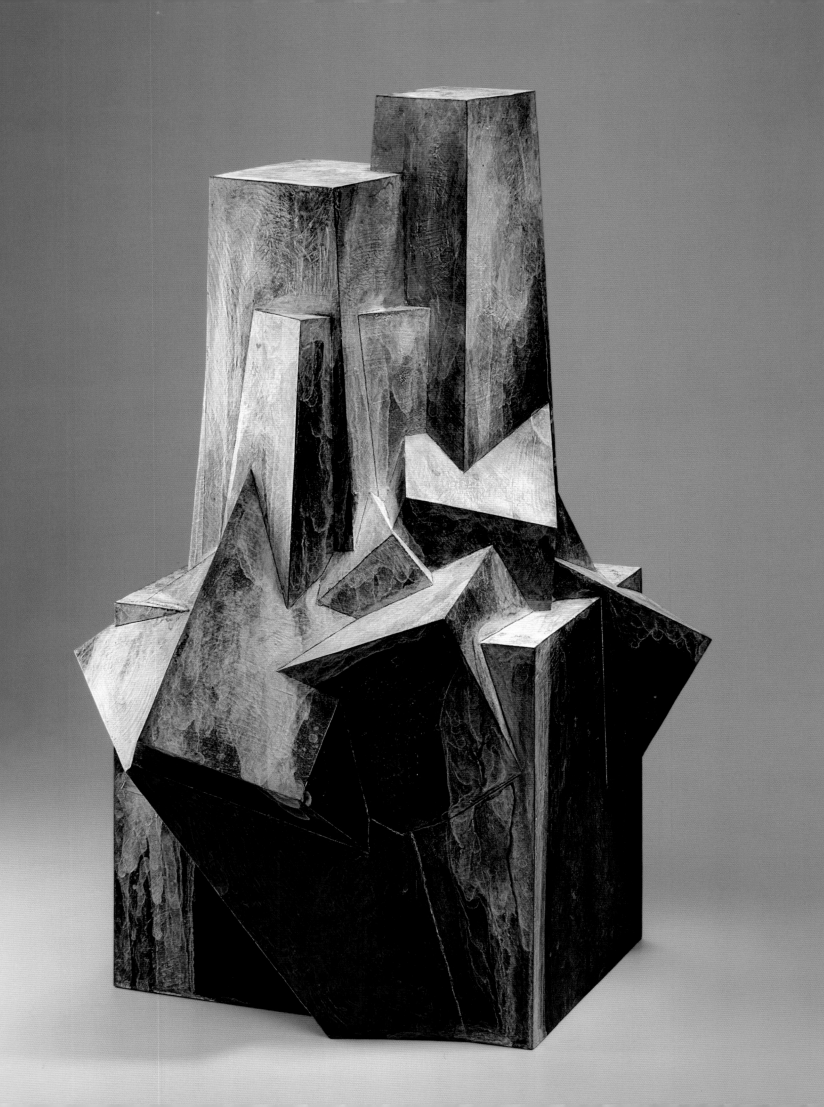

their own way. That presence that every living thing has is the quality that I'm striving for in my work. I'm not trying to get it by making it look like an animal, of course. It's not through resemblance; it's through a sense that when it's right, you can't change it without destroying it.

PF: It has a metaphysical balance. You might call it an inherency.

BB: Yes, that's a good way to put it. My process of working is that I'm trying things at first almost at random. I'm just kind of sticking things together imaginatively. And then at some point it's as though it comes to life, and it starts taking me in a certain direction, and we go the way it wants to go. But along the way to that new place it picks up excess baggage, so when we arrive at the end of the journey there's too much. Then I start removing parts of it, trying to get to the core—just to the point where everything is necessary. But it's not minimalism in the formal art-world sense. So I start taking parts out to see what can be removed without killing it, down to the point where I say, "No, that last removal—no, I killed it." It is that sense of absolute rightness that all living animals have that is the quality I am striving for. Everything from a slug to an eagle has this incredible correctness to it. My reference point is that sense of rightness that comes from the natural world, and that's why the sculptures are about nature and not geometry. There is nothing in geometry, or mathematics itself, that has that because they are eternal conceptualizations; they have not been honed by evolution and function.

PF: The mathematical sciences have a beauty to them but not this palpable inherency, not this kind of—what's the word? When things have fallen together into a physical harmony? Euphony? Well, that's a musical term, so that will work.

BB: That's a good way to put it. I want them to feel like the whole thing would come apart if you took any part of it away. For me, geometry is just a tool or a path to get where I want to go, but I'm not interested in it for itself.

PF: I'm trying to determine whether or not you are a genuine constructivist. I think you may be, in the fact that you assemble. In other words, you involve distinctively geometric solids in a process of assembly, in a process of relating elements one to another, so that you come up with essentially relational compositions. But as you say, these shapes and relations are based on living forms as opposed to basic, mathematically defined geometric structures, so that they relate back to figural sculpture as opposed to architectural sculpture.

BB: Right.

PF: There can be something architectonic in your work, and it can be very strong, but it's actually incidental to the unifying set of the work's characteristics, the thing that makes one of your pieces from your last two decades so much like the next.

BB: I'm glad that comes across.

PF: It's a kind of complexity that still has reached a point of irreducibility.

BB: That's what I look for in a sculpture, first of all that feeling that it's alive, and then that feeling that it can't be different. Any sculpture that has that is a sculpture I love, whether it's mine or someone else's.

PF: And it can even be a sculpture that has an awkward aspect to it.

BB: Certainly, awkwardness can be as important as grace.

PF: But that awkward aspect, if it's in your work at least, adds to its dynamic because your sculpture is dynamic. It implies movement and yet achieves stasis.

BB: I am very interested in the implication of movement and the anticipation of movement. I am less interested in the actuality of movement. I certainly want some of the pieces to *feel* like they are moving, and others I want to feel like they are *about* to move or have just come to rest after having moved. There is a moment of great energy and beauty when a bird is just about to take off, or just before a diver leaves the board, or a dancer just before leaping—I try to capture that anticipation of movement and its compressed energy.

PF: Your involvement in these things is not at all passive. You don't know what you're going to do when you start out, but you don't leave much to accident.

BB: There may be an accidental quality in the sense that when I start, I start arranging almost at random, but it feels more like doors opening than like accidents. I am always looking for the unexpected. Often I will be on the path of discovery with a sculpture trying to get to the end of its journey, and

I'll look down a side path and say, "Well, that looks interesting, I think I'll come back to that later and see where it goes," and that path becomes the beginning of the next sculpture. In effect, some of the interesting but wrong directions of any one sculpture become the door for the next piece.

PF: I can't imagine you do that when you're working full-size or on a monumental scale.

BB: On the big sculptures, the composition has already been determined. I can't do a forty-foot piece and feel free to make major changes along the way. With the large pieces, I know the composition; the excitement is seeing it grow. Like the big piece that we saw out in the studio today—no matter how much I pictured walking under that arch, it's not the same as finally being able to do it.

PF: So that there's an element you simply can't control.

BB: I think it's more about knowing what you are dealing with. For example, scale is a very important issue in sculpture. We saw a lot of sculpture in the seventies by artists who really didn't understand scale and were having small pieces just blown up at the sculpture factories. We saw these occupy a lot of plazas. Some of these sculptors really didn't understand the particular demands of scale and what happens when sculptures get bigger.

PF: Somebody like Mark di Suvero can command an out-scale, can make something the size of a building work.

BB: Di Suvero is unusual in that from the beginning he worked directly in large scale. He didn't take a model and then just measure it and enlarge it; he was working compositionally in the large scale with his crane arranging the steel beams. That's one of the reasons they are so good. One of the reasons that I have always insisted on doing the large work here at the studio and expanding the studio as the work got bigger is that I want to be in control of that scale-up and see it—not only to know that it's made right but that it's aesthetically working in the large size. I want that involvement all the way. I want to be out there every day as they grow. I can't physically do all the welding and grinding anymore. I have a wonderful assistant, Albert Dicruttalo, a very good sculptor in his own right, whom I need very much. But I'm involved in every part of the sculpture. I'm there from cutting the plate to when the finished piece is loaded onto the truck and strapped down. I'm there when the truck arrives at the site and we pick it up with the crane and set it in place.

PF: I think that's the image we now have of a sculptor, of what a sculptor is supposed to do, whether it's you working in bronze or stone or Richard Serra working in steel or lead. There is this literally hands-on aspect to it.

BB: I think that's fundamental to sculpture. That's what sculptors are: we're hands-on people. I feel sorry for those who aren't. It's so much fun, as well as a lot of work.

PF: So you get along with somebody who works in granite or wood.

BB: Absolutely. One of the artists I admire most is Manuel Neri. His work is completely different from mine. He's a wonderful sculptor.

PF: Did we talk about public sculpture? So much of your work has taken part in the discourse of public sculpture. But I don't think it would be proper to think of you as a public sculptor, that is, an artist the bulk of whose work is public sculpture.

BB: Certainly not the bulk of it. I work in the public arena because I like the scale of it, and there is the attraction of a large audience. It may be a bigger audience, but it's also a tough audience and often indifferent compared to the more loving audience for private pieces that someone buys for their home. It's a different kind of engagement. Large scale comes naturally to me, so I'm drawn to making public pieces not only for the desire to have a larger audience but also for the opportunity to have those spaces to work in.

With regard to public reaction, I'm in a strange place. With much of the public we are still fighting for the acceptability of abstraction, and the public response is still "What's it supposed to be?" Yet in terms of the contemporary art world, the kind of formal work I'm doing many think of as passé. So I'm in a rather strange position, to make work that compared to the cutting edge is considered passé but to the public is still too avant-garde.

PF: Doesn't it seem to you that when people get mad at public art, at least these days, it's usually at sculpture?

BB: I think that that goes back to what we talked about

earlier, about the sense that sculpture is really more *there*, and because it's more real and more there, it's also more objectionable if you don't like it. Maybe the counterside of that is, when sculpture connects it is a very strong connection.

PF: Right.

BB: Perhaps there's a stronger reaction to sculpture because it really *is* in your space and it is a part of your world and you can't ignore it as much. I just wish people would get as upset about billboards polluting the visual environment as they do about sculpture they don't like. Public sculpture gets reactions that murals don't get, unless the murals get overtly political; an abstract mural on the side of a building does not generate the kind of negative reaction a sculpture does. In a way, I take that as a vote that sculpture has more impact.

PF: You've been dogged in your discussion of maintaining your allegiance to modernism.

BB: Modernism makes fundamental sense to me. I feel it genuinely. I didn't choose it, like choosing it over some other "ism." It is a genuinely true explanation of how art relates to man. It is a real position that I understand now and that I understood immediately. It just went "click" for me when I first started making art. It was like discovering something that I didn't know I knew.

PF: When did you discover that?

BB: In my first art class at Dartmouth College, in the first art class I ever took; it was a drawing class. The final exam for the class was fifty independent drawings. I don't know what possessed me, but I asked the teacher if I could do five models instead. So my first impulse in art was to make something three-dimensional. They weren't good sculptures, and I knew then that they weren't. But the fact that I was making something three-dimensional, that had meaning, and that hadn't existed before, felt wonderful. On the basis of that, I decided I was going to be a sculptor. And I've never looked back. I've never wanted to do anything else. It's never lost its excitement or engagement. I am very fortunate, I found

the right thing for me, and I found it early. It is deep, engaging, and powerful. I feel a great connection with the long path of man's engagement with art, and I am honored to be a part of it.

PF: So do you find any connection to sculptors who may not subscribe to the modernist aesthetic to the same extent that you do?

BB: I'll admit that I find a little less in common with a genuinely postmodernist sculptor who believes that the aesthetic is external to the work. I really do have trouble with that.

PF: I can understand that. How about somebody who stands on the cusp, like a minimalist?

BB: Yes, I can connect there. But what are the better minimalist pieces? They're the ones with the best formal values. You can't escape from modernism because it expresses something that is true. It doesn't matter how many times you say that all aesthetics is completely culturally based. It isn't true. Modernism articulates issues about art that are genuinely profound and true. It is not just another flavor of the month, so to speak.

My wife, Laurence, and I have been very involved in prehistoric art. I have published papers on it, and I was part of the team that described the newly discovered prehistoric cave of Chauvet in France, which dates back to 30,000 BCE. I've had the privilege of taking people to the original cave of Lascaux probably fifty times, and they always come out in tears. It is a deeply moving experience. It is not just the sense of time they're responding to; the work is beautiful, and it communicates to us. What comes across is the artists striving for and achieving beauty. It is not factual information that is being communicated. What we feel is the feeling conveyed by those artists. We know nothing of the language, the ceremonies, or the myths of these people. There is no people and no culture in the world that we know less about, yet their art speaks directly to us across thirty thousand years of time. I can see no better demonstration than this that there are inherent values in art, and I know of no better validation for modernism.

STEEL, IRON, ALUMINUM, BRONZE, SILVER 1960–1967

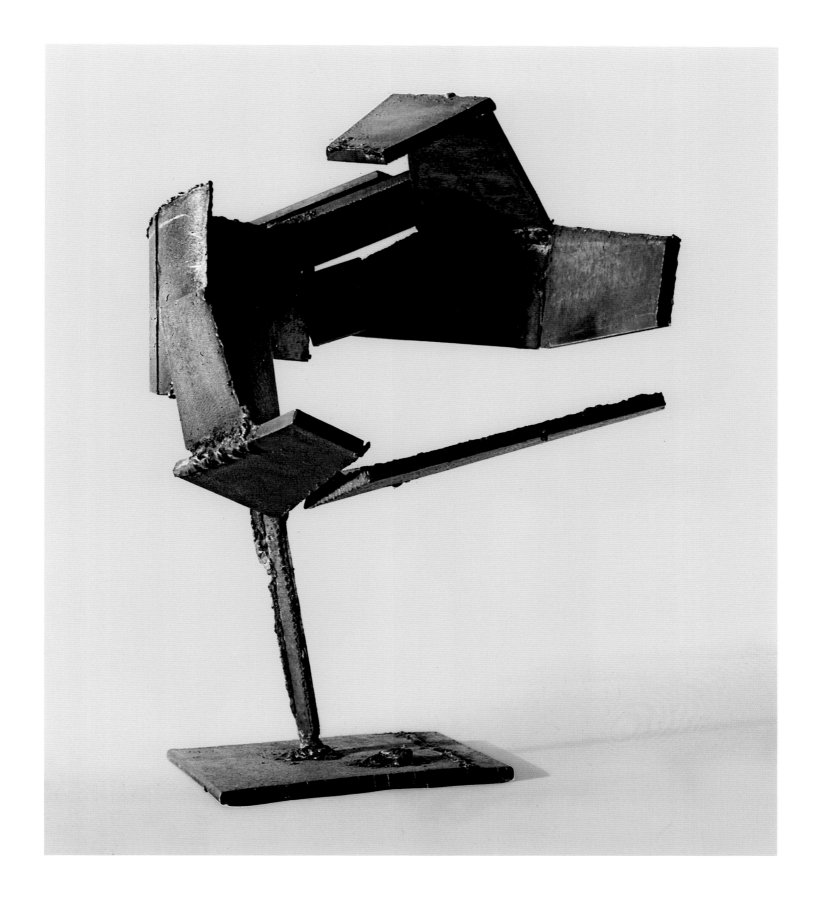

Plate 21. *Roraril*, 1960. Welded steel, height 18 in. Private collection.

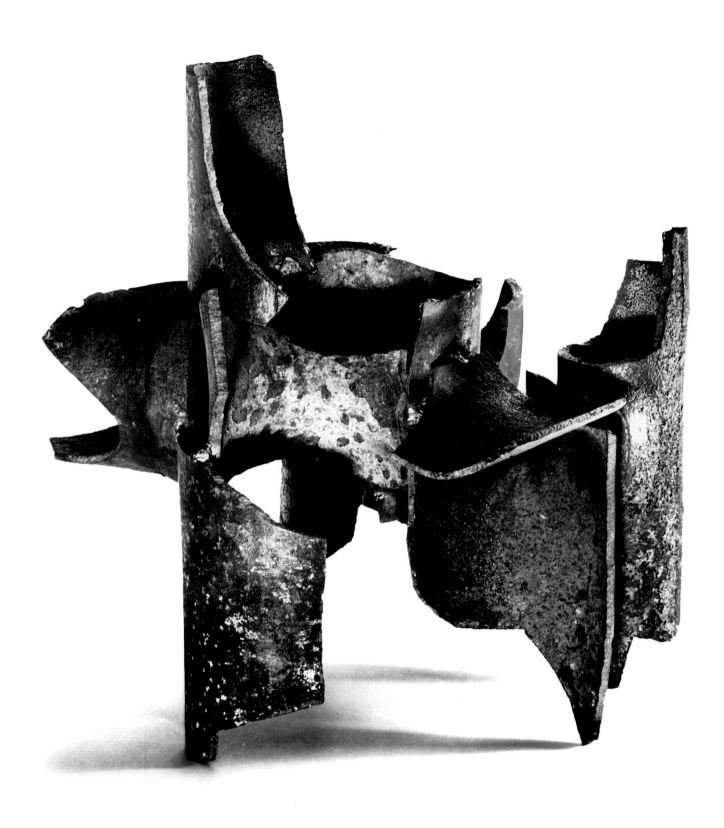

Plate 22 [above]. *Horae*, 1960. Welded cast iron, height 14 in. Private collection.

Plate 23 [facing]. Untitled, 1960. Welded cast iron, 22 × 19 × 14 in. Private collection.

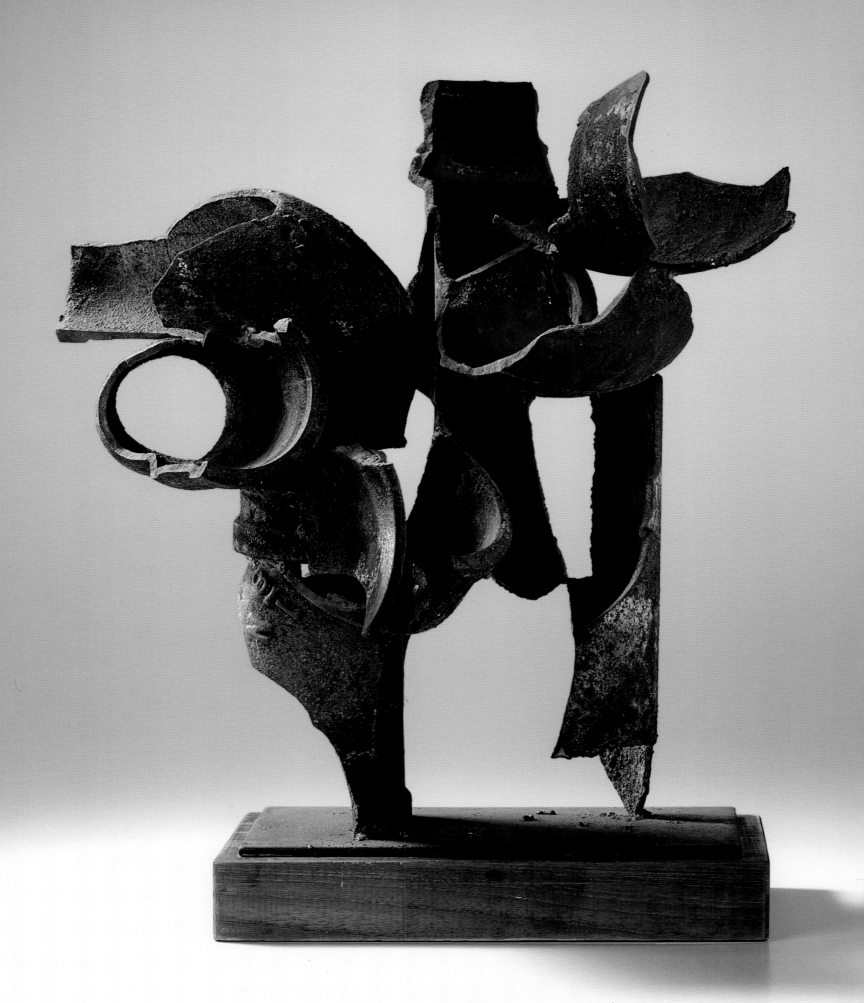

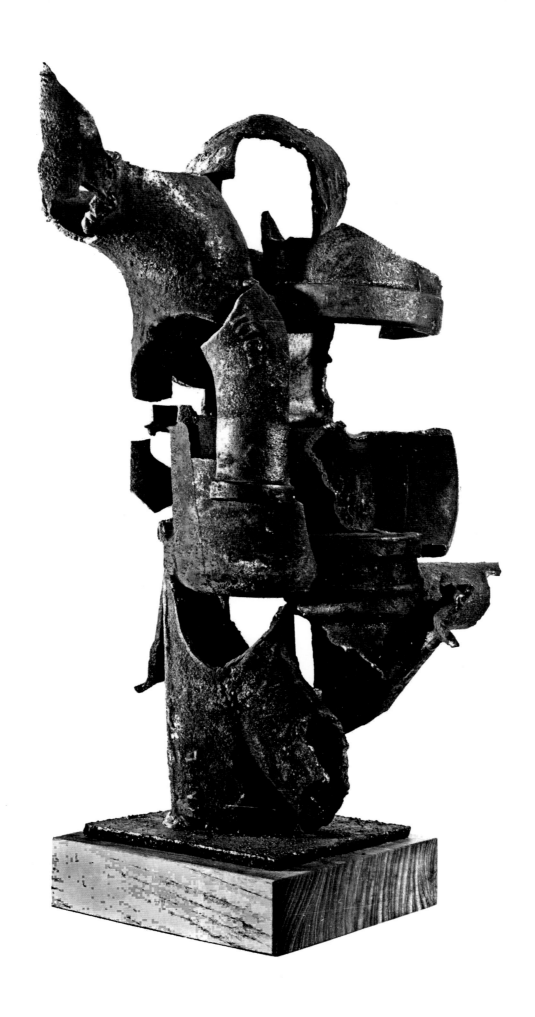

Plate 24 [above]. *Druid*, 1961. Welded cast iron, height 34 in. Private collection.
Plate 25 [facing]. *Tree House*, 1960. Welded cast iron, 24 × 15 in. Private collection. (See also plate 2.)

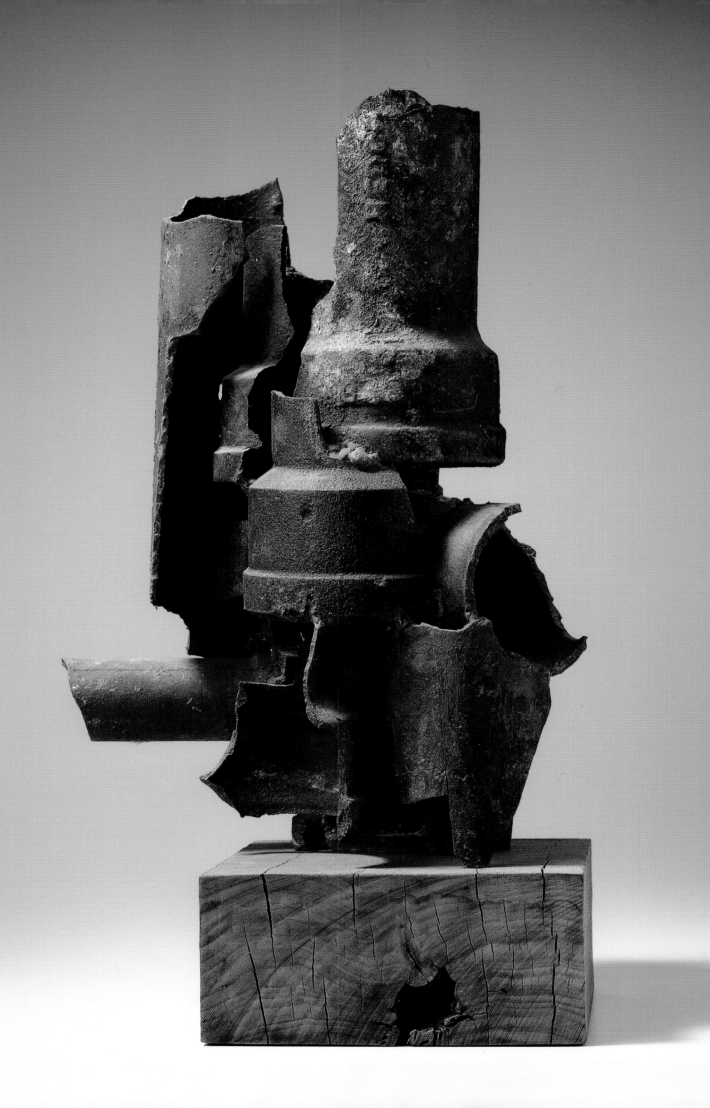

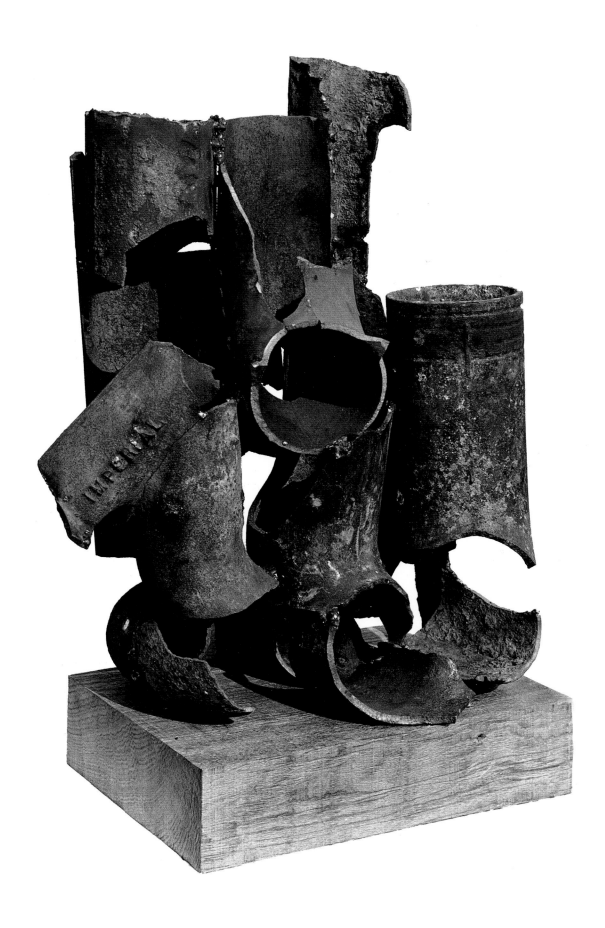

Plate 26 [above]. Untitled, 1960. Welded cast iron, height 36 in. Private collection.

Plate 27 [facing]. *Lemures*, 1961. Welded cast iron, 19 × 15 in. Private collection. (See also plate 8.)

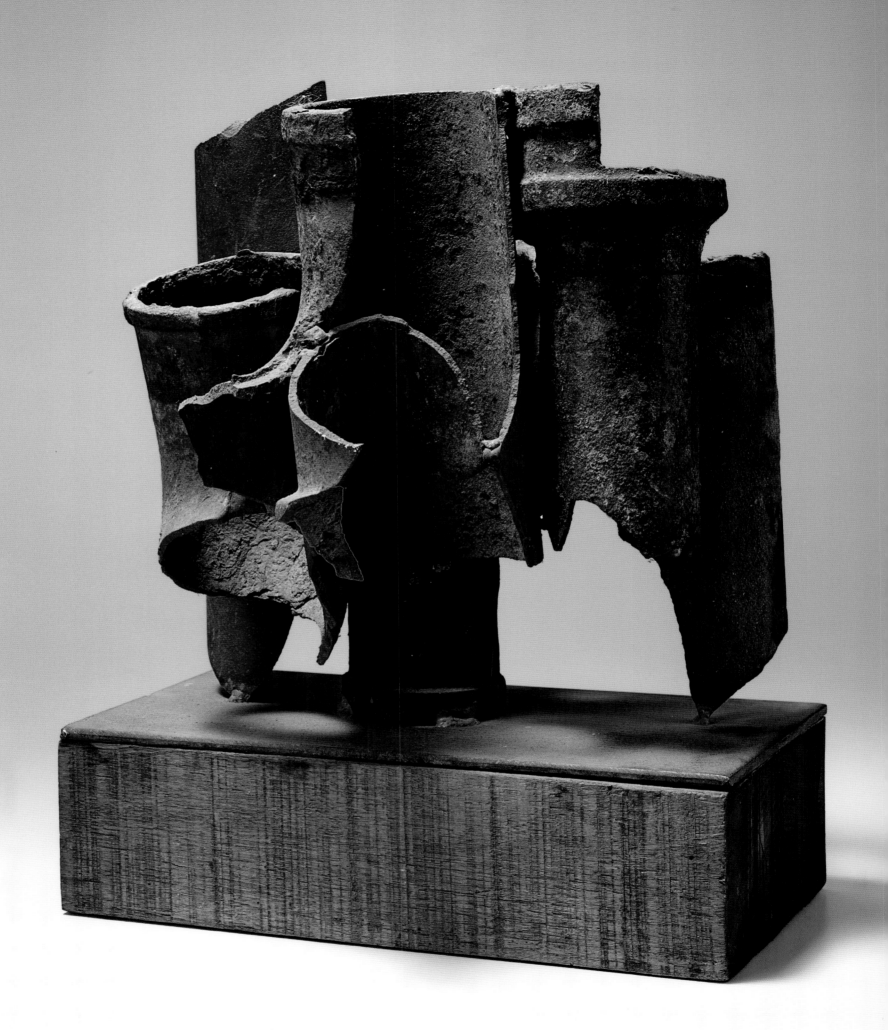

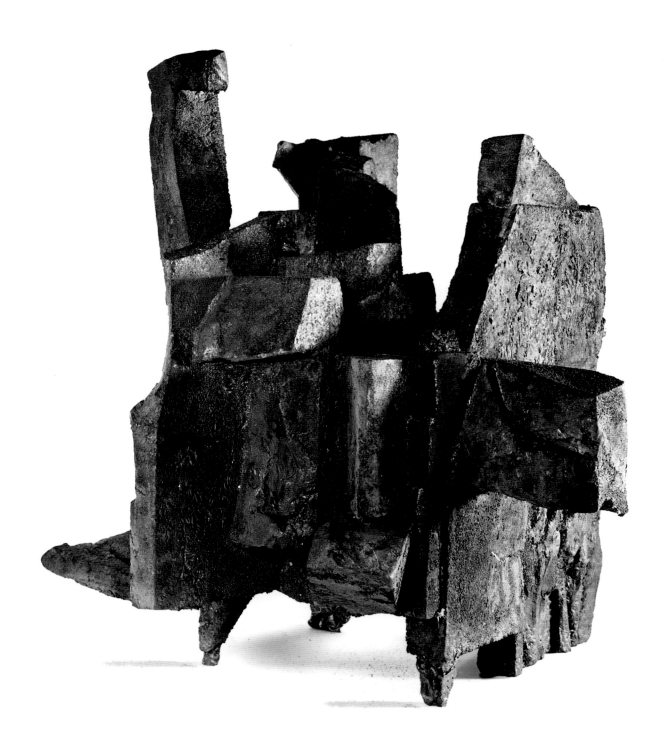

Plate 28. *Trillion*, 1960. Cast iron, height 16 in. Private collection.

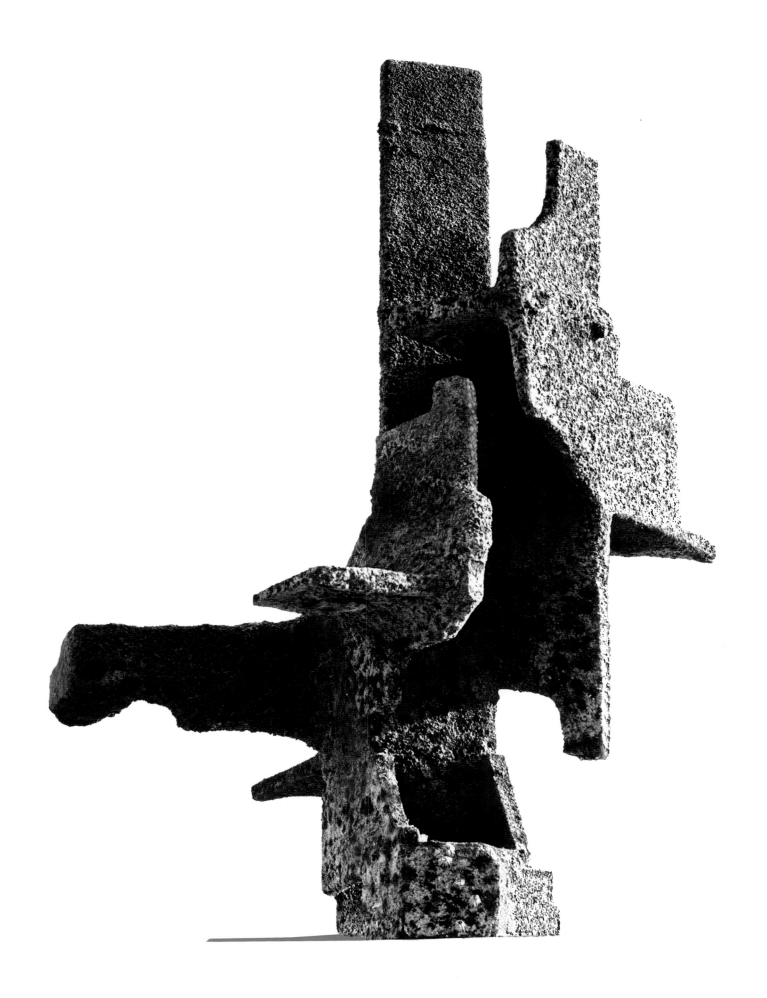

Plate 29. Untitled, 1960. Cast iron, height 40 in. Private collection.

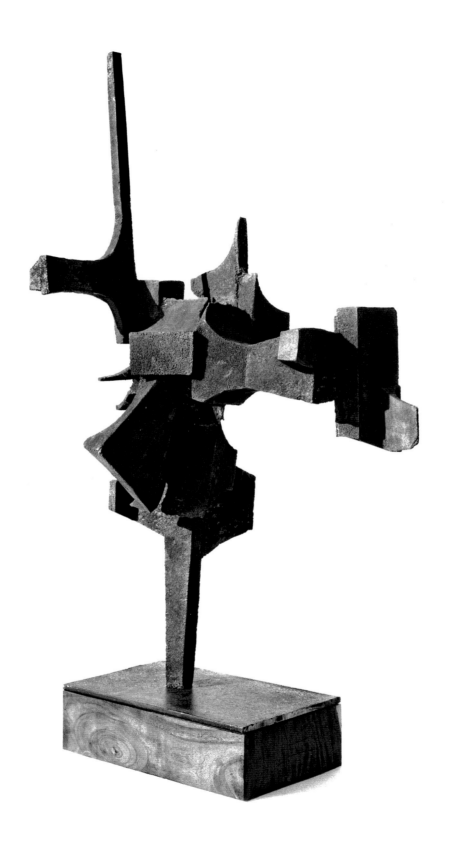

Plate 30. *Charisma*, 1961. Cast iron, 18 × 18 in. Private collection.

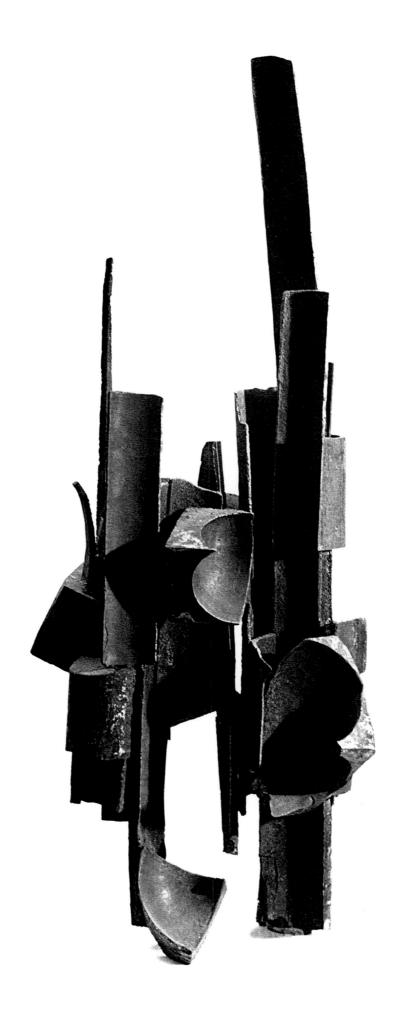

Plate 31. *Proteus*, 1962. Cast bronze, height 48 in. Private collection.

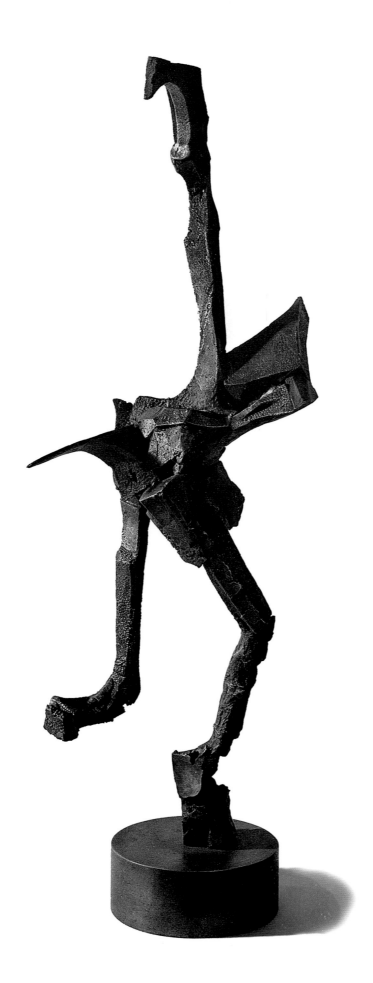

Plate 32. *Tallos*, 1962. Cast aluminum, height 38 in. Private collection.

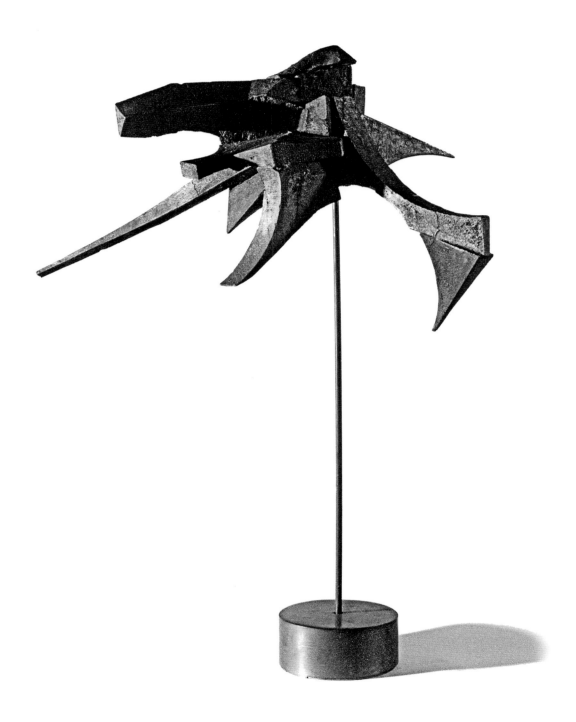

Plate 33. *Horus*, 1962. Cast aluminum, height 26 in. Private collection.

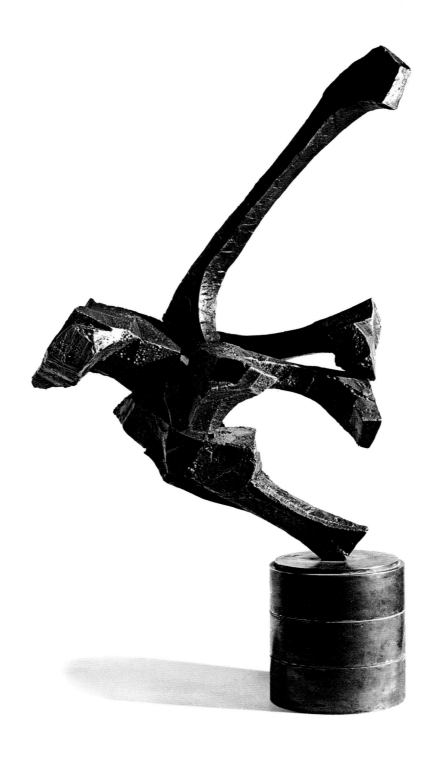

Plate 34. *Dares*, 1962. Cast aluminum, height 18 in. Private collection.

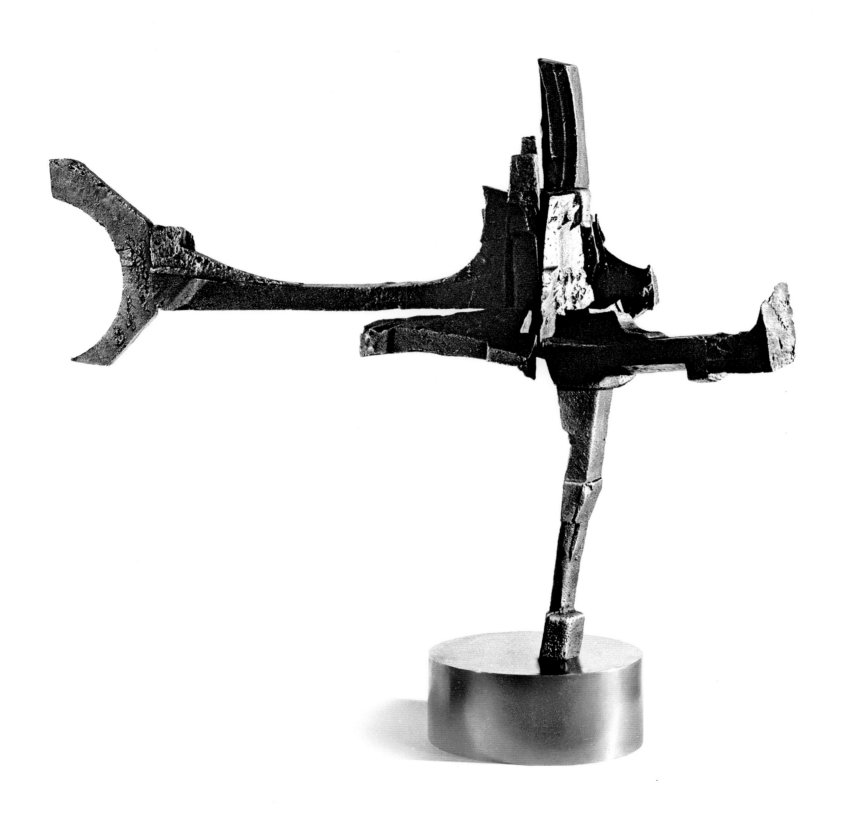

Plate 35. *Seneca*, 1962. Cast aluminum, width 26 in. Private collection.

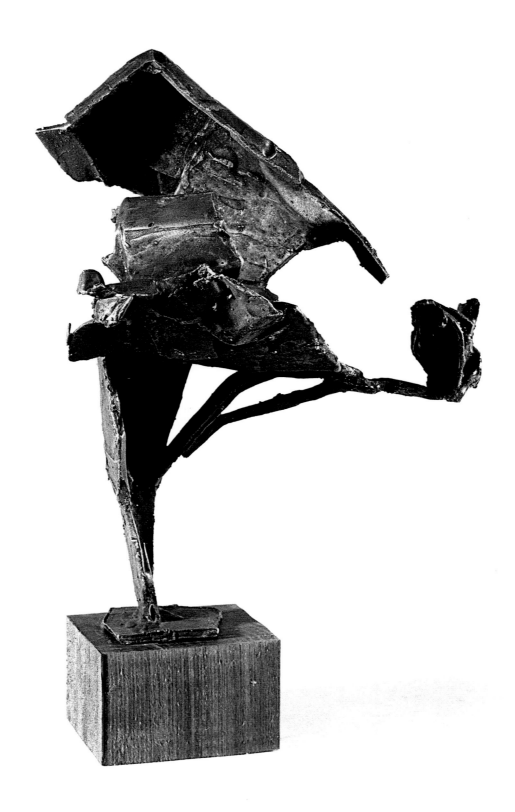

Plate 36. *Indictment*, 1960. Cast bronze, height 12 in. Private collection.

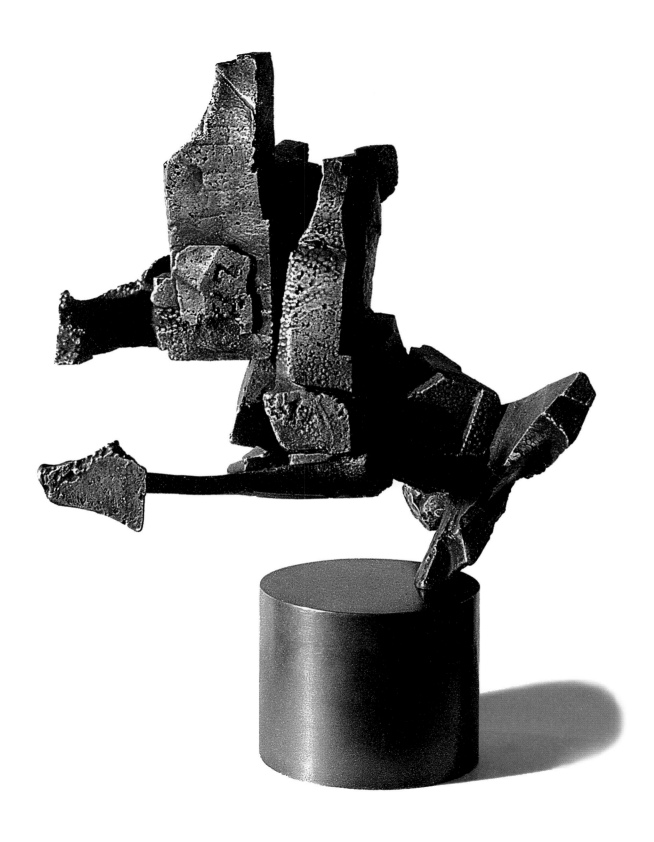

Plate 37. *Amycus*, 1962. Cast aluminum, height 16 ³/₄ in. Private collection.

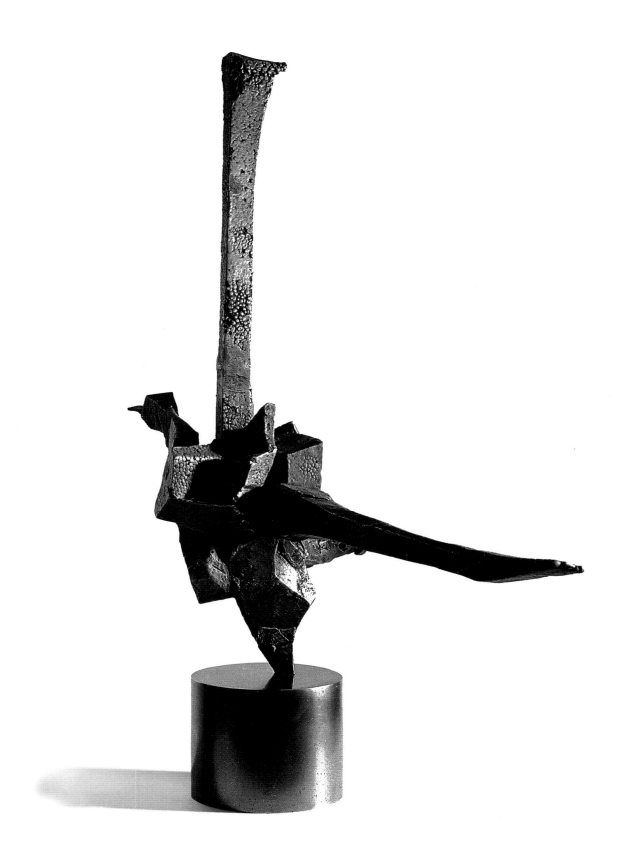

Plate 38 [above]. *Dryad*, 1962. Cast aluminum, height 26 in. Private collection.
Plate 39 [facing]. *Dardanus*, 1962. Cast aluminum, 42 × 13 in. Private collection.

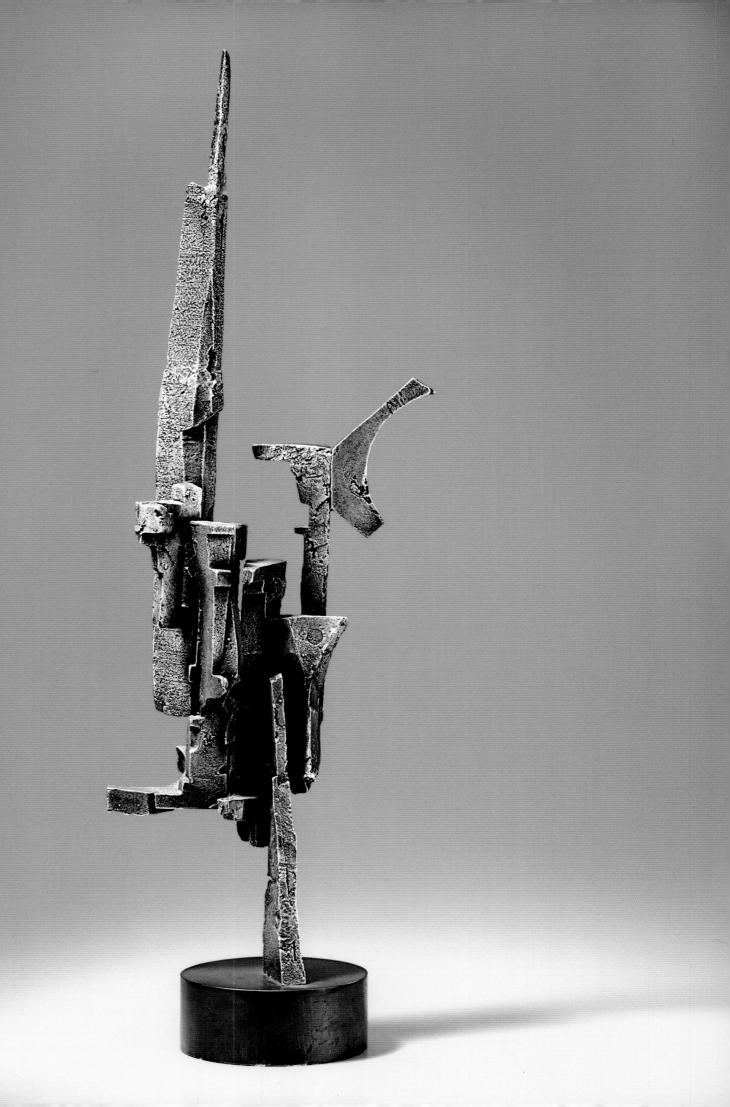

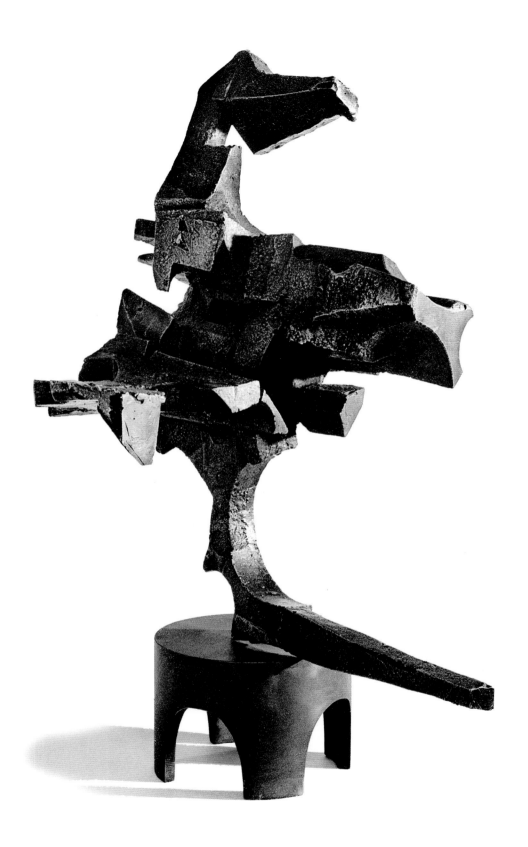

Plate 42. *Ammon*, 1963. Cast aluminum, 26 × 18 × 18 in. Private collection.

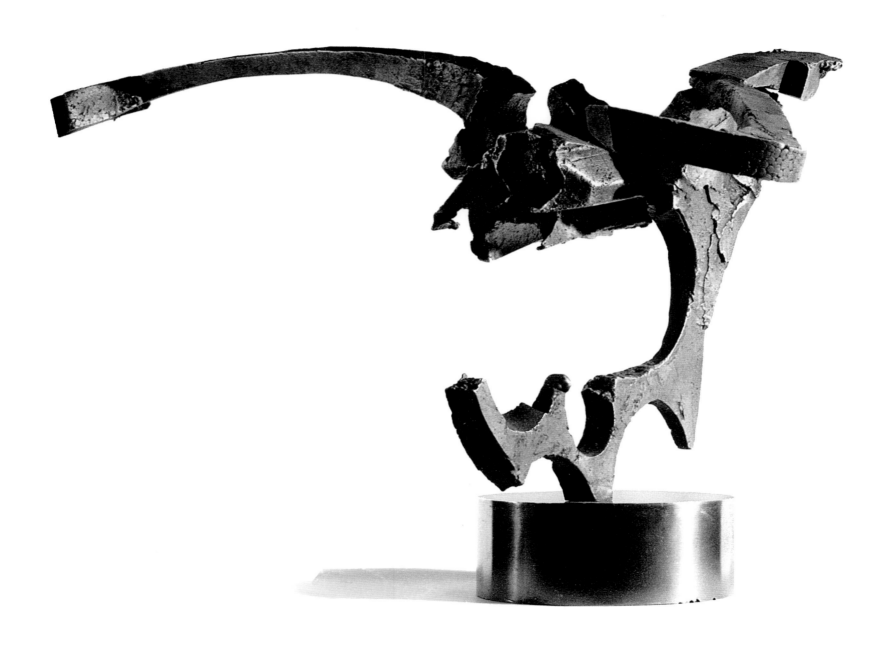

Plate 43. *Alkyone*, 1963. Cast aluminum, 20 × 40 in. Private collection.

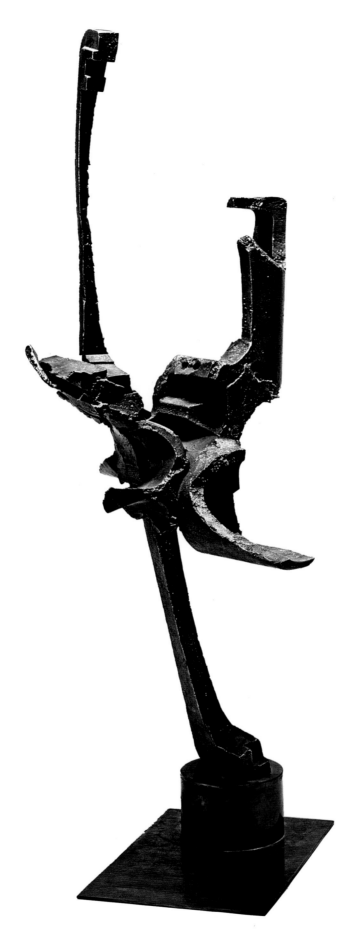

Plate 44 [above]. *Prometheus II*, 1963. Cast aluminum, 48 × 18 in.
Solomon R. Guggenheim Museum, New York, New York. (See also plate 15.)

Plate 45 [facing]. *Daedalus*, 1963. Cast aluminum, height 38 in. Los Angeles
County Museum of Art, Los Angeles, California; Gift of Anna Bing Arnold.

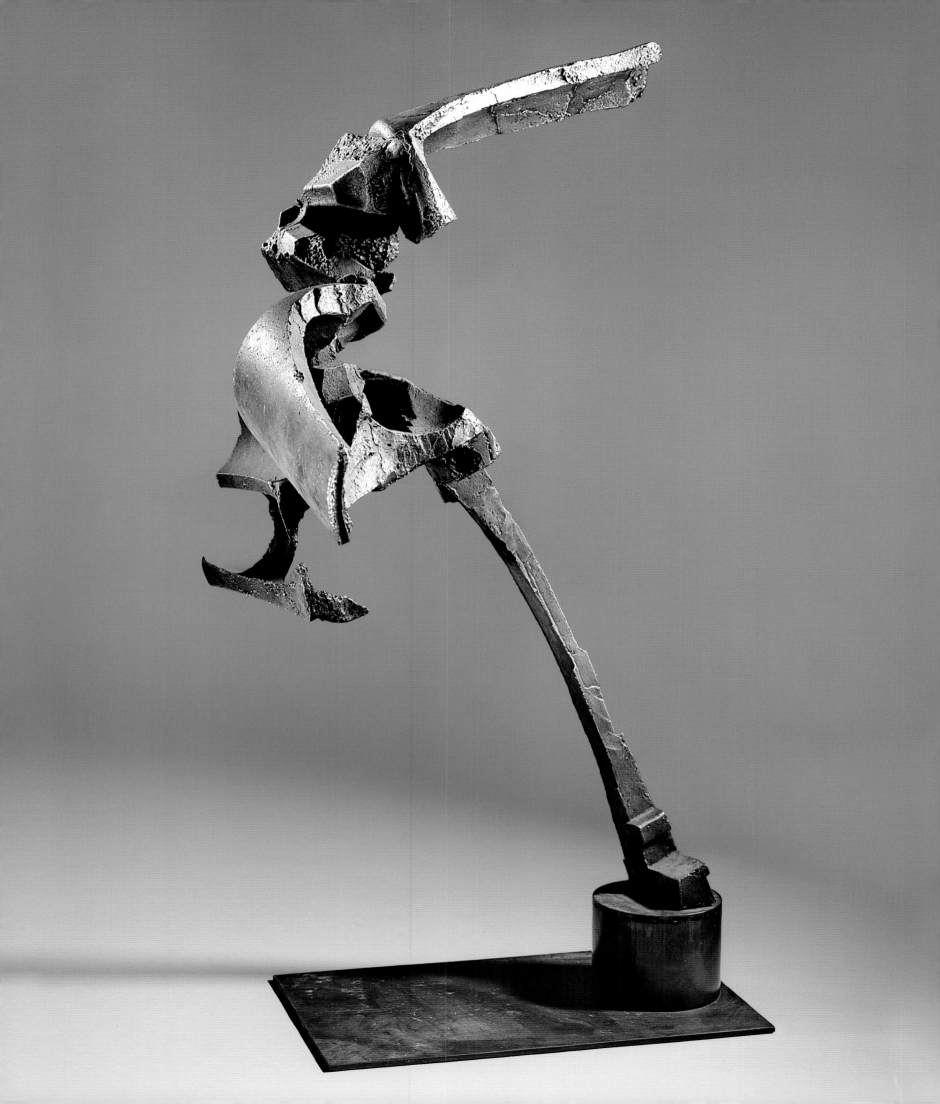

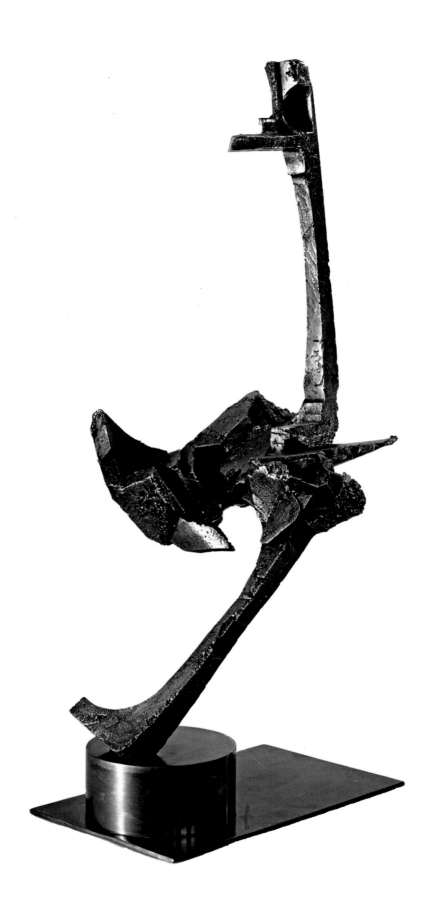

Plate 46 [above]. *Isadas*, 1964. Cast aluminum, height 35 in. Private collection.

Plate 47 [facing]. *Hephaistos*, 1963. Cast aluminum, 45 × 36 in. Private collection. (See also plate 9.)

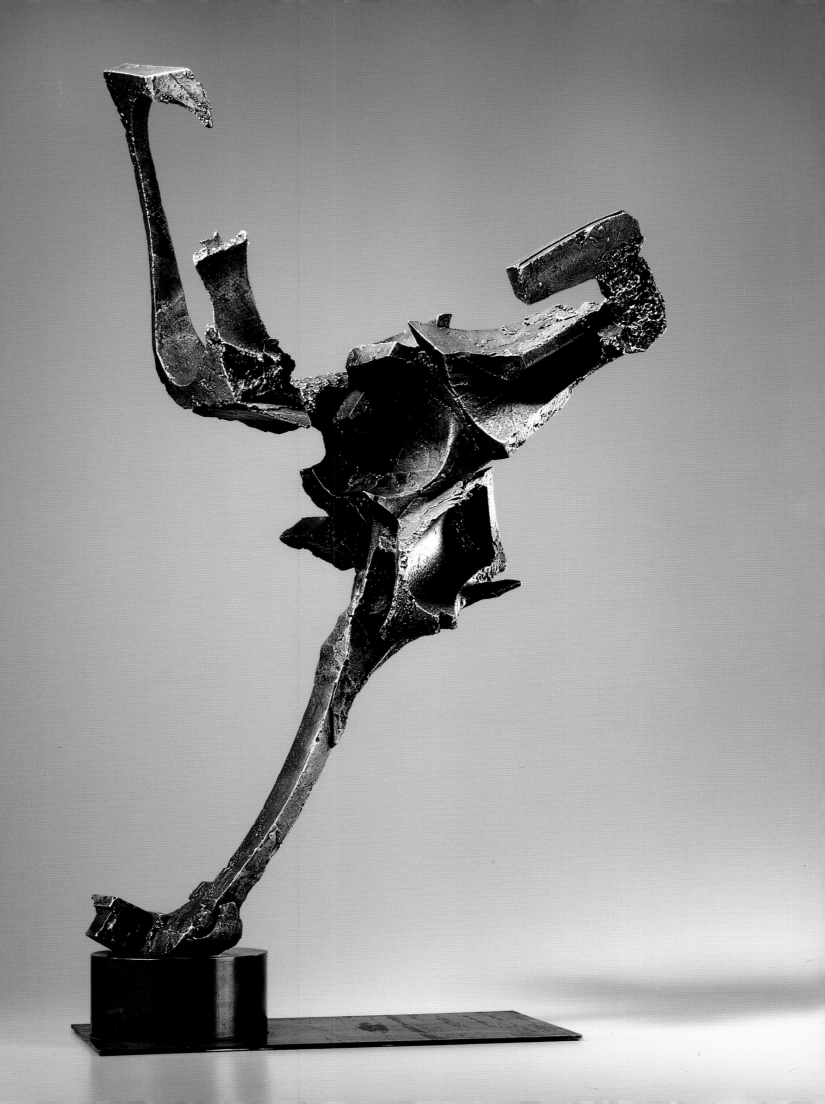

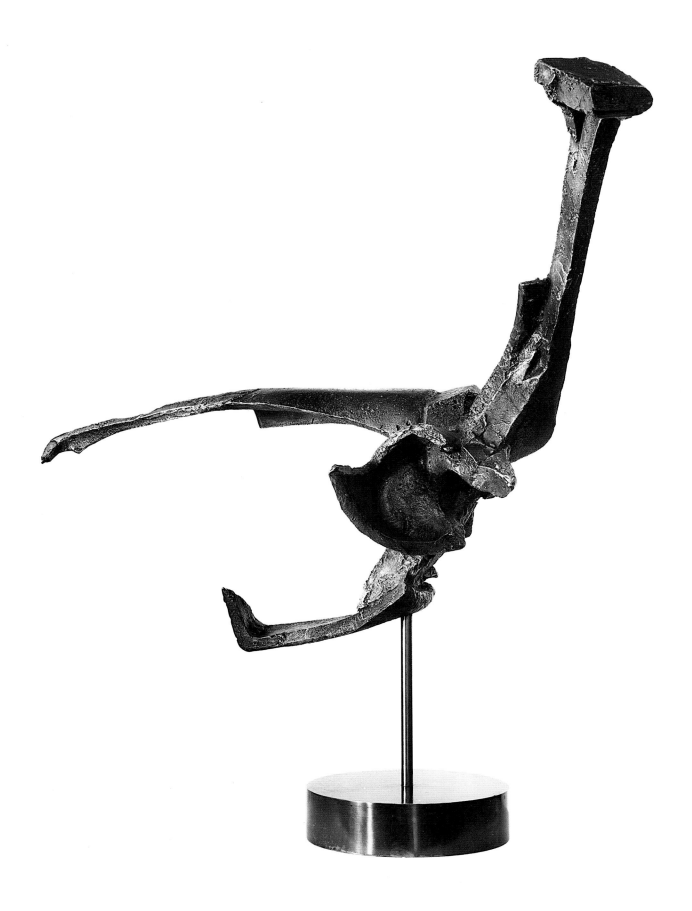

Plate 48 [above]. *Dione*, 1964. Cast aluminum, 39 × 41 in. Franklin Murphy
Sculpture Garden, University of California, Los Angeles, California.
Plate 49 [facing]. *Damon*, 1964. Cast aluminum, 37 × 33 in. Private collection. (See also plate 14.)

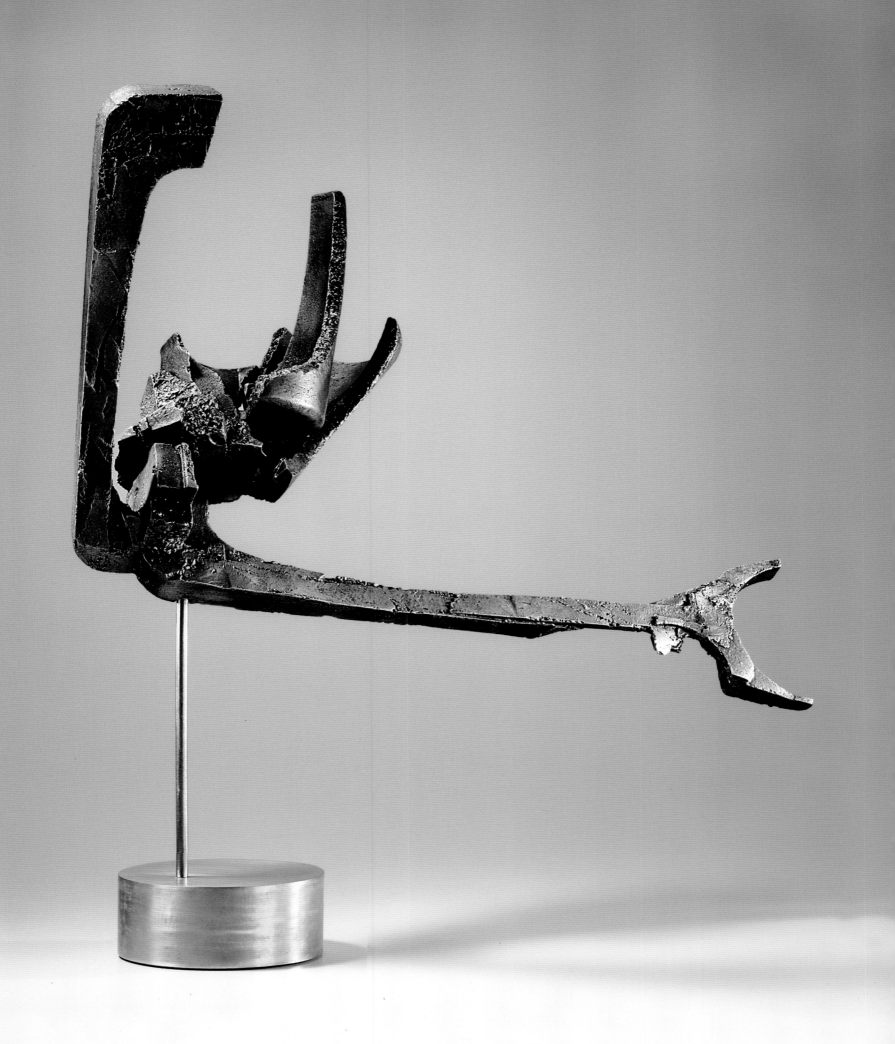

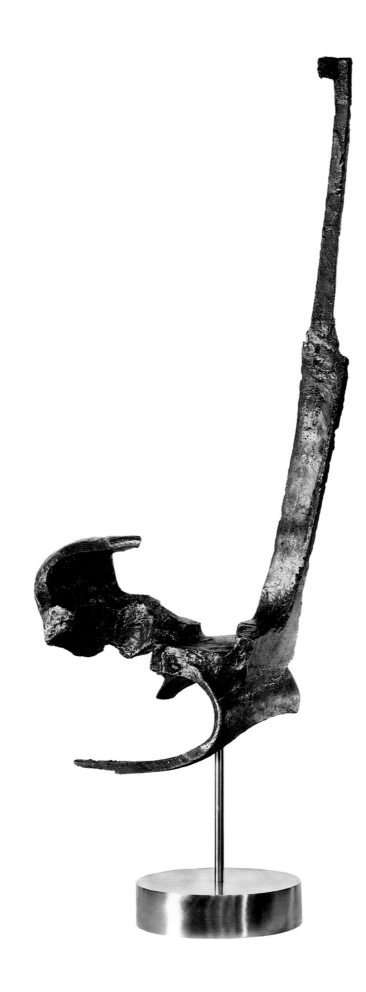

Plate 50. *Agron*, 1964. Cast bronze, height 57 in. Private collection.

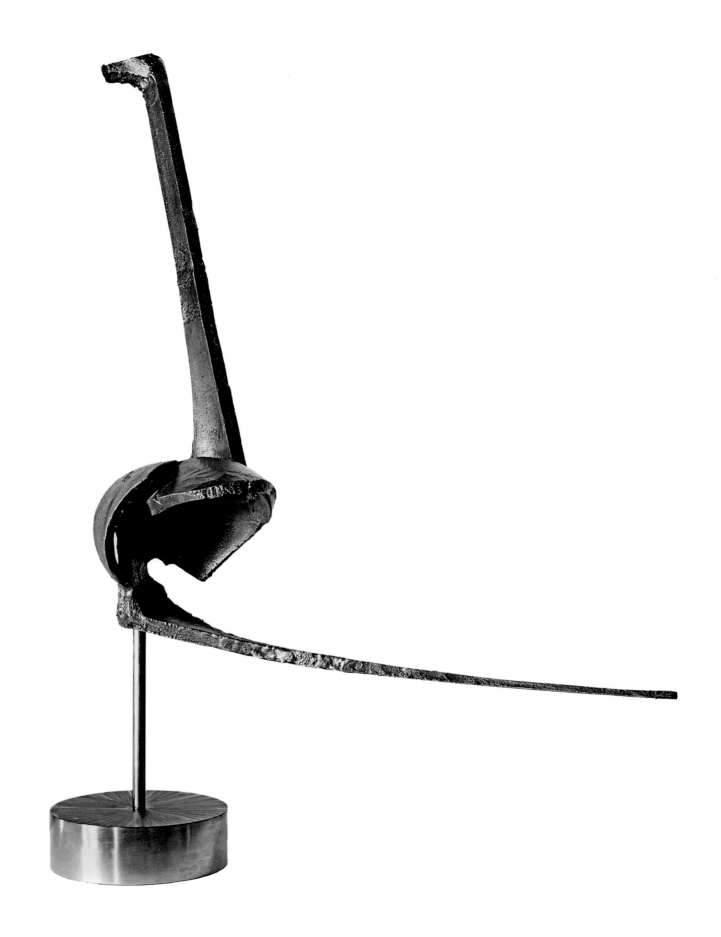

Plate 51. *Inarus*, 1964. Cast bronze, height 55 in. Marin County Civic Building, San Rafael, California.

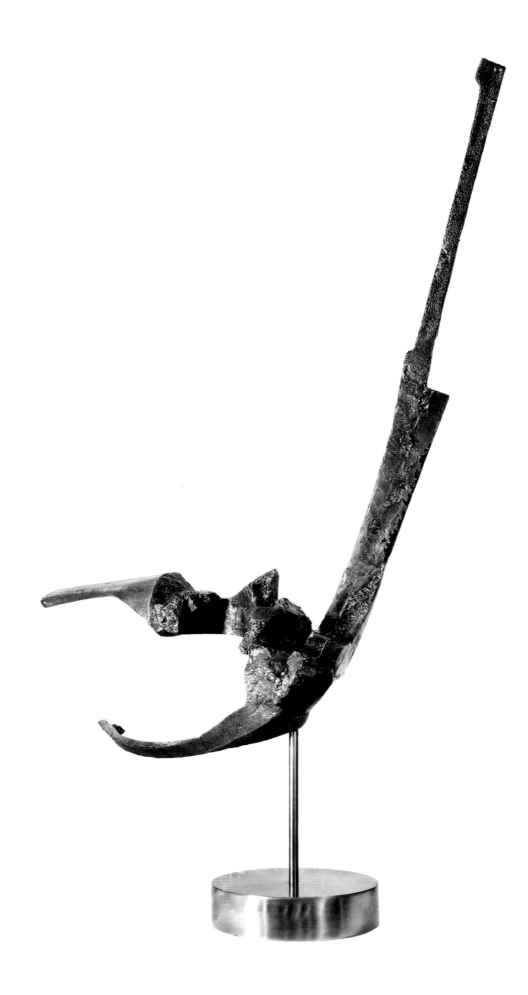

Plate 52. *Arione*, 1964. Cast bronze, height 57 in. Private collection.

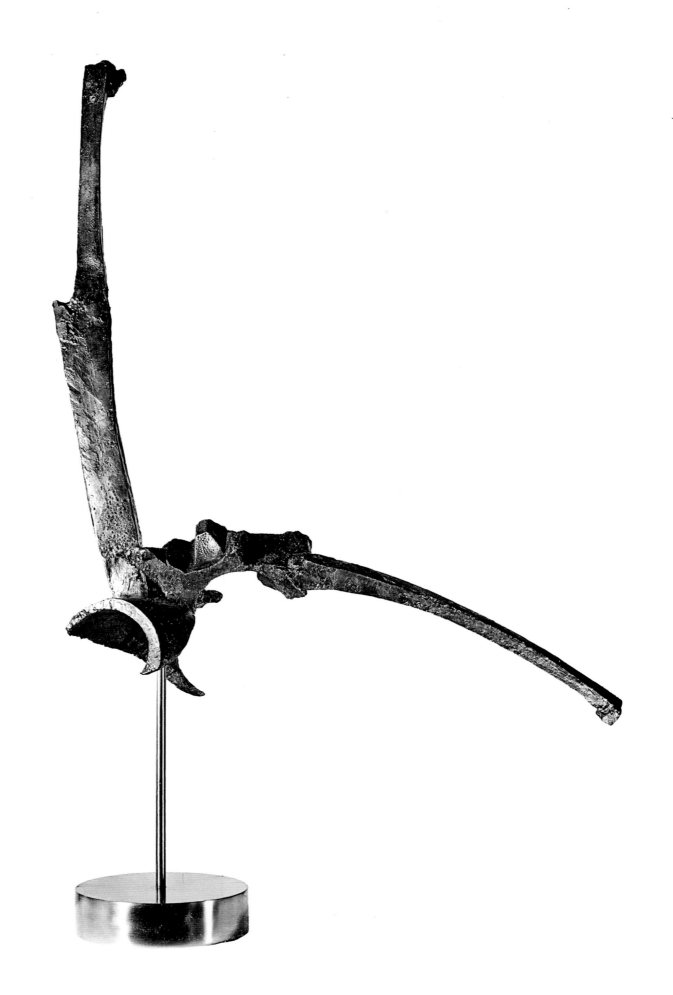

Plate 53. *Tercel*, 1964. Cast bronze, height 57 in. Private collection.

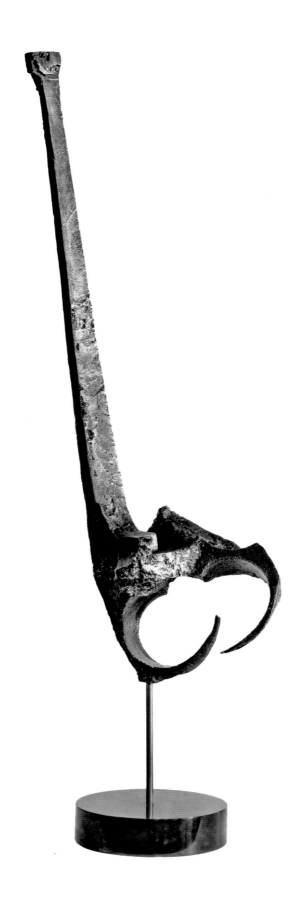

Plate 54 [above]. *Nessus*, 1964. Cast aluminum, height 57 in. Private collection.

Plate 55 [facing]. *Naiad*, 1964. Cast aluminum, height 51 in. Private collection.

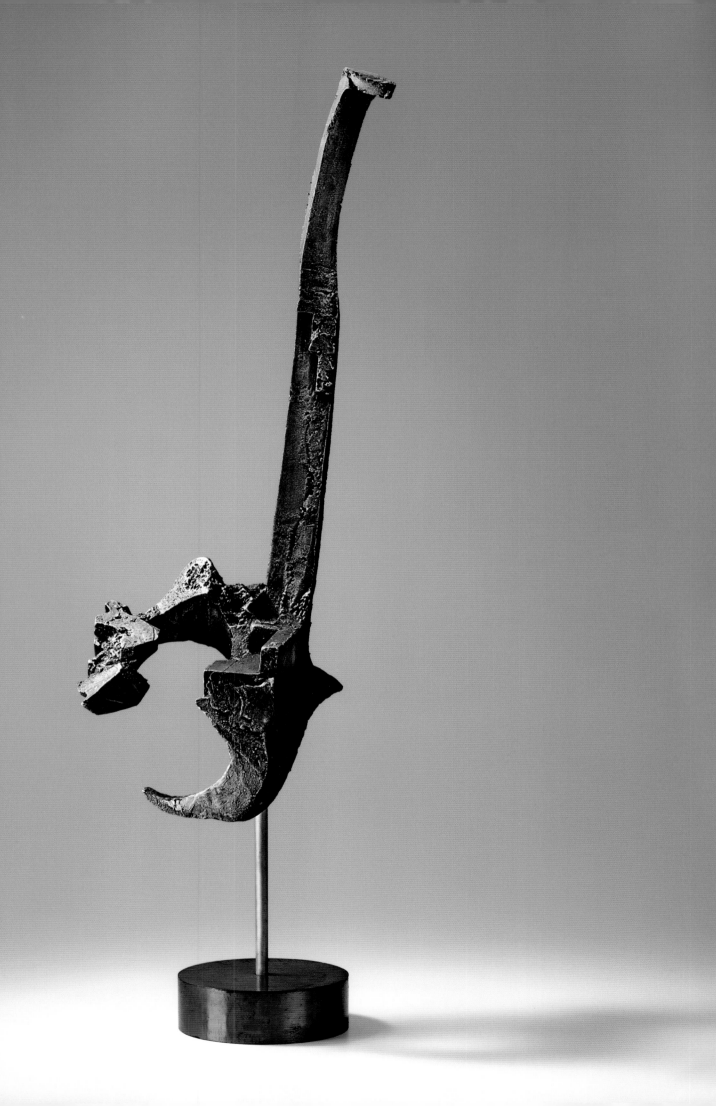

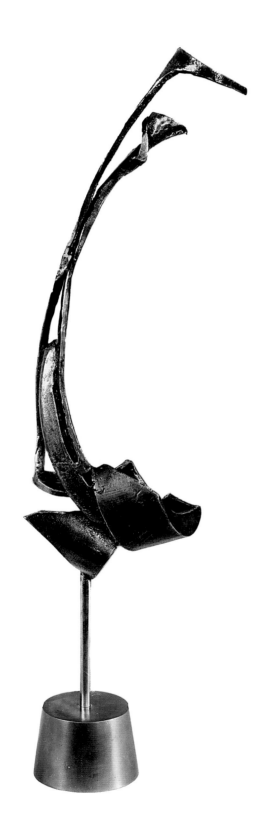

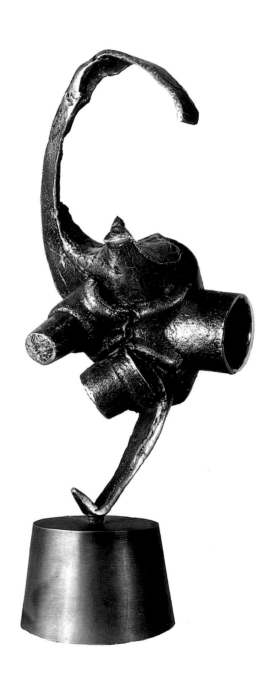

Plate 56 [left]. *Casmillus*, 1964. Cast sterling silver, height 12 in. Private collection.
Plate 57 [right]. *Telamon*, 1965. Cast sterling silver, height 9^1/$_2$ in. Private collection.

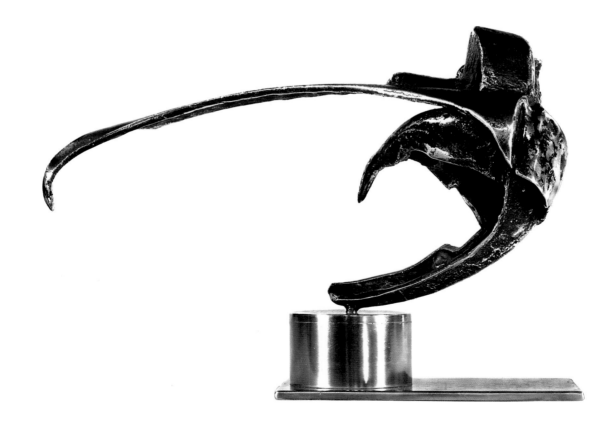

Plate 58. *Carlingot*, 1964. Cast sterling silver, width 8 in. Private collection.

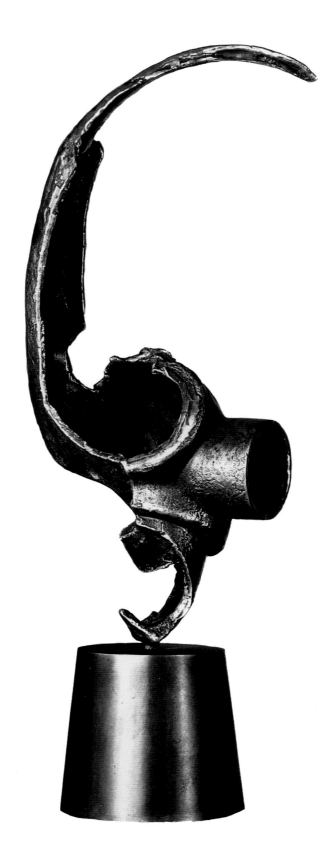

Plate 59. *Solon*, 1965. Cast sterling silver, height 10 in. Private collection.

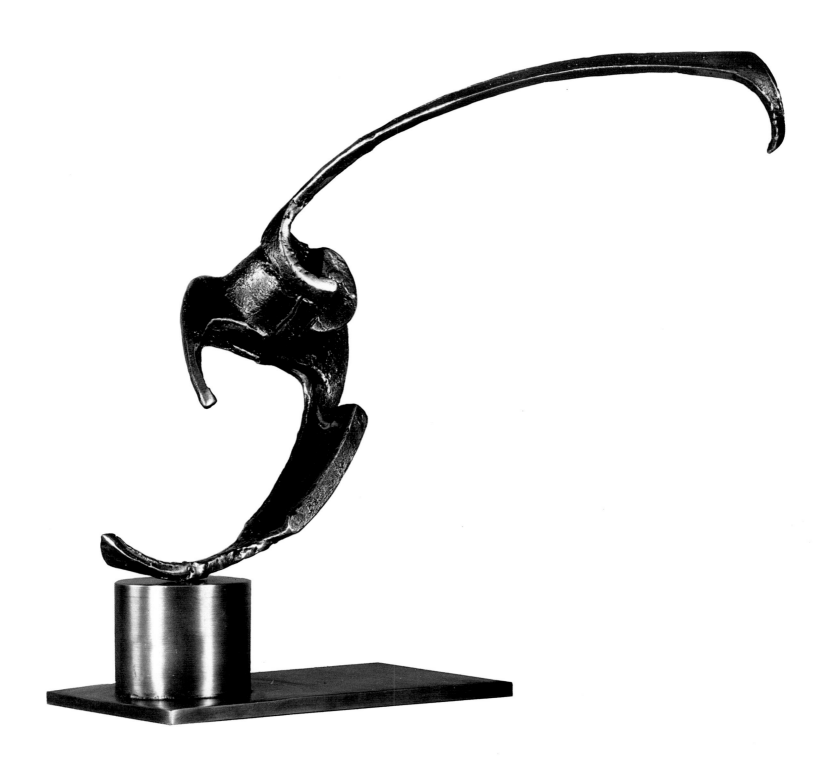

Plate 60. *Grongermain*, 1965. Cast sterling silver, height 10 in. Johnson Foundation, Racine, Wisconsin.

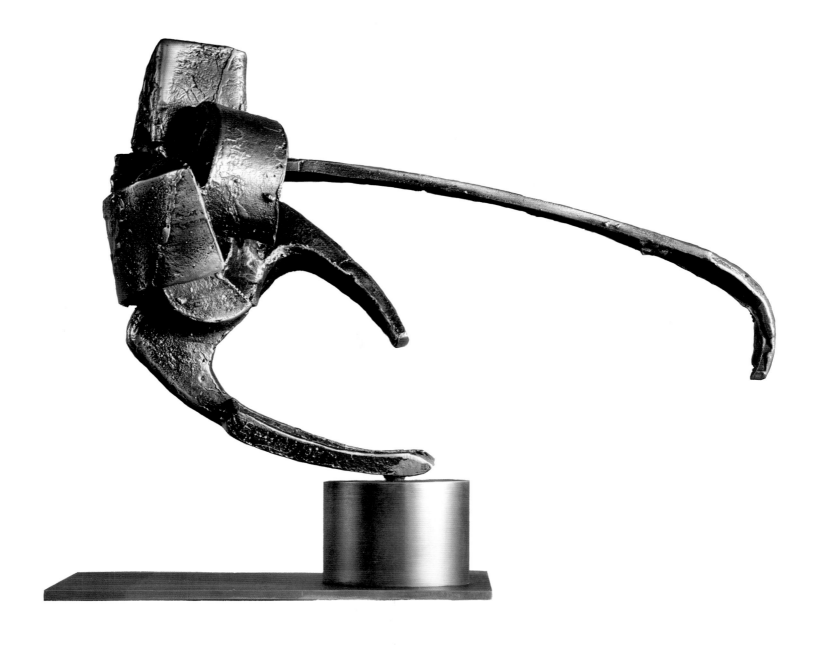

Plate 61. *Sordello*, 1965. Cast sterling silver, 8 × 9 in. Private collection.

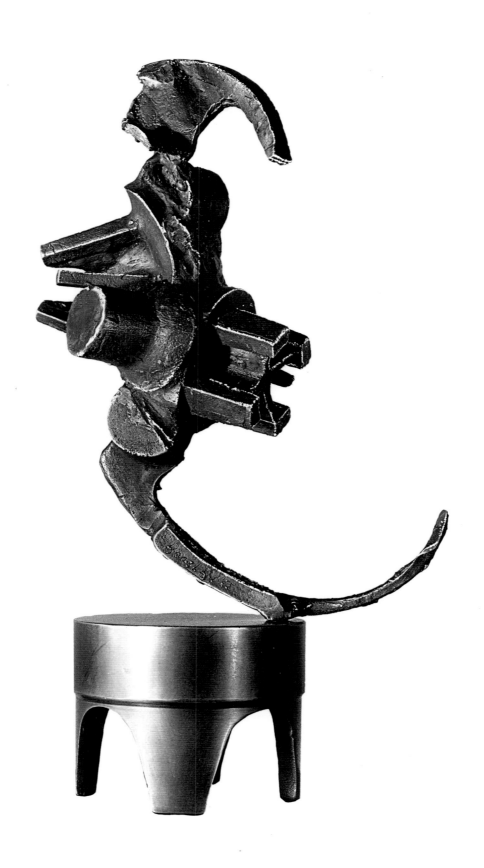

Plate 62. *Small Ammon*, 1965. Cast bronze, height 14 in. Private collection.

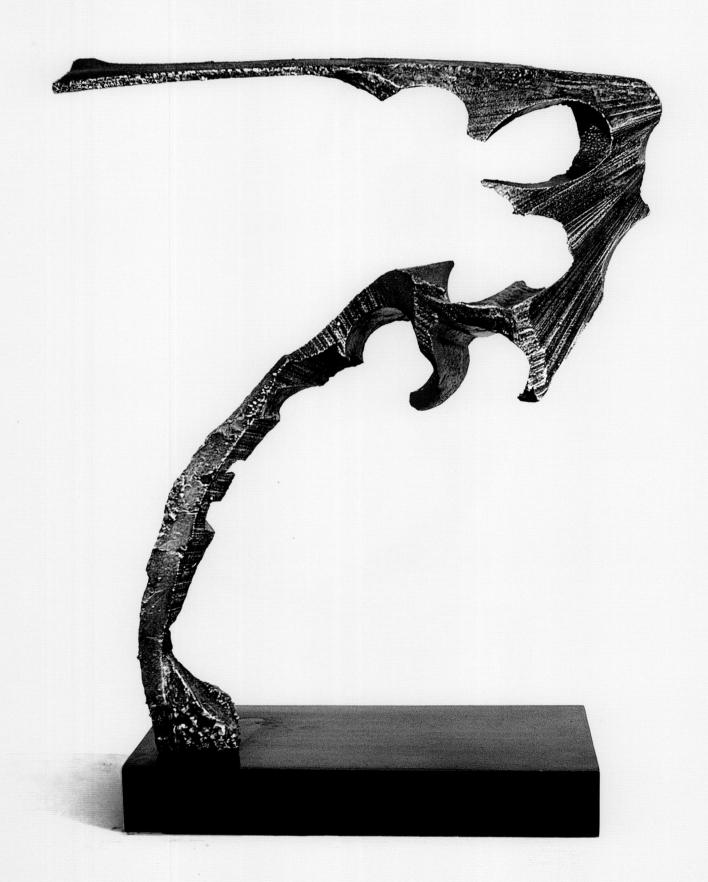

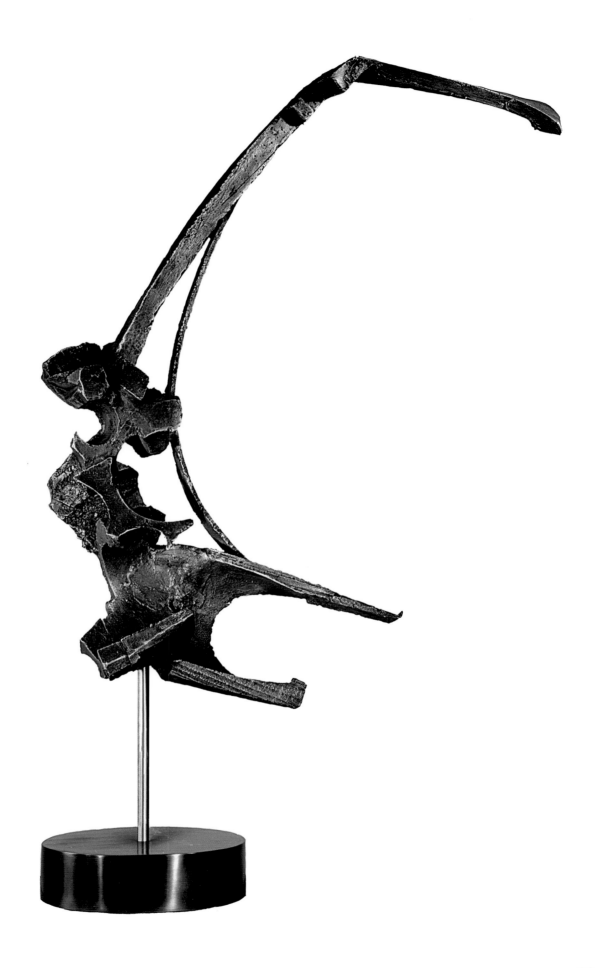

Plate 63 [facing]. *Thestor*, 1965. Cast aluminum, height 32 in. Private collection.

Plate 64 [above]. *Vascone*, 1965. Cast aluminum, height 43 in. Private collection.

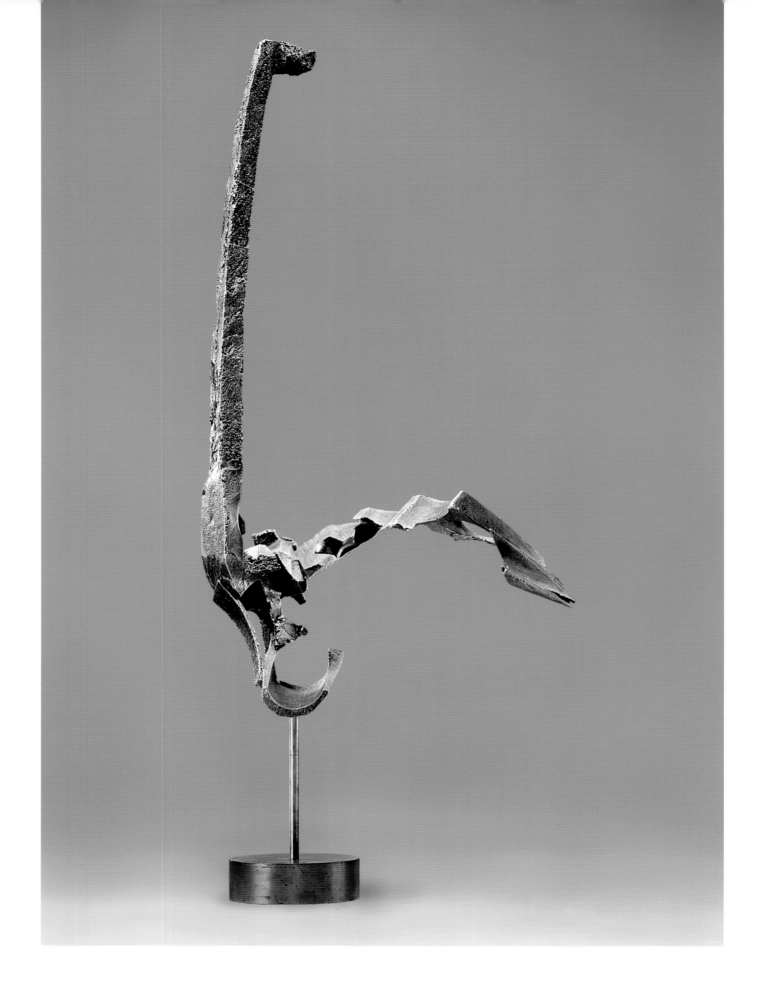

Plate 65 [above]. *Tercel II*, 1966. Cast aluminum, height 55 in. Private collection.

Plate 66 [facing]. *Vascone II*, 1967. Cast aluminum, 36 × 32 × 14 in.

City and County of San Francisco, California. (See also plate 193.)

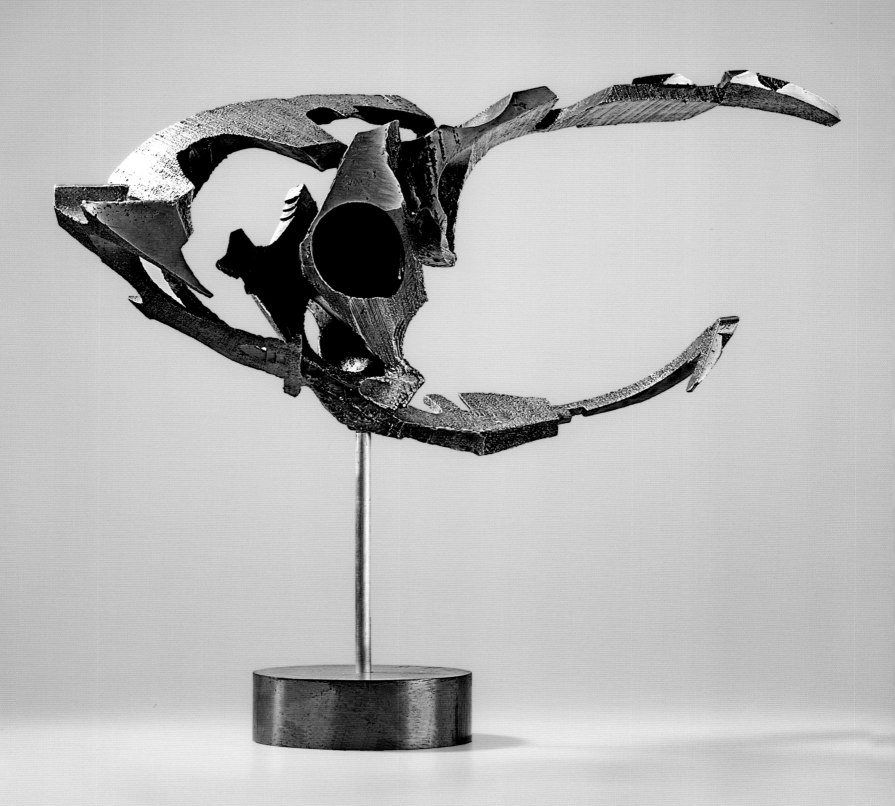

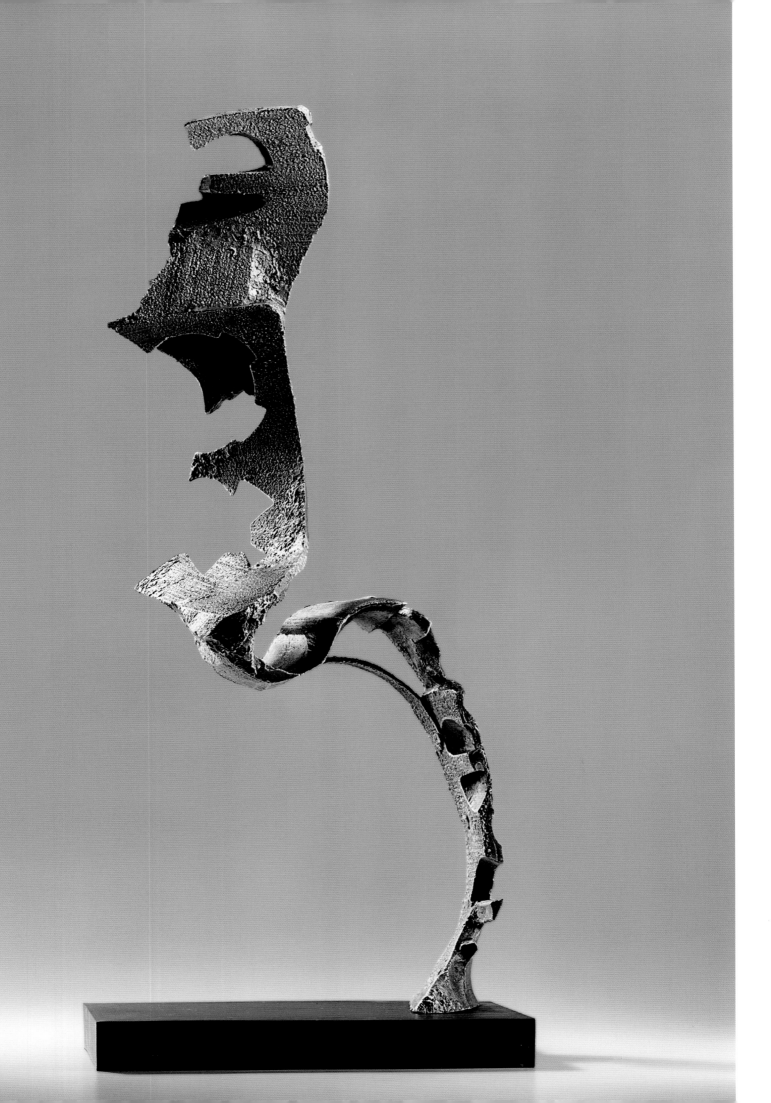

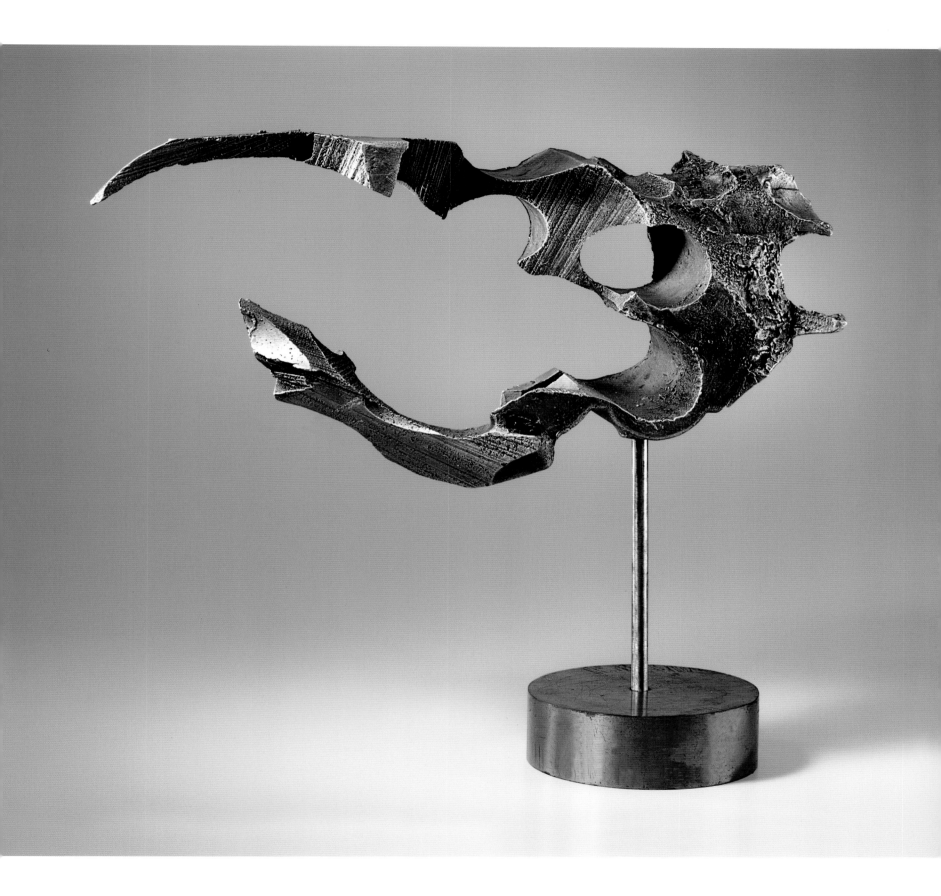

Plate 67 [facing]. *Danastus*, 1966. Cast aluminum, 40 × 18 × 13 in. Private collection.

Plate 68 [above]. *Chiron*, 1966. Cast aluminum, 24 × 28 × 11 in. Private collection.

CAST ACRYLIC 1967–1986

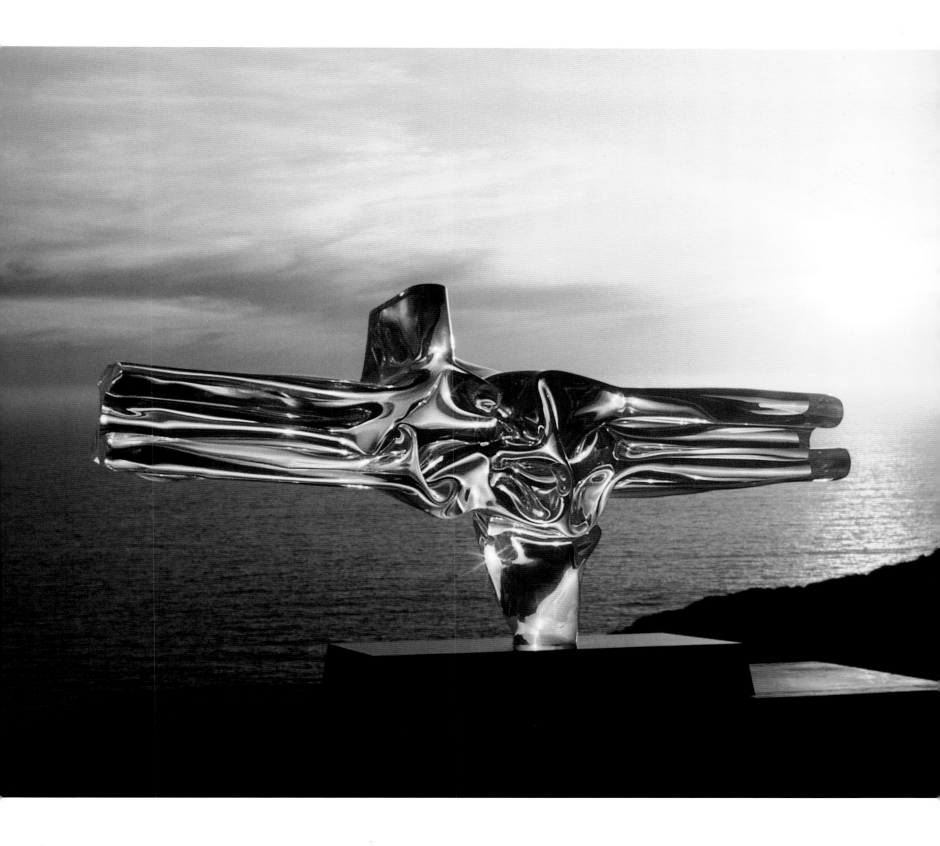

Plate 69. *Tigibus*, 1968. Cast acrylic, width 34 in. Helen Spencer Museum of Art, University of Kansas, Lawrence, Kansas.

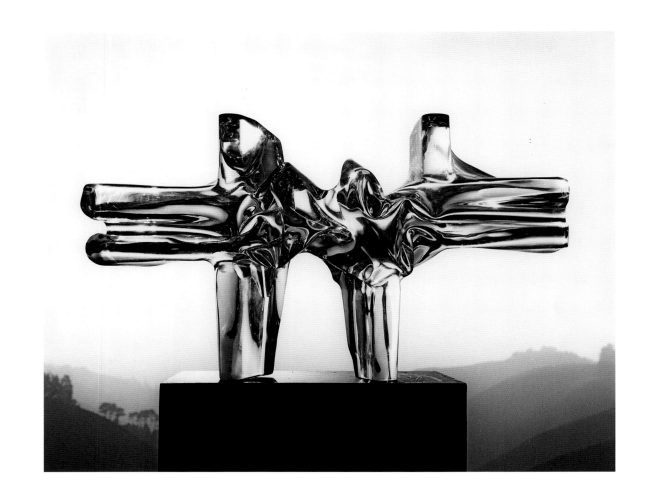

Plate 70 [above]. *Apolymon* model, 1967. Cast acrylic, 29 × 40 in. The Crocker Art Museum, Sacramento, California.

Plate 71 [facing]. *Apolymon*, 1970. Cast acrylic, 108 × 180 × 72 in. State of California, Sacramento, California. (See also plate 11.)

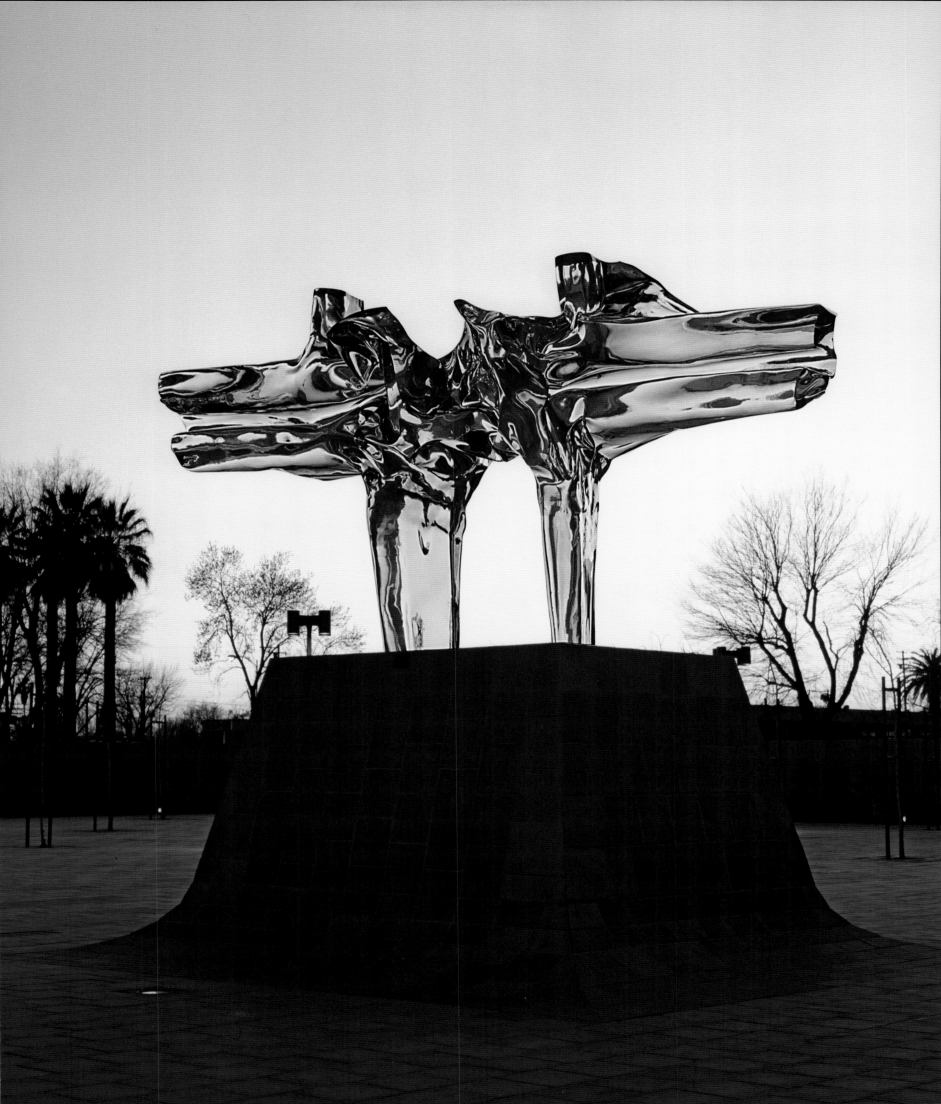

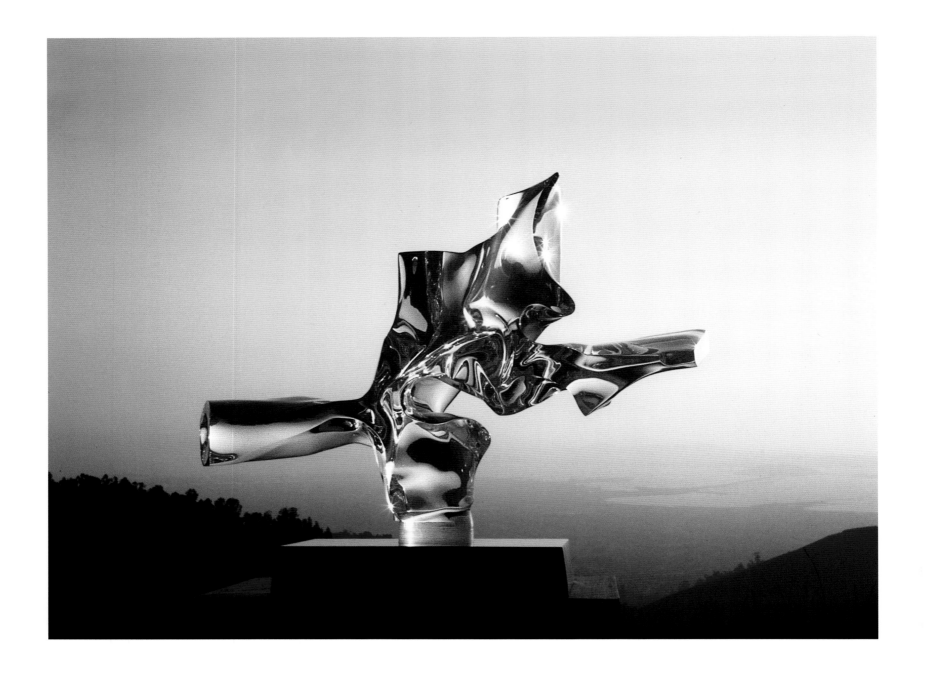

Plate 72. *Klikitat*, 1968. Cast acrylic, width 32 in. Private collection.

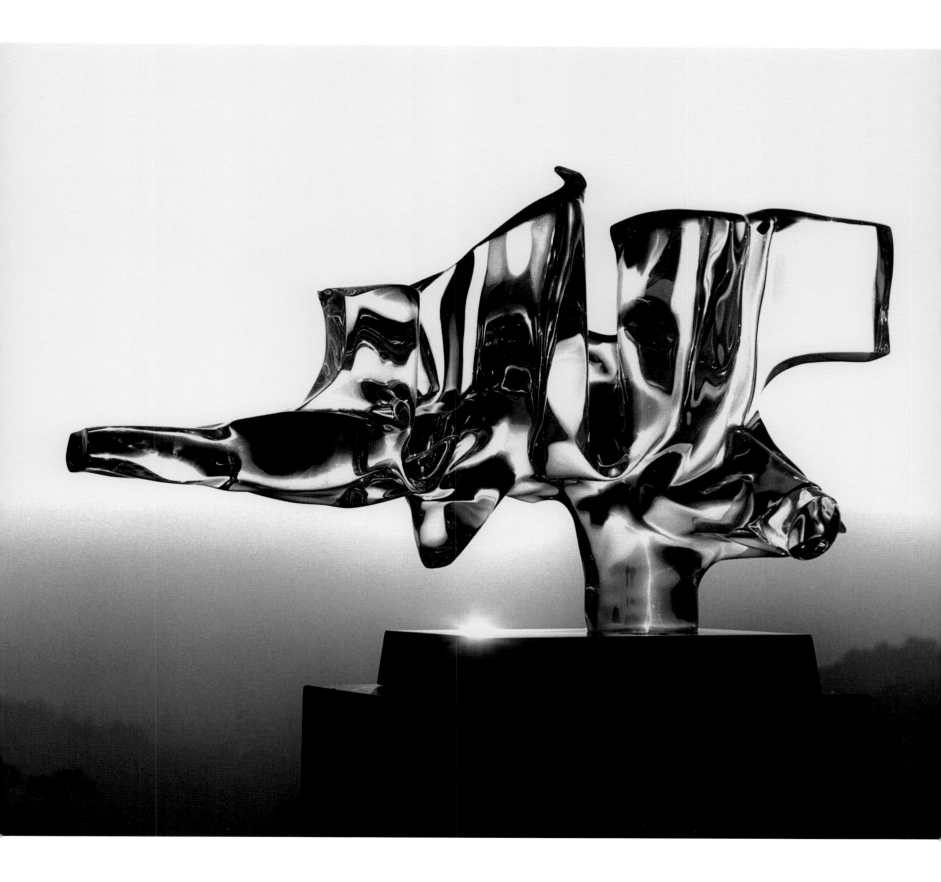

Plate 73. *Killyboffin*, 1968. Cast acrylic, width 44 in. Private collection.

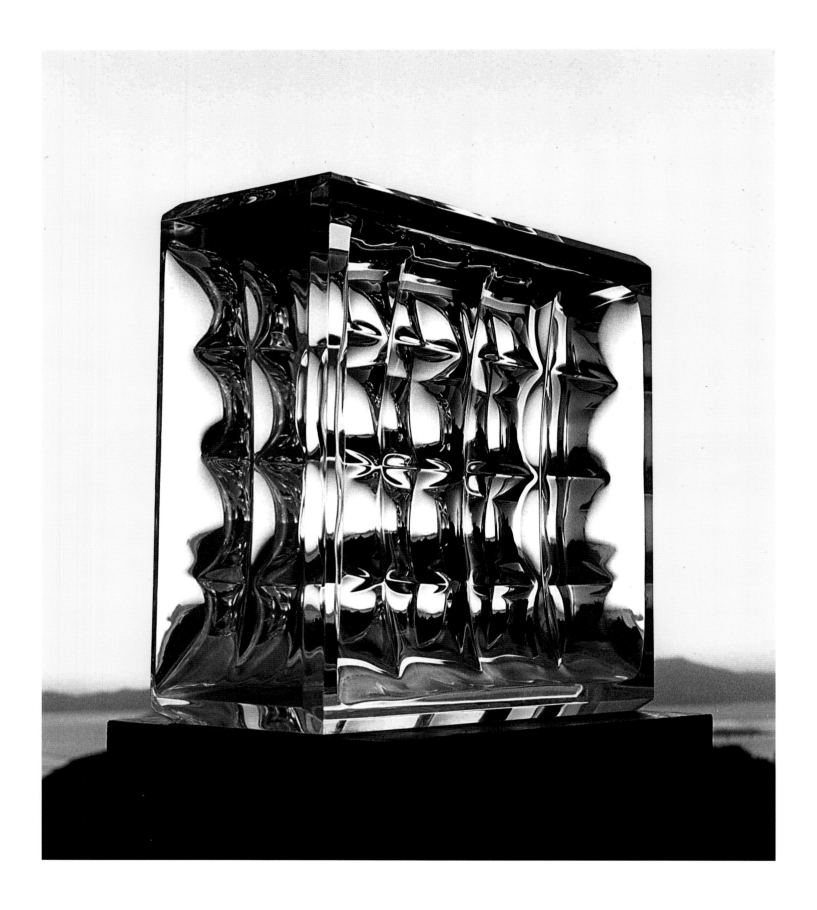

Plate 74 [above]. *Suzanne's Window*, 1969. Cast acrylic, 24 × 24 in. Private collection.

Plate 75 [facing]. *Light Cube*, 1969. Cast acrylic, height 19 in. Private collection.

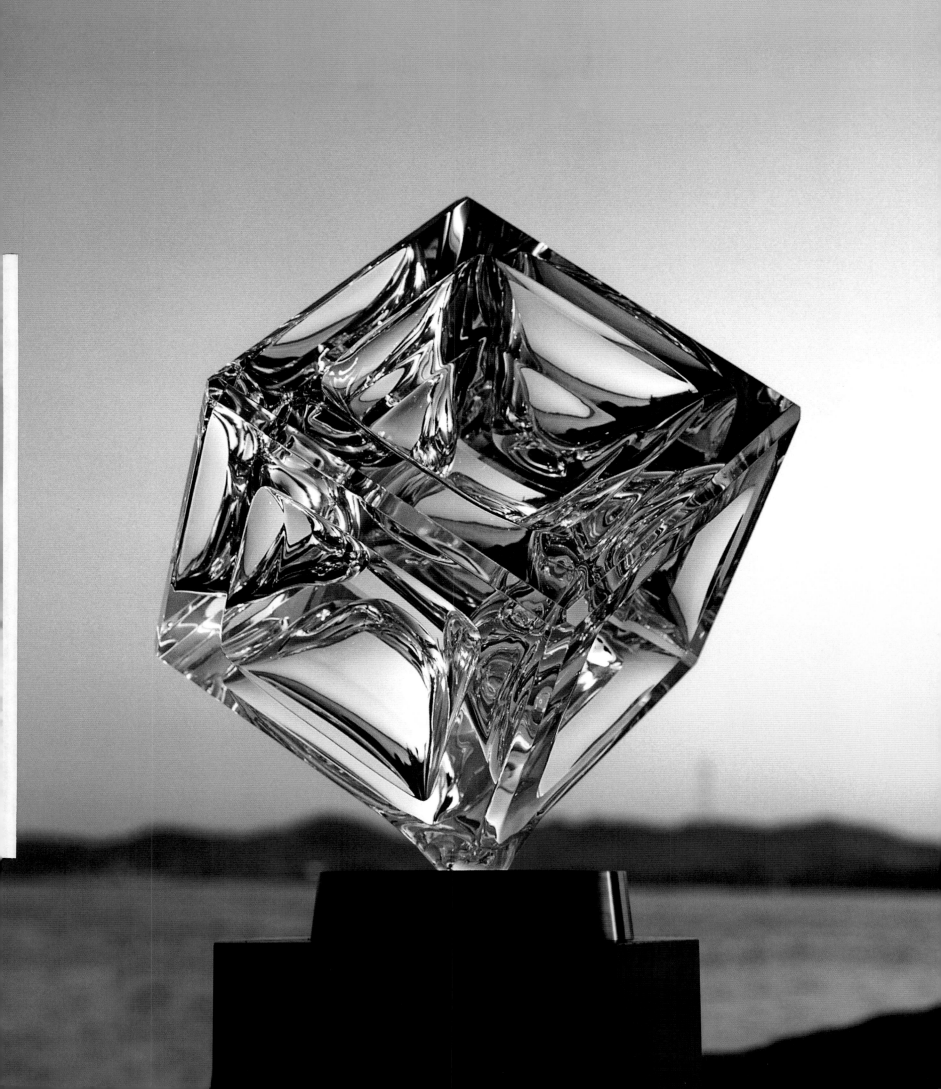

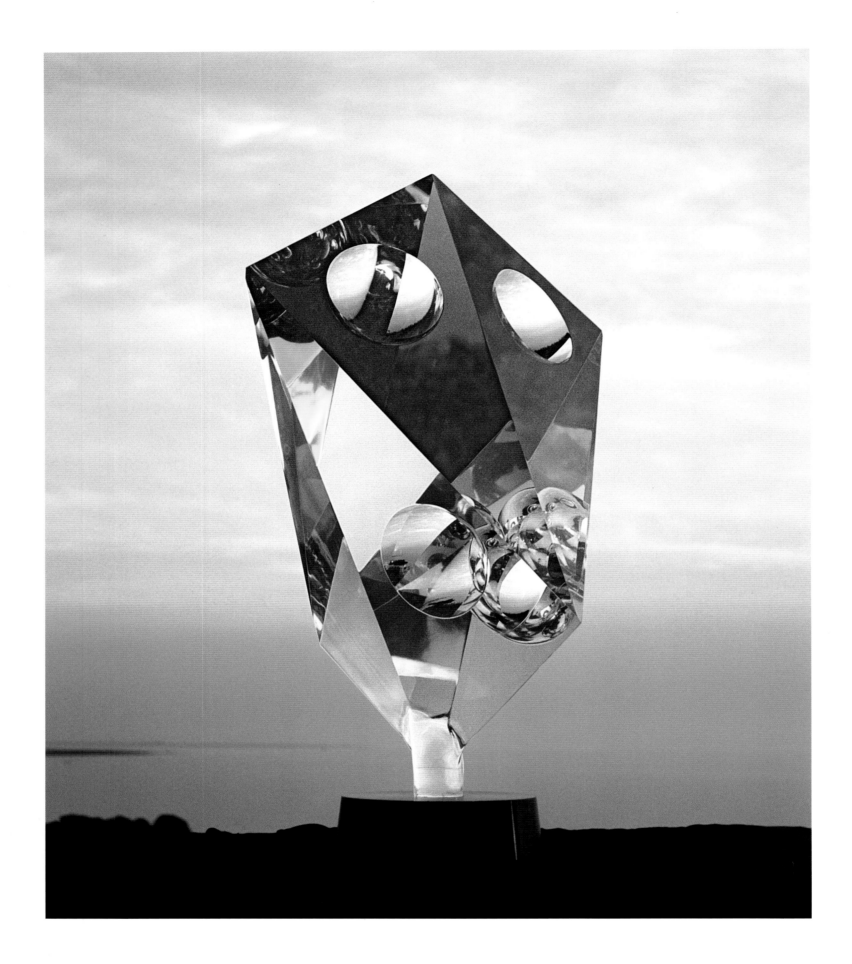

Plate 76 [above]. *Tragamitus*, 1970. Cast acrylic, height 28 in. Wichita Art Museum, Wichita, Kansas.
Plate 77 [facing]. *Tragamon*, 1972. Cast acrylic, height 90 in. The Oakland Museum, Oakland, California.

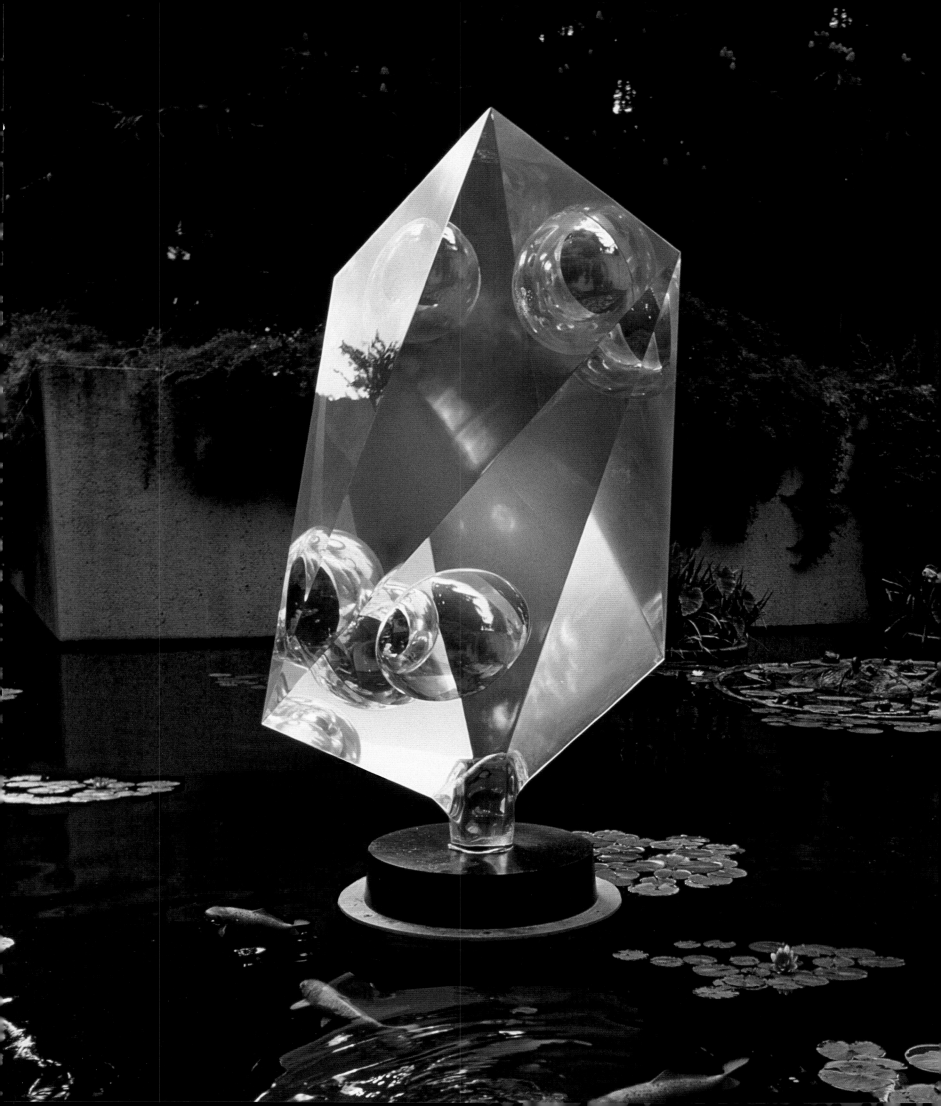

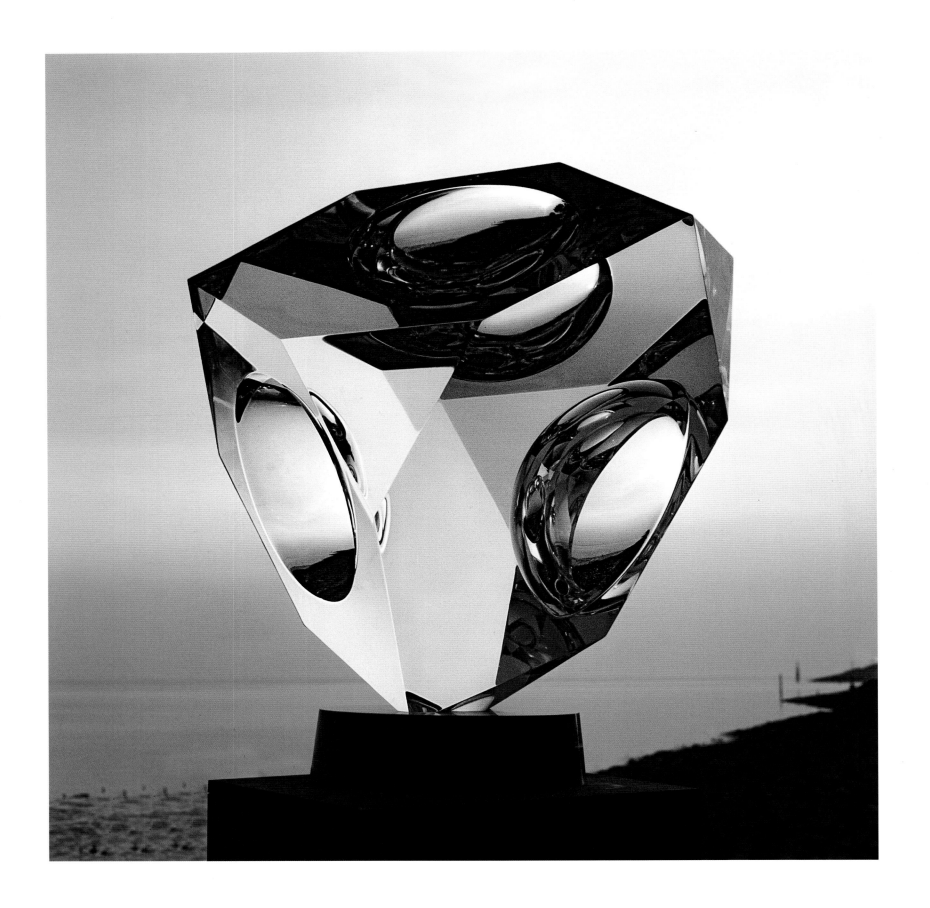

Plate 78. *Titiopoli's Light-House*, 1970. Cast acrylic, 34 × 32 in.
Hood Museum of Art, Dartmouth College, Hanover, New Hampshire.

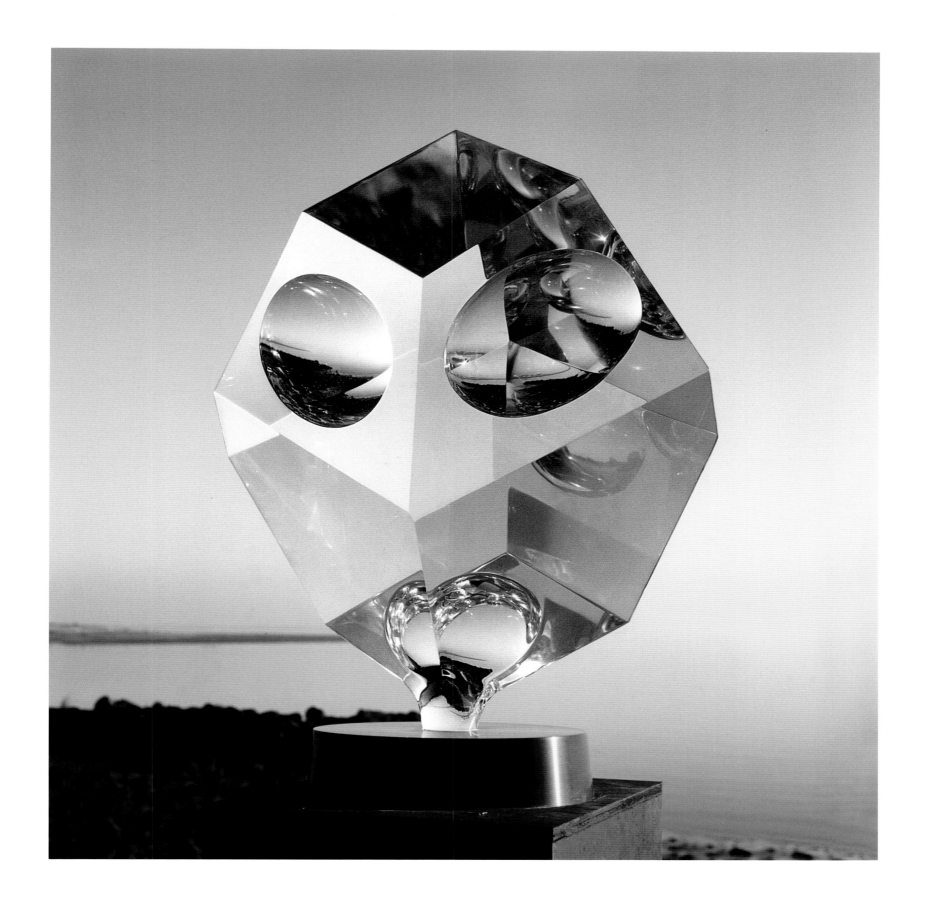

Plate 79. *Triclinic Eclipse*, 1970. Cast acrylic, height 36½ in. Private collection.

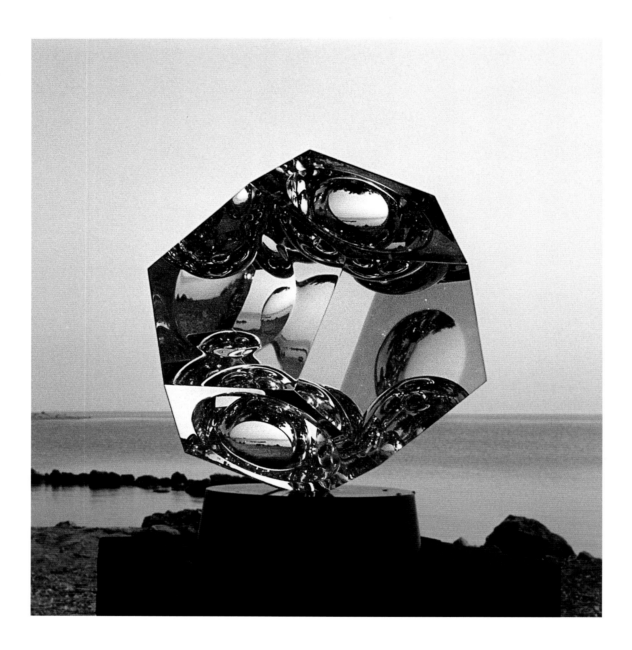

Plate 80. *Dodecker*, 1970. Cast acrylic, height 16 in. Norton Museum of Art, West Palm Beach, Florida.

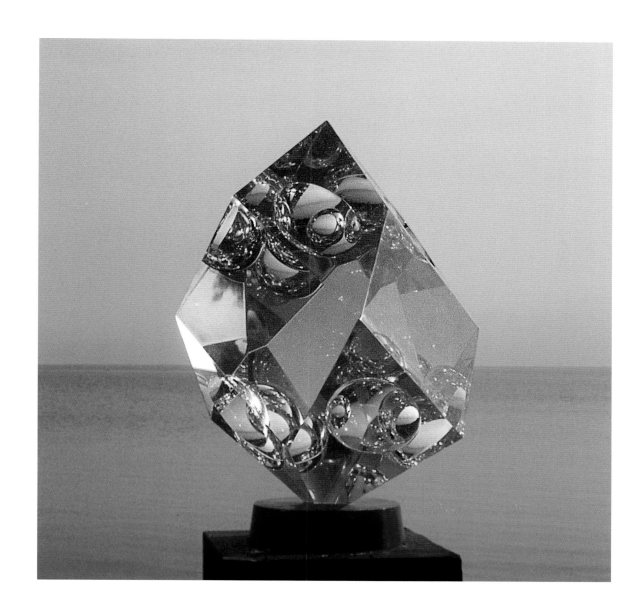

Plate 81. *Trapidon*, 1970. Cast acrylic, height 26 in. Private collection.

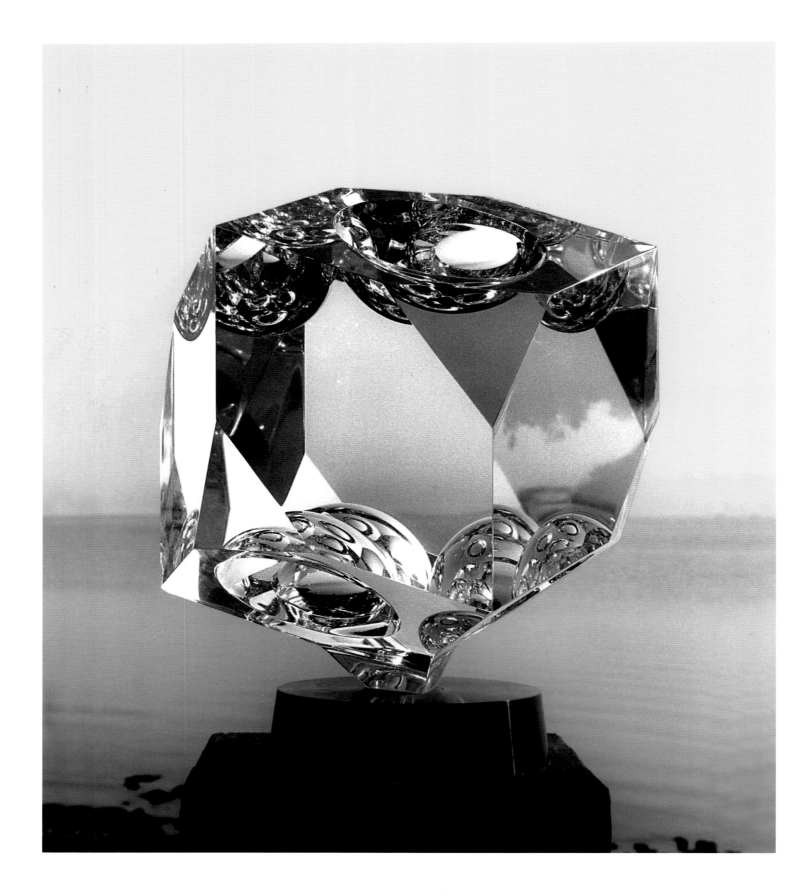

Plate 82. *Dihexamon*, 1970. Cast acrylic, height 20 in. Seattle Art Museum, Seattle, Washington.

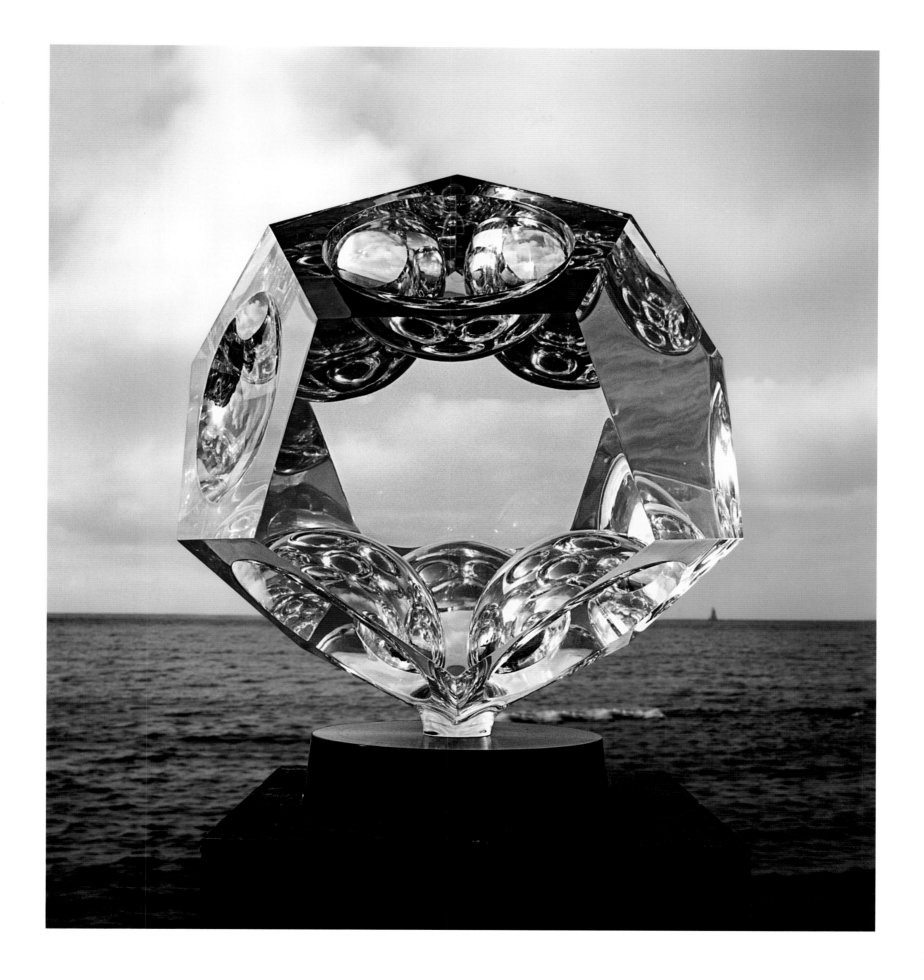

Plate 83. *Dodectamon*, 1971. Cast acrylic, height 32 in. Private collection.

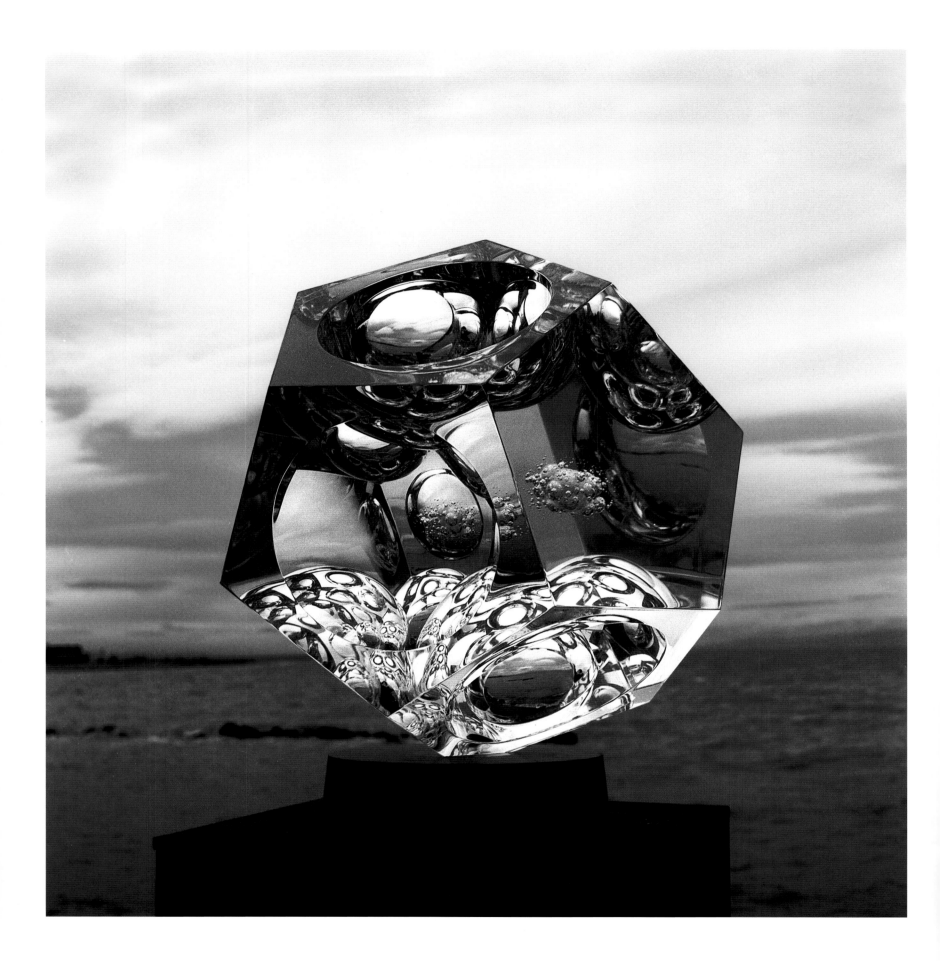

Plate 84 [above]. *Nova Dodecker*, 1971. Cast acrylic, height 32 in. Private collection.

Plate 85 [facing]. *Tintinuvin*, 1970. Cast acrylic, height 51 in. Private collection.

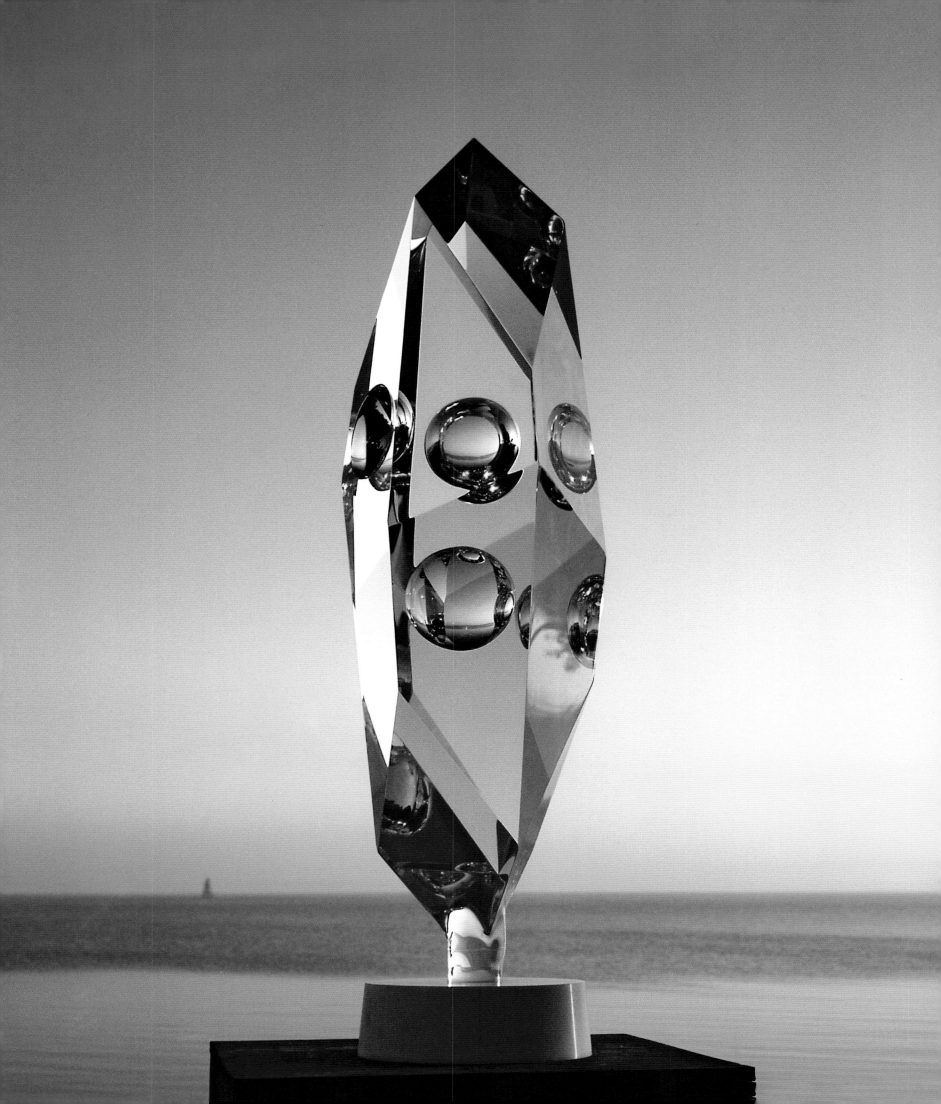

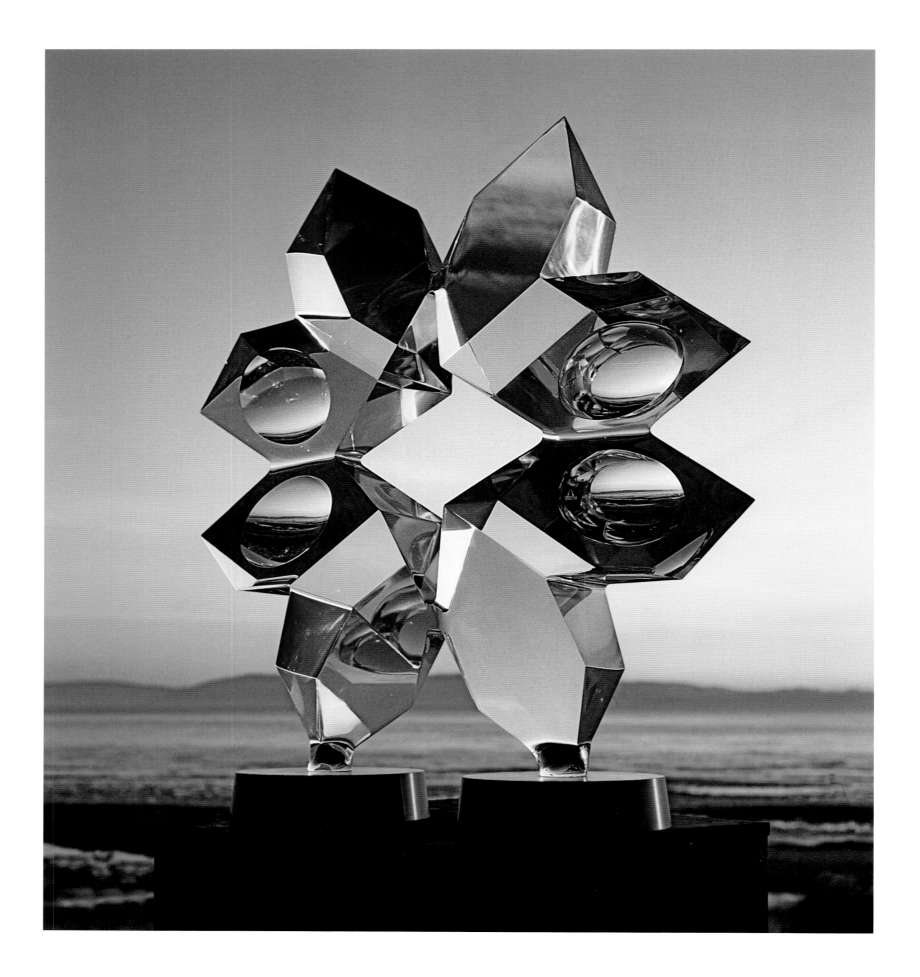

Plate 86. *Star Gazer*, 1971. Cast acrylic, height 33 in. Private collection.

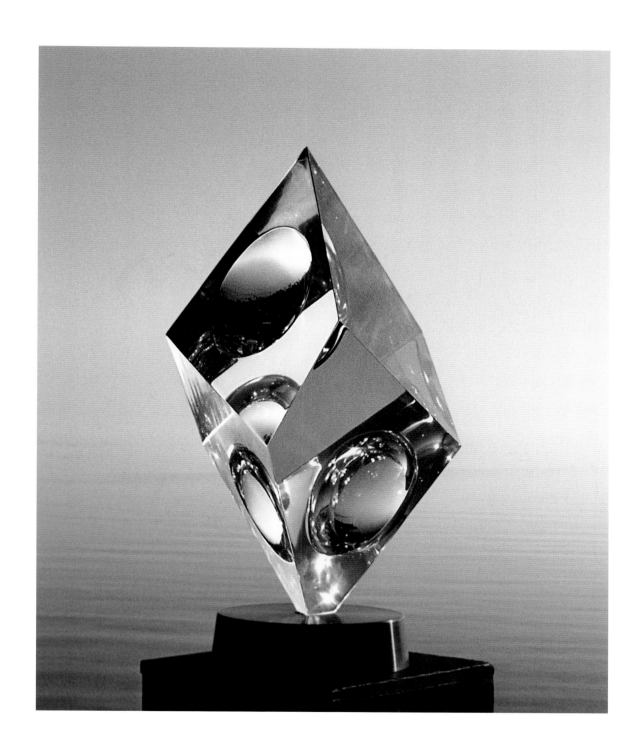

Plate 87. *Trigonal*, 1970. Cast acrylic, height 26 in. Tupperware Corporation, Orlando, Florida.

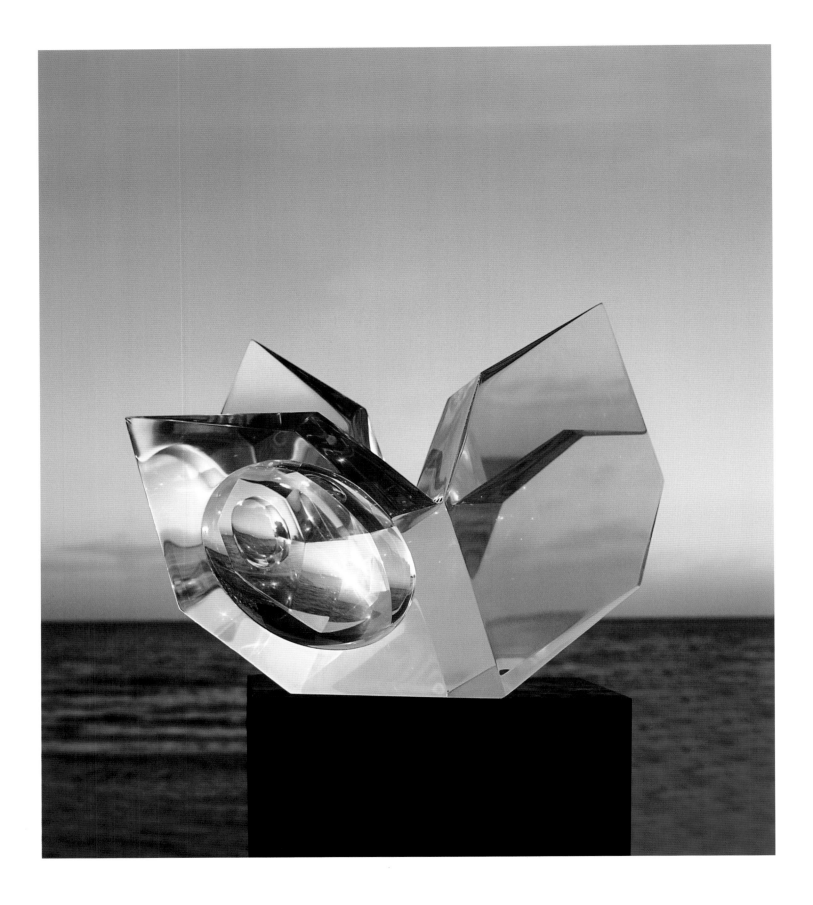

Plate 88 [above]. *Contemplative Order*, 1971. Cast acrylic, width 24 in. Private collection.

Plate 89 [facing]. *Cambarelle*, 1971. Cast acrylic, height 19 in. Private collection.

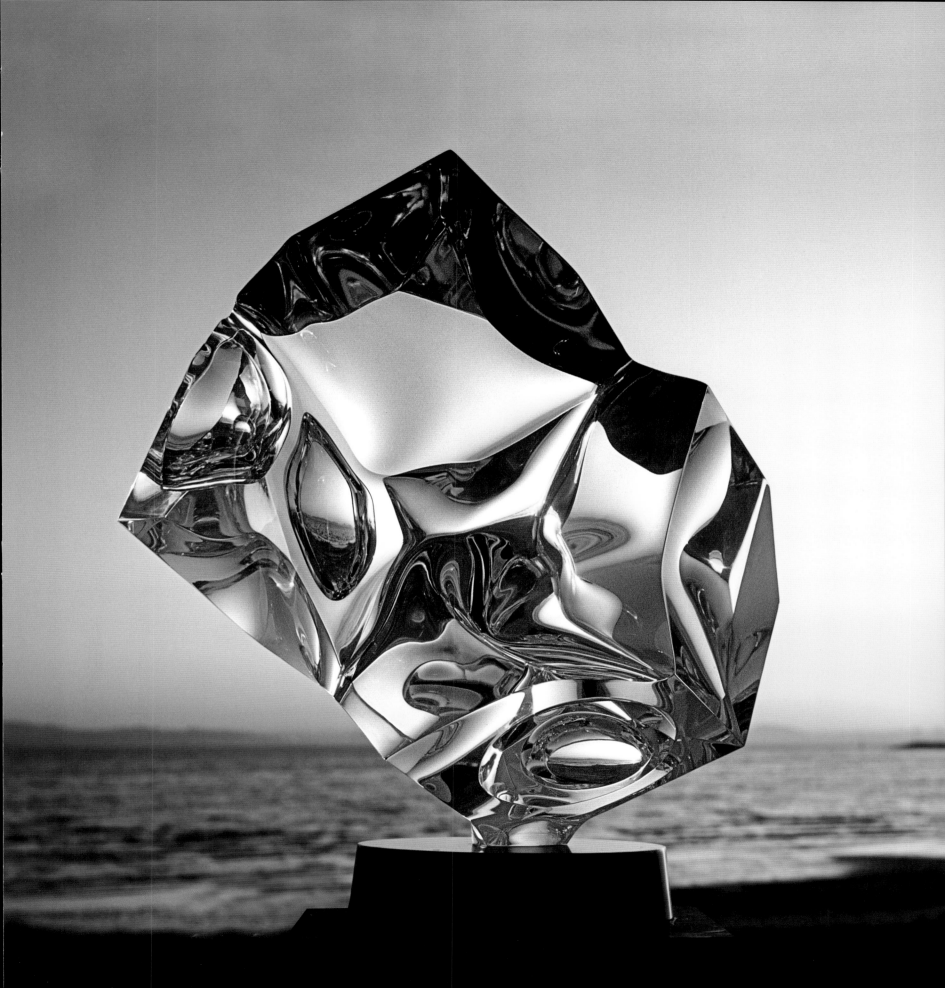

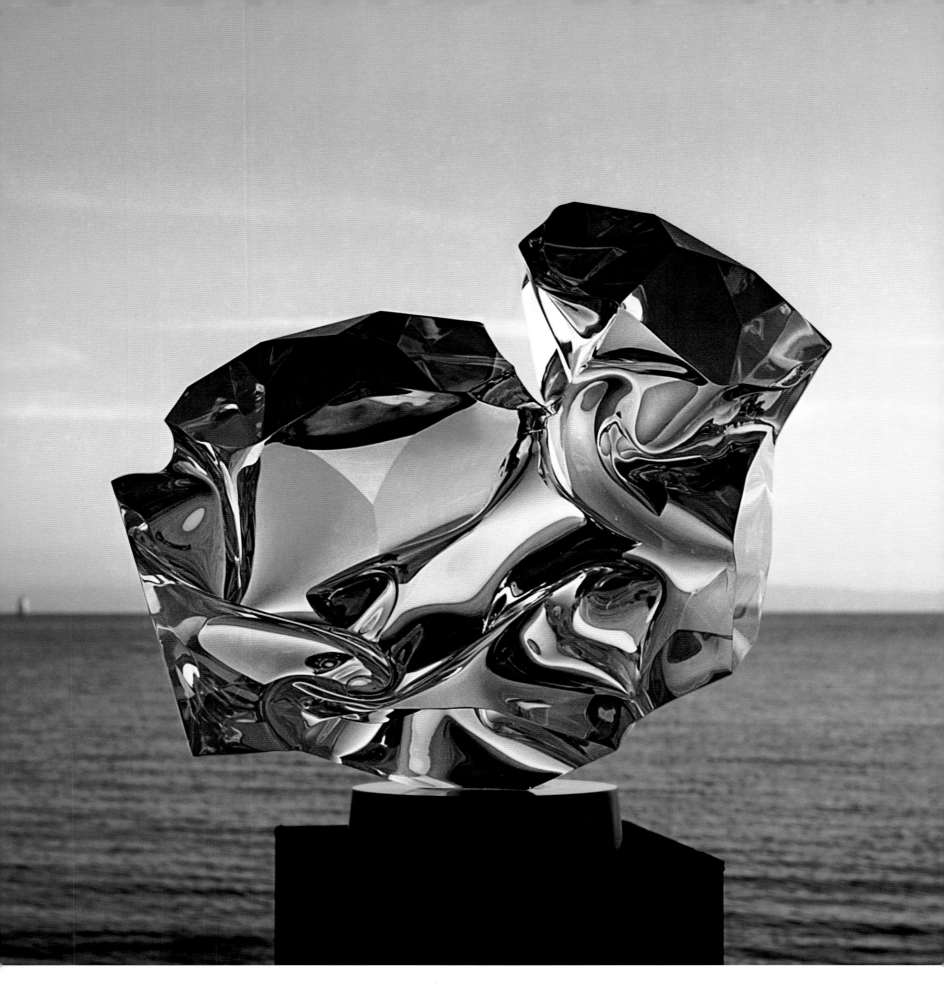

Plate 90. *Axial Gyration*, 1978. Cast acrylic, 27 × 31 in. Capitol Group Companies, Los Angeles, California.

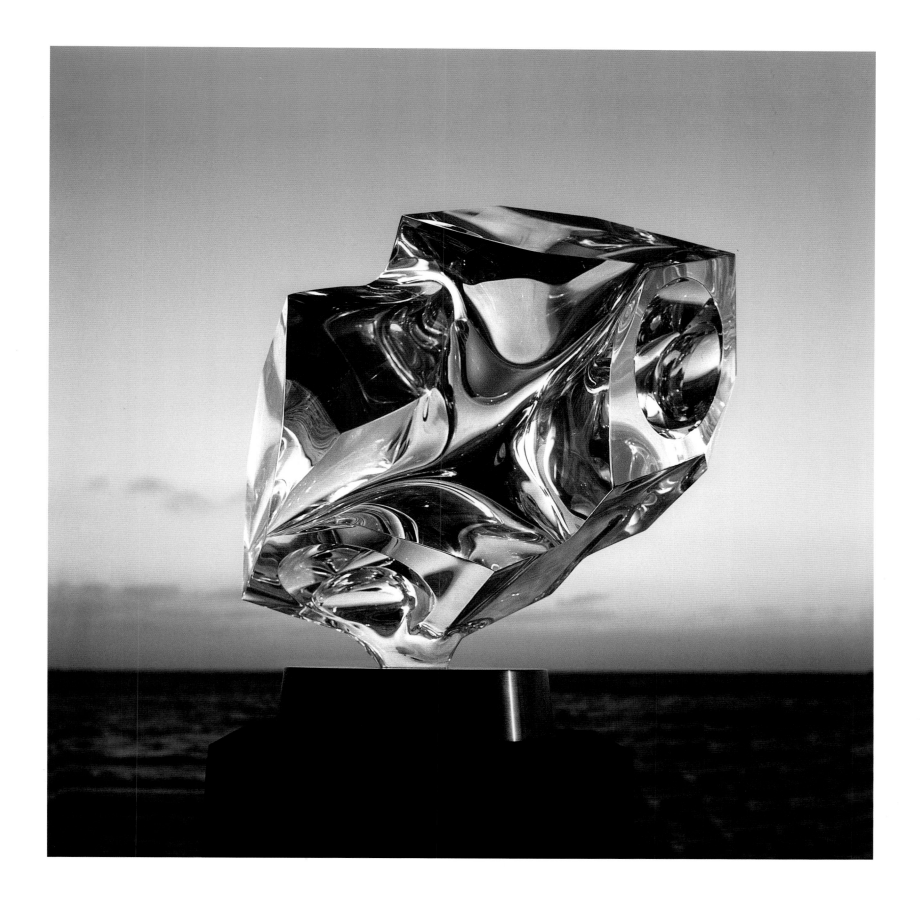

Plate 91. *Tacoignier*, 1972. Cast acrylic, height 18 in. Santa Barbara Museum of Art, Santa Barbara, California.

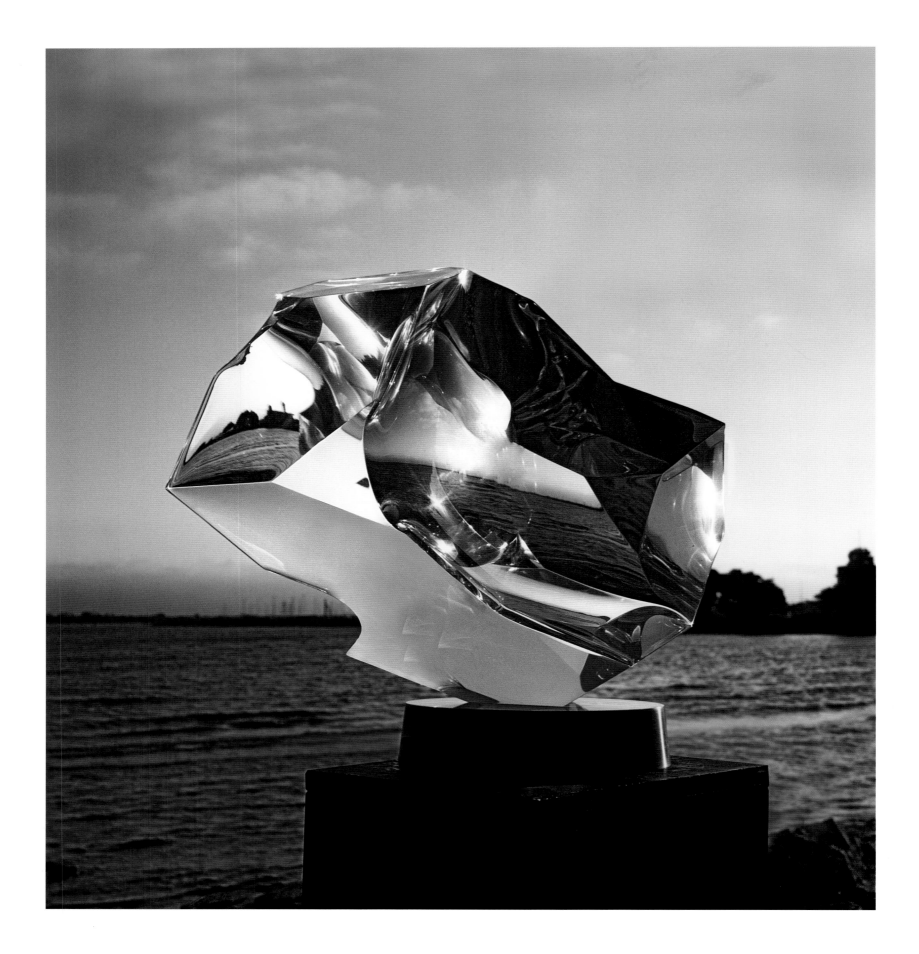

Plate 92. *Monoclinic Repose*, 1972. Cast acrylic, width 19 in. Private collection.

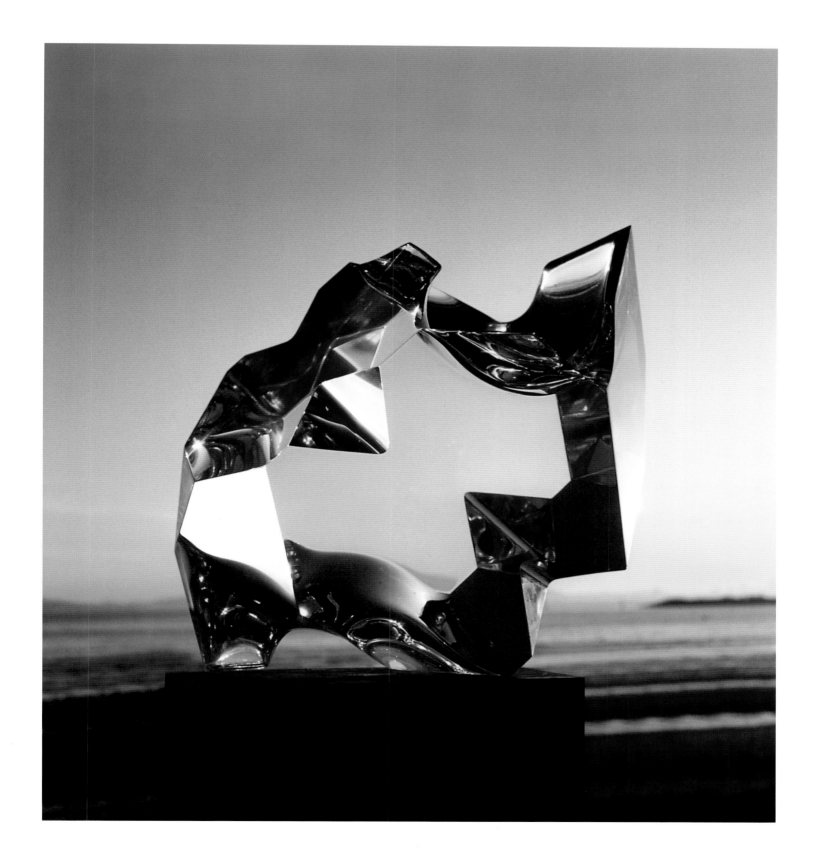

Plate 93. *Tectodon*, 1972. Cast acrylic, height 16 in. Private collection.

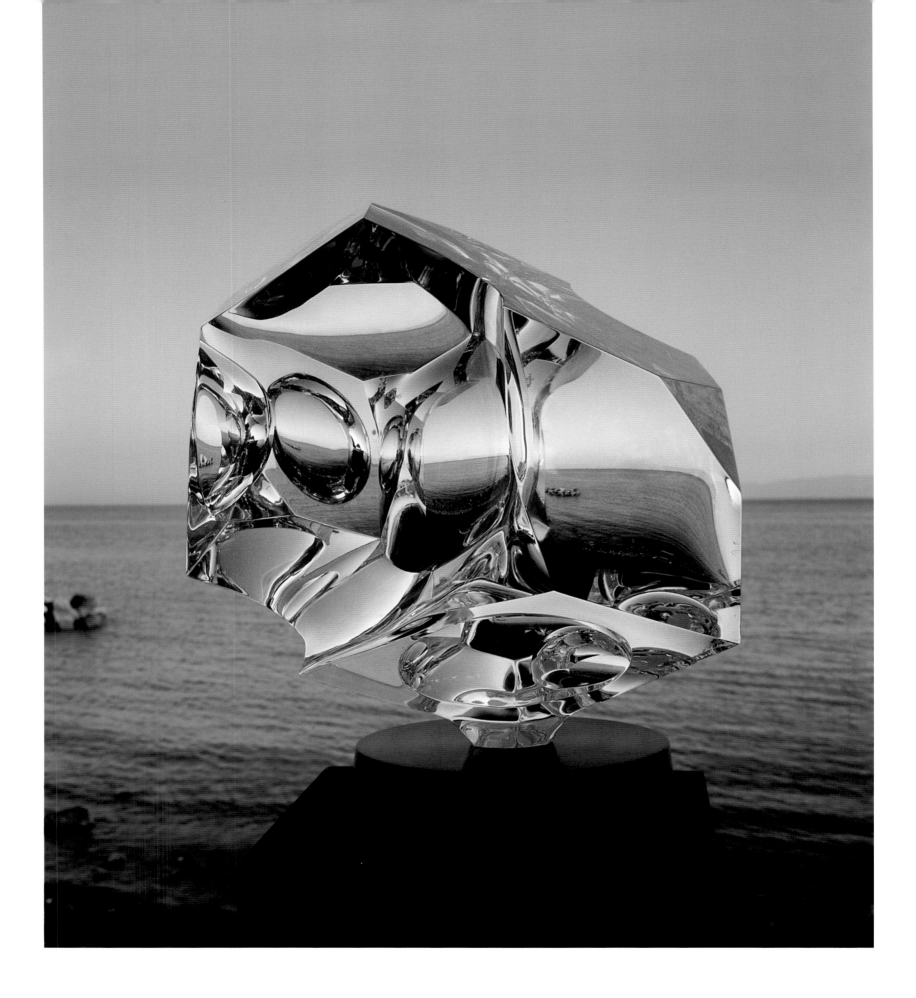

Plate 94. *Hemihedral Eclipse*, 1971. Cast acrylic, height 18 in. Private collection.

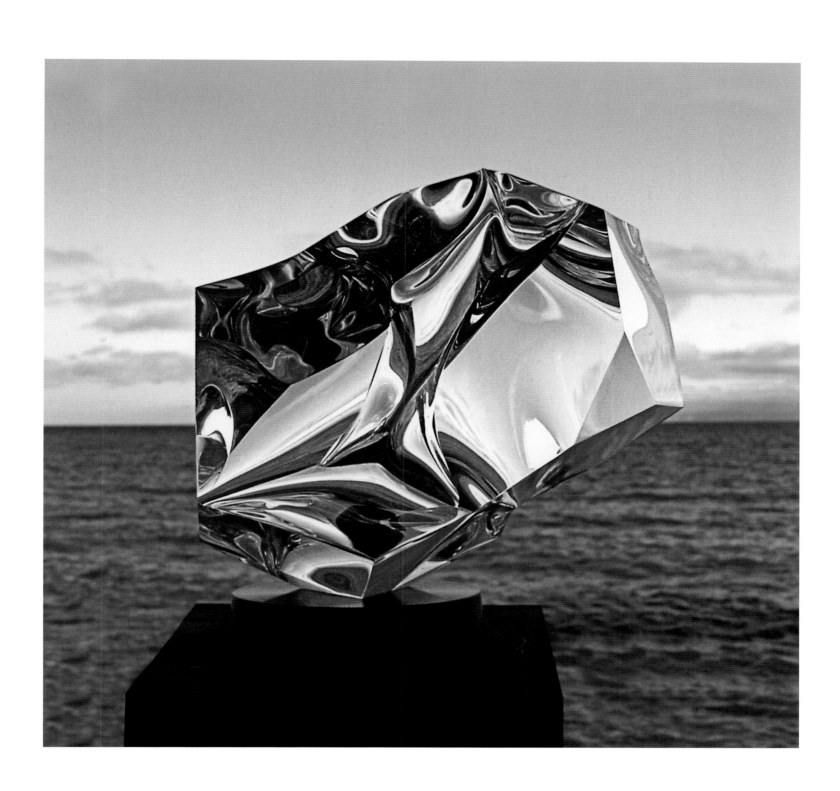

Plate 95. *Pechemele*, 1972. Cast acrylic, width 19 in. Private collection.

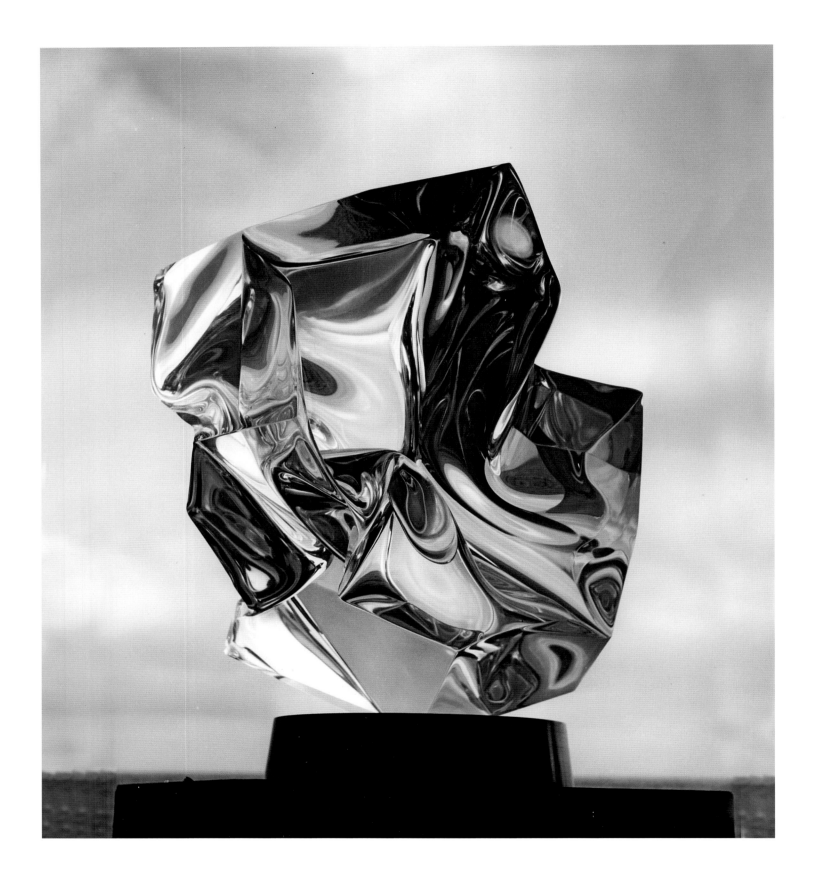

Plate 96. *Ateadon*, 1972. Cast acrylic, height 19 in. Private collection.

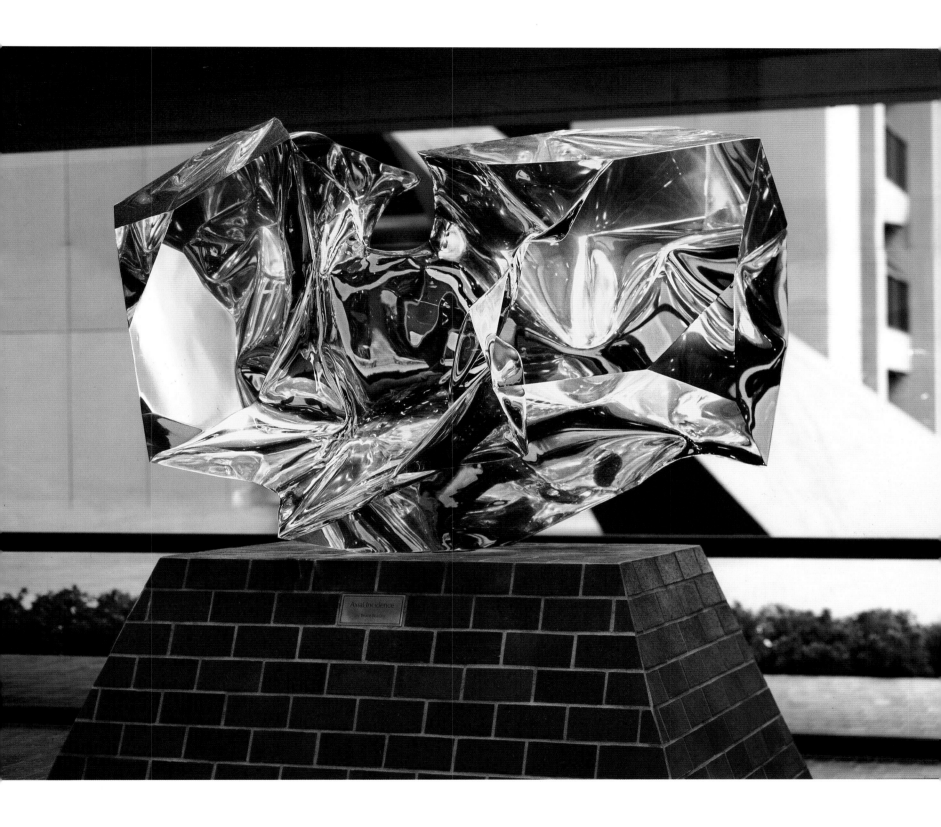

Plate 97. *Axial Incidence*, 1976. Cast acrylic, width 96 in. United States Courthouse, San Diego, California.

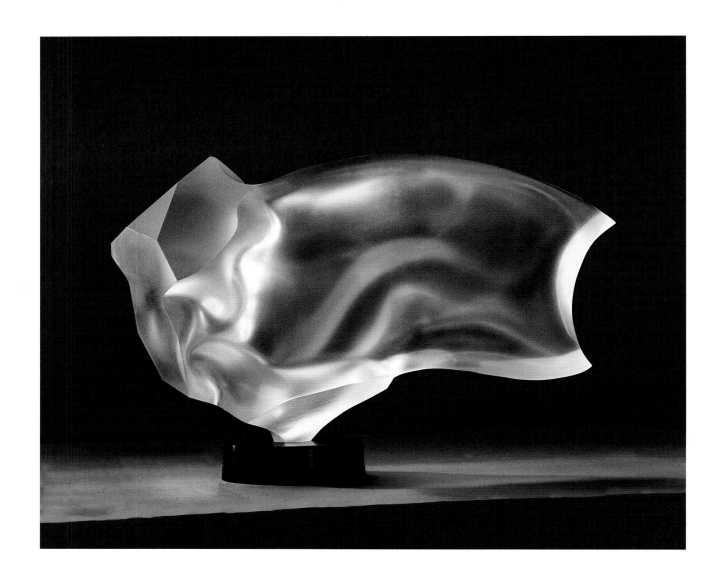

Plate 98. *Selene*, 1986. Cast acrylic, 23 × 35 in. Private collection.

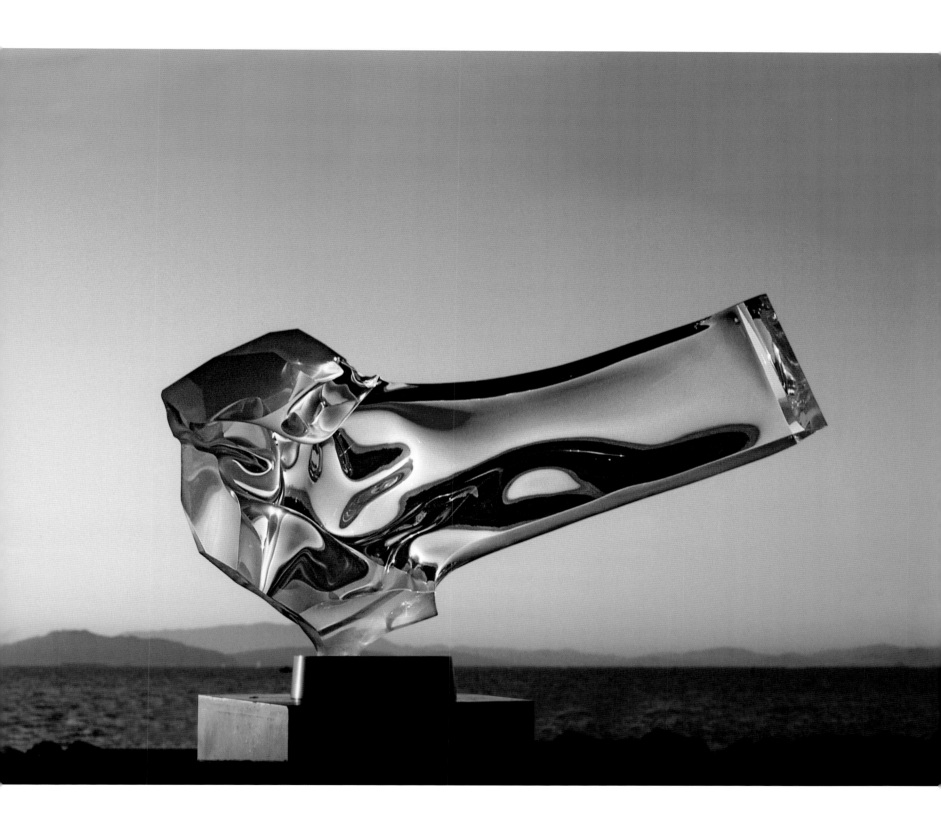

Plate 99. *Circis*, 1986. Cast acrylic, 21 × 39 in. Private collection.

MAPLE, STEEL, ALUMINUM, STAINLESS STEEL, BRONZE

1974–1986

Plate 100 [facing]. *Six Tonner*, 1976. Welded steel, height 300 in. Lakeside Center, Sterling Heights, Michigan.

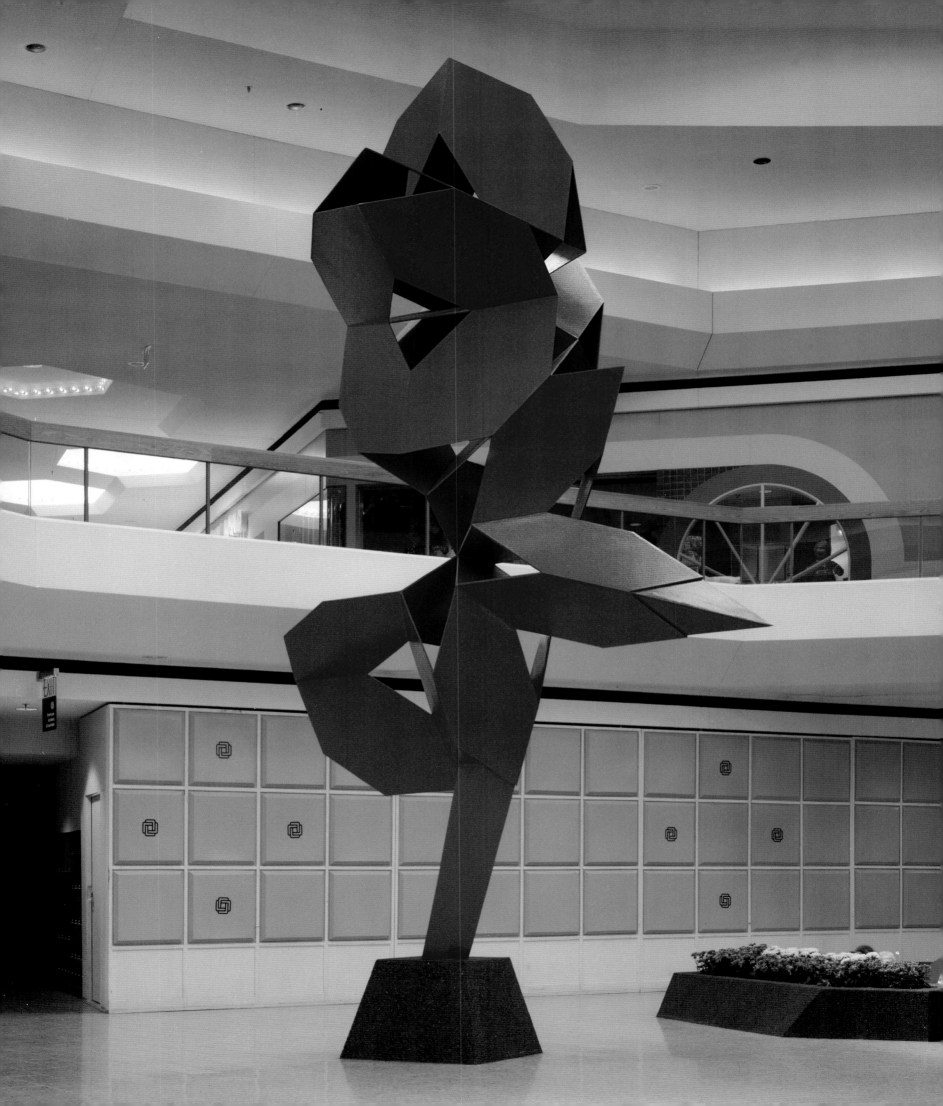

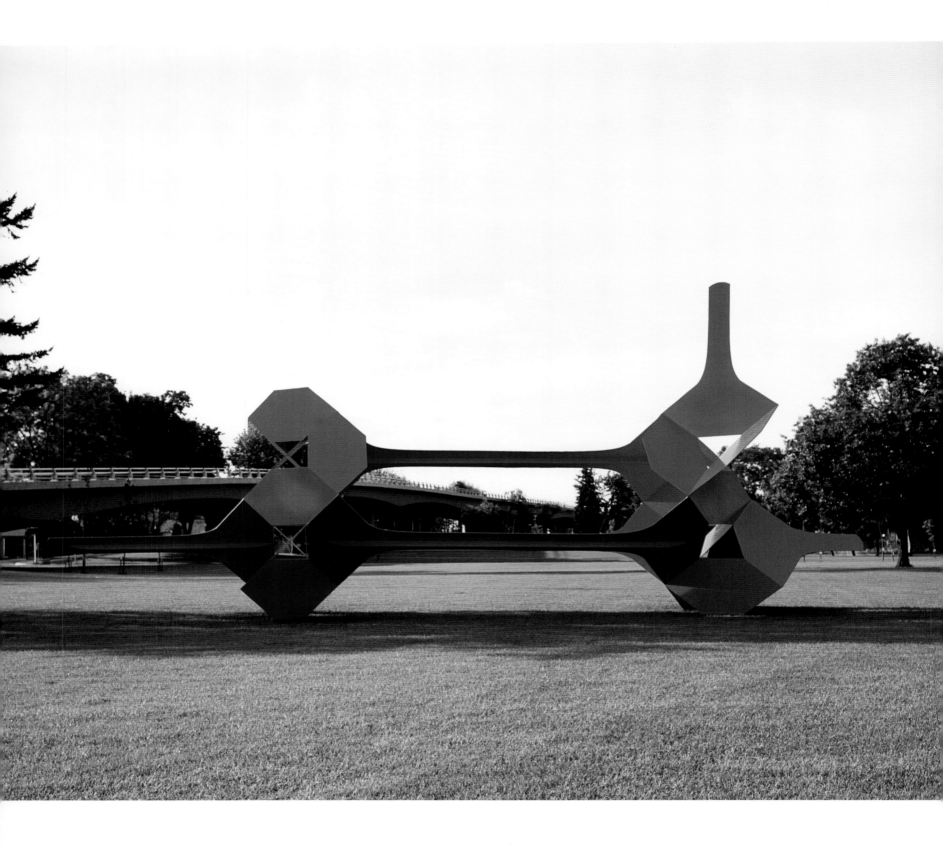

Plate 101. *Big Red*, 1974. Welded steel, width 480 in. City of Eugene, Oregon.

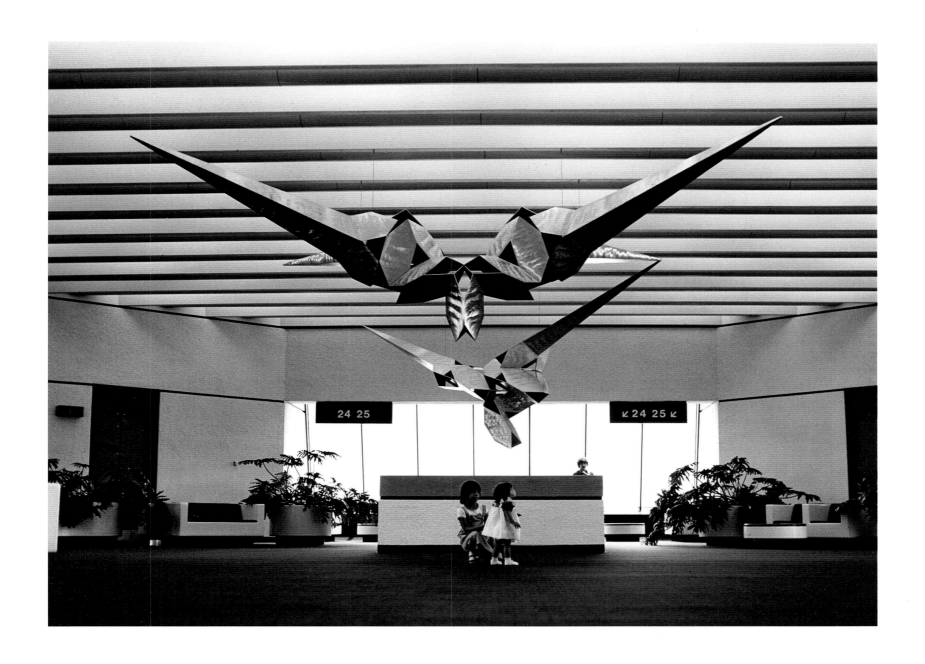

Plate 102. *Atea*, 1978. Welded aluminum, width 444 in. Miami International Airport, Miami, Florida.

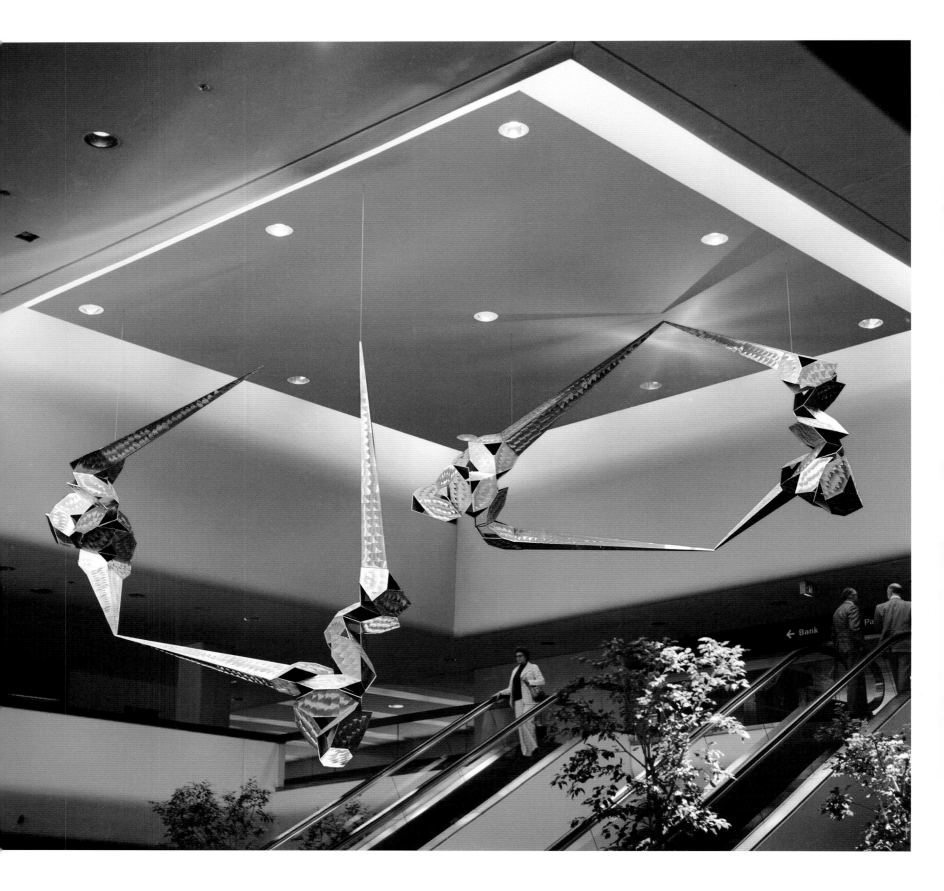

Plate 103. *The Hesperides*, 1980. Aluminum, 264 × 384 in. San Francisco International Airport, San Francisco, California.

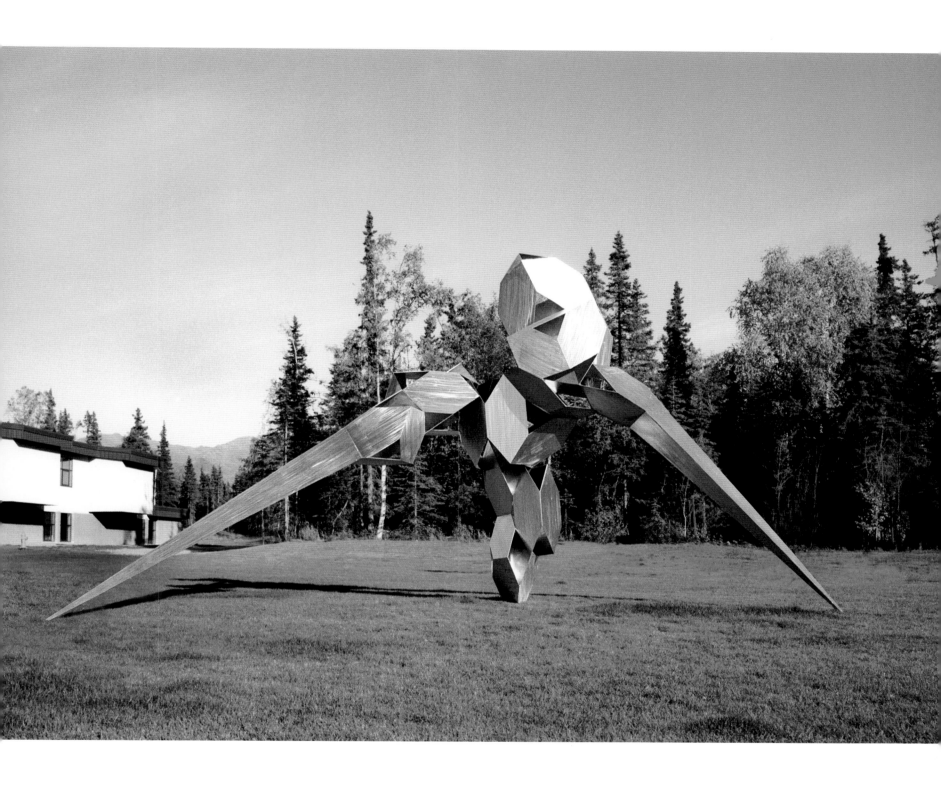

Plate 104. *Arctos*, 1985. Stainless steel, width 384 in. Municipality of Anchorage, Alaska.

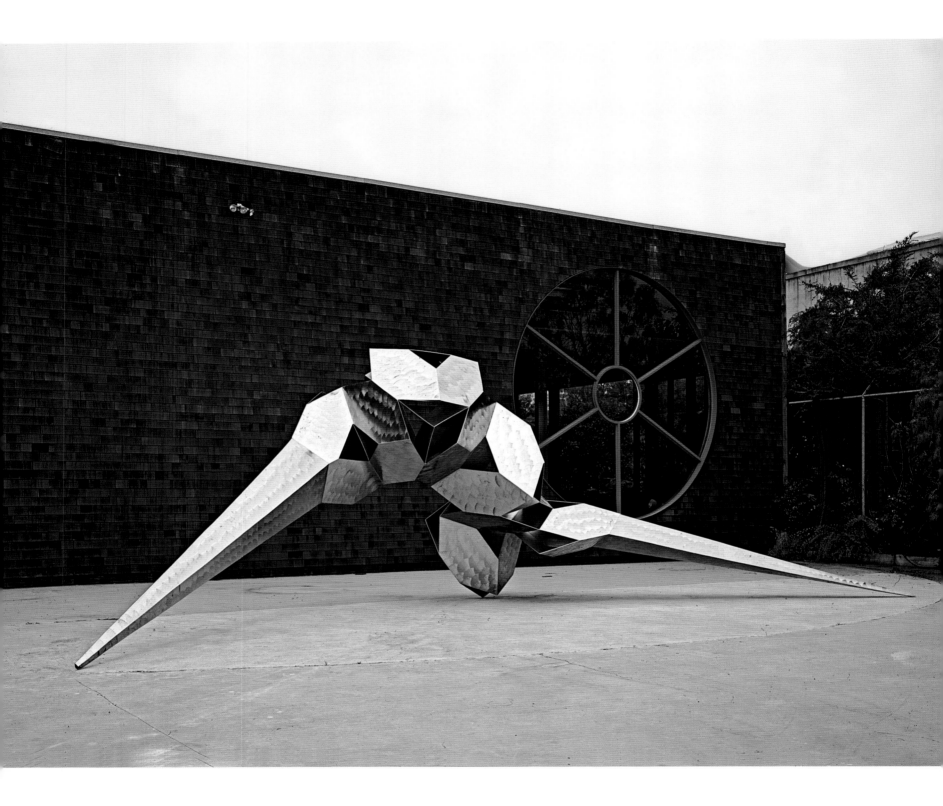

144

Plate 105. *The Gallup Flyer*, 1978. Stainless steel, width 360 in. State of California, San Bernadino, California.

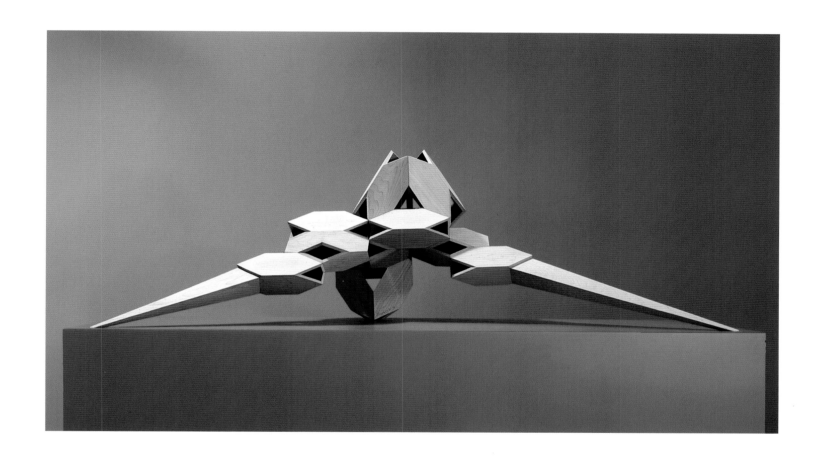

Plate 106. *Thana*, 1981. Maple construction, 18 × 56 × 20 in. Private collection.

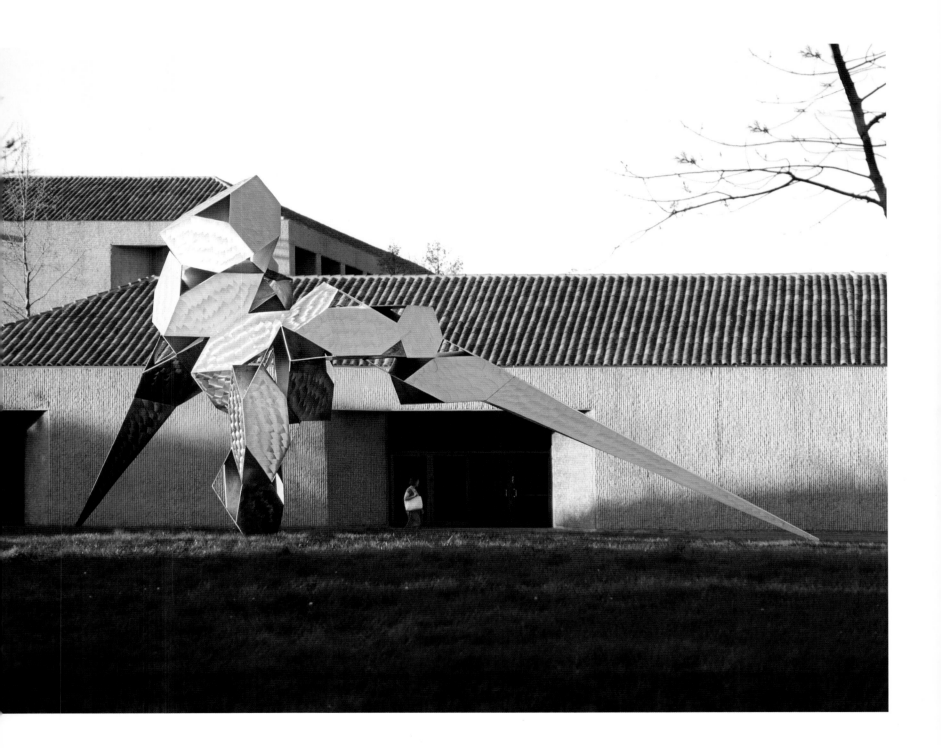

Plate 107. *Vanguard*, 1980. Stainless steel, width 336 in. Stanford University, Stanford, California.

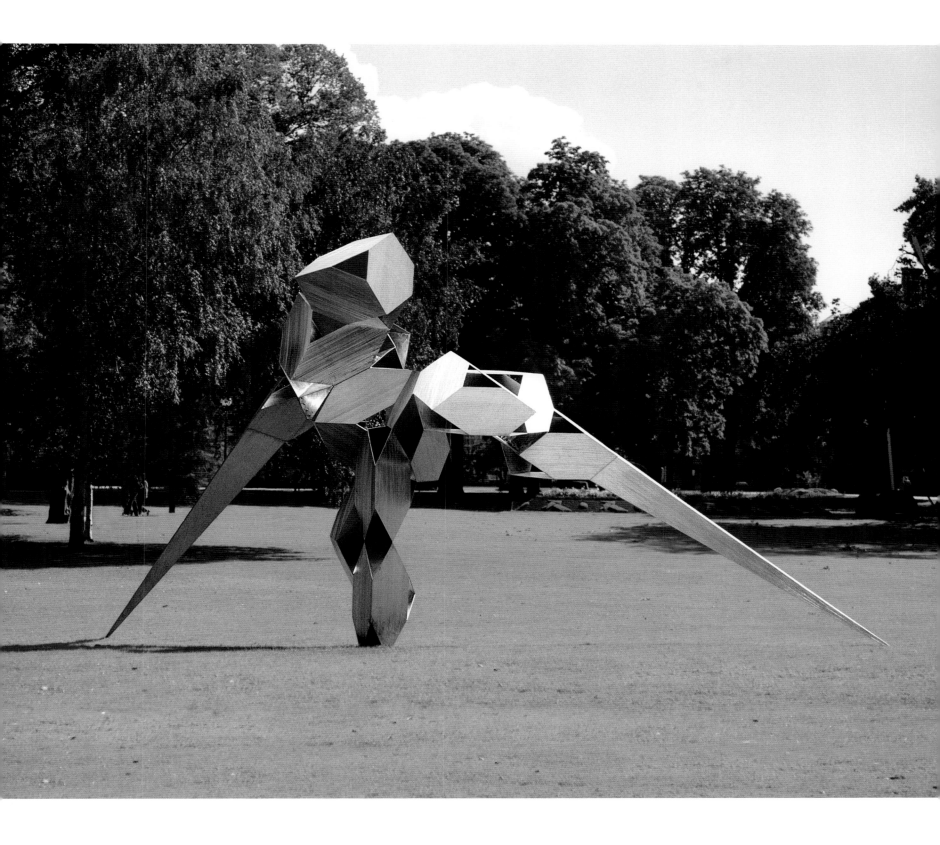

Plate 108. *Artemon*, 1984. Stainless steel, 180 × 384 in. Private collection.

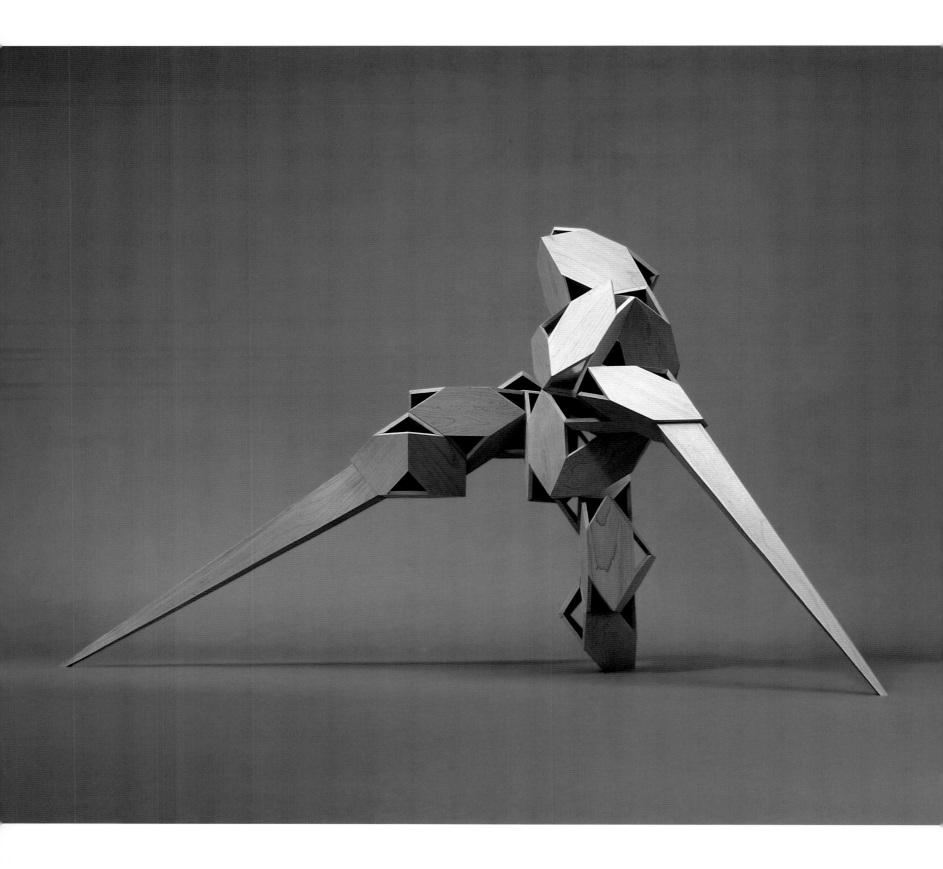

Plate 109 [above]. *Arteus*, 1980. Maple construction, 31 × 61 × 18 in. Private collection.

Plate 110 [facing]. *Arrisus*, 1981. Maple construction, 45 × 37 × 30 in. Private collection.

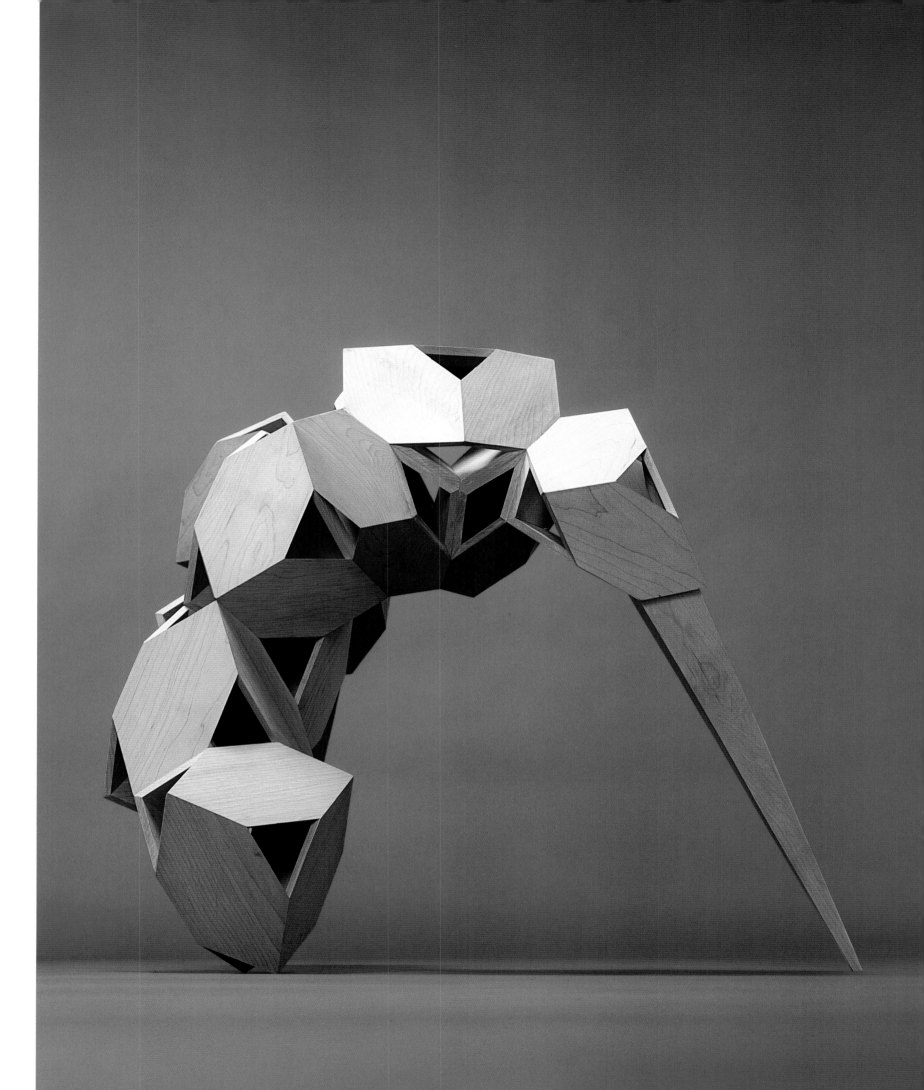

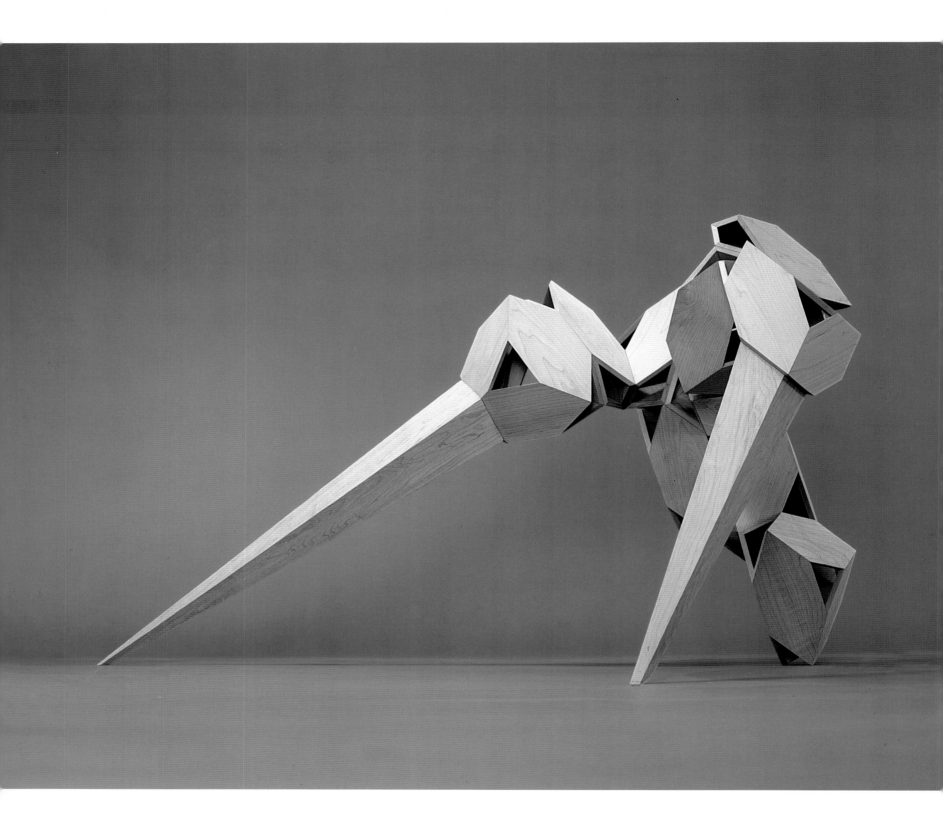

Plate 111. *Chiron II*, 1981. Maple construction, 23 × 35 × 29 in. Private collection.

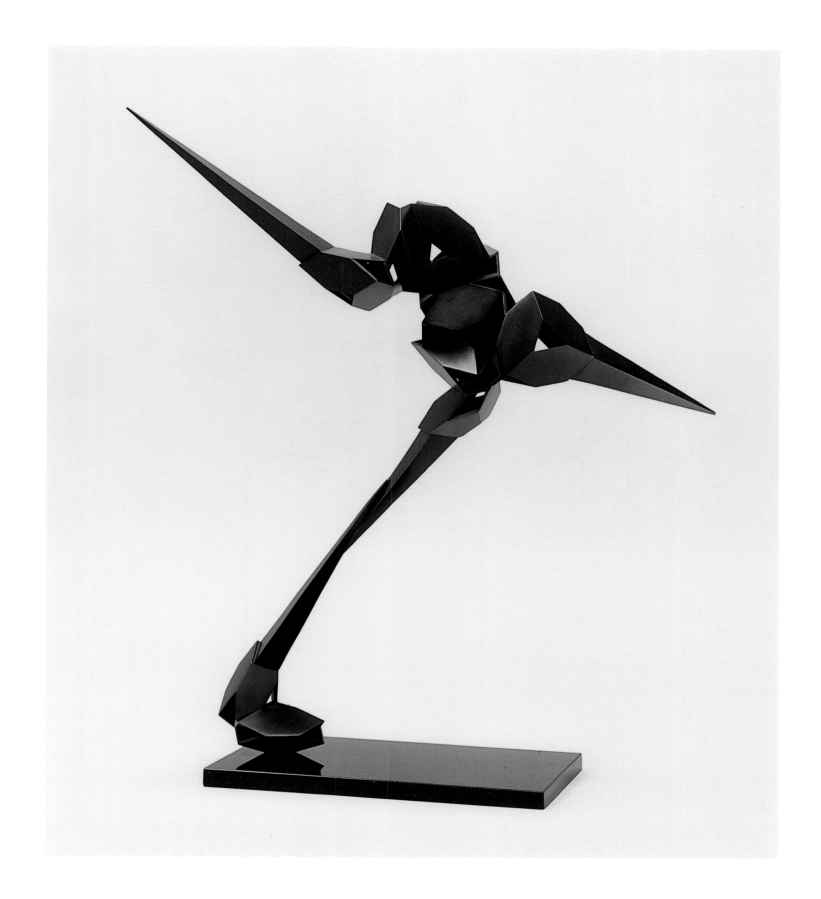

Plate 112. *Terina*, 1981. Cast bronze, 32 × 21 in. Private collection. (See also plate 10.)

Plate 113 [facing]. *Dorion*, 1986. Stainless steel, 240 × 360 × 120 in. Grounds for Sculpture, Hamilton, New Jersey.

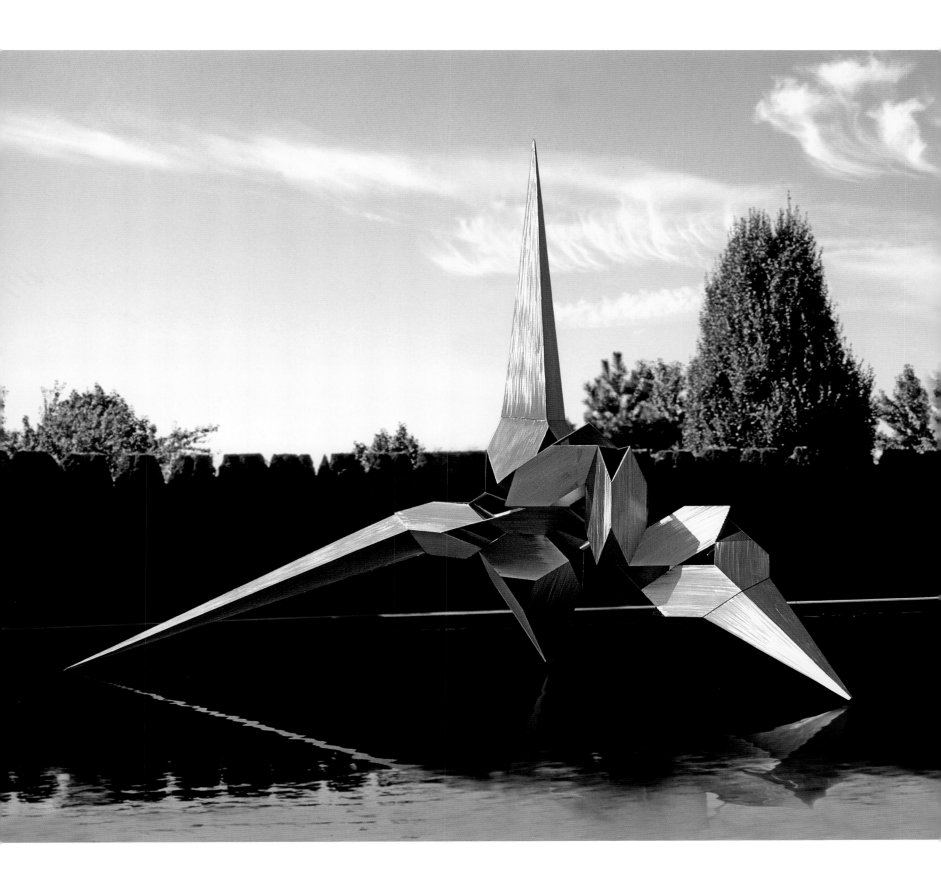

BRONZE, STEEL, GRANITE 1987–2004

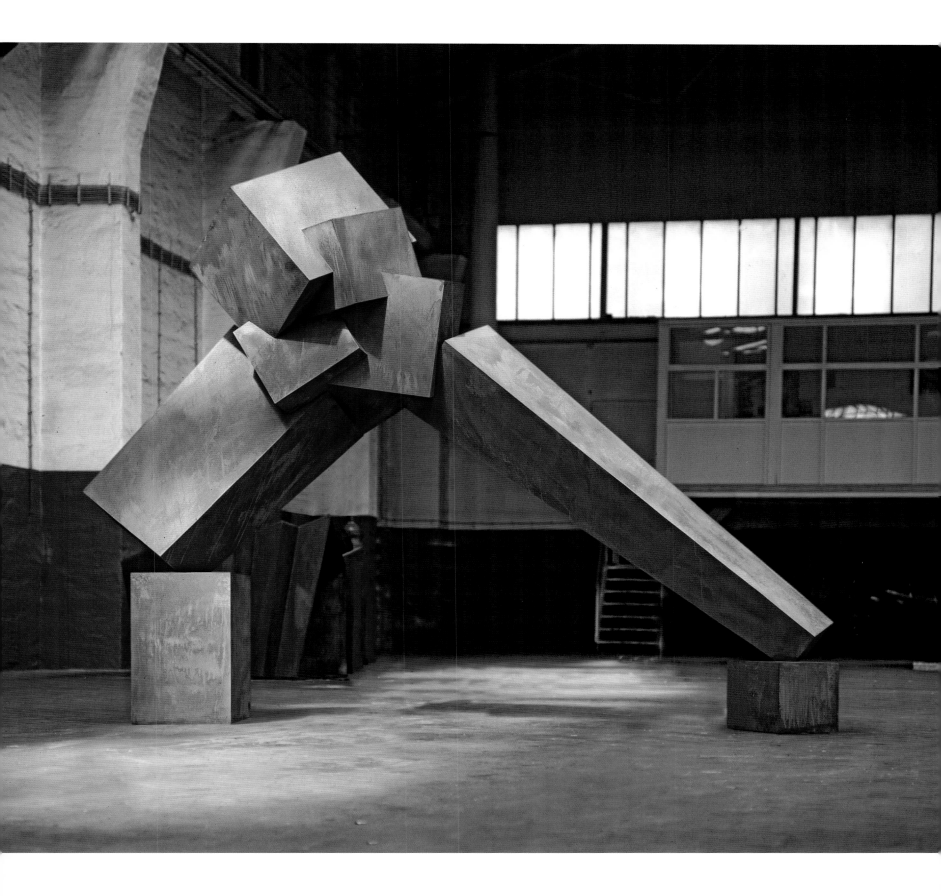

Plate 114. *Titiopoli's Arch*, 1987. Cor-Ten steel, 116 × 132 in. Private collection.

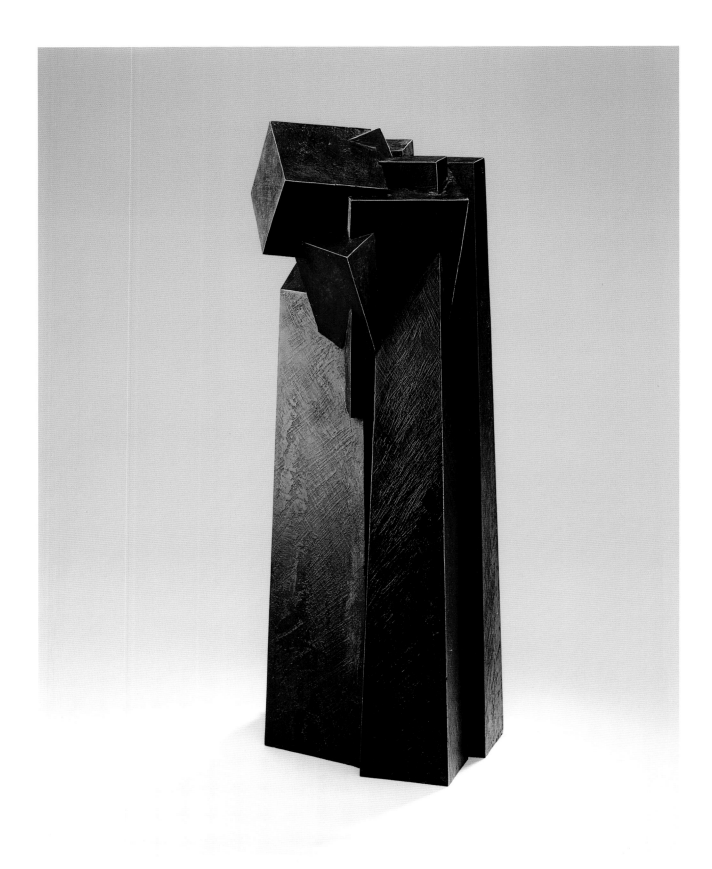

Plate 115. *Tower of Silence*, 1991. Cast bronze, 24 × 11 × 9 in. Private collection.

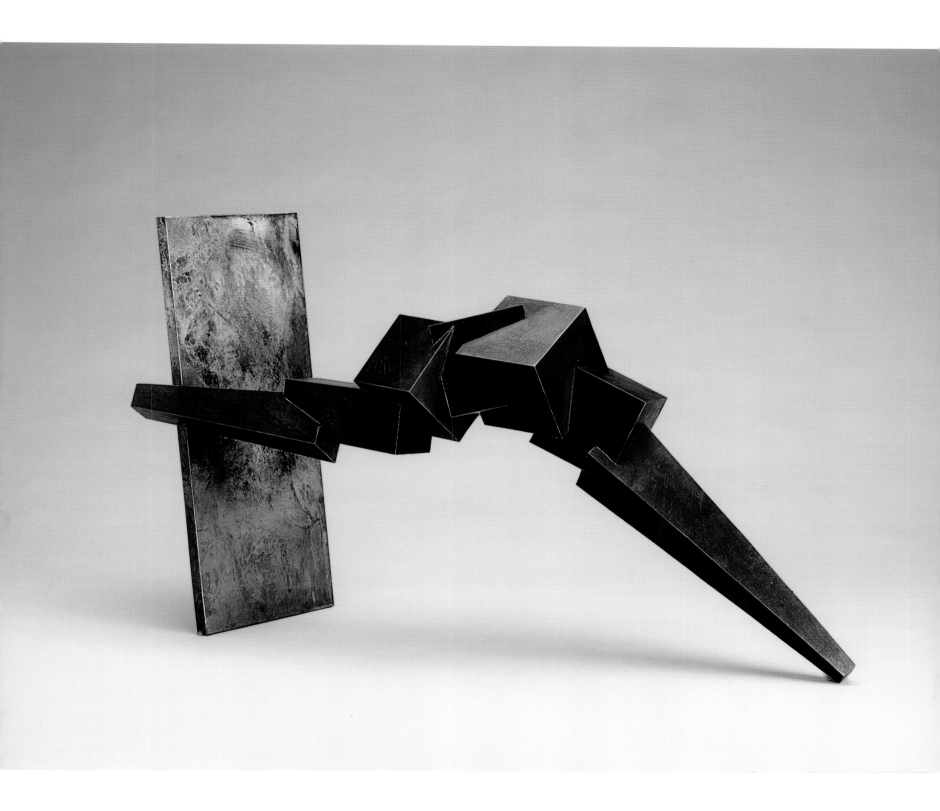

Plate 116. *Departure*, 1988. Cast bronze, 20 × 35 × 11 in. Private collection.

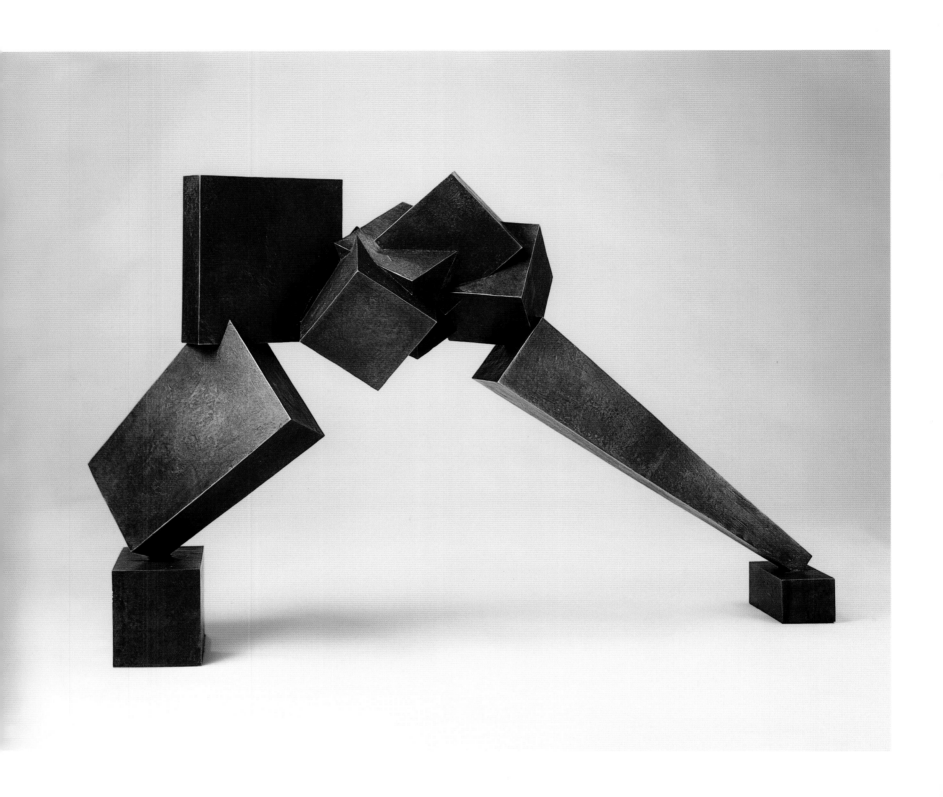

Plate 117 [above]. *Keystone*, 1988. Cast bronze, 26 × 39 × 12 in. Private collection.
Plate 118 [facing]. *Pillars of Cypress*, 1990. Cast steel, 53 × 17 × 16 in.
The Oakland Museum, gift of an anonymous donor, Oakland, California.

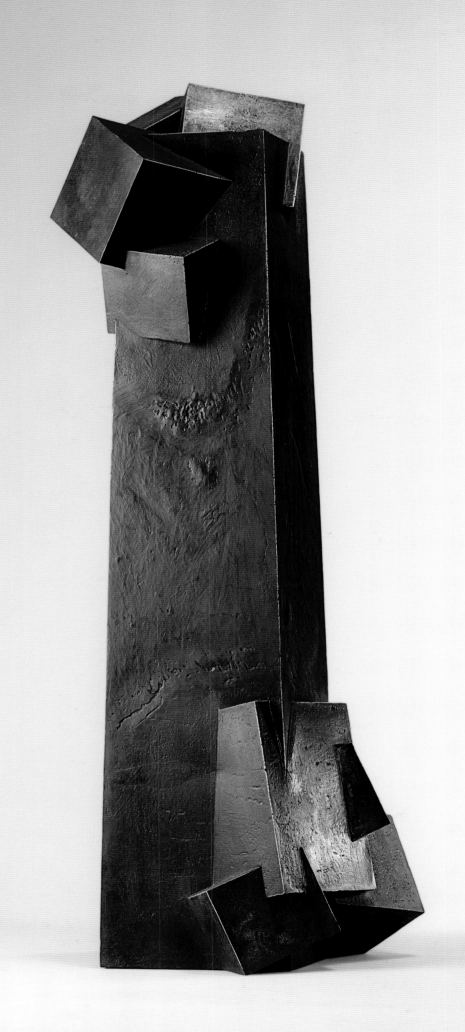

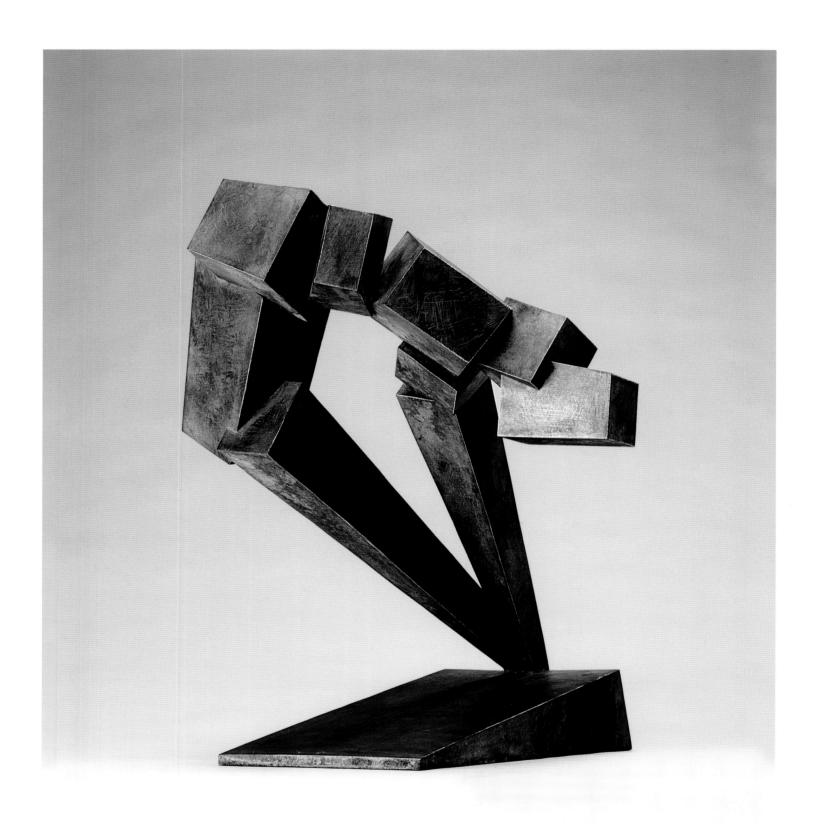

160

Plate 119 [above]. *Apparition*, 1989. Cast bronze, 24 × 27 × 19 in. Private collection.
Plate 120 [facing]. *Ceremony*, 1989. Cast bronze, 54 × 18 × 11 in. Private collection.

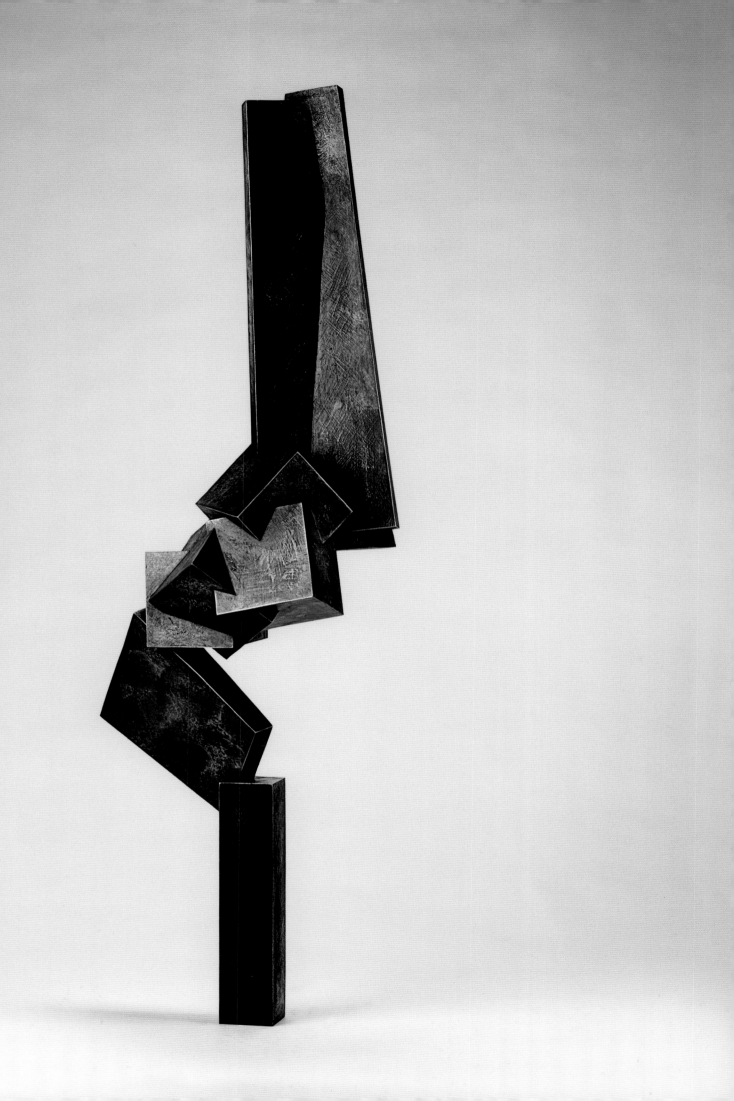

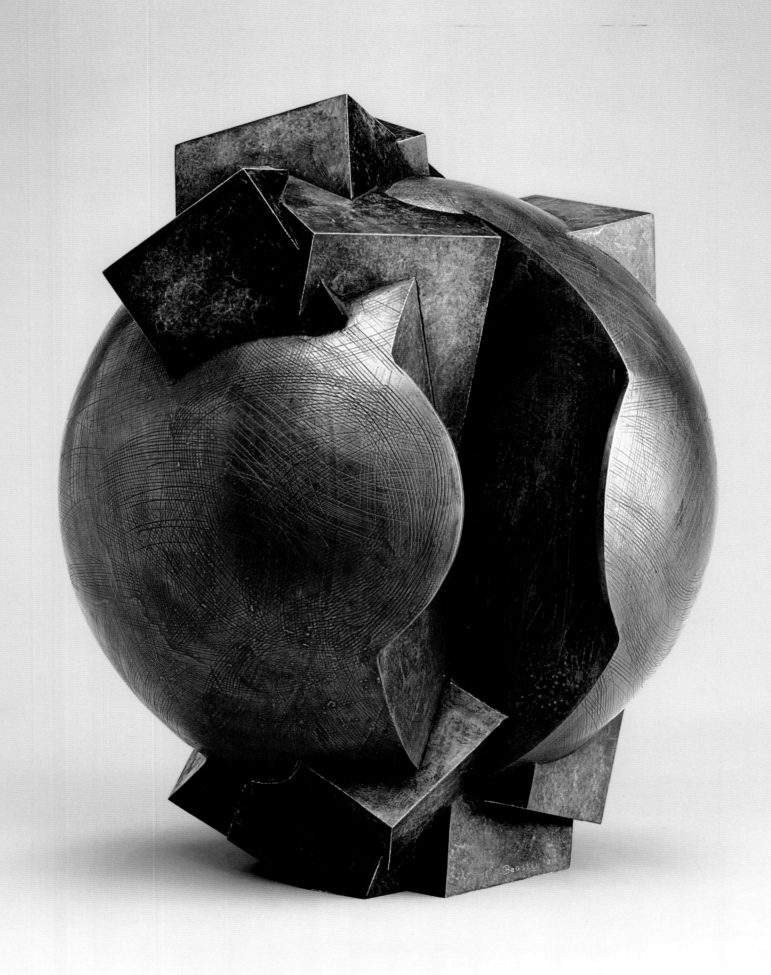

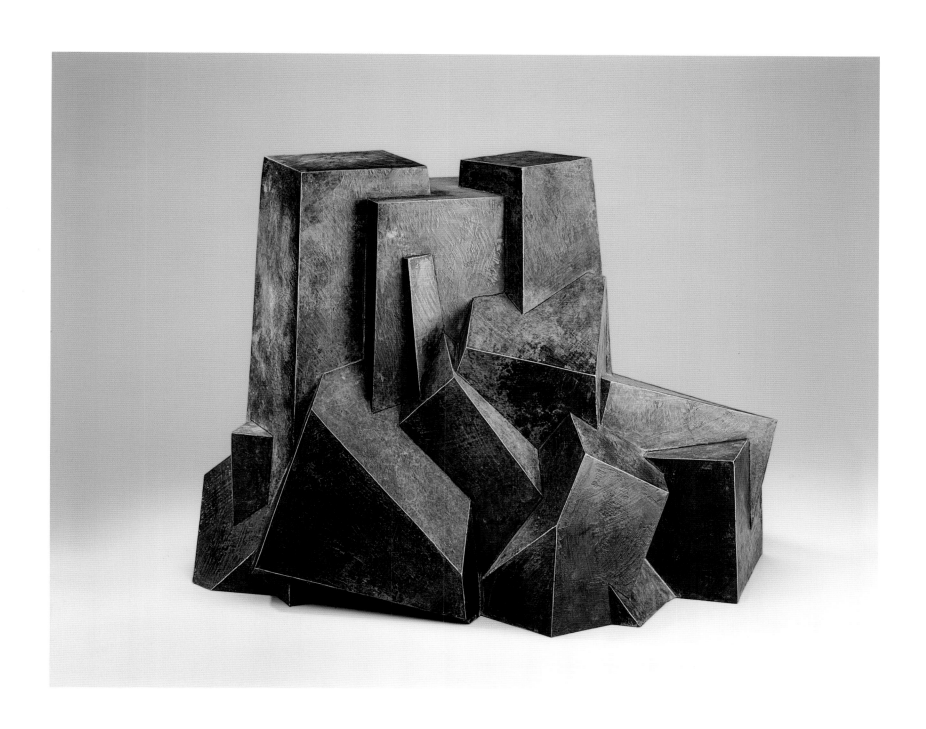

Plate 121 [facing]. *Tenacity*, 1990. Cast bronze, 22 × 18 × 18 in. Private collection.

Plate 122 [above]. *Convergence*, 1993. Cast bronze, 20 × 27 × 17 in. Private collection.

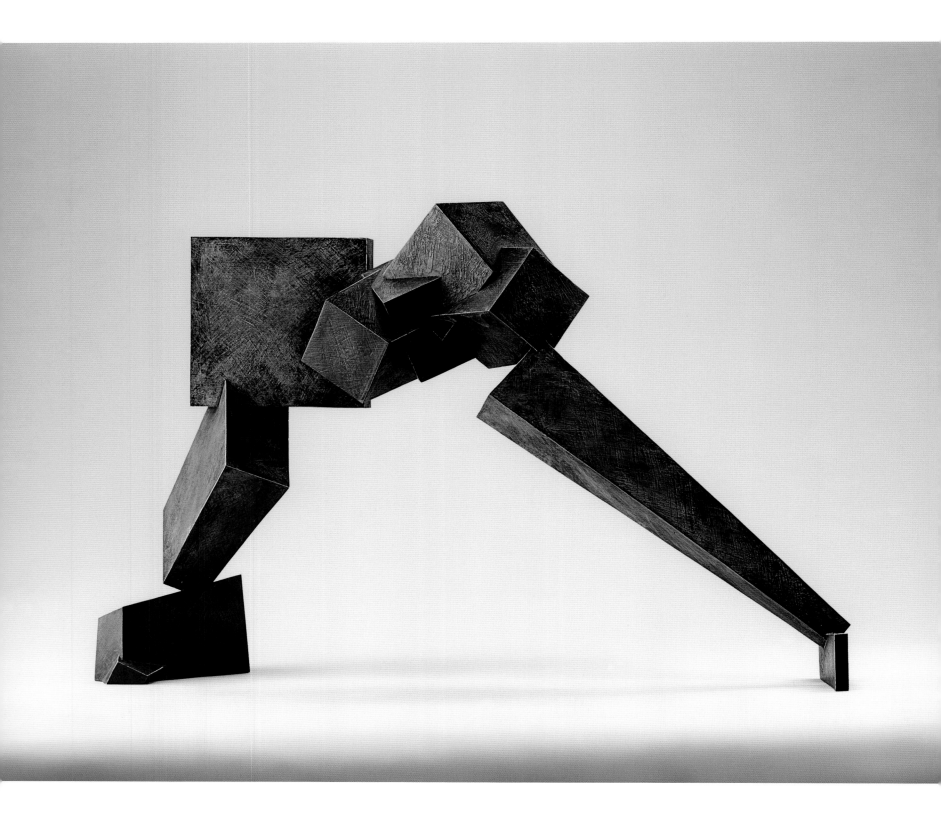

Plate 123. *Breakout*, 1991. Cast bronze, 28 × 44 × 12 in. Museum of Modern Art, San Francisco, California.

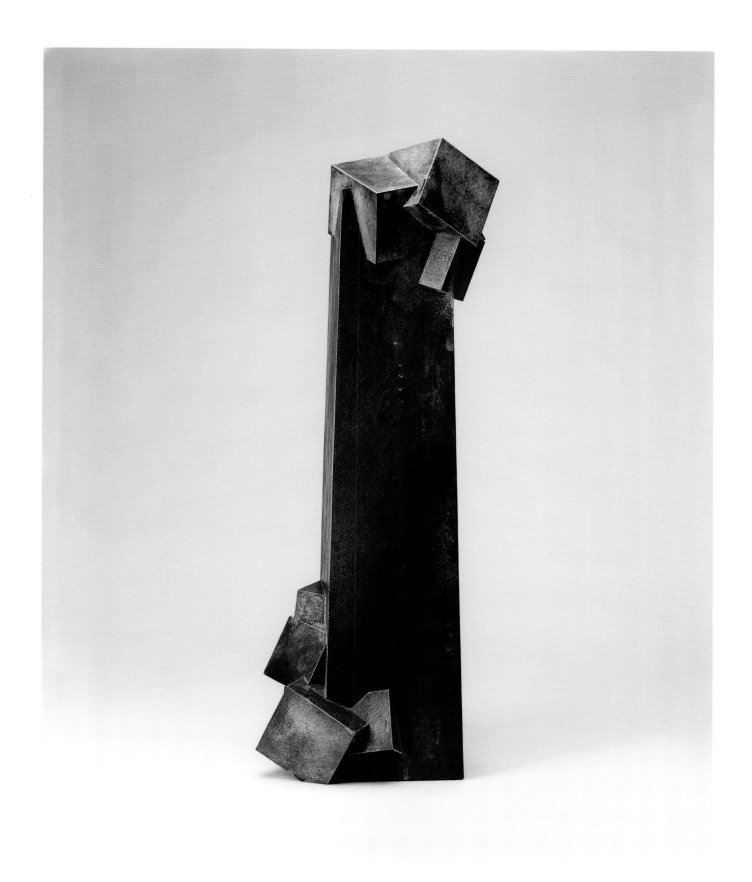

Plate 124. *Pillars of Cypress II*, 1990. Cast bronze, 35 × 11 × 11 in. Private collection.

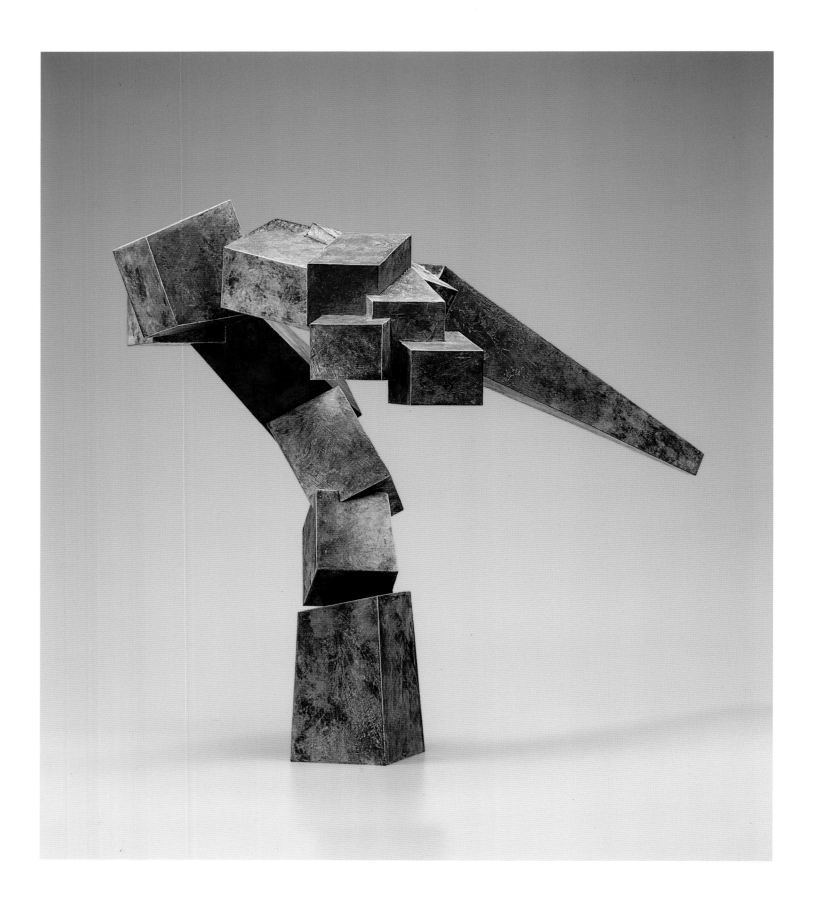

Plate 125 [above]. *Knight's Gambit*, 1991. Cast bronze, 25 × 32 × 24 in. Private collection.
Plate 126 [facing]. *Knight's Gambit II*, 1992. Cast bronze, 50 × 60 × 48 in. Fine Arts Museums, San Francisco, California.

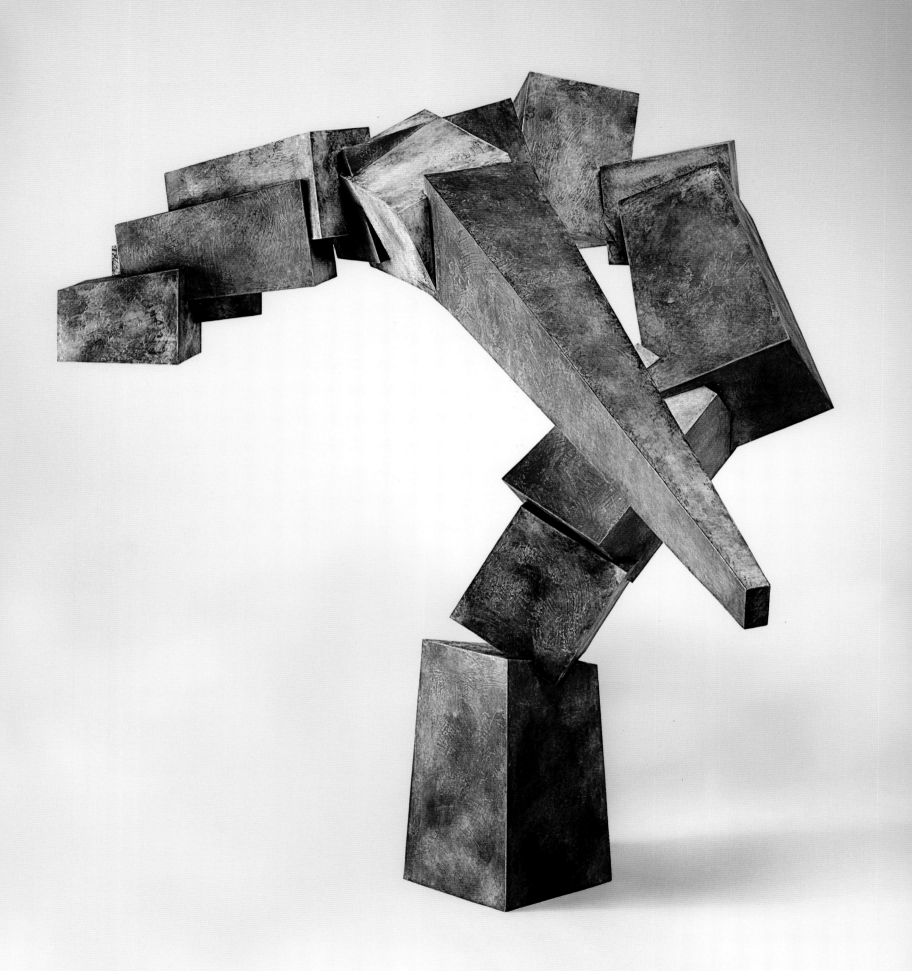

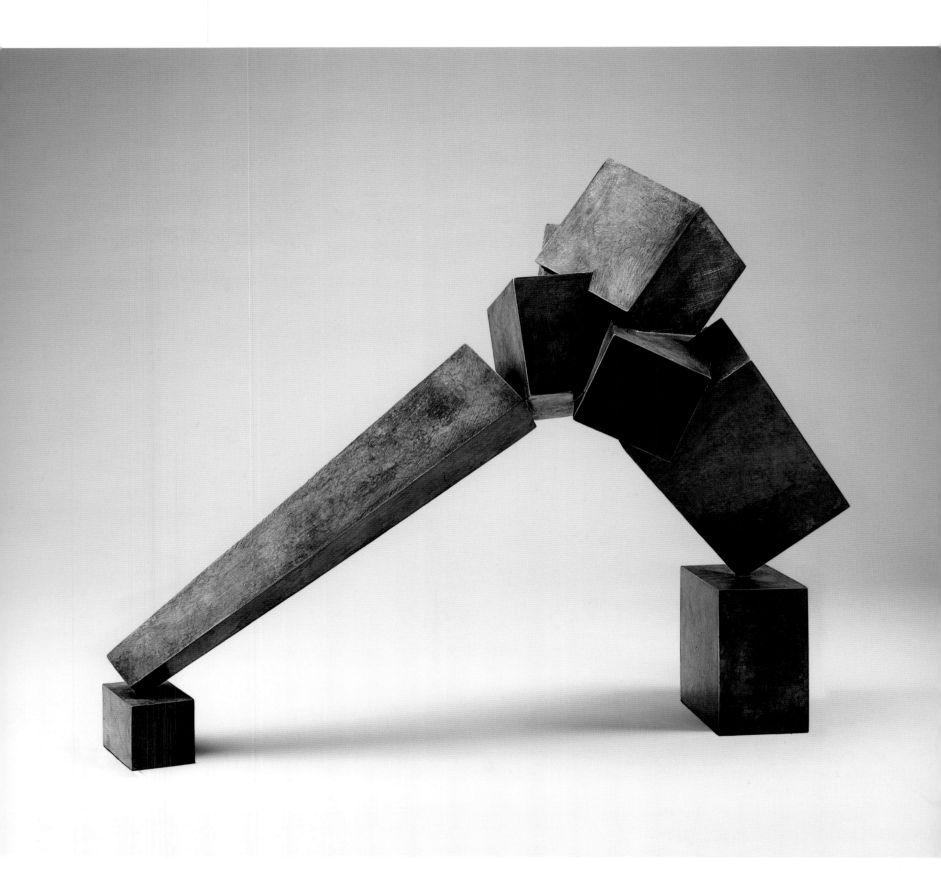

Plate 127. *Intersections*, 1987. Cast bronze, 24 × 33 × 12 in. Private collection. (See also plate 19.)

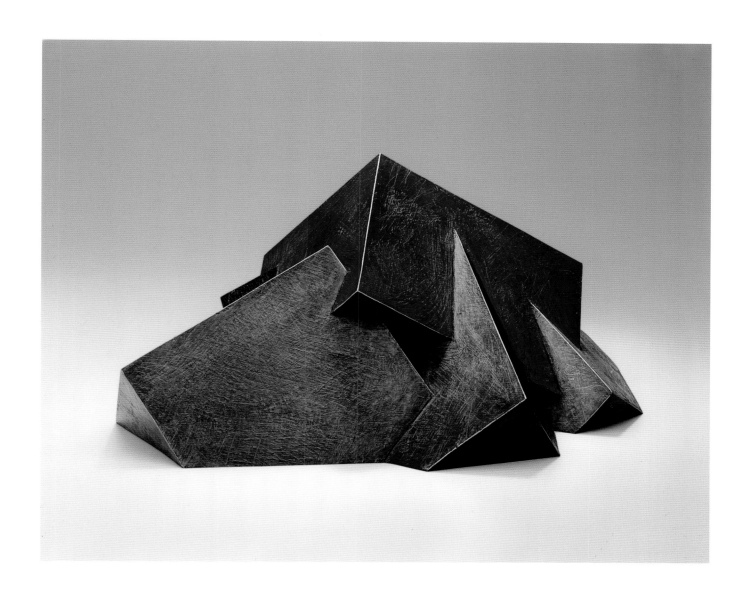

Plate 128. *Uplift*, 1992. Cast bronze, 7 × 18 × 13 in. Private collection.

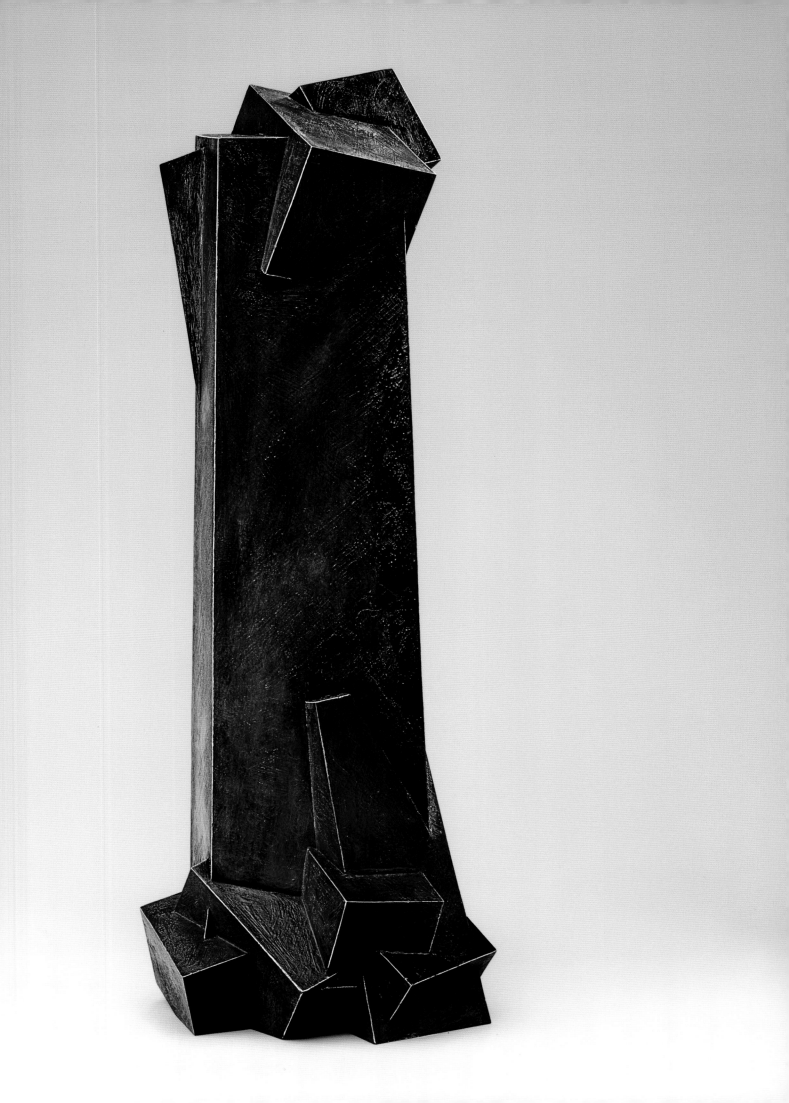

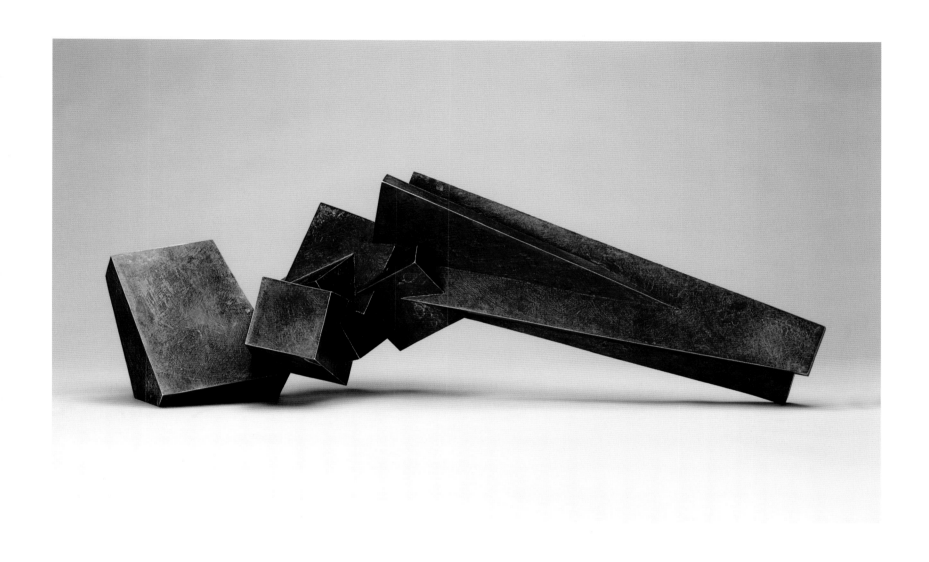

Plate 129 [facing]. *Sentinel*, 1990. Cast bronze, 28 × 11 × 10 in. Private collection.

Plate 130 [above]. *Seaborne*, 1989. Cast bronze, 14 × 41 × 16 in. The Fresno Art Museum, Fresno, California.

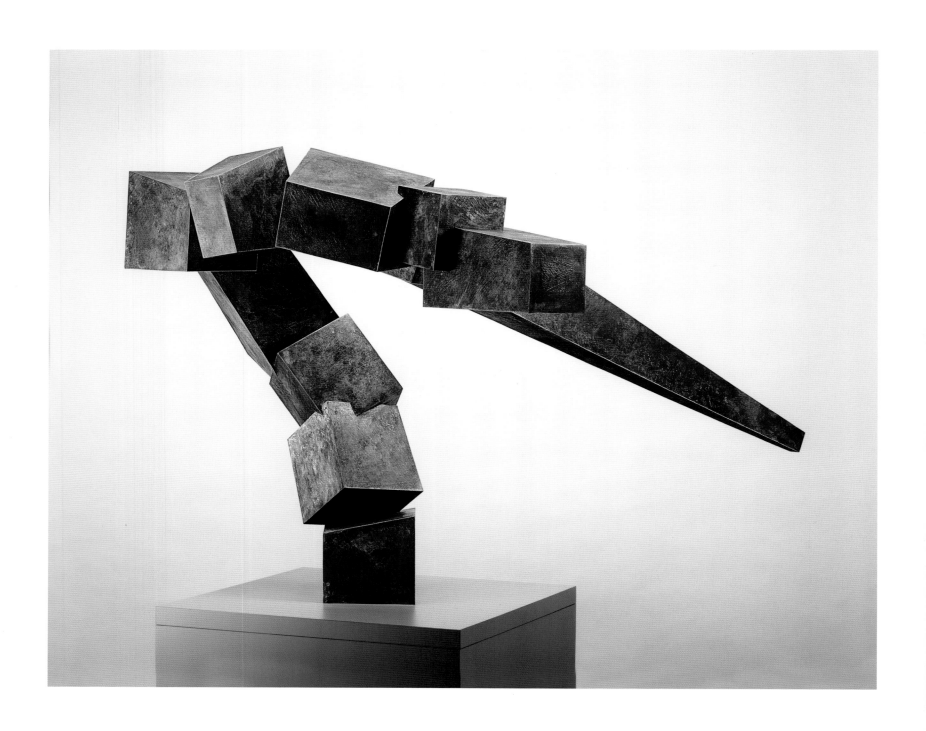

Plate 131 [above]. *Bateleur II*, 1989. Cast bronze, 38 × 66 × 42 in.
Sheldon Memorial Art Gallery, University of Nebraska, Lincoln, Nebraska.
Plate 132 [facing]. *Intersections II*, 1991. Bronze, 102 × 140 × 50 in.
Gateway Center, Walnut Creek, California.

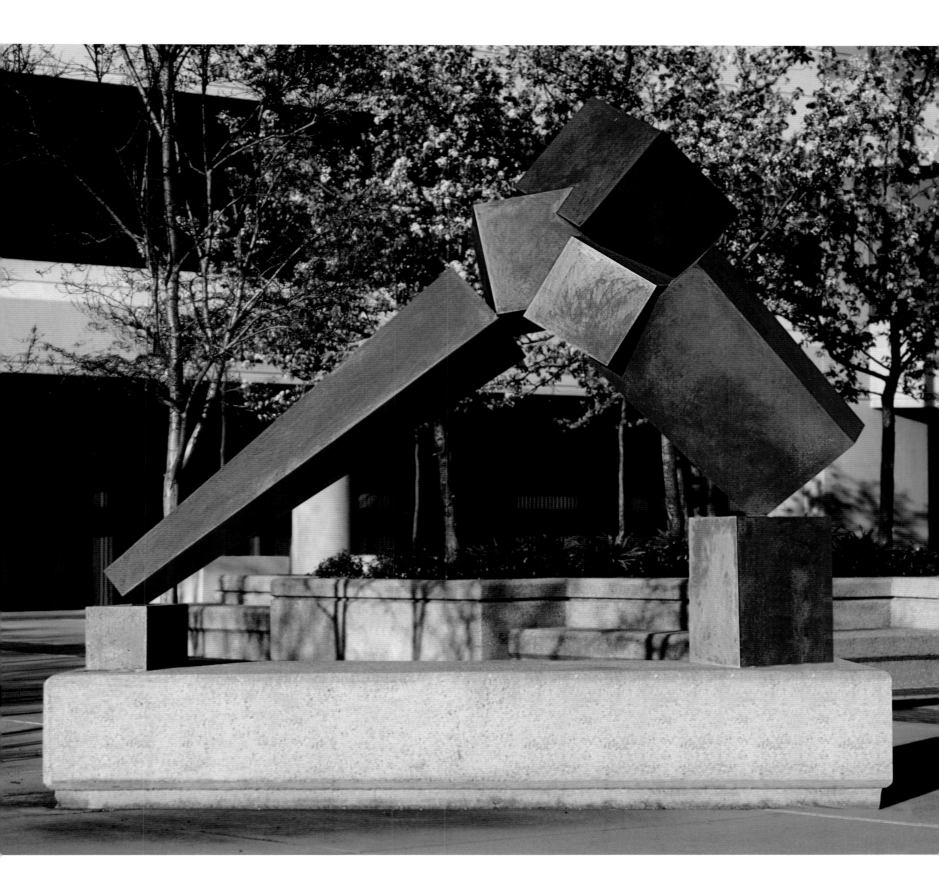

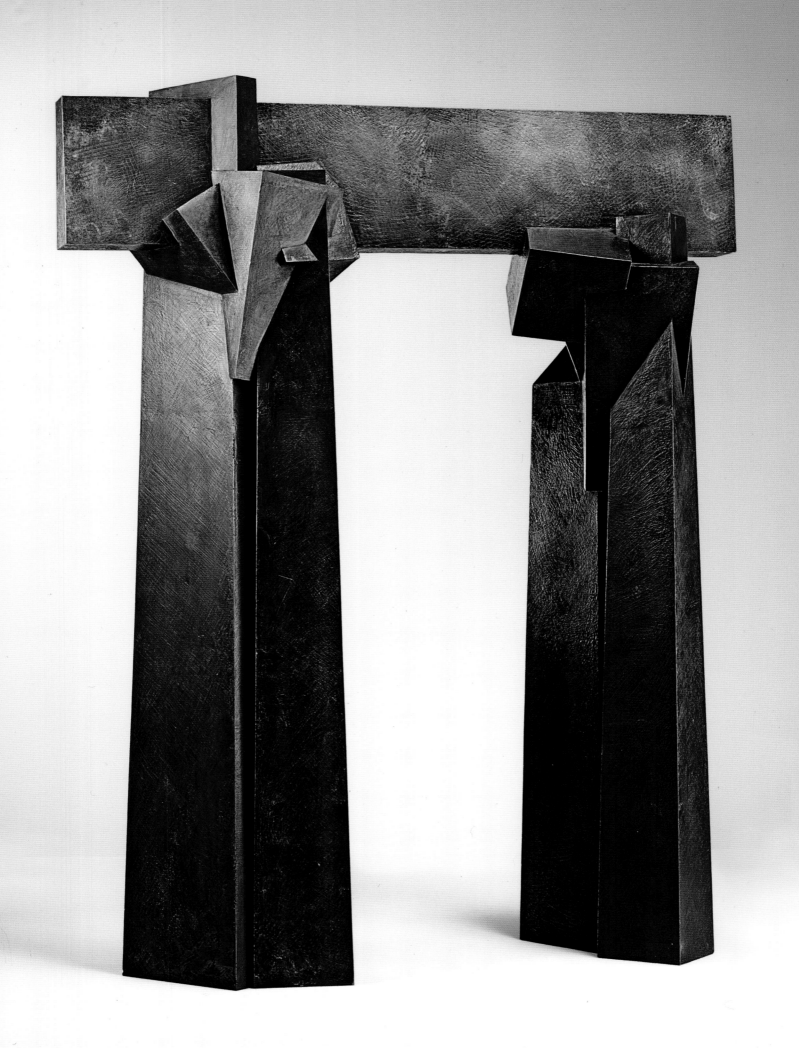

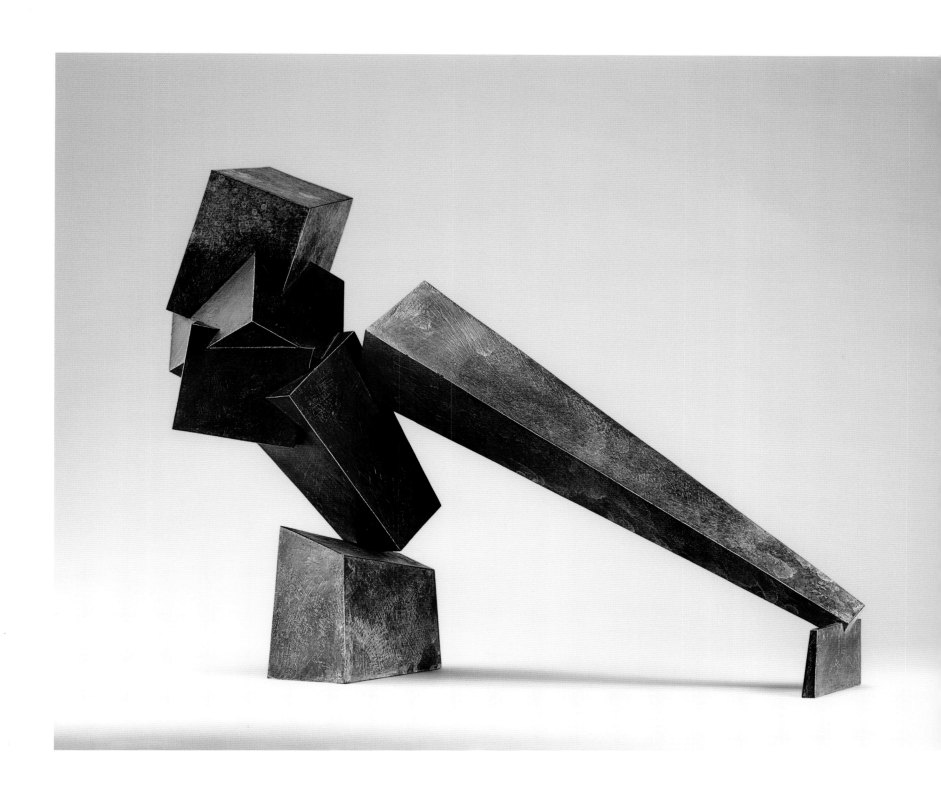

Plate 133 [facing]. *Ascender II*, 1991. Cast bronze, 64 × 49 × 20 in. Private collection.

Plate 134 [above]. *Thrust*, 1991. Cast bronze, 25 × 32 × 13 in. Private collection.

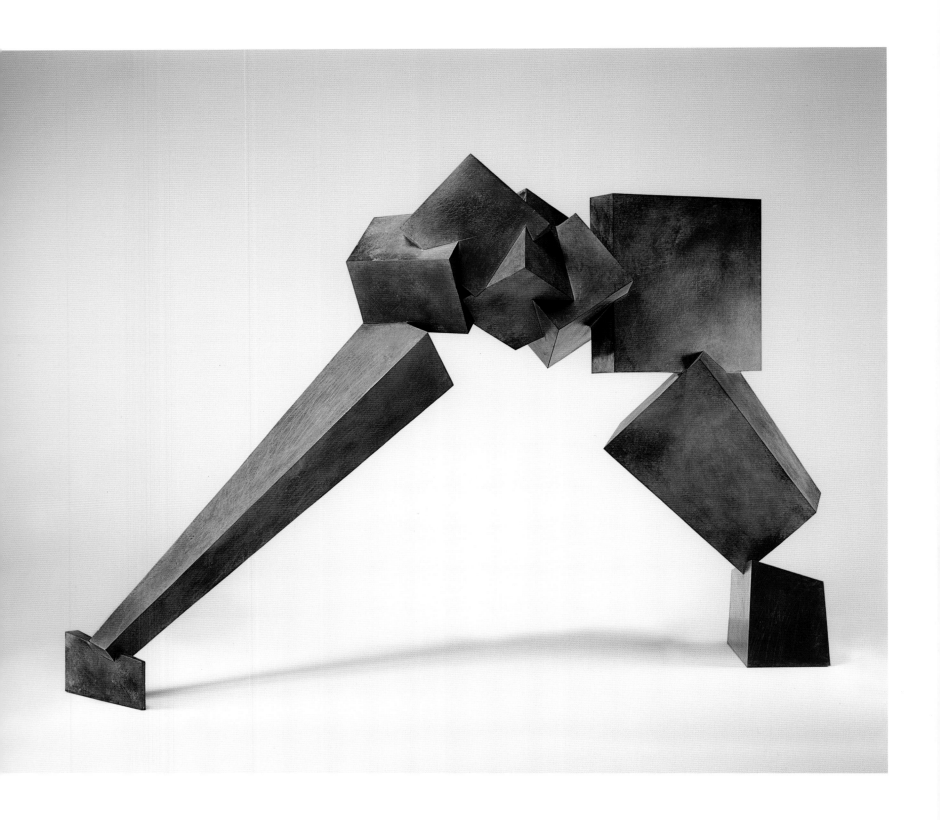

Plate 135 [above]. *Breakout II*, 1992. Bronze, 57 × 90 × 24 in. Private collection.

Plate 136 [facing]. *Sentinel II*, 1991. Bronze, 80 × 28 × 24 in. Private collection.

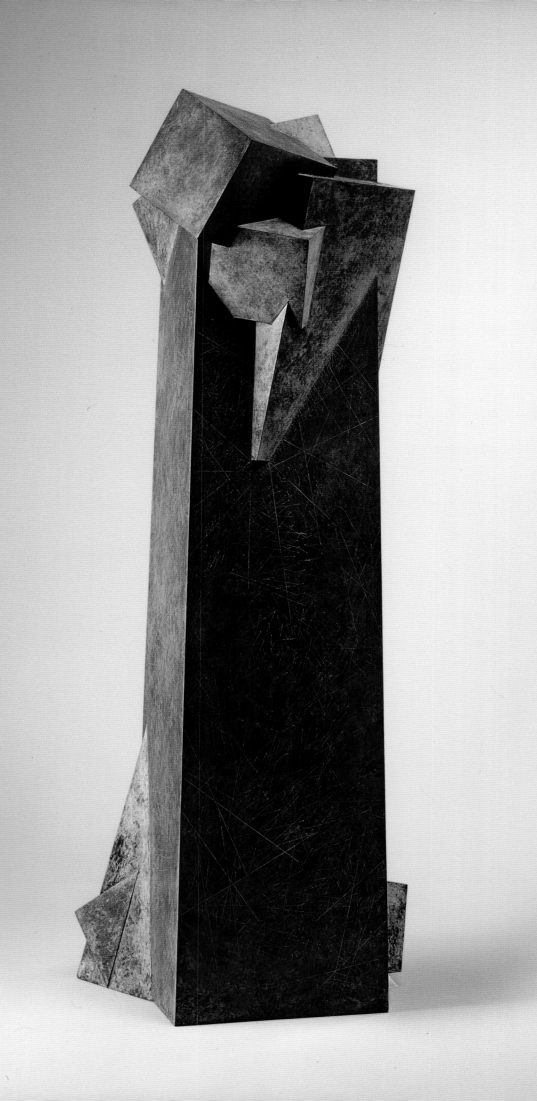

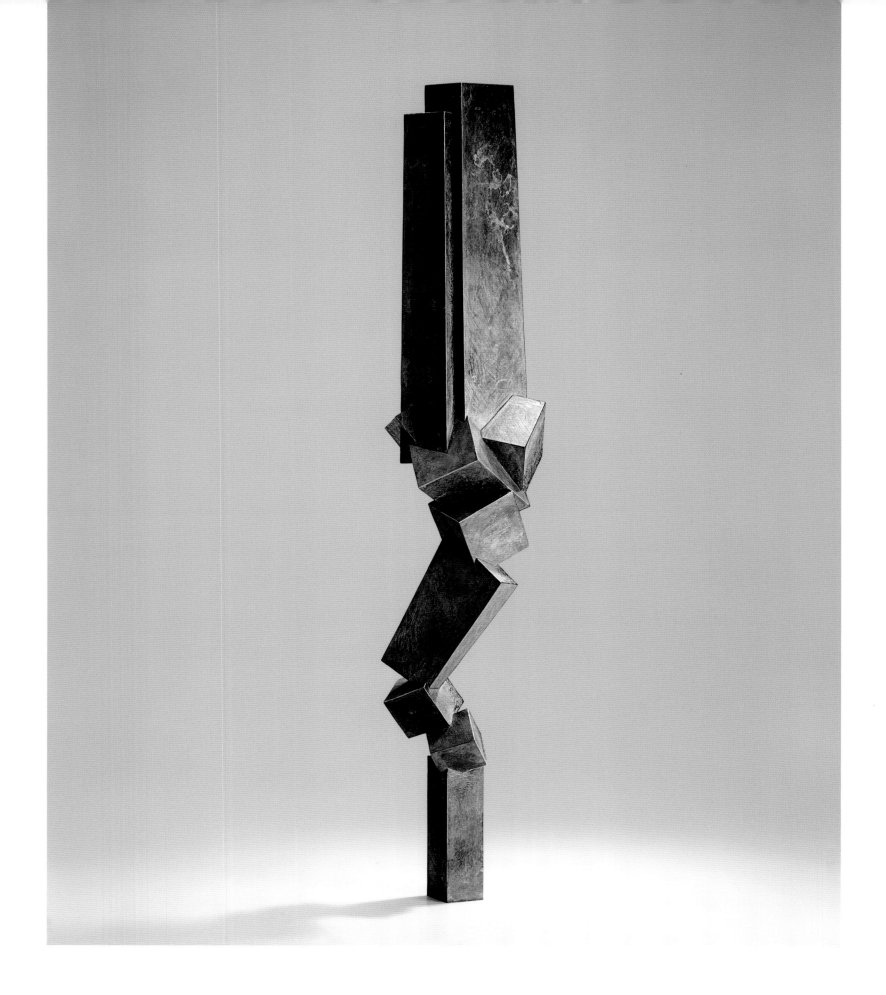

Plate 137 [above]. *Spokesman*, 1993. Cast bronze, 36 × 7 × 7 in. Private collection.

Plate 138 [facing]. *Refuge*, 1993. Cast bronze, 24 × 22 × 17 in. Private collection.

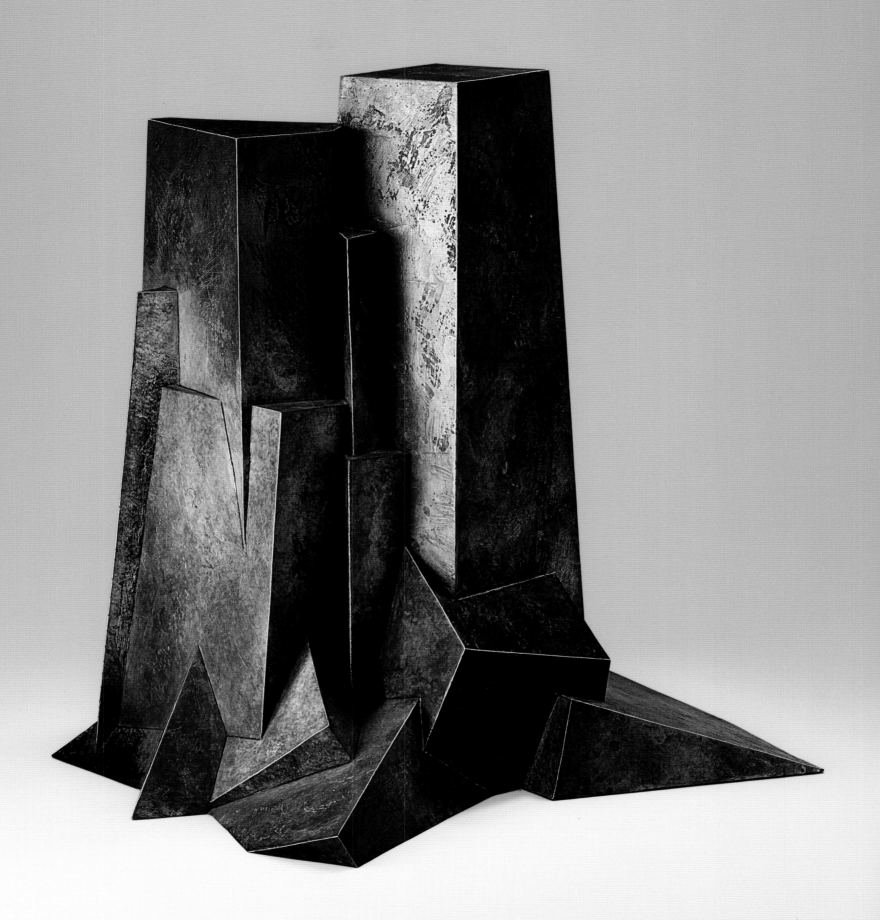

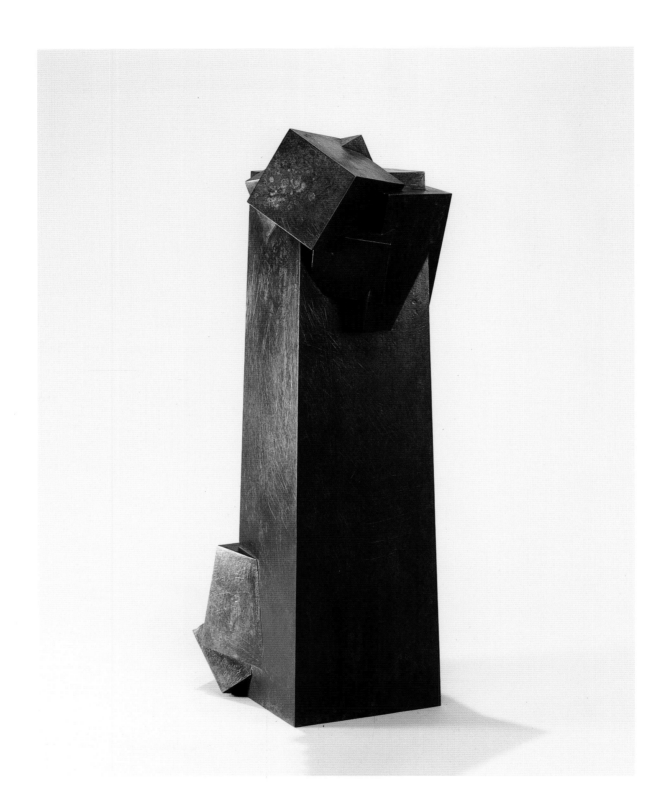

Plate 139. *Sentry*, 1989. Cast bronze, 24 × 8 × 7 in. Private collection.

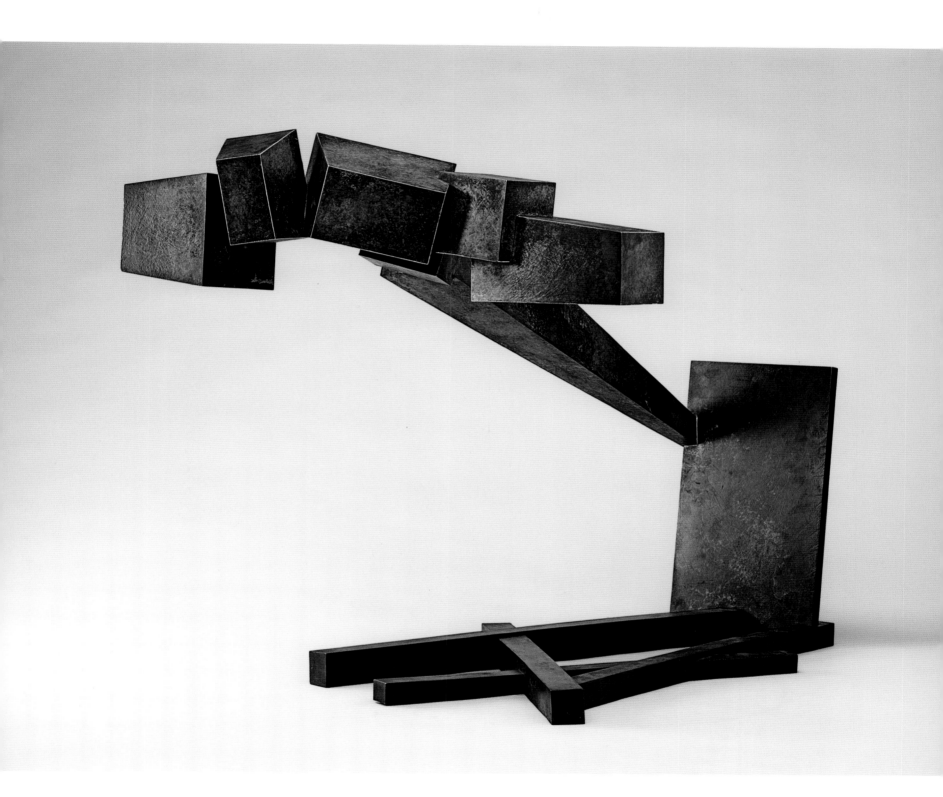

Plate 140. *Storm*, 1989. Cast bronze, 28 × 41 × 22 in. Private collection.

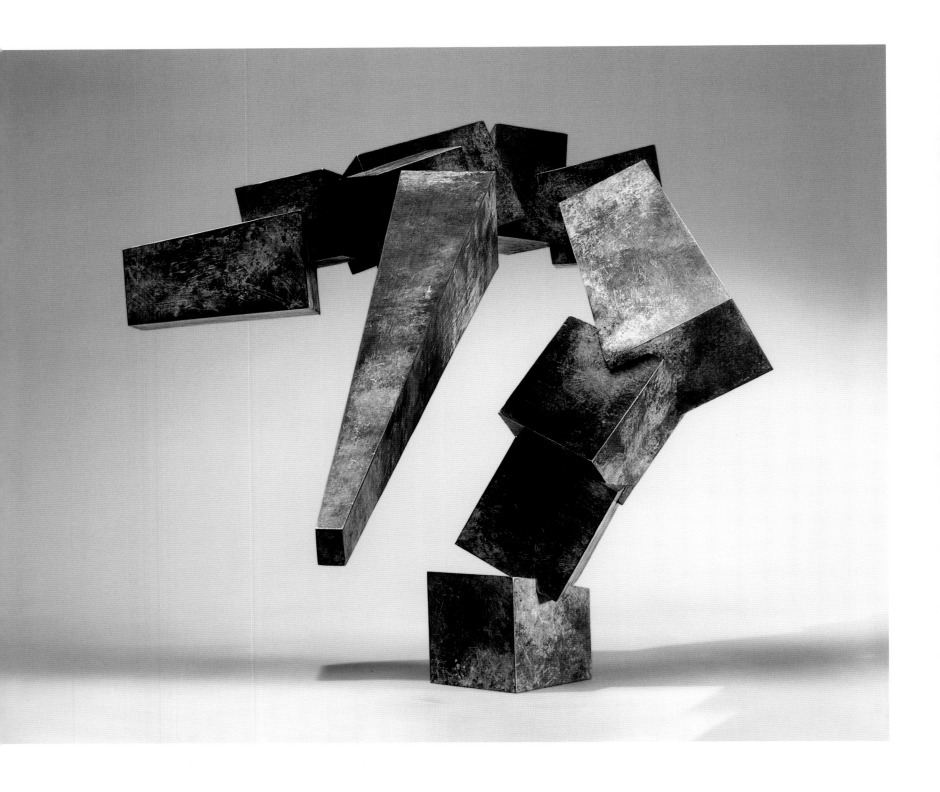

Plate 141 [above]. *Bateleur*, 1989. Cast bronze,
19 × 33 × 21 in. The Museum of Fine Arts, Houston, Texas.
Plate 142 [facing]. *Foray II*, 1994. Cast bronze, 48 × 48 × 14 in.
Hood Museum of Art, Dartmouth College, Hanover, New Hampshire.

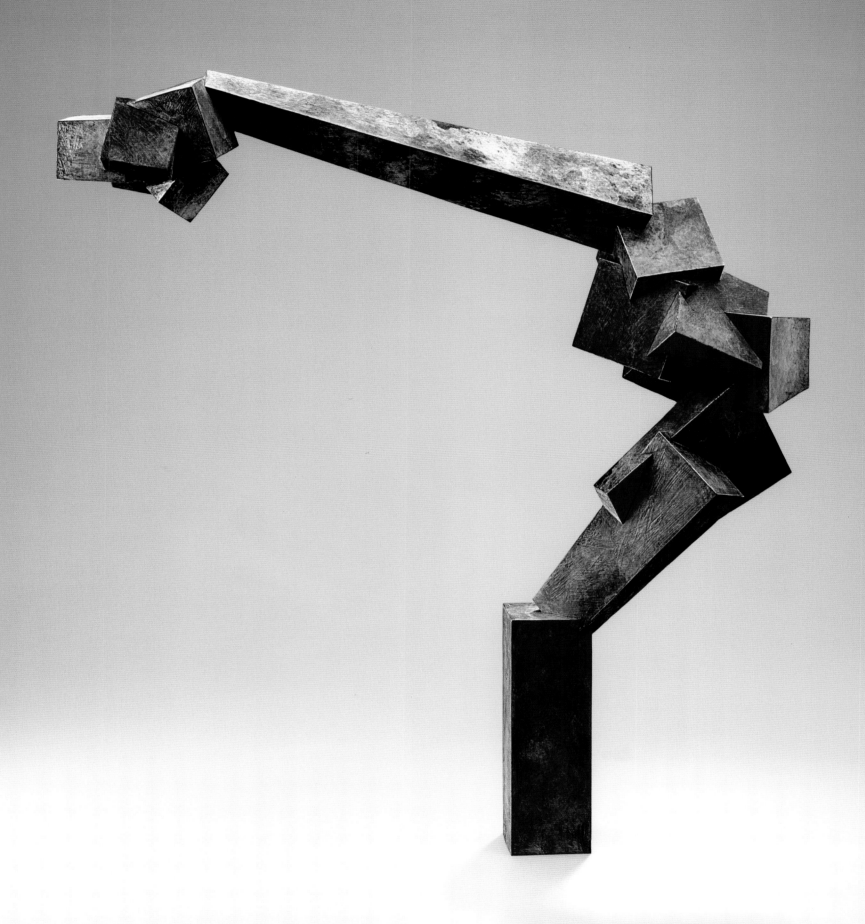

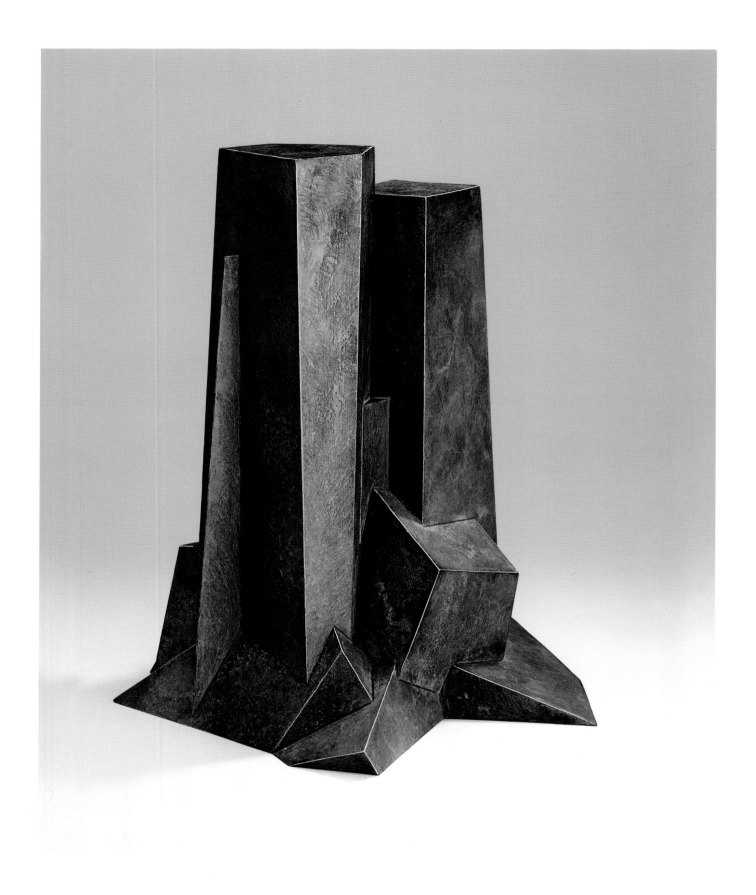

Plate 143 [above]. *Upthrust*, 1993. Cast bronze, 19 × 16 × 13 in. Private collection.
Plate 144 [facing]. *Spokesman II*, 1994. Bronze, 144 × 29 × 24 in. City of Bad Homberg, Germany.

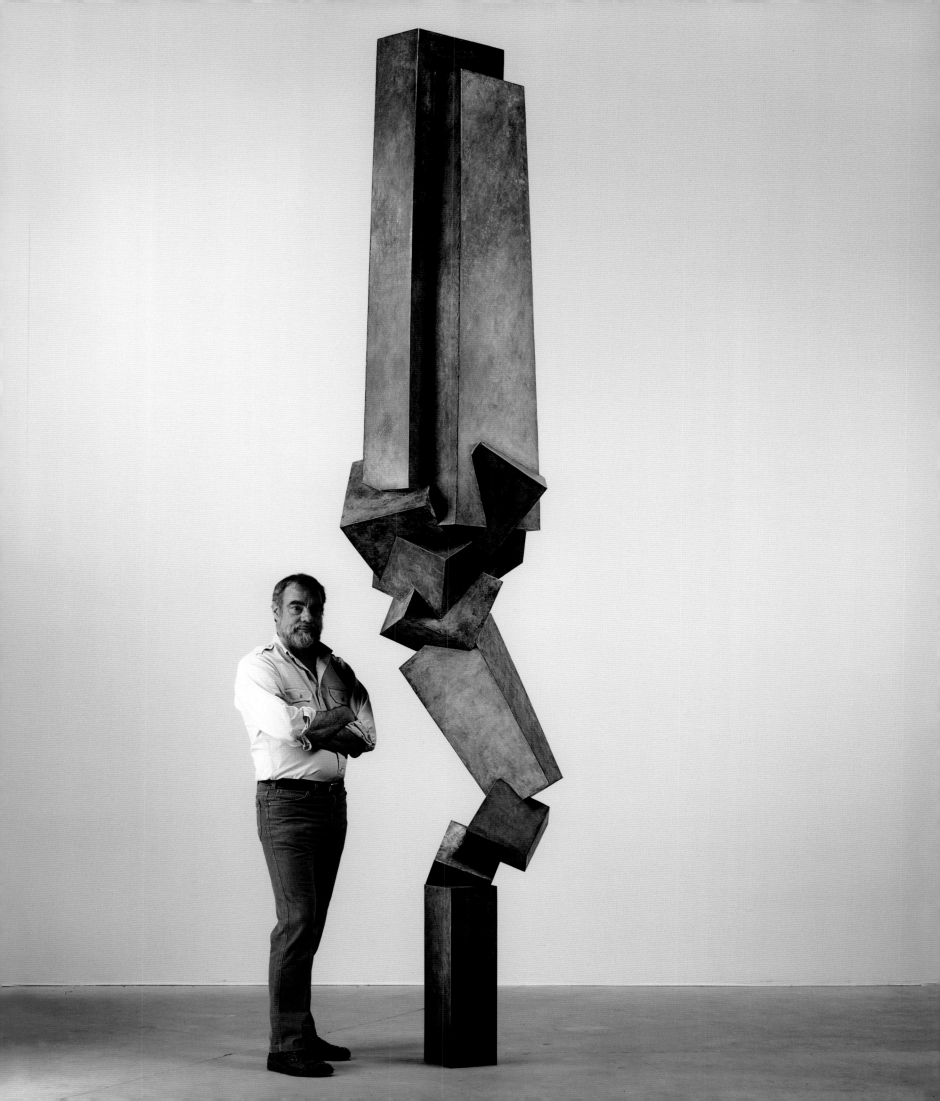

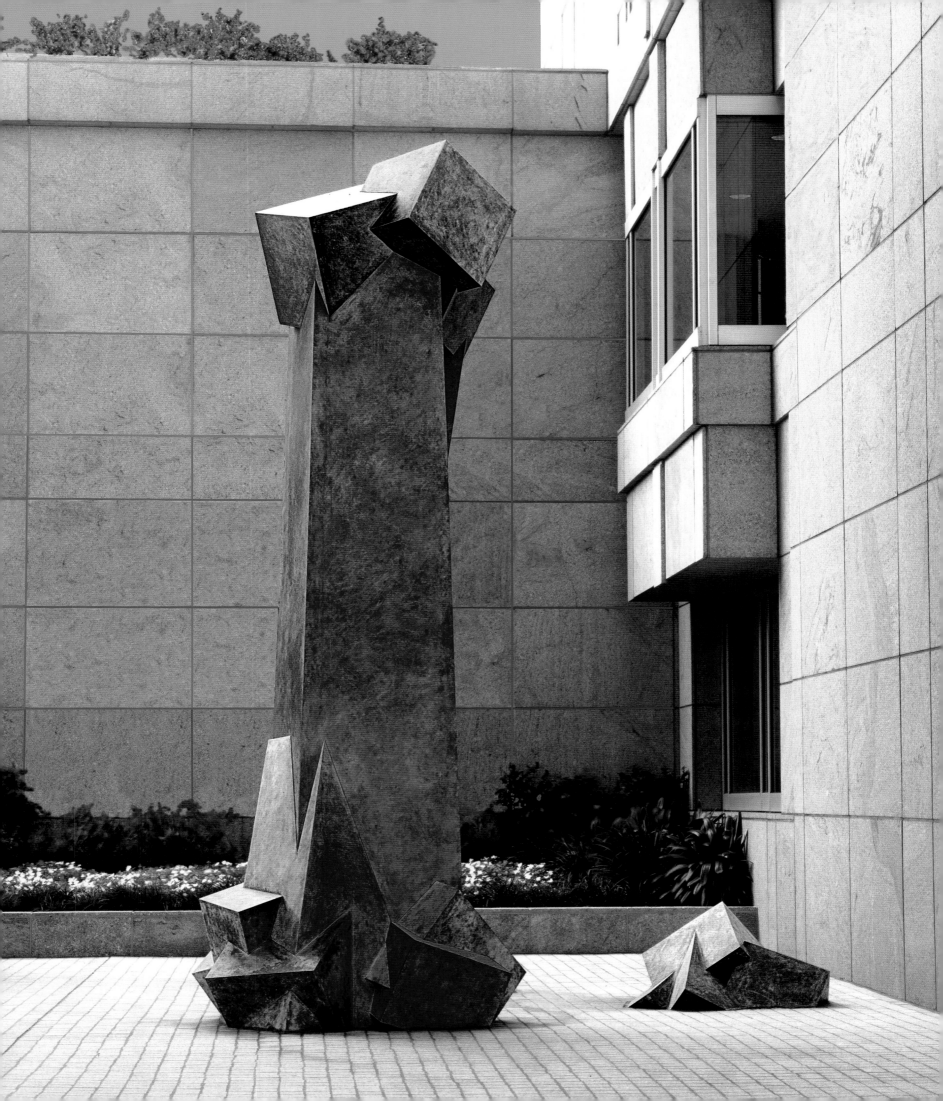

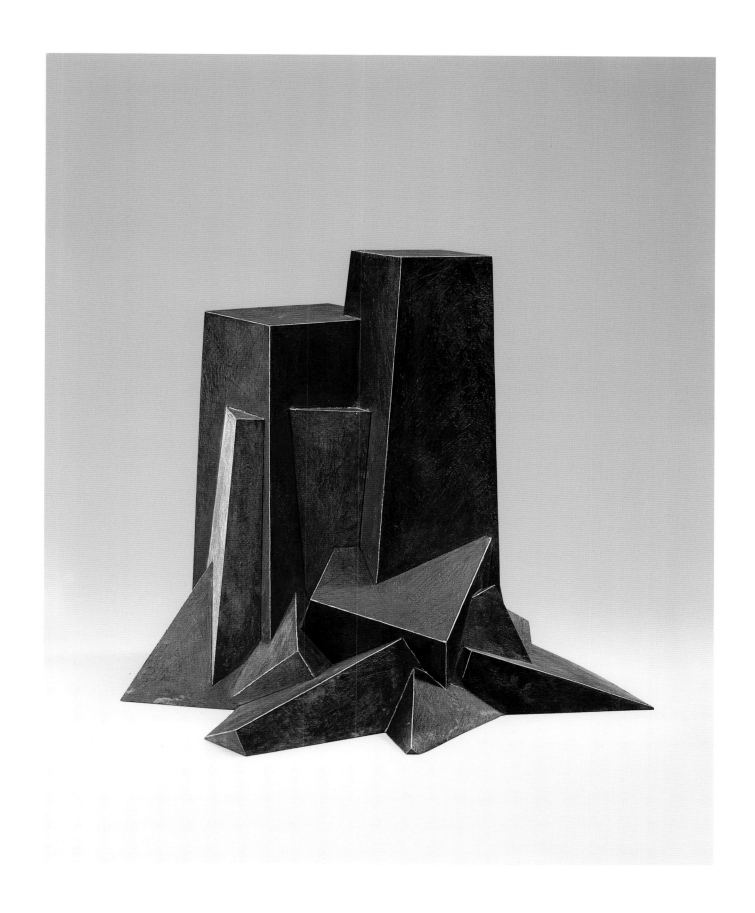

Plate 145 [facing]. *Guardian*, 1992. Bronze, 204 × 132 × 108 in. San Francisco Federal Home Loan Bank, San Francisco, California.

Plate 146 [above]. *Mesa*, 1992. Cast bronze, 16 × 17 × 15 in. De Saisset Museum, Santa Clara, California.

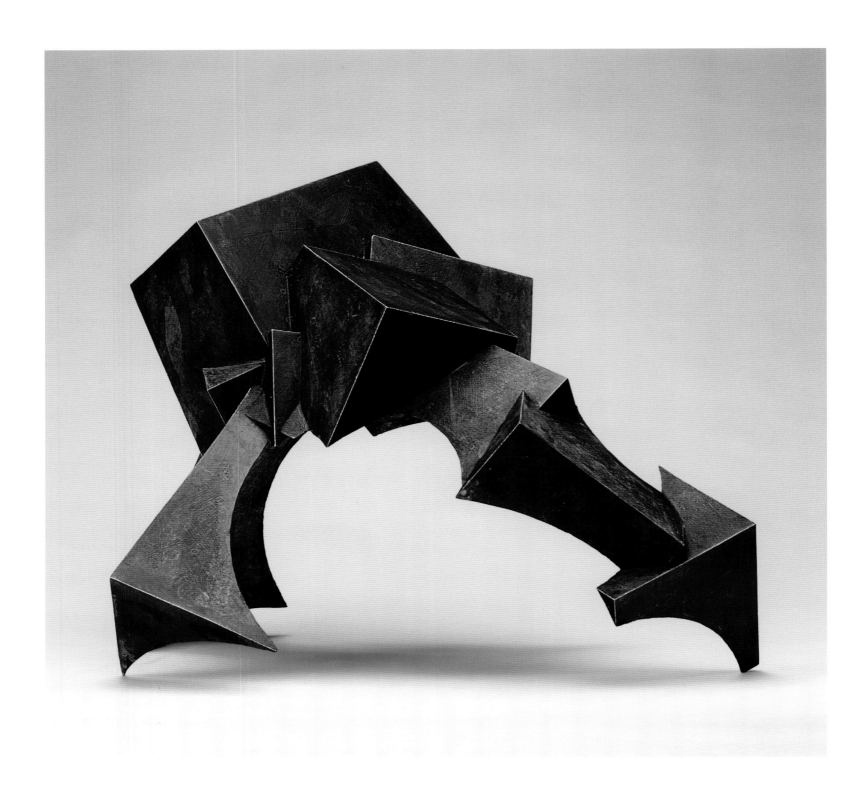

Plate 147 [above]. *Raptor*, 1990. Cast bronze, 19 × 24 × 22 in. Private collection. (See also plate 18.)

Plate 148 [facing]. *Ascender*, 1991. Cast bronze, 32 × 24 × 10 in. Private collection.

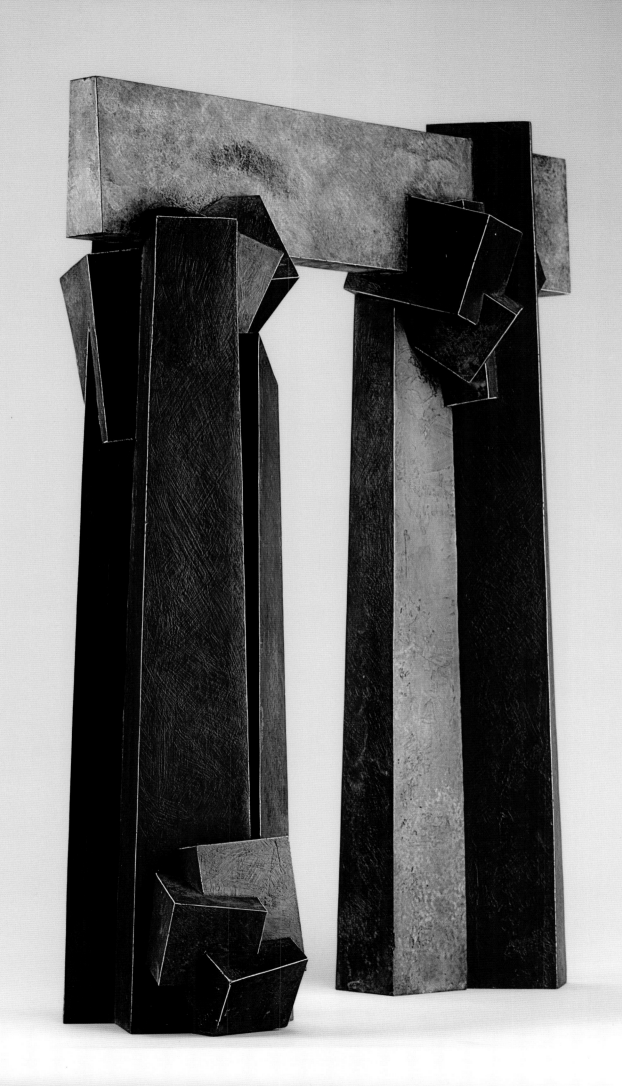

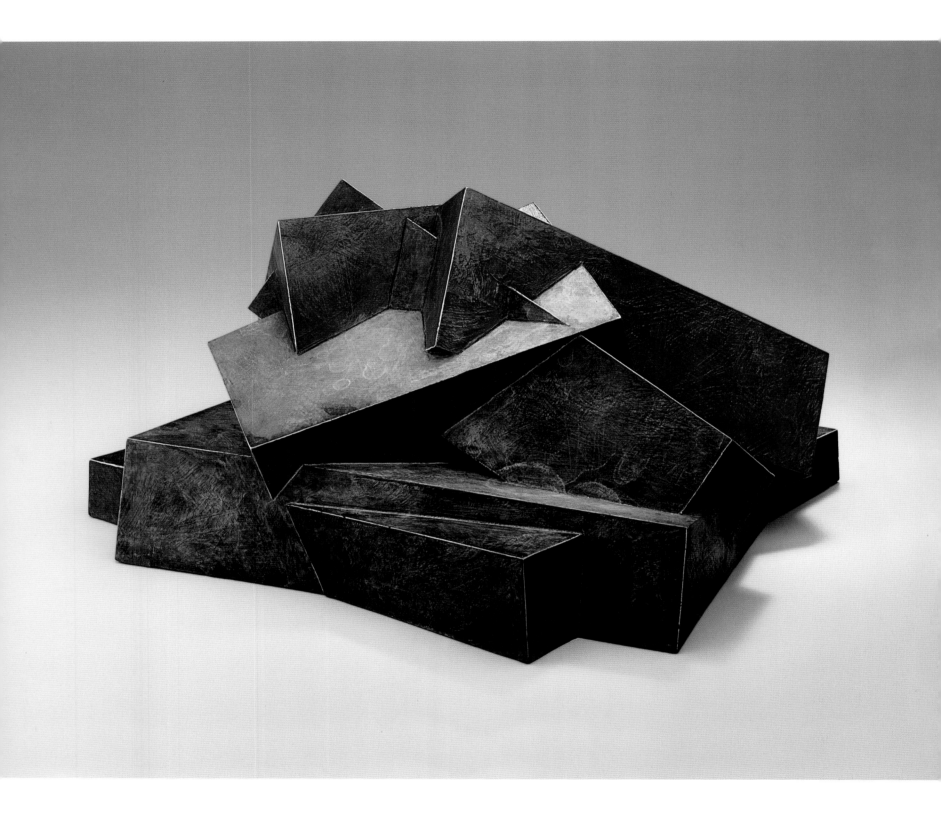

Plate 149. *Precursor*, 1992. Cast bronze, 10 × 20 × 19 in. Private collection.

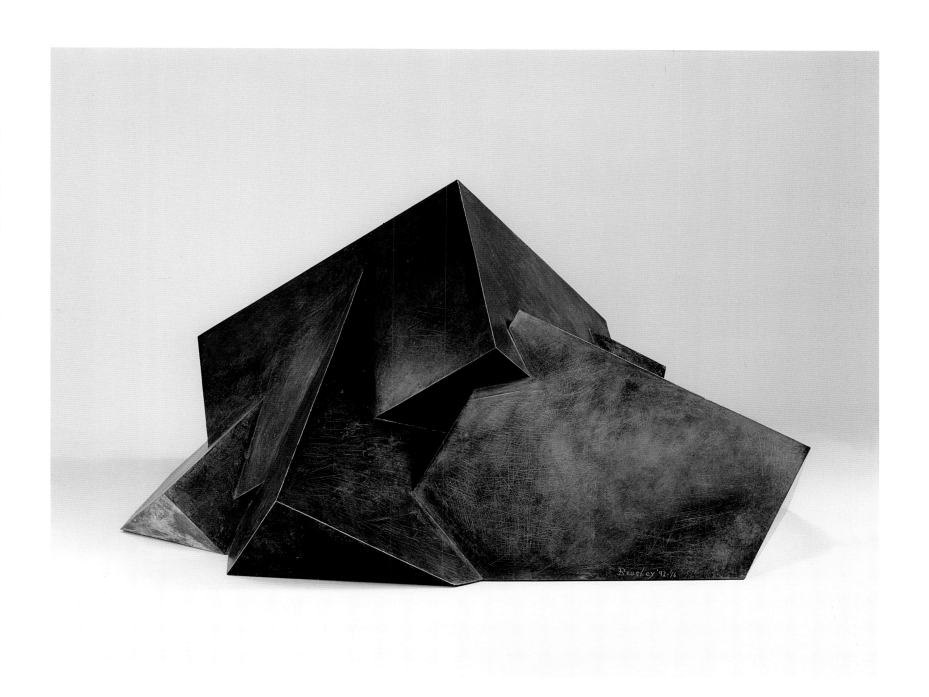

Plate 150. *Uplift II*, 1992. Bronze, 35 × 77 × 54 in. Private collection.

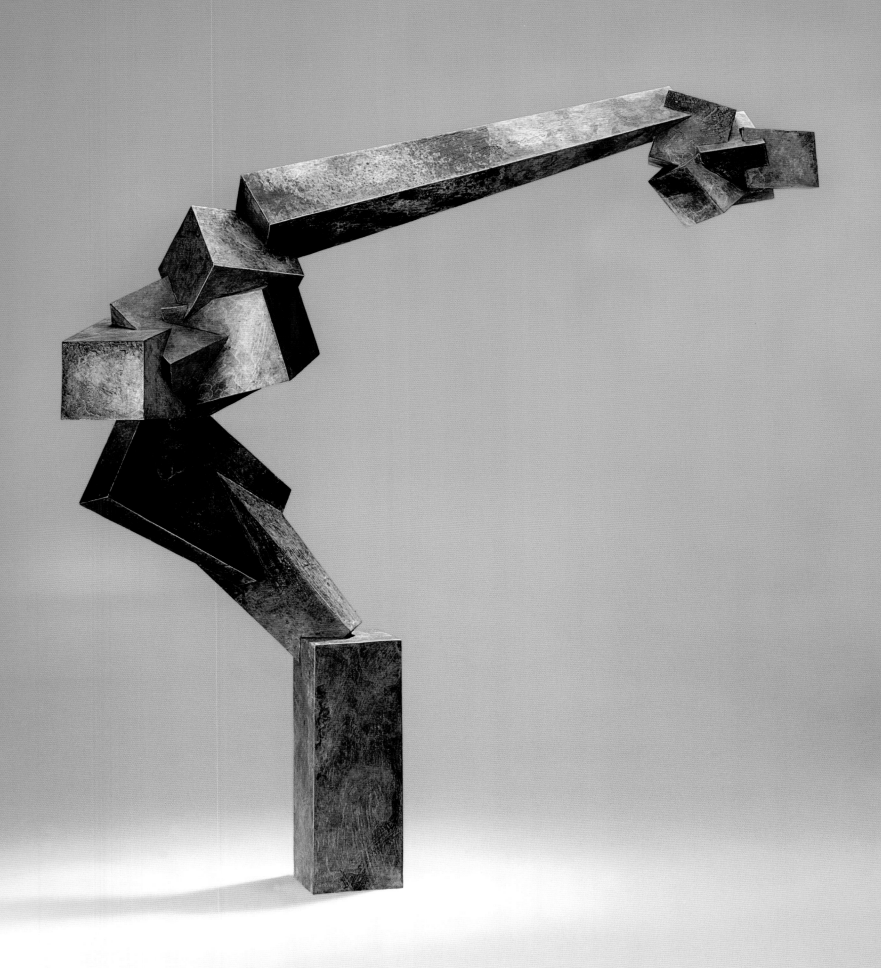

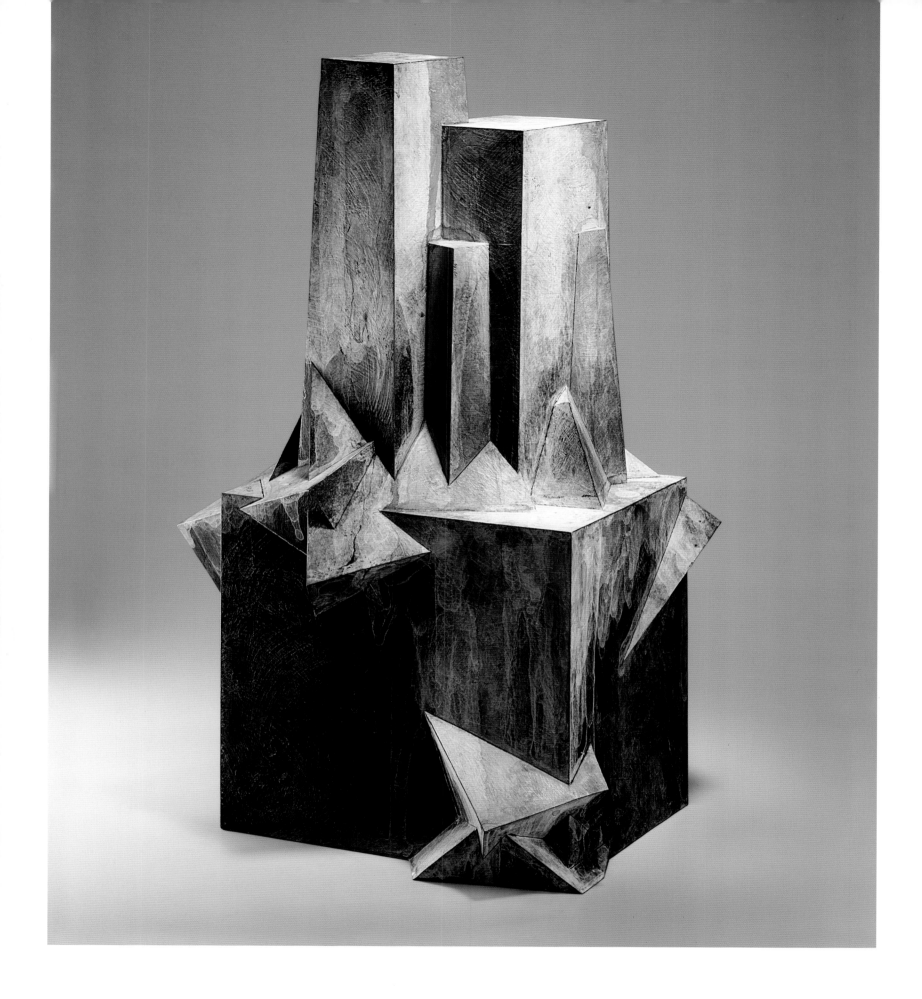

Plate 151 [facing]. *Foray*, 1993. Cast bronze, 32 × 30 × 9 in. Private collection.

Plate 152 [above]. *Solid Sequence*, 1993. Cast bronze, 34 × 21 × 21 in. Private collection. (See also plate 20.)

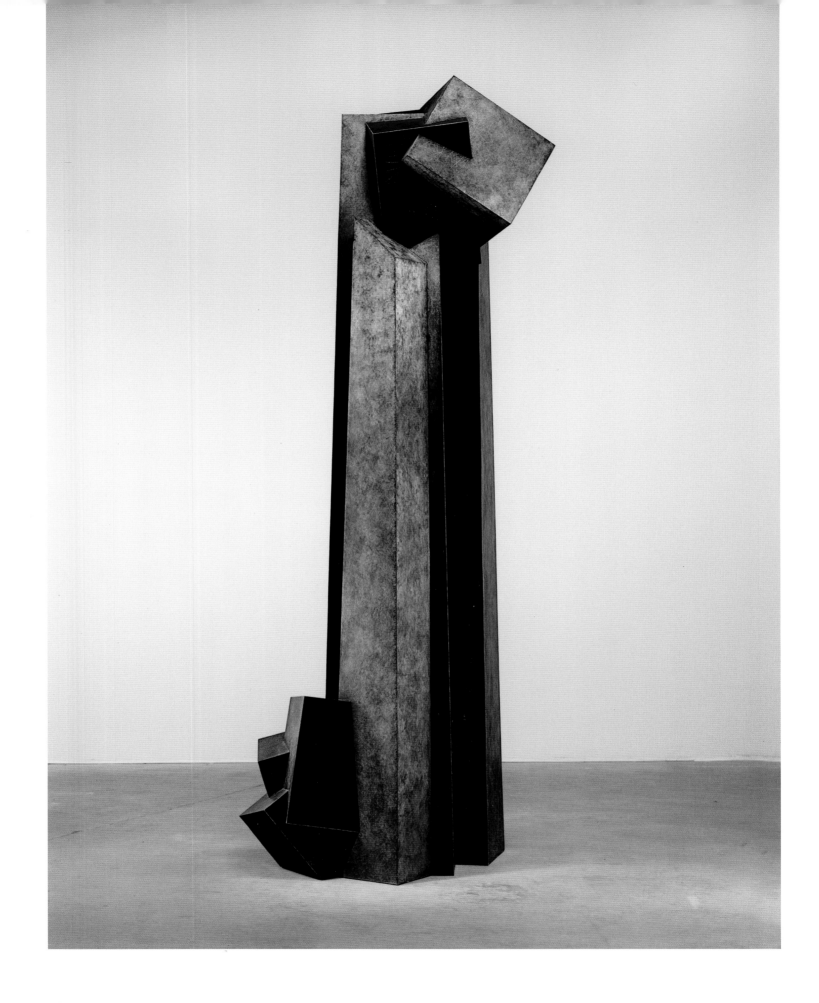

Plate 153 [above]. *Watchtower II*, 1993. Bronze, 117 × 42 × 33 in. City of Dortmund, Germany.
Plate 154 [facing]. *Messenger II*, 1993. Bronze, 157 × 30 × 27 in. Landeszentral Bank, Hessen, Germany.

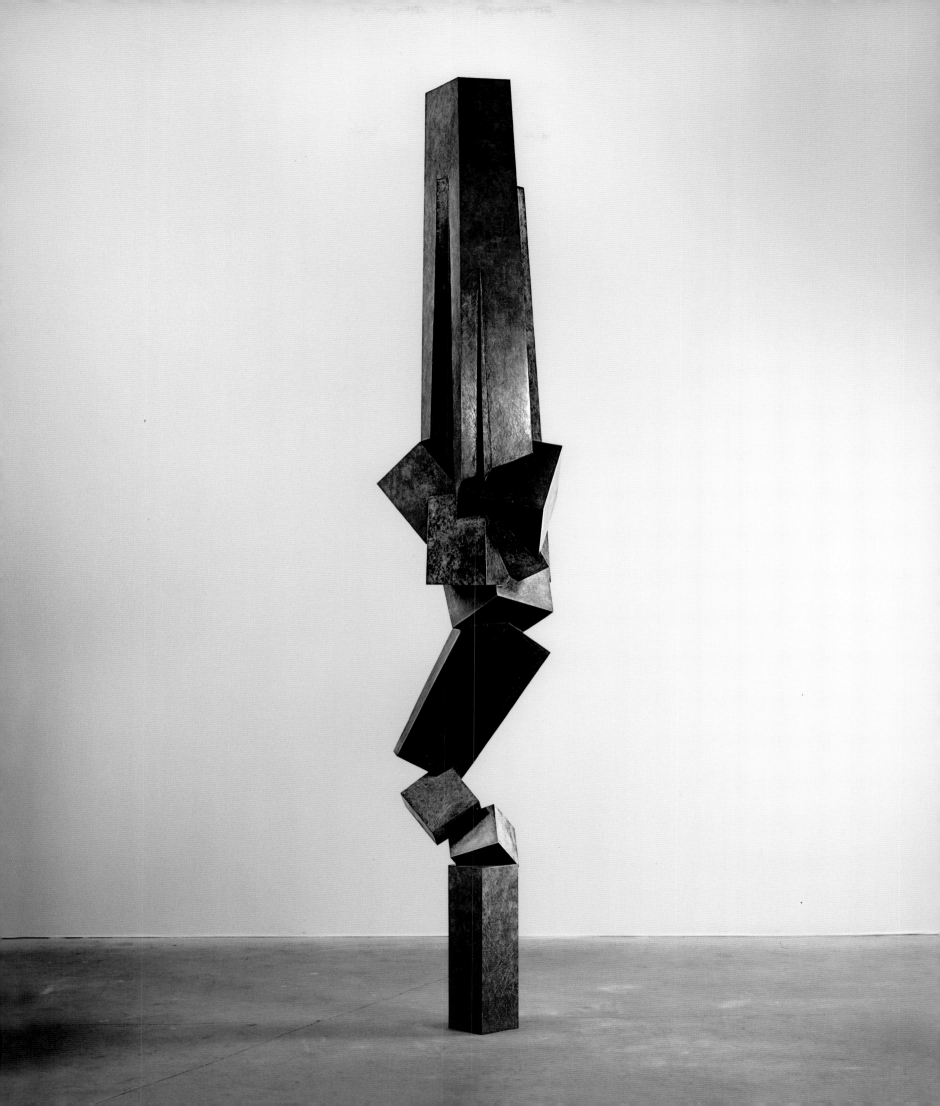

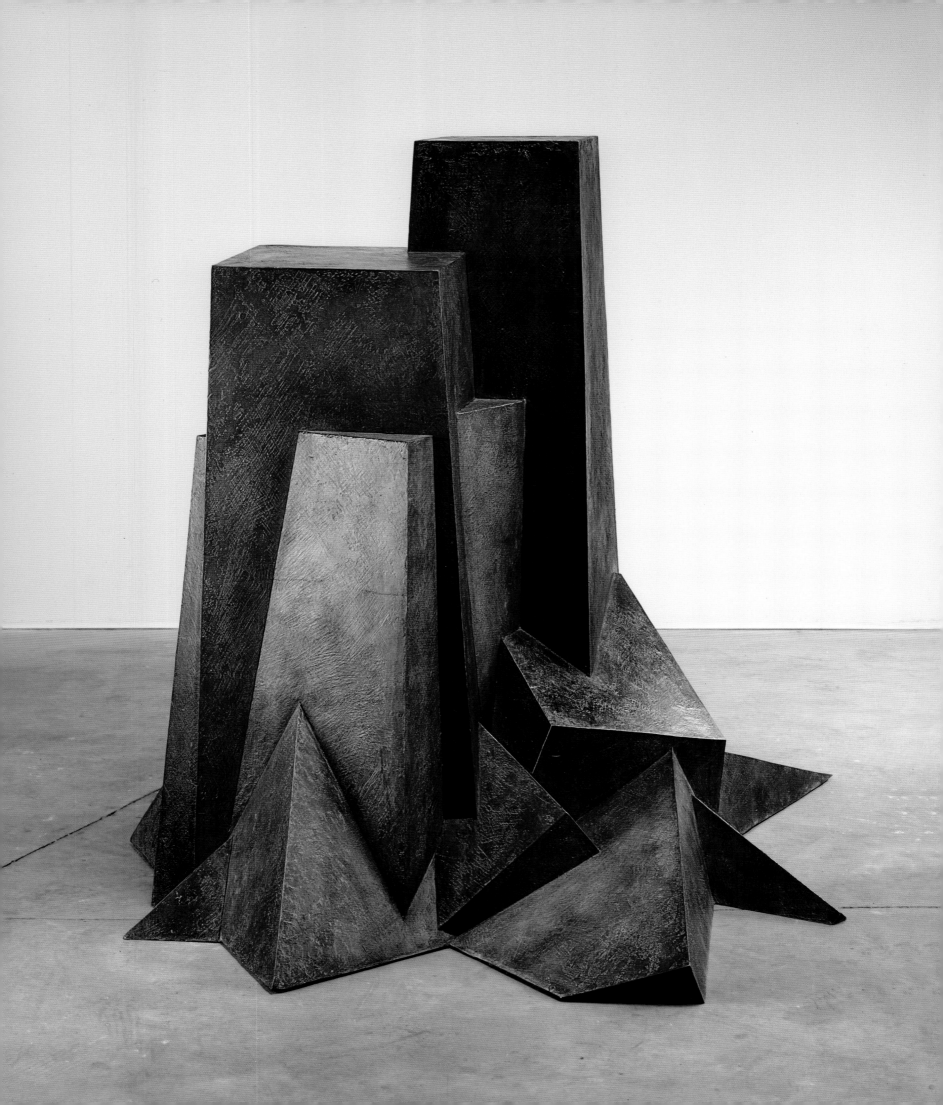

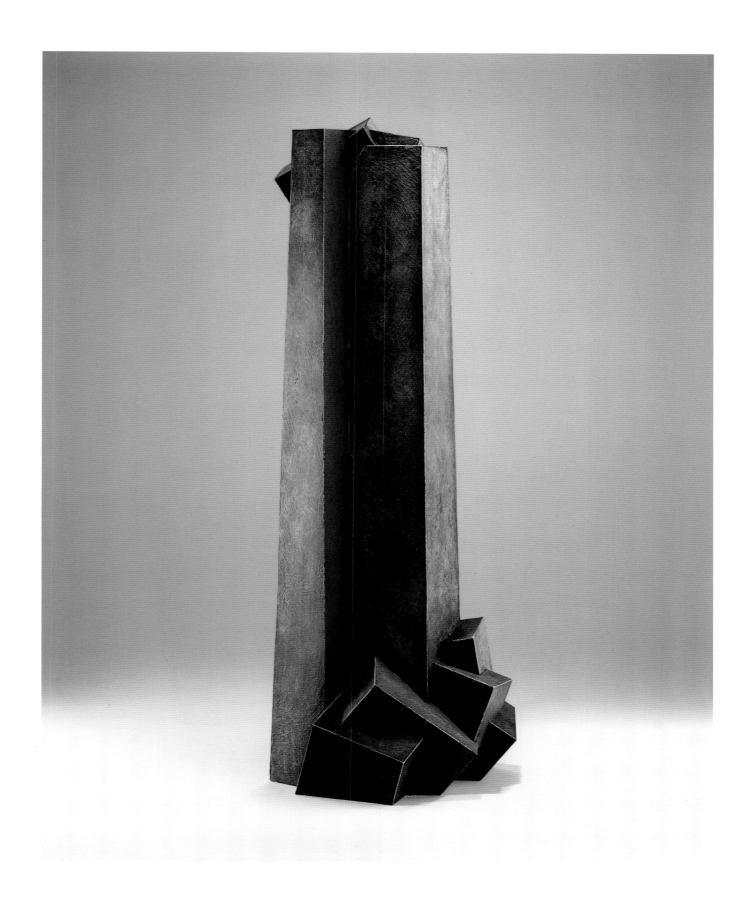

Plate 155 [facing]. *Mesa II*, 1993. Cast bronze, 54 × 67 × 56 in. Private collection.

Plate 156 [above]. *Watchtower*, 1992. Cast bronze, 38 × 15 × 13 in. Private collection.

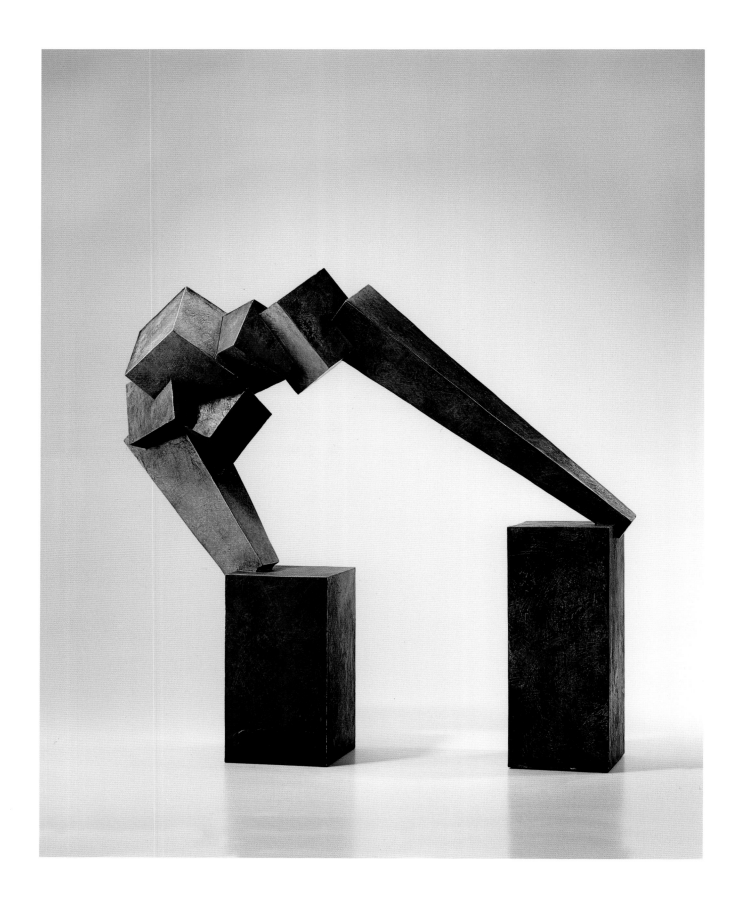

Plate 157 [above]. *Caper*, 2000. Cast bronze, 31 × 32 × 12 in. Private collection.
Plate 158 [facing]. *Partisan II*, 1997. Cast bronze, 52 × 56 × 40 in. Hewlett Packard, Bristol, England.

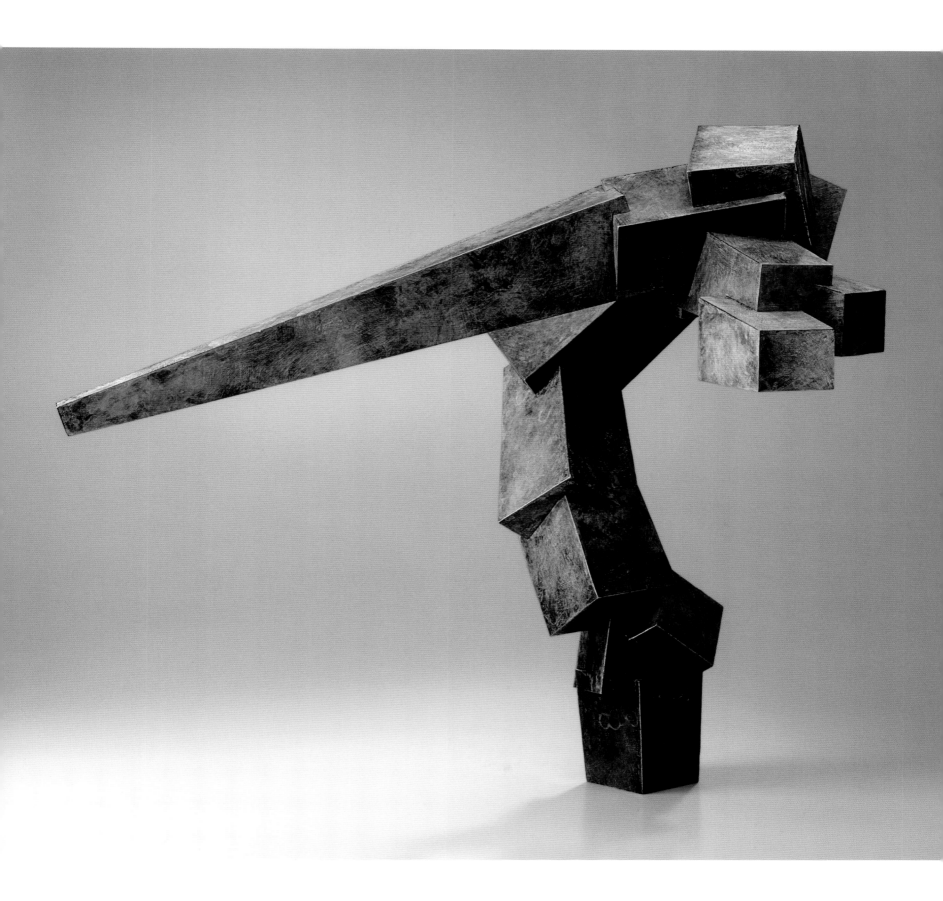

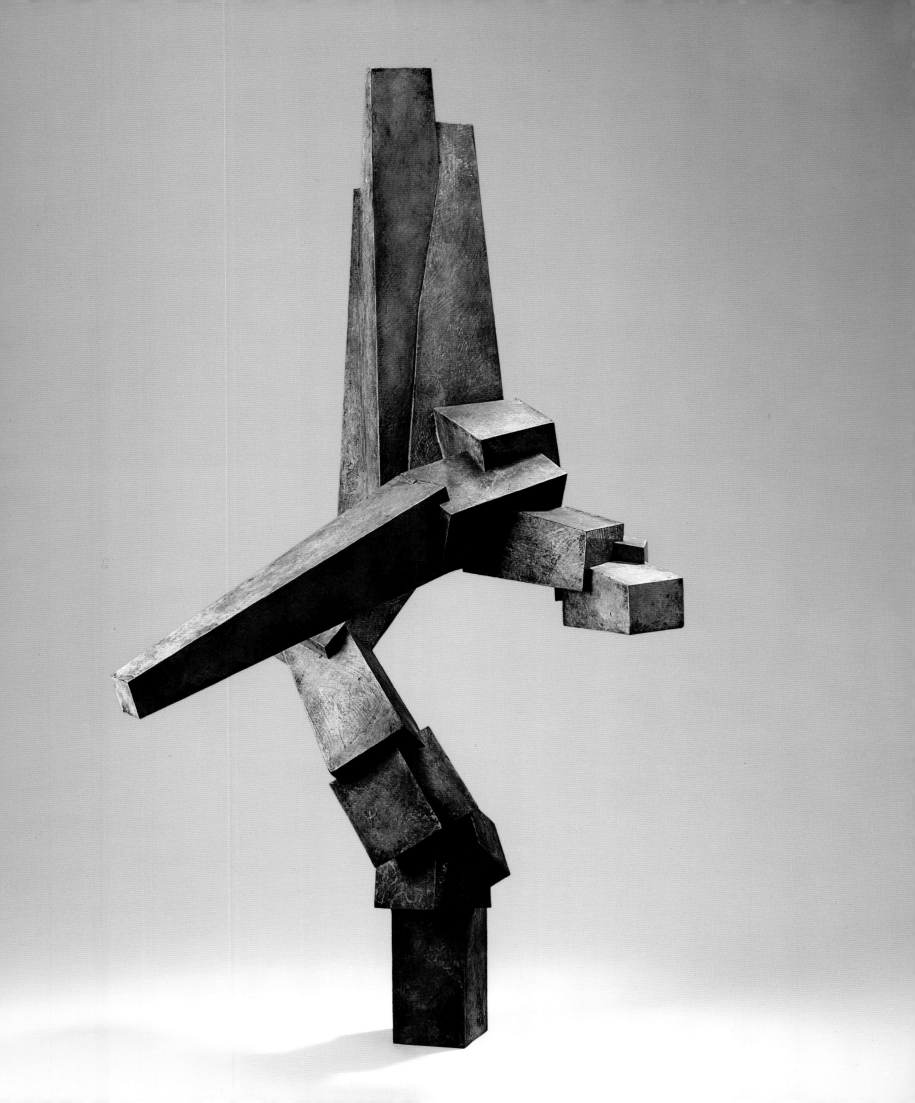

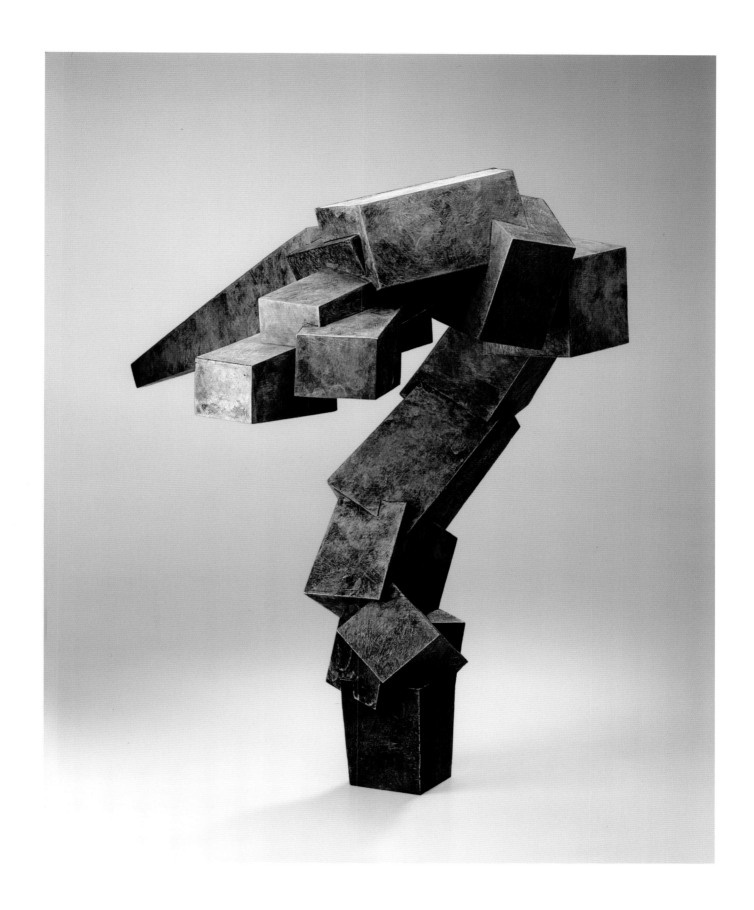

Plate 159 [facing]. *Voyager*, 1995. Cast bronze, 44 × 24 × 18 in. Private collection.

Plate 160 [above]. *Partisan*, 1995. Cast bronze, 26 × 28 × 20 in. Private collection.

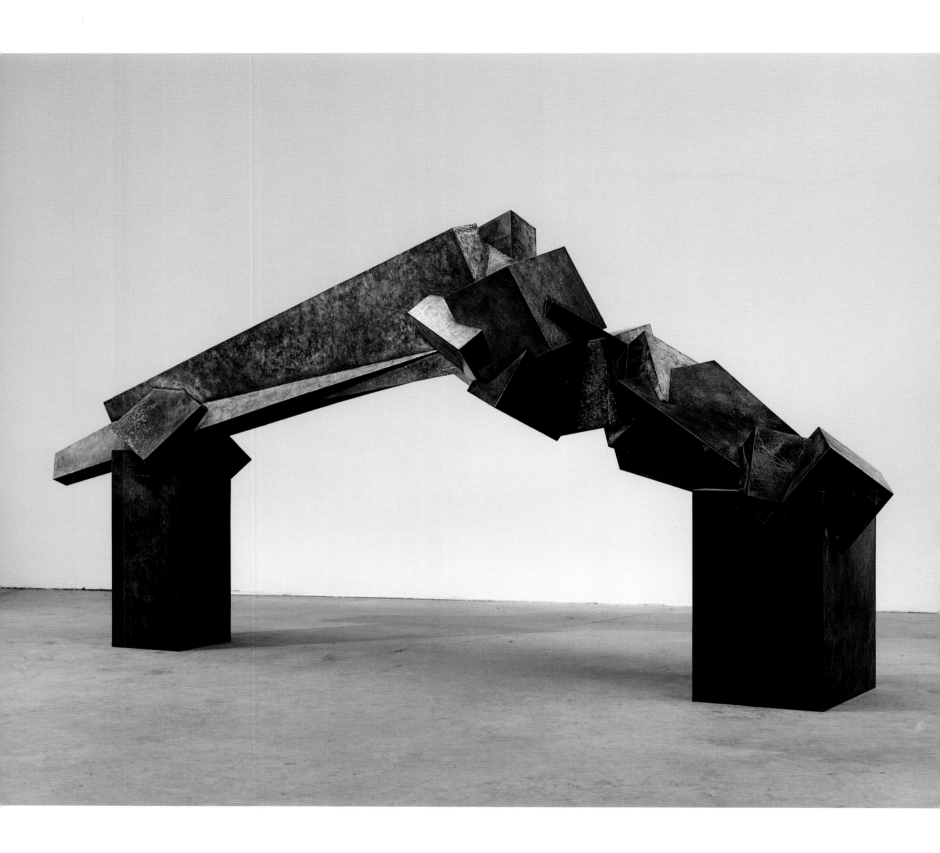

Plate 161 [above]. *Oceanus III*, 2000. Bronze, 77 × 160 × 36 in. Private collection.

Plate 162 [facing]. *Outreach II*, 2002. Cast bronze, 65 × 45 × 13 in.

Hood Museum of Art, Dartmouth College, Hanover, New Hampshire.

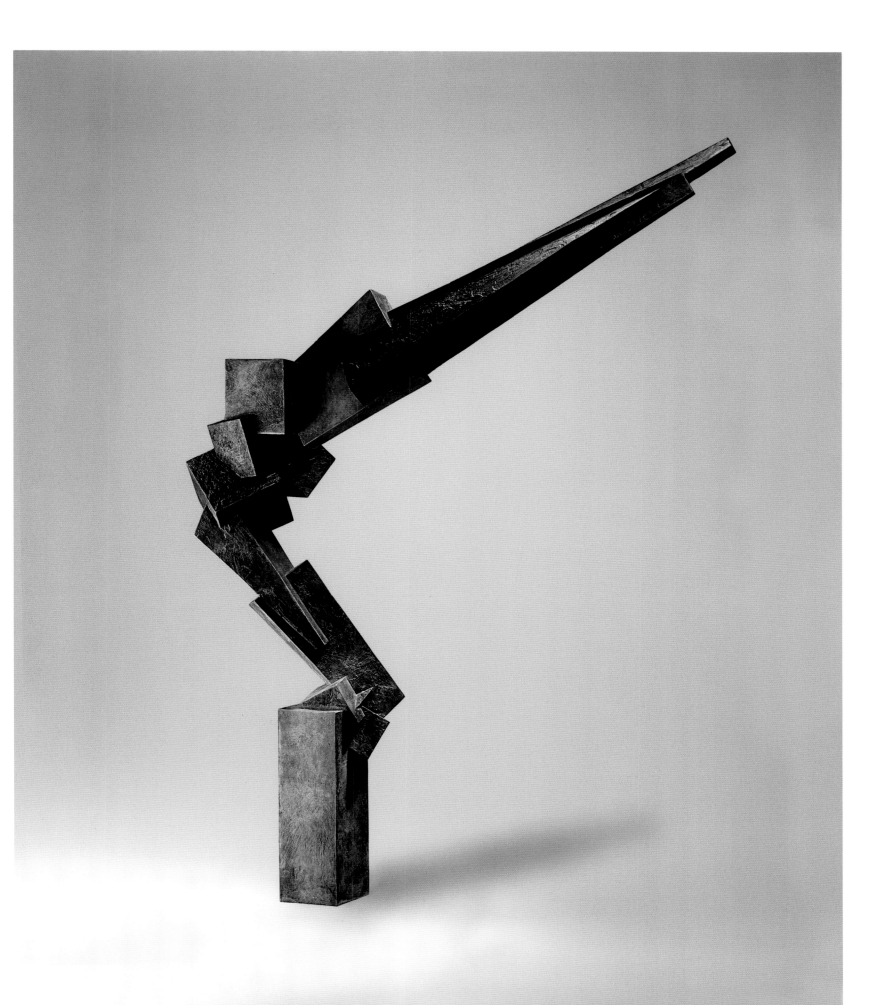

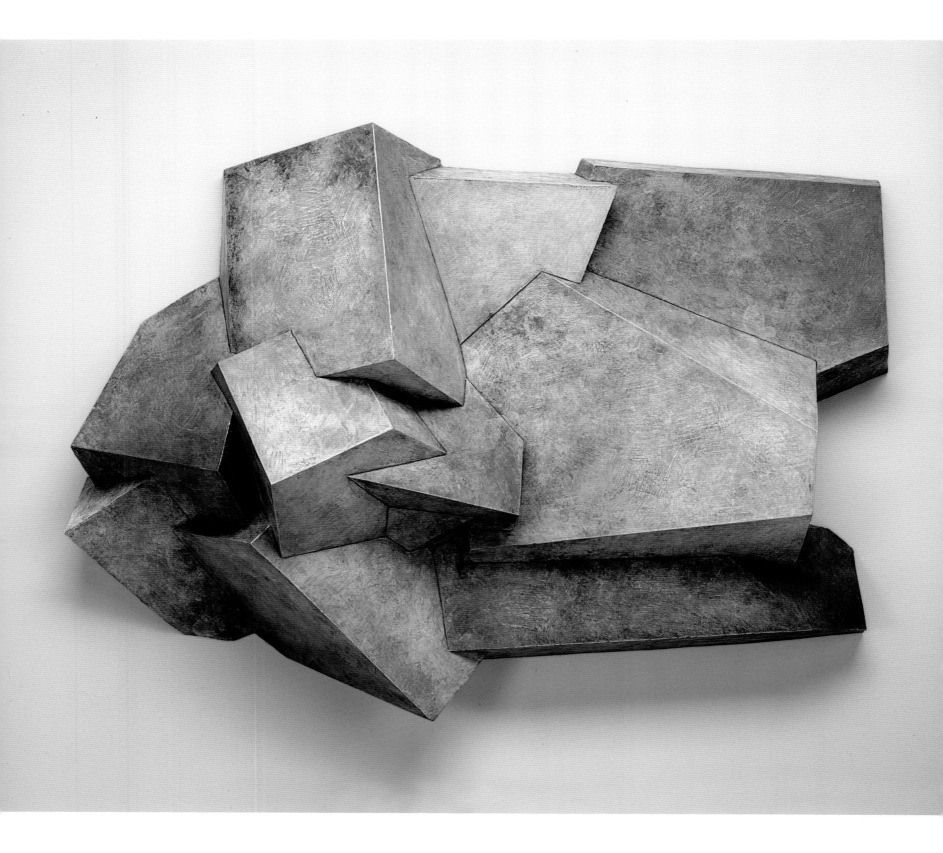

Plate 163. *Custos*, 2001. Cast bronze, 28 × 38 × 9 in. Private collection.

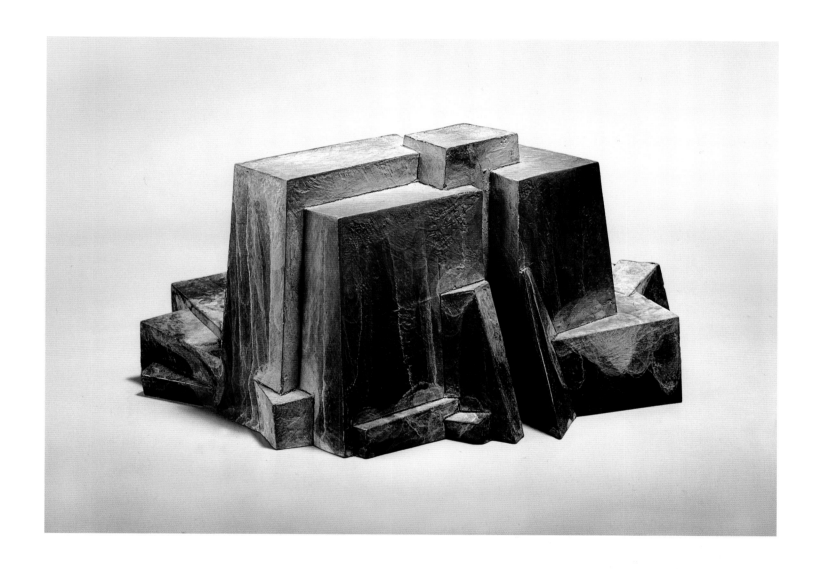

Plate 164. *Offspring II*, 1995. Cast bronze, 5 × 10 × 8 in. Private collection.

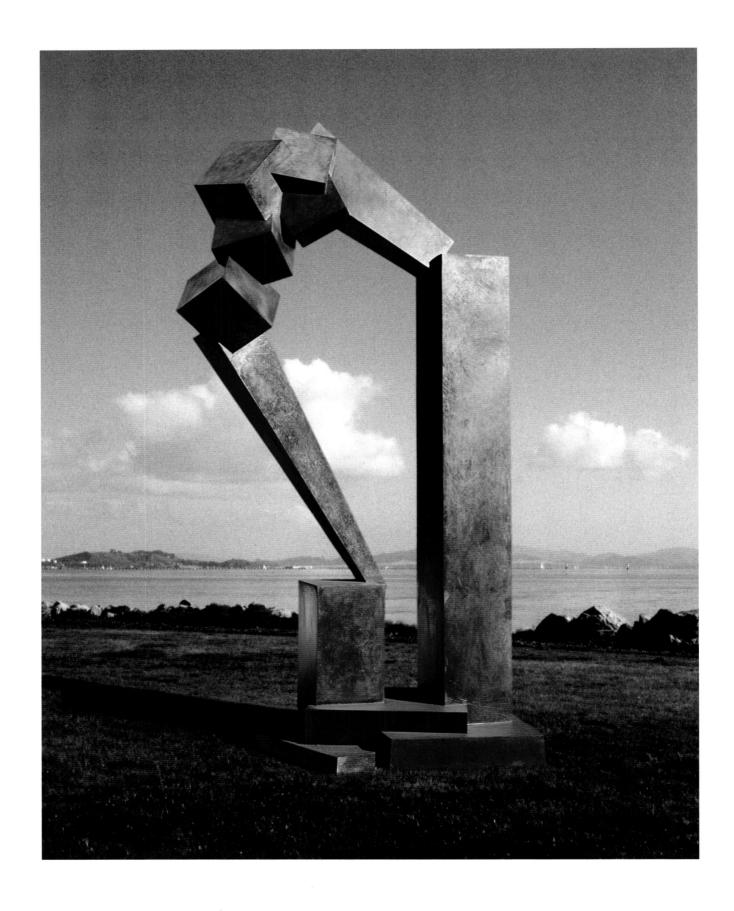

Plate 165 [above]. *Insurgent III*, 2001. Bronze, 144 × 80 × 52 in. Private collection.

Plate 166 [facing]. *Ascender IV*, 2003. Bronze, 173 × 117 × 50 in. City of Brea, California.

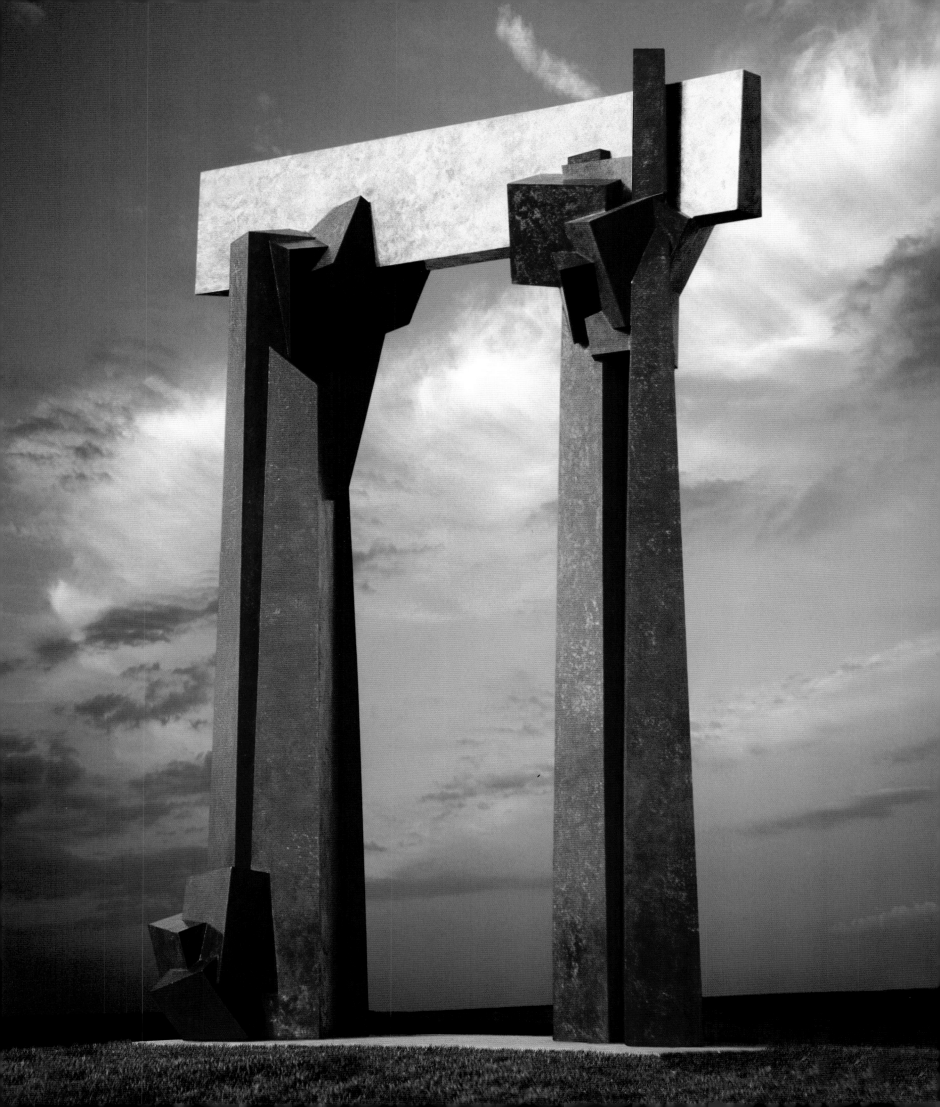

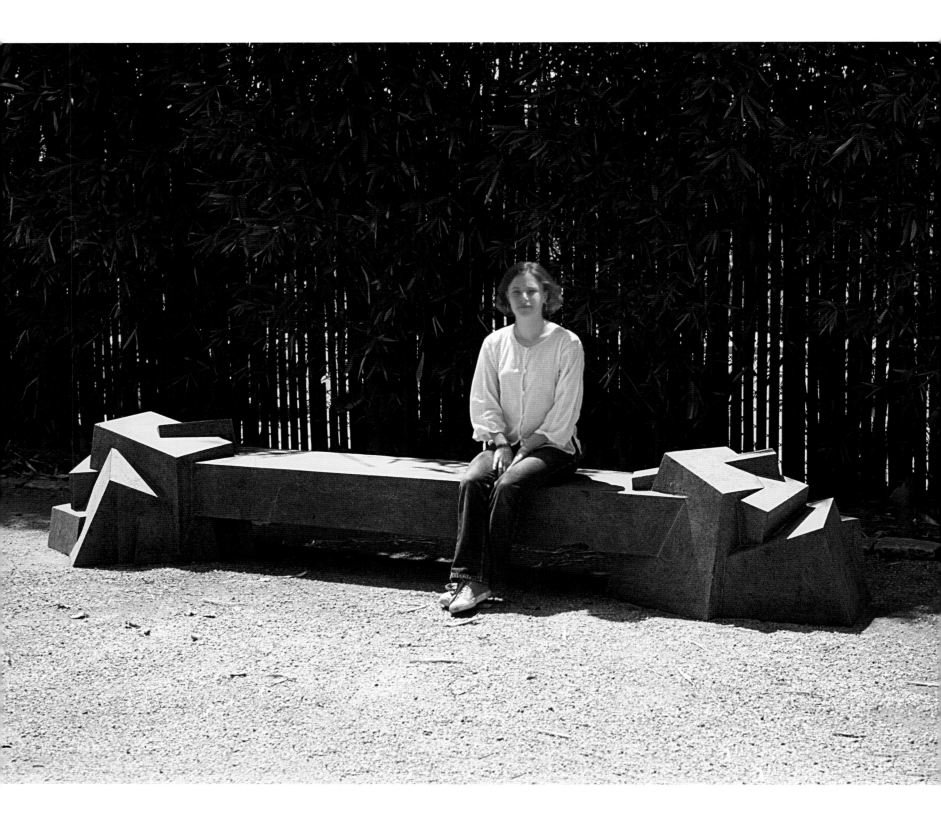

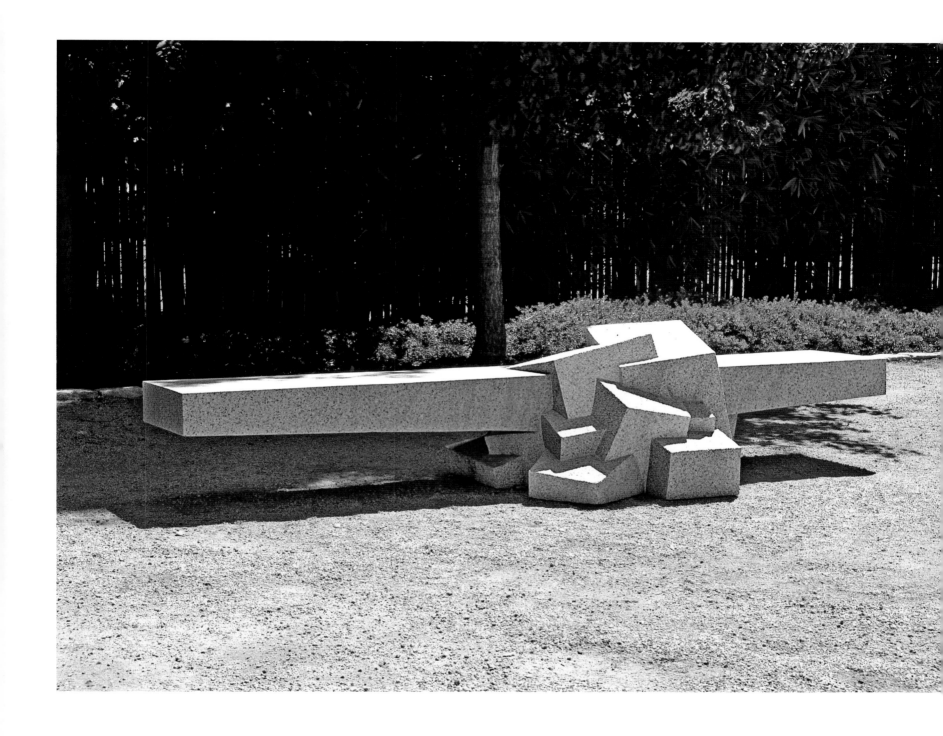

Plate 167 [facing]. *Bridge*, 2000. Granite, 25 × 154 × 41 in. Private collection.

Plate 168 [above]. *Stone Horizon*, 2000. Granite, 26 × 127 × 40 in. Private collection.

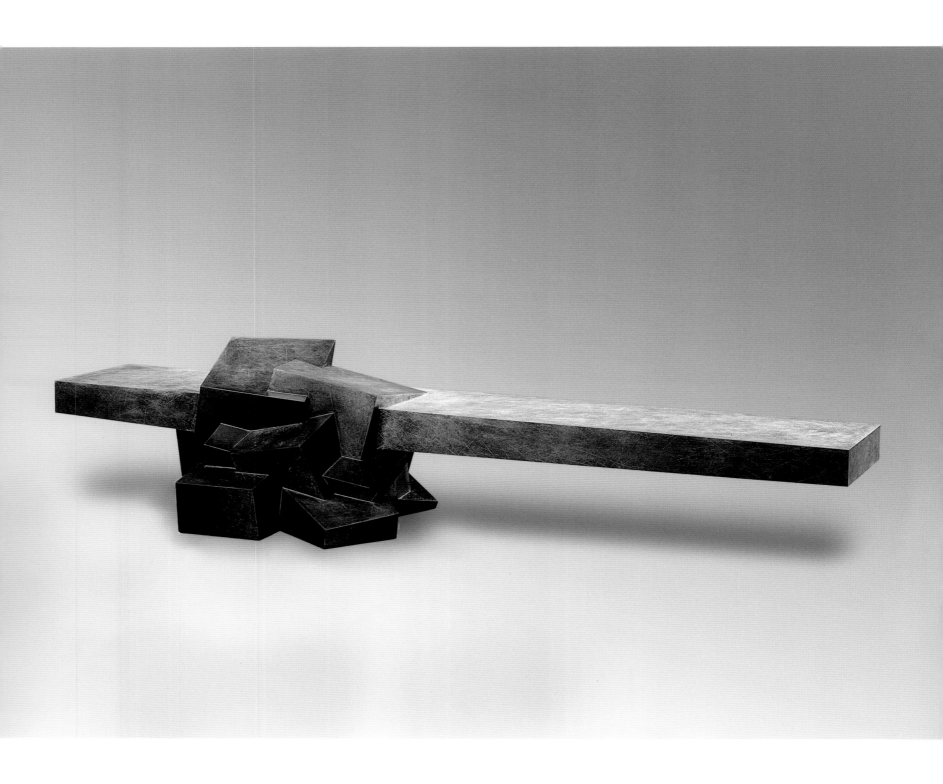

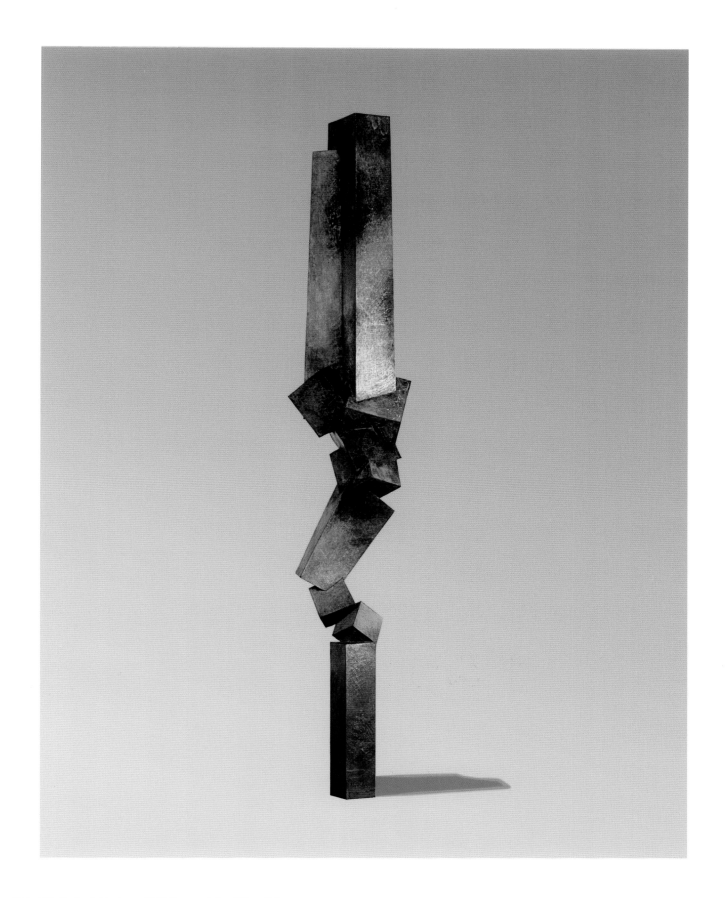

Plate 169 [facing]. *Horizon*, 1997. Bronze, 26 × 126 × 40 in.

Berkeley Repertory Theater, Berkeley, California.

Plate 170 [above]. *Advocate II*, 2002. Cast bronze, 72 × 14 × 13 in.

Hood Museum of Art, Dartmouth College, Hanover, New Hampshire.

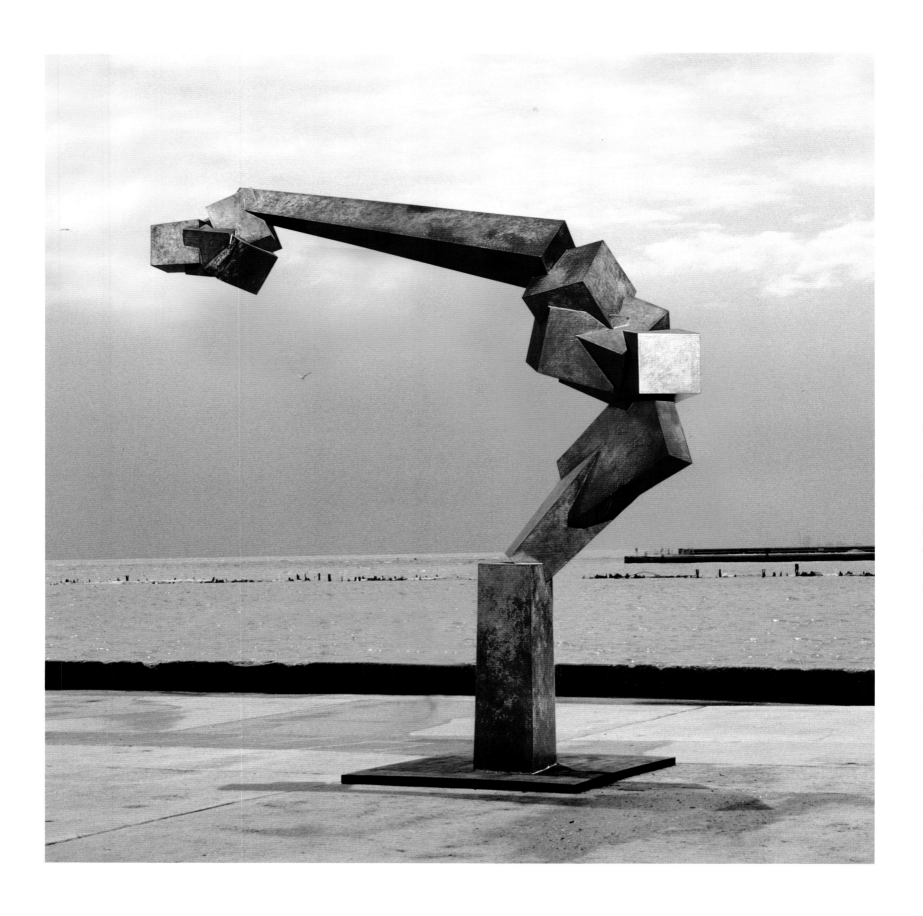

Plate 171 [above]. *Foray III*, 1997. Bronze, 120 × 120 × 32 in. Private collection.
Plate 172 [facing]. *Quest*, 2003. Bronze, 192 × 103 × 70 in. Miami University, Oxford, Ohio.

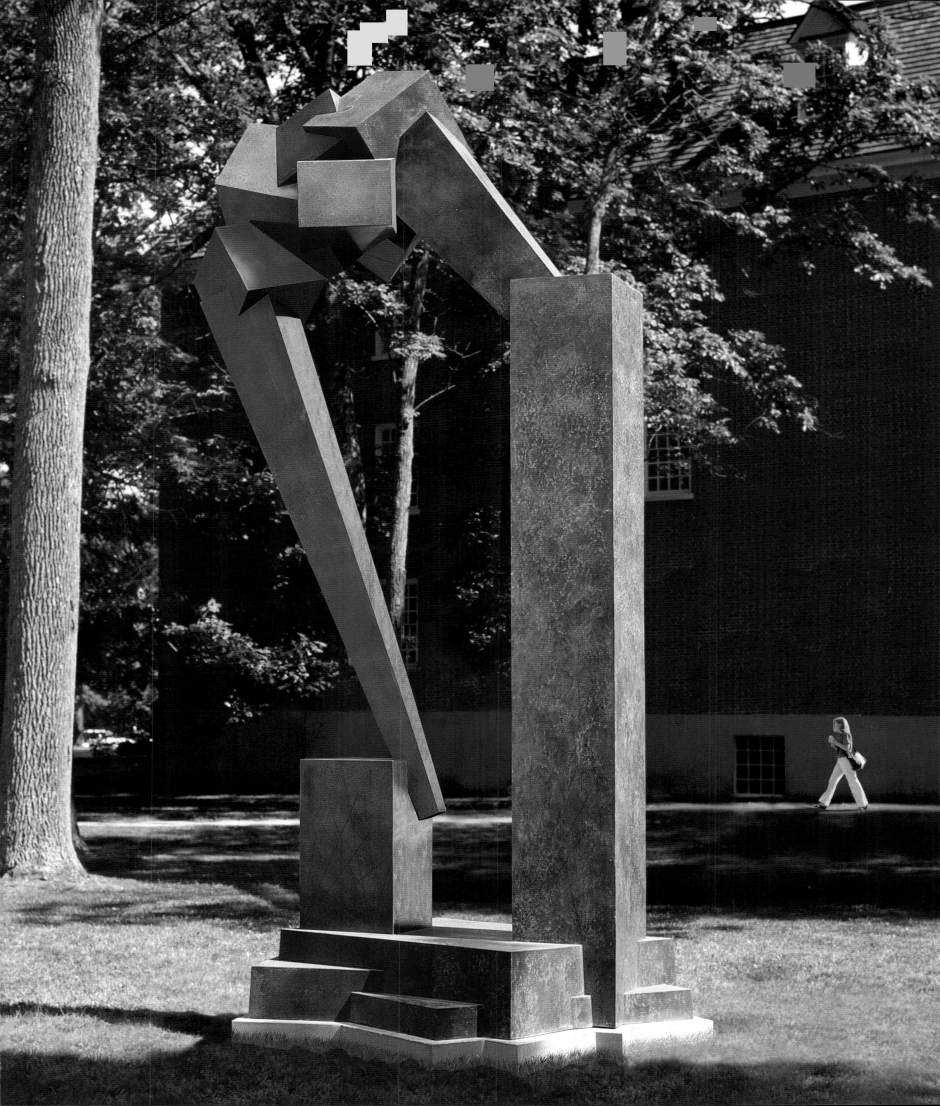

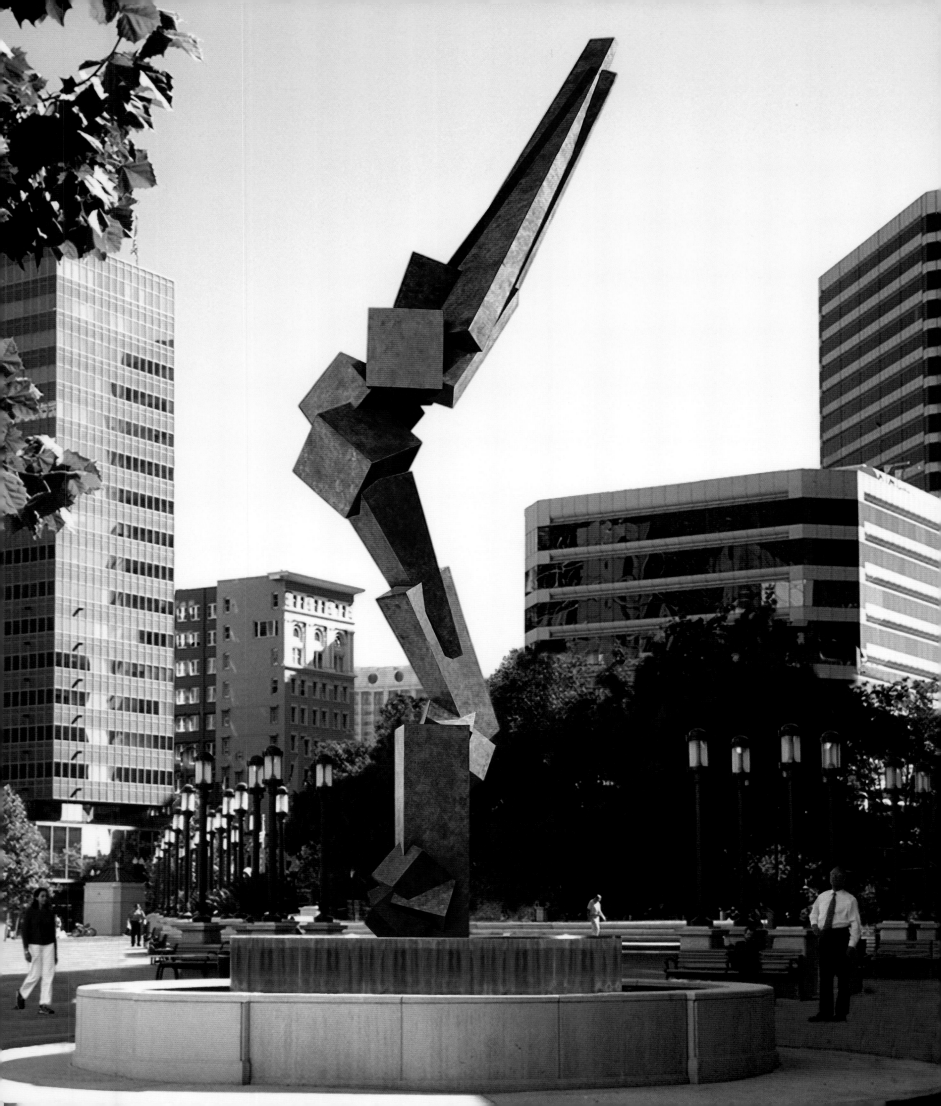

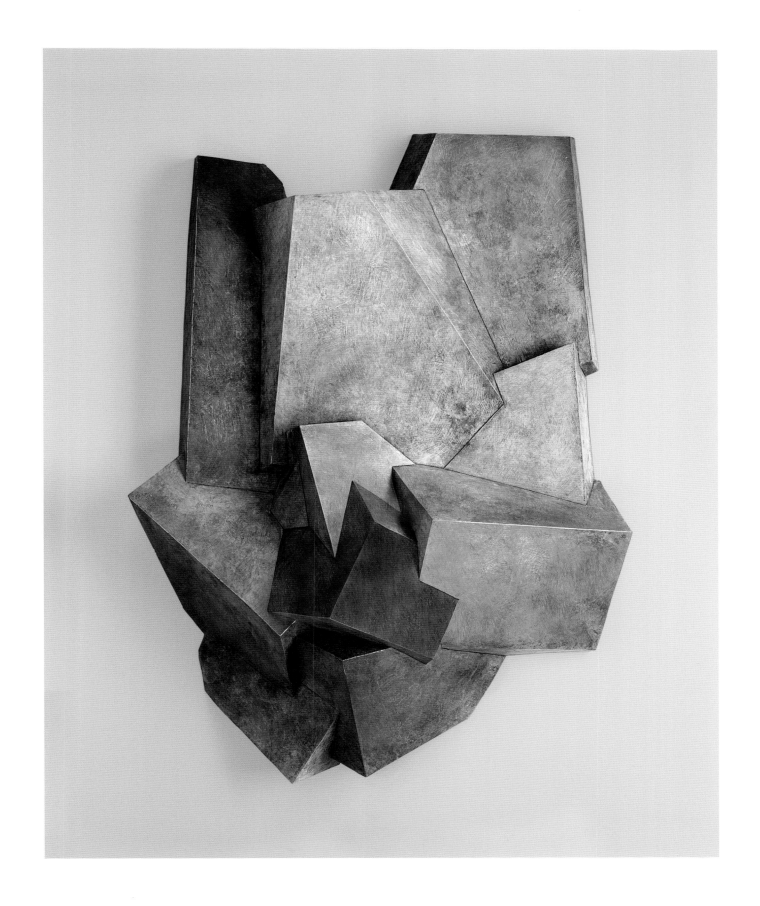

Plate 173 [facing]. *Vitality*, 2002. Bronze, 360 × 132 × 108 in. City of Oakland, California.

Plate 174 [above]. *Ancile,* 2002. Cast bronze, 38 × 28 × 9 in. Private collection.

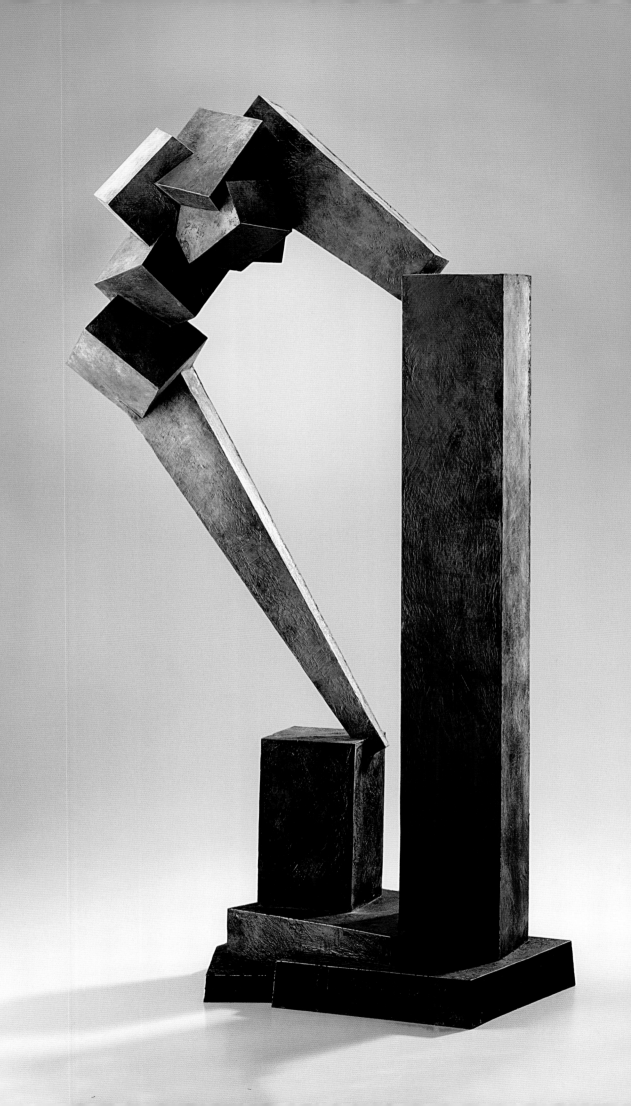

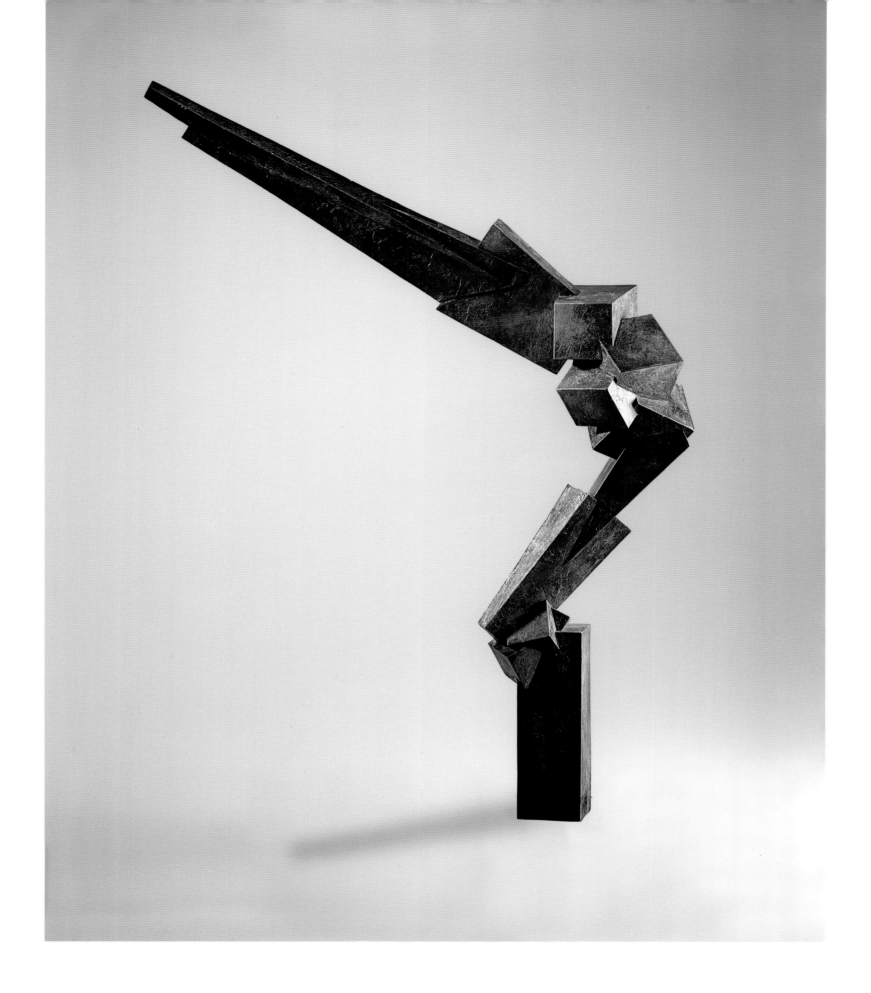

Plate 175 [facing]. *Insurgent*, 2001. Cast bronze, 50 × 25 × 18 in. Private collection. (See also plate 6.)
Plate 176 [above]. *Outreach*, 1998. Cast bronze, 41 × 28 × 10 in. Private collection.

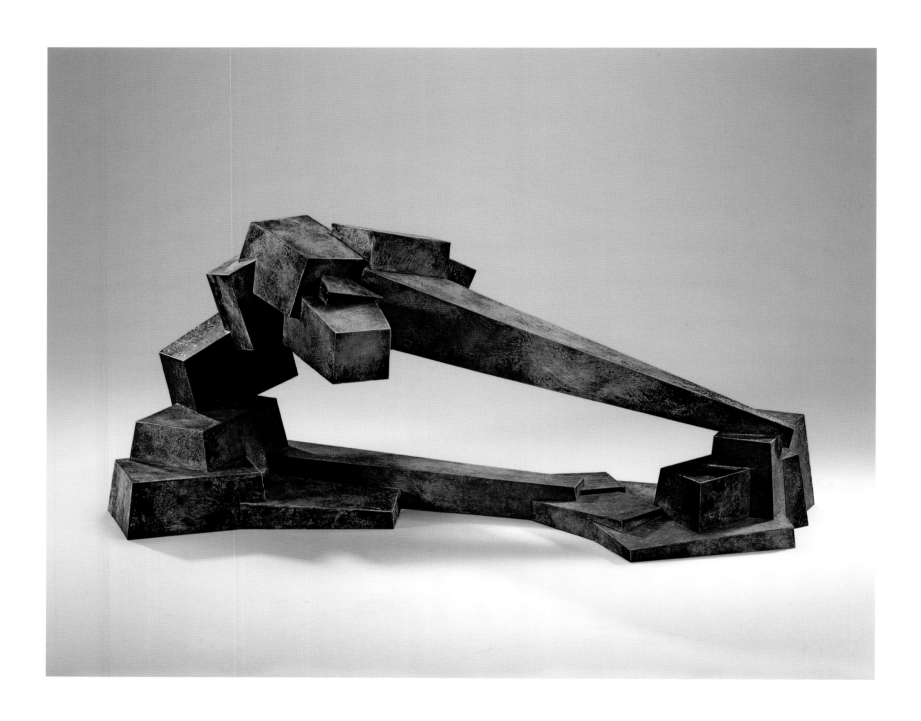

Plate 177 [above]. *Encounter*, 1995. Cast bronze, 15 × 36 × 13 in. Private collection.

Plate 178 [facing]. *Ally*, 1997. Cast bronze, 60 × 29 × 18 in. Private collection.

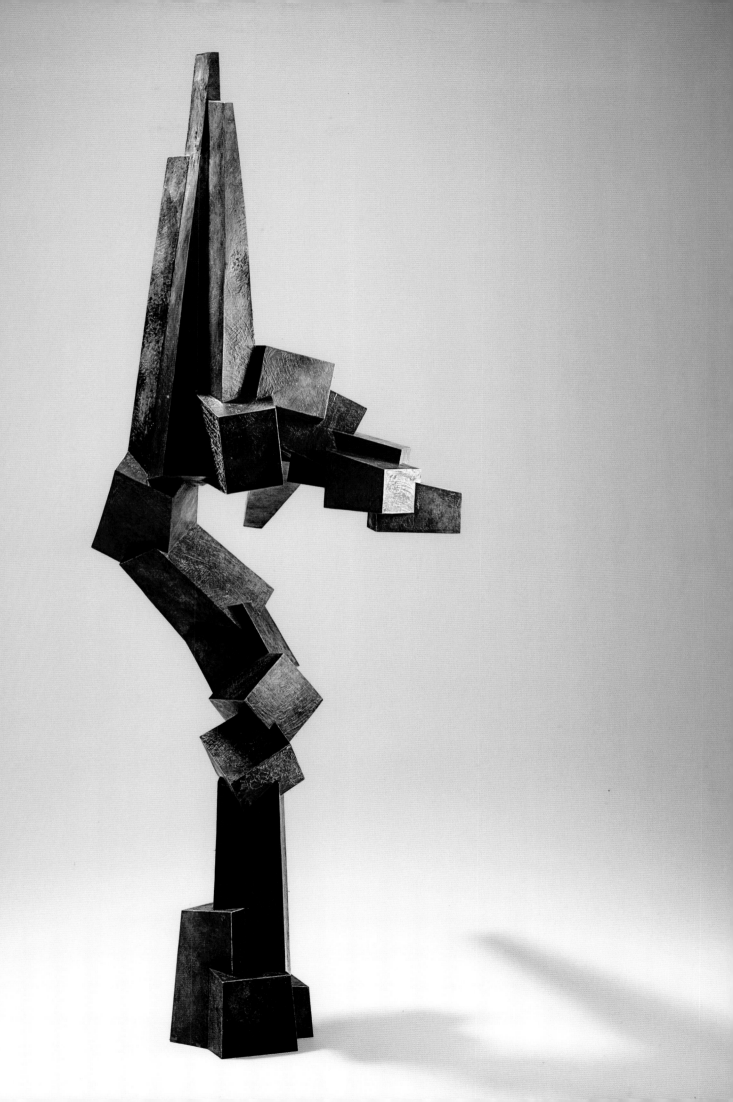

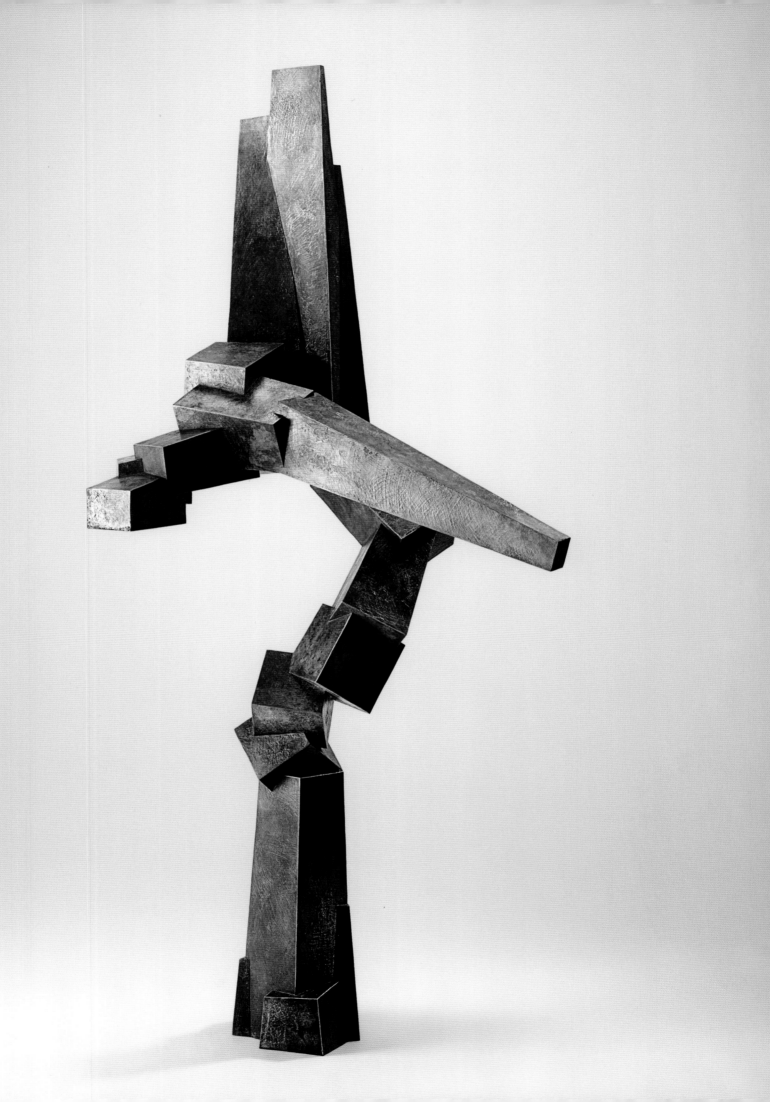

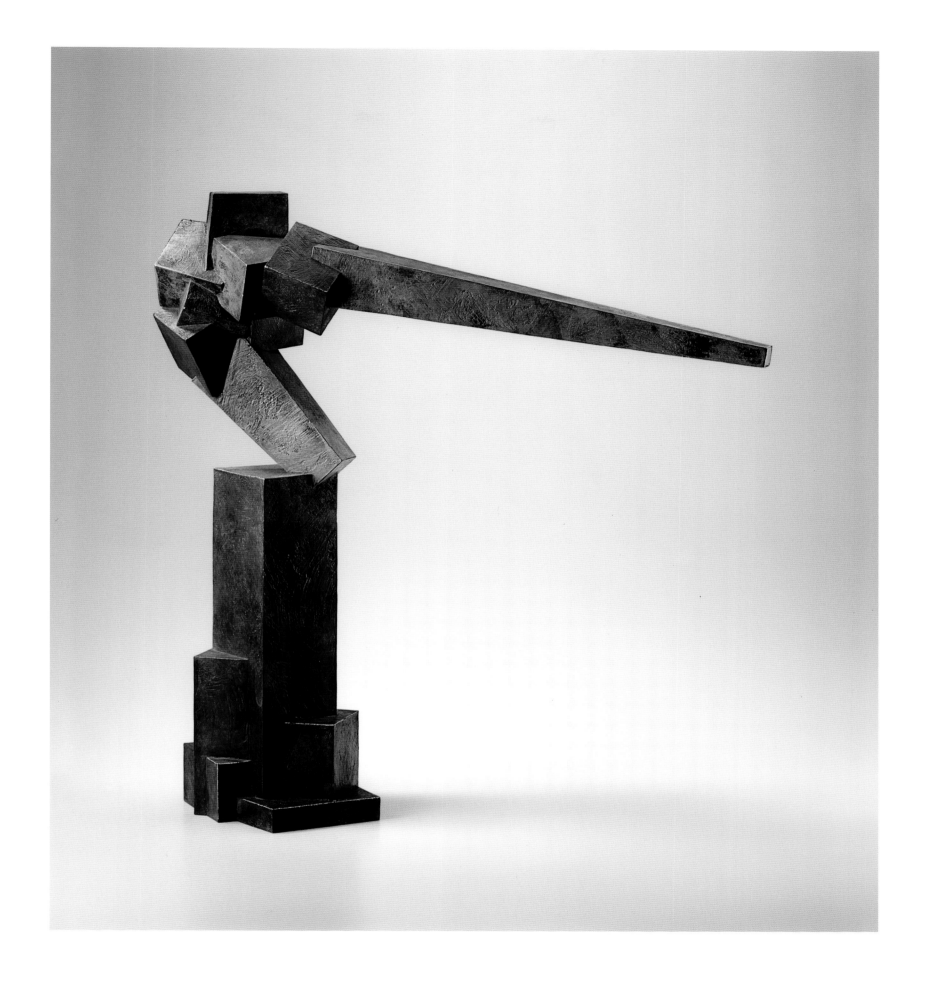

Plate 179 [facing]. *Ally II*, 1998. Cast bronze, 108 × 52 × 33 in. Islamic Museum, Cairo, Egypt.

Plate 180 [above]. *Inducer*, 2001. Cast bronze, 30 × 29 × 9 in. Private collection.

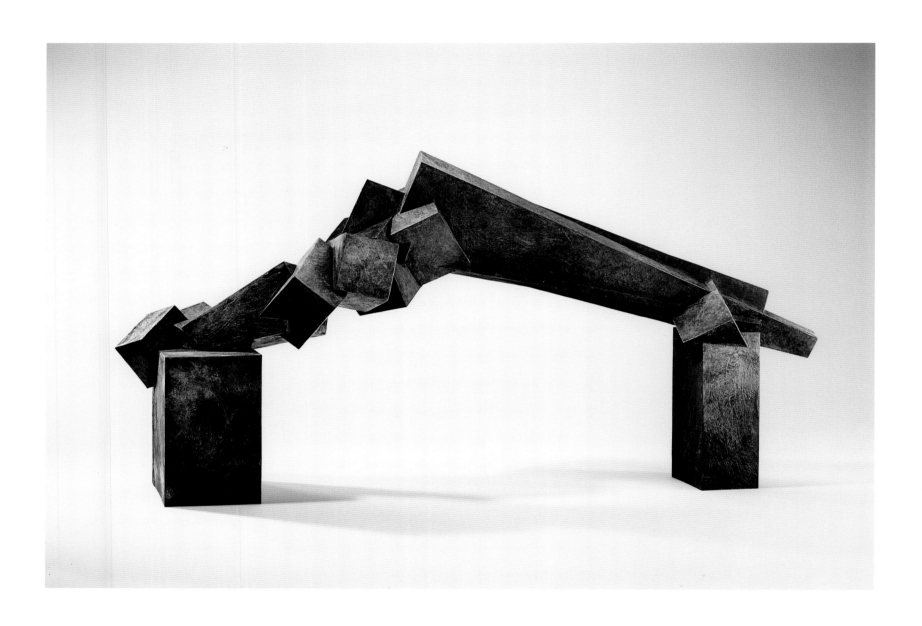

Plate 181 [above]. *Oceanus*, 2000. Cast bronze, 20 × 42 × 11 in. Private collection.

Plate 182 [facing]. *Thrust II*, 2001. Cast bronze, 63 × 82 × 33 in. Private collection.

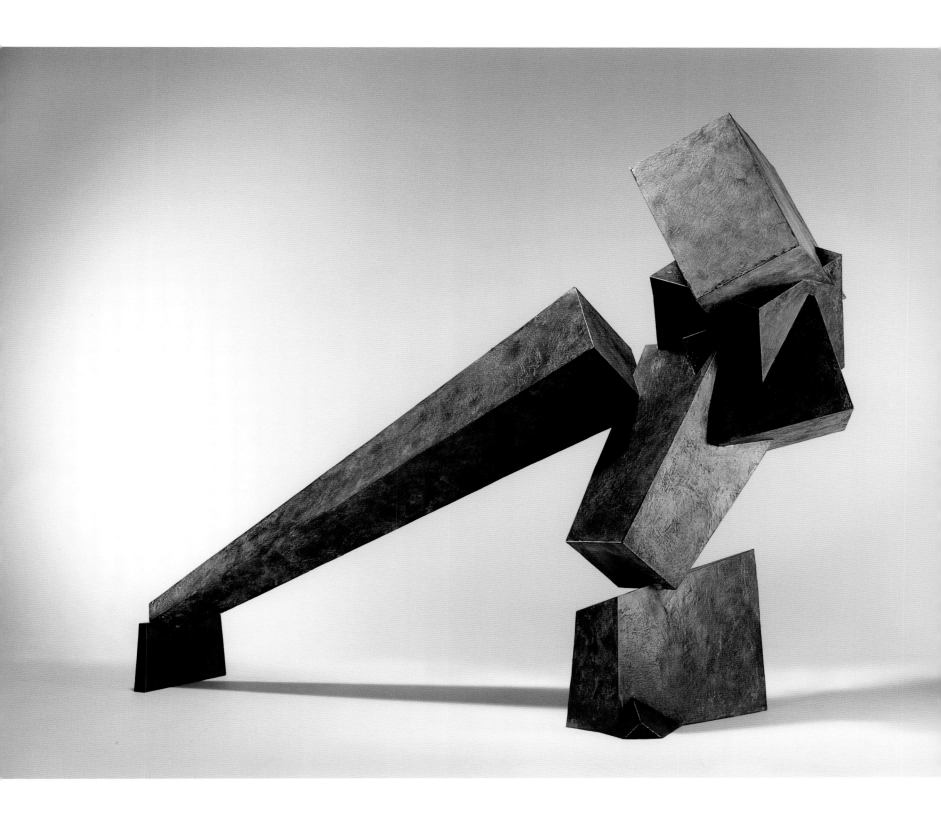

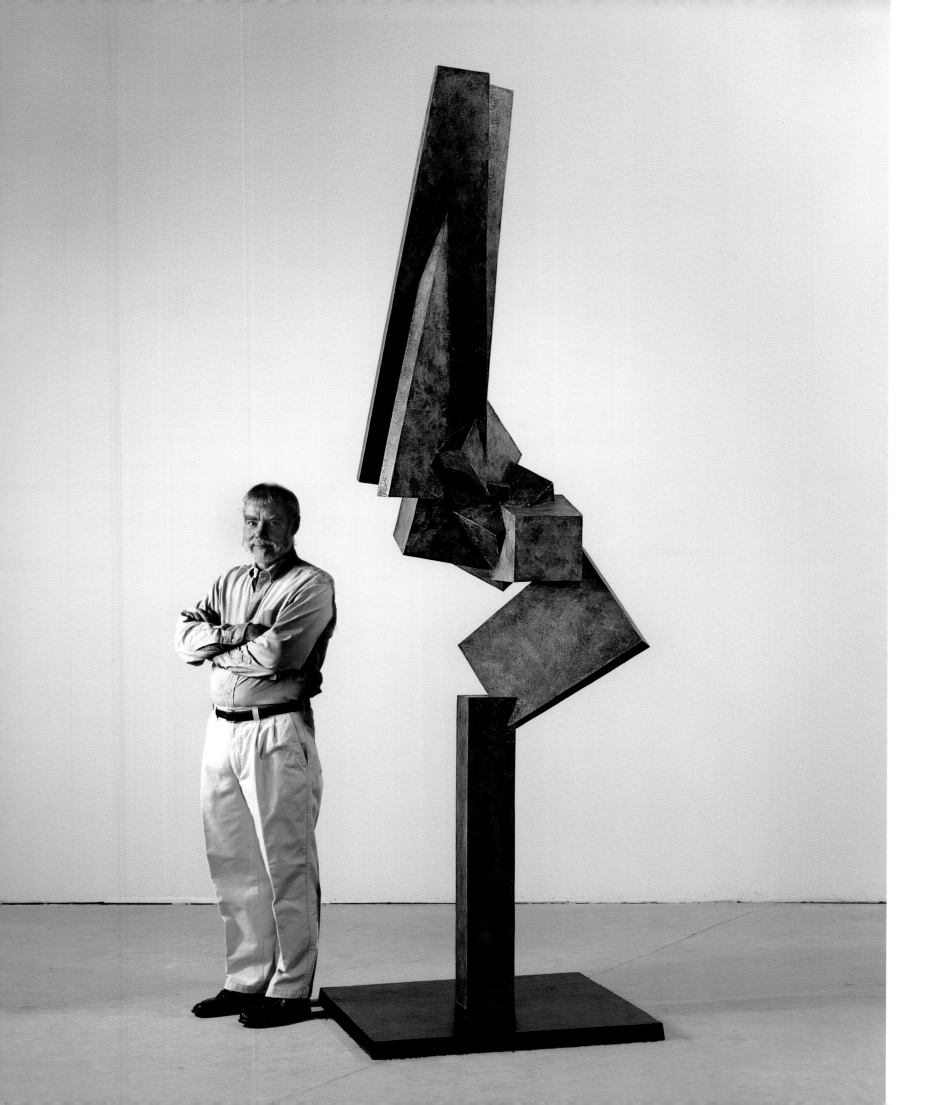

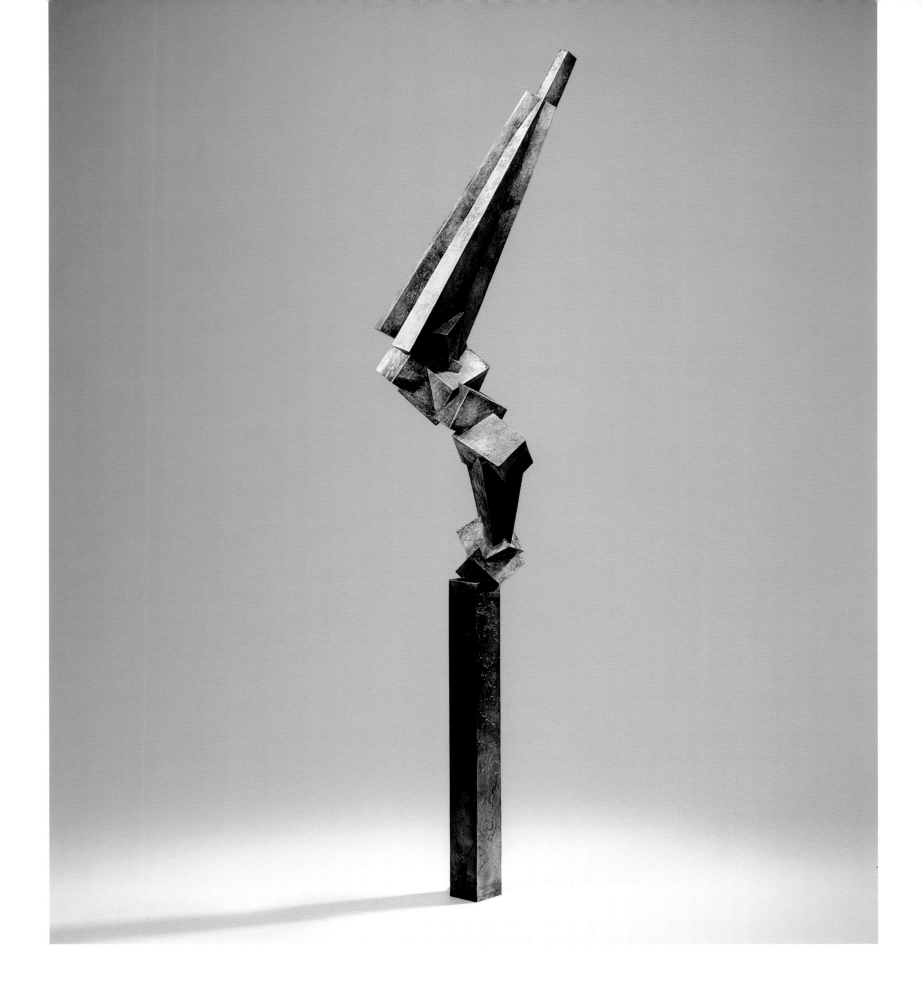

Plate 183 [facing]. *Ceremony II*, 1995. Cast bronze, 108 × 36 × 22 in. Private collection.

Plate 184 [above]. *Escape*, 1996. Cast bronze, 44 × 11 × 8 in. Private collection.

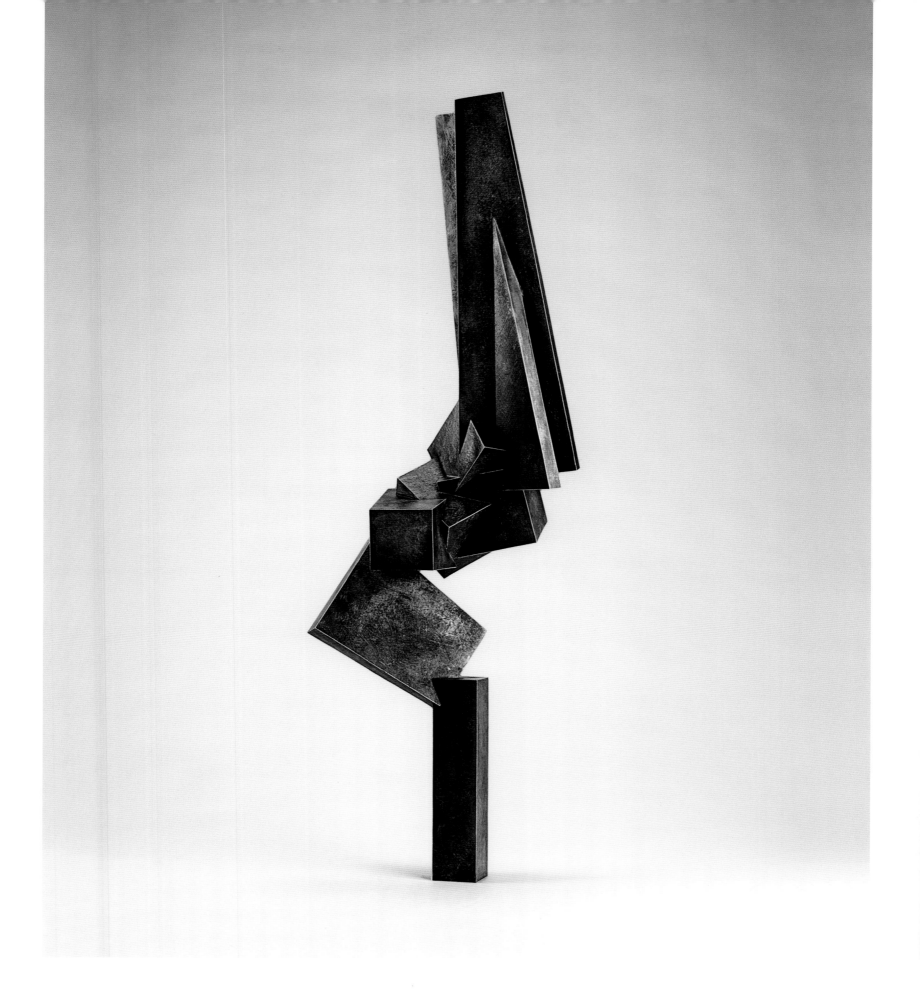

Plate 185 [above]. *Observer*, 2002. Cast bronze, 70 × 22 × 13 in.
Hood Museum of Art, Dartmouth College, Hanover, New Hampshire.
Plate 186 [facing]. *Caper III*, 2001. Bronze, 110 × 115 × 35 in. Private collection.

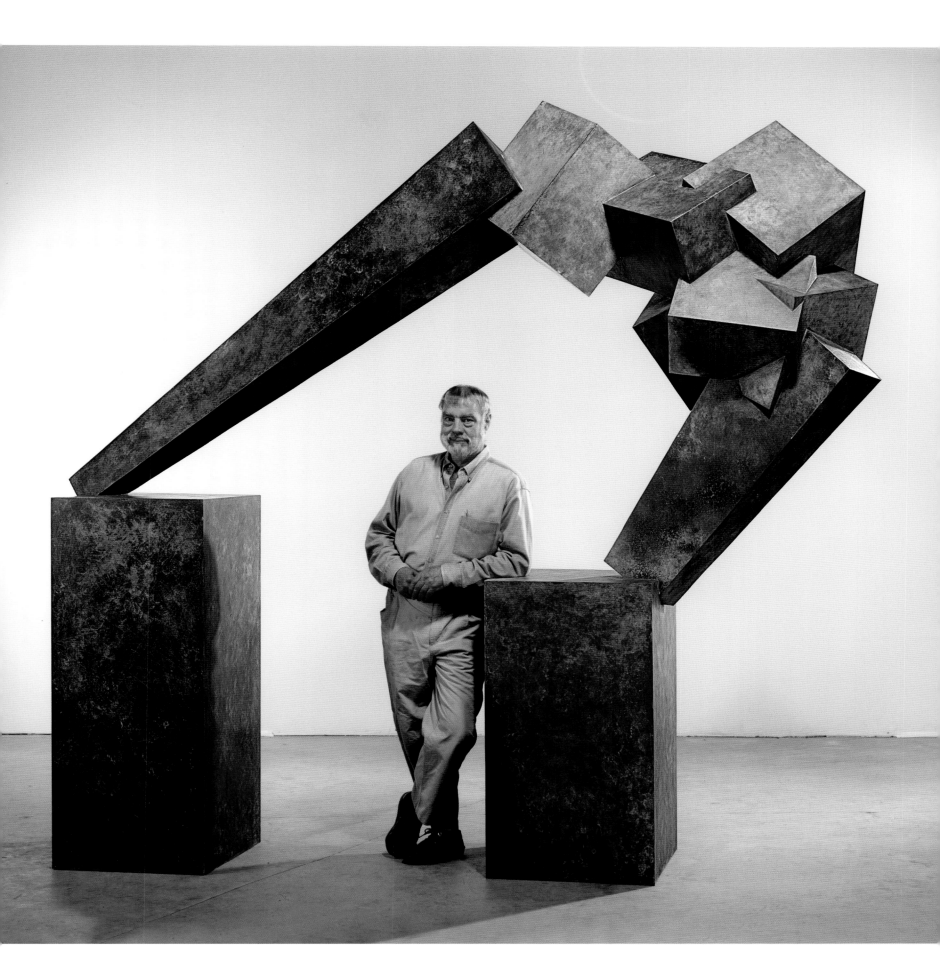

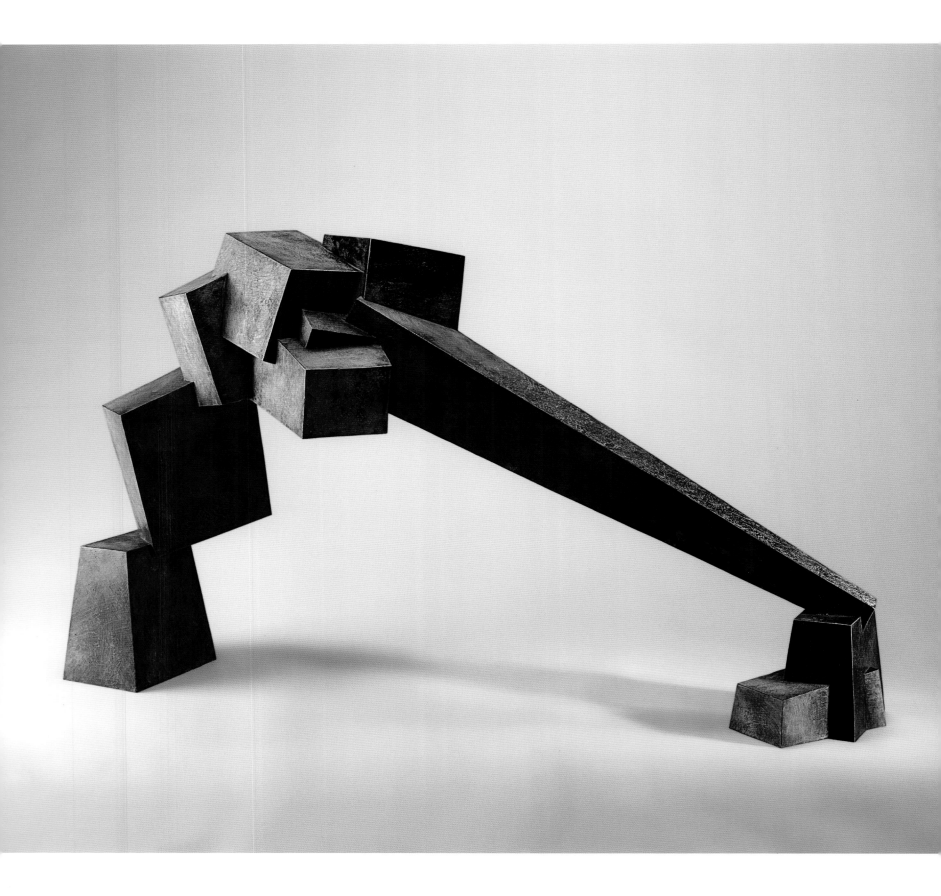

Plate 187. *Prologue*, 1997. Cast bronze, 25 × 43 × 21 in. Private collection.

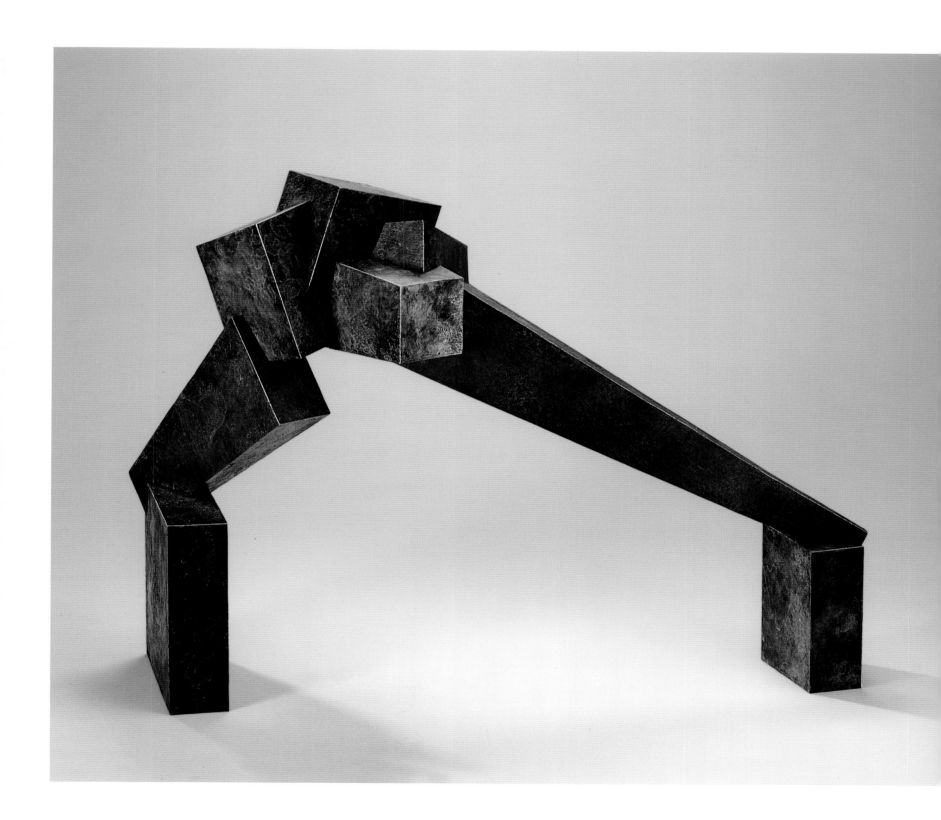

Plate 188. *Vigil*, 1995. Cast bronze, 25 × 36 × 12 in. Private collection.

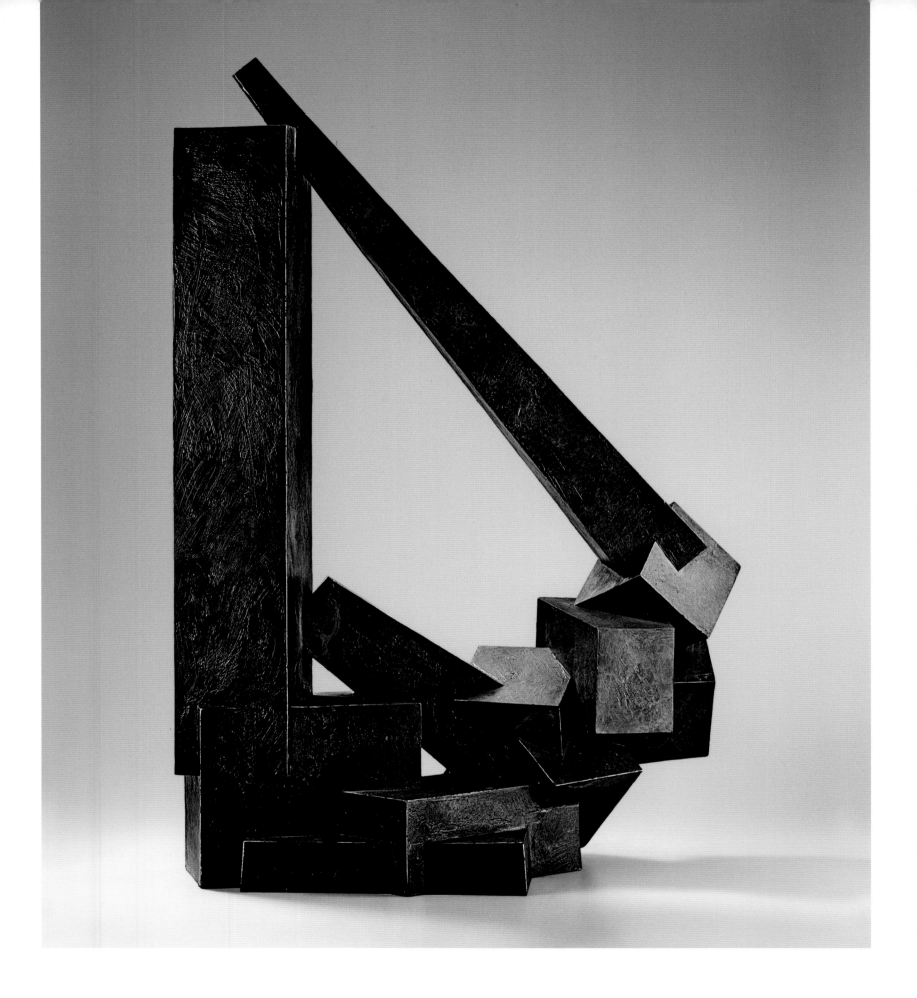

Plate 189 [above]. *Query*, 2003. Cast bronze, 49 × 27 × 15 in. Private collection.

Plate 190 [facing]. *Outreach III*, 2000. Bronze, 152 × 100 × 38 in. Private collection.

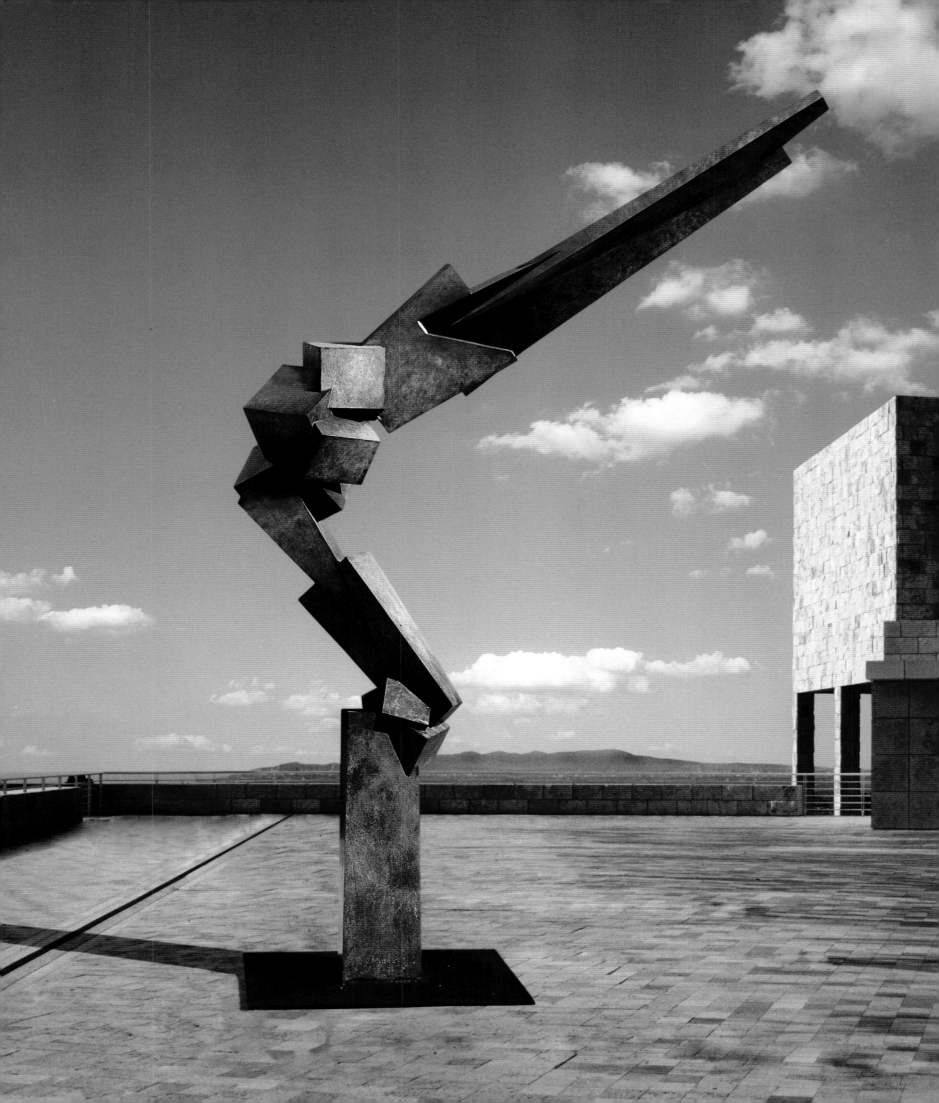

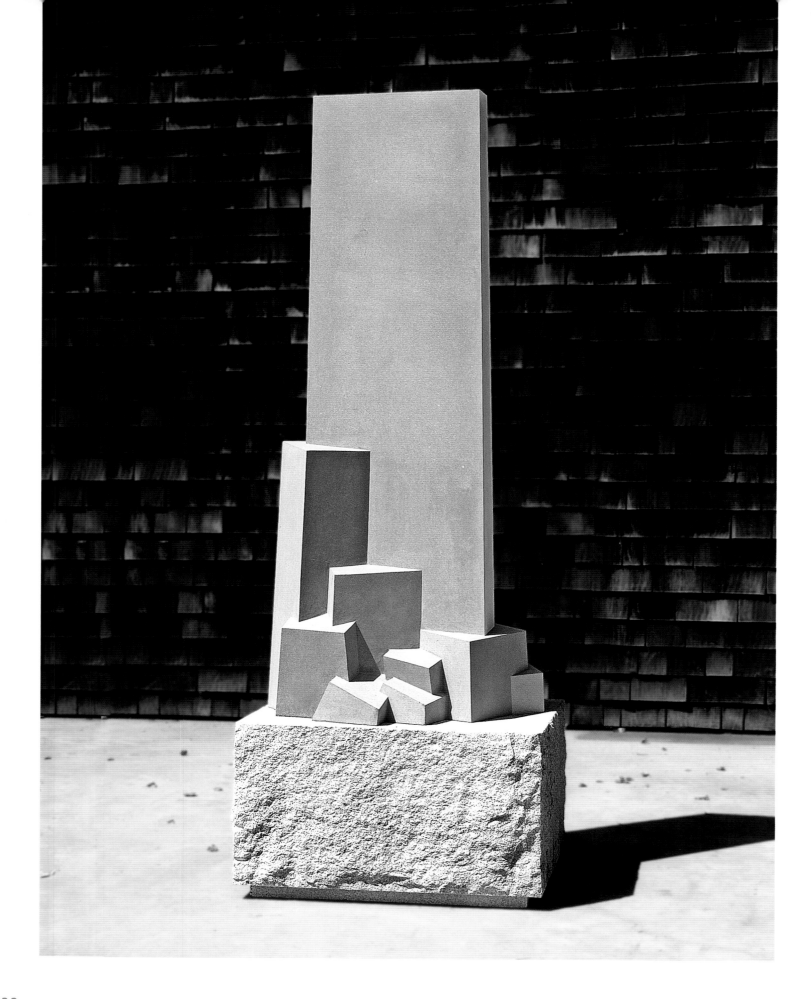

Plate 191. *Lithic Legend III*, 2004. Granite, 75 × 33 × 21 in. Private collection.

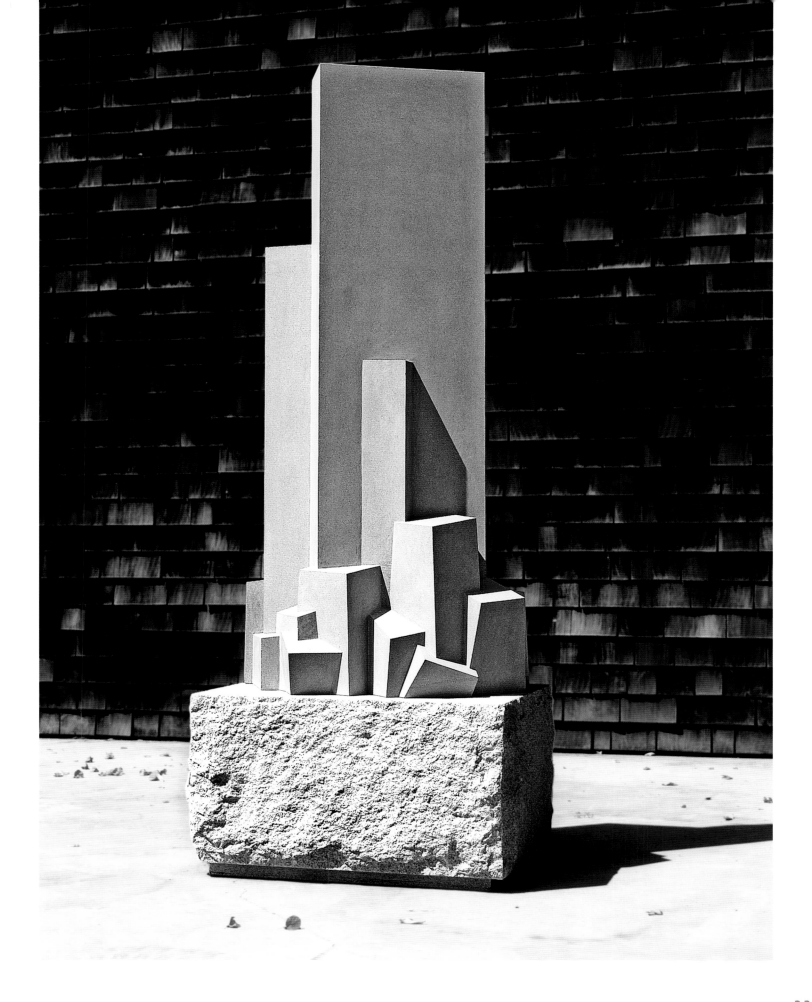

Plate 192. *Lithos III*, 2004. Granite, 73 × 33 × 23 in. Private collection.

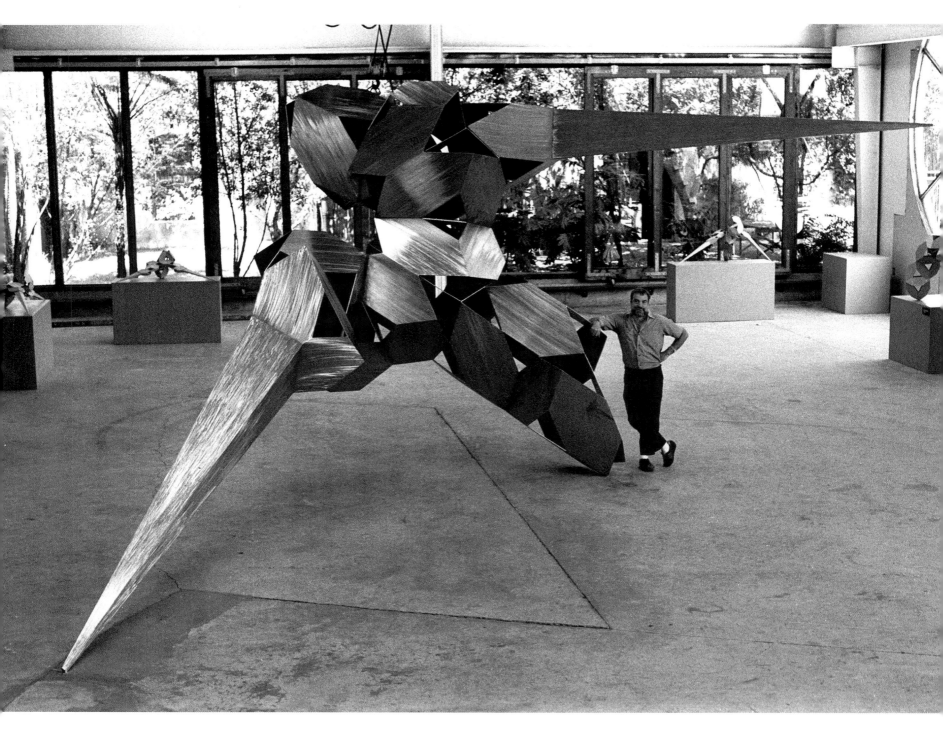

Bruce Beasley trying *Artemon* in a different orientation, new Lewis Street studio, 1984.

1939

Born Los Angeles, California. Parents Robert Seth Beasley and Bernice (Palmer) Beasley. Brother, Palmer, three years older. Attends public schools.

1948

Seriously injured in fall from tree, misses a half year of school. Extensive therapy is required to regain ability to walk.

1952

Takes required metal shop class in eighth grade. Discovers a talent for metalwork and spends as much time as possible during and after school working in the metal shop.

1954

Wins prize in national contest in metalworking.

Robert Seth Beasley. Bernice (Palmer) Beasley.

Bruce Beasley at age two, 1941.

Bruce Beasley at the Japanese National
Boy Scout Jamboree, Japan, 1955.

1955

Travels to Japan with a group of Boy Scouts sponsored by the Japanese government.

1955–57

Seriously involved in building racing cars while attending high school. Helps build a Bonneville "flat-head Ford" racer that breaks the 150 mph barrier.

1957–59

Attends Dartmouth College. Takes first art courses. Requests permission to do sculptures instead of drawings for final course assignment. Studies with sculptor Winslow Eaves, does first bronze casting. Attends summer school at Otis Art Institute.

1959

Transfers to the University of California, Berkeley, as a sculpture major. Studies with Sidney Gordin and Richard O'Hanlon. While at Berkeley Beasley is exposed to sculptors Jacques Schnier, Julius Schmidt, Wilfred Zogbaum, William King, Eduardo Paolozzi, and critic Harold Rosenberg.

1960

Wins prize in The Oakland Museum Sculpture Annual with the cast-iron sculpture *Trillion* (plate 28). Begins studies with Peter Voulkos and Harold Paris, who have just joined the faculty at Berkeley. Helps build the Garbanzo Works foundry in Berkeley, one of the country's first artist-run foundries.

Bruce Beasley (right) and friend wrestling
a caddy engine into an old Ford.

Scuba diving in
Key Largo, Florida,
during spring break
from Dartmouth
College, 1958.

1961

In January, leaves school to hitchhike through Mexico and Central America and works as a deckhand on interisland schooners in the West Indies. Returns to Berkeley in September and resumes his studies. Begins showing at the Everett Ellin Gallery in Los Angeles. Wins prize in San Francisco Art Annual with sculpture *Lemures* (plates 8 and 27). Museum of Modern Art curator Dorothy Miller introduces Beasley's work to fellow MOMA curator William Seitz, who selects *Tree House* (plates 2 and 25) to be in The Art of Assemblage show at the Museum of Modern Art in New York. Beasley works for Peter Voulkos, casting and welding the work for Voulkos's first show of bronze sculpture. Meets Willem de Kooning, who comes to U.C. Berkeley for a workshop.

1962

Graduates from U.C. Berkeley with a bachelor of arts degree. *Chorus* (plate 13) acquired for the permanent collection of New York's Museum of Modern Art. Rents a dilapidated warehouse in West Oakland and builds his own foundry.

1963

First major solo show held at the Everett Ellin Gallery in Los Angeles. Receives important reviews from the Los Angeles art critics. *Prometheus II* (plates 15 and 44) acquired by the Guggenheim Museum in New York, and *Daedalus* (plate 45) by the Los Angeles County Museum of Art. Beasley is selected to be one of eleven sculptors to represent the United States at the Biennale de Paris. His sculpture *Icarus* (plates 3 and 41) wins the Purchase Prize and is acquired by André Malraux, Minister of Culture, for the French National Collection. Beasley makes first trip to Europe. Travels to France, Italy, Spain, and Greece. Visits the important art museums as well as the prehistoric cave of Altamira in Spain for the first of many visits.

1964

Beasley's first New York solo show at the Kornblee Gallery. Meets David Smith. Buys a run-down, abandoned factory complex on Lewis Street in West Oakland and builds a one-man foundry and living quarters in the new studio. Photographer Joanne Leonard joins him living at the studio.

Bronze sculpture poured at a New Hampshire industrial foundry while Bruce Beasley was a student at Dartmouth.

Bruce Beasley hitchhiking around Martinique, 1961.

Bruce Beasley's first studio after leaving
U.C. Berkeley, Cypress Street, West Oakland, 1962.

Interior of the Cypress Street studio.

Bruce Beasley modeling for
a life drawing group, 1963.

Former grain-milling factory, built in
1912, that Bruce Beasley purchased,
Lewis Street, West Oakland, 1964.

1965

Has his first San Francisco solo show at the Hansen Gallery. Meets young Canadian Kwakiutl Indian carver Tony Hunt, who is having an exhibition at the Kroeber Museum at U.C. Berkeley. Buys three of Hunt's carvings, beginning a lasting friendship with this artist, and initiates a collection of ethnographic art.

1966

Second Los Angeles solo show at David Stuart Gallery. U.C.L.A. acquires *Dione* (plate 48) for the Franklin Murphy Sculpture Garden.

1967

Begins dreaming about transparent sculpture and undertakes research on transparent materials. Settles on acrylic, even though industry experts are discouraging about the possibility of doing large castings in this material.

1968

After months of experimentation, achieves acrylic castings up to four inches thick. Is selected for an invitational competition for the first monumental sculpture to be commissioned by the State of California. Shows the jury his first attempts at transparent sculpture and is selected as a finalist for the commission. Makes his largest casting to date and wins the competition (*Apolymon* model; plate 70). Visits DuPont Corporation headquarters in Wilmington, Delaware, seeking technical and financial assistance for the monumental cast-acrylic sculpture. DuPont agrees to supply a generous amount of material but declines any technical help. For the first time Beasley attends the International Sculpture Conference, lecturing on his developments in acrylic casting. Visits Willem de Kooning at his new studio in Springs, New York.

1969

Through exhaustive research, makes a major breakthrough in casting technology. Develops a process that can cast acrylic sculpture in monumental scale. Builds the mold for the State of California commission and pours thirteen thousand pounds of liquid acrylic into it. The casting cures for six weeks before the mold is opened.

Bruce Beasley installing his first San Francisco solo exhibition, Hansen Gallery, 1965.

Party at Manuel Neri's home in Benicia, California, ca. 1970. Standing (from left): Jim Pomeroy, Susan and Max Neri, Jean Lockhart, Bruce Beasley (in hat), Joanne Leonard. Seated (from back corner of table): Tom Browne, unidentified woman, Peter Voulkos, Ann Adair, Emmy and Jimmy Suzuki with baby. Foreground: Jim, Mary Ann, and Christopher Melchert.

1970

The large sculpture for California is finished and polished. *Apolymon* (plates 11 and 71) is unveiled at the state capitol and draws abundant national press attention. Beasley participates in a number of important nationwide group shows at museums, including Milwaukee Art Center, Stanford University Art Museum, Sheldon Art Museum, Crocker Art Museum, and U.C. Berkeley Art Museum, and at the Osaka World's Fair.

1971

The Wichita Art Museum acquires *Tragamitus* (plate 76) for its permanent collection. Beasley is included in *Time* magazine article "Transparent Sculpture." Meets sculptor Kenneth Snelson and begins long friendship. Meets Laurence Leaute, a young French woman

visiting California. Three weeks later, travels with her back to Paris, where he convinces her to move to Oakland to live with him. Has solo show at Andre Emmerich Gallery in New York, and Emmerich Gallery becomes his New York dealer.

1972–73

Exhibits in two shows in Paris, Salon de Mai and Salon de la Jeune Sculptures. Marries Laurence in France. Makes *Tragamon* (plate 77), a seven-foot-high cast-acrylic sculpture, for The Oakland Museum. Santa Barbara Museum of Art acquires *Tacoignier* (plate 91) for its permanent collection. Bruce and Laurence travel to Truk in Micronesia to go scuba diving, and then on to New Guinea, where they visit remote villages on the Sepik River.

Laurence Leaute with cast-acrylic sculpture, Lewis Street studio, 1972.

Laurence Leaute and Bruce Beasley at their wedding, Tacoigniers, France, 1973.

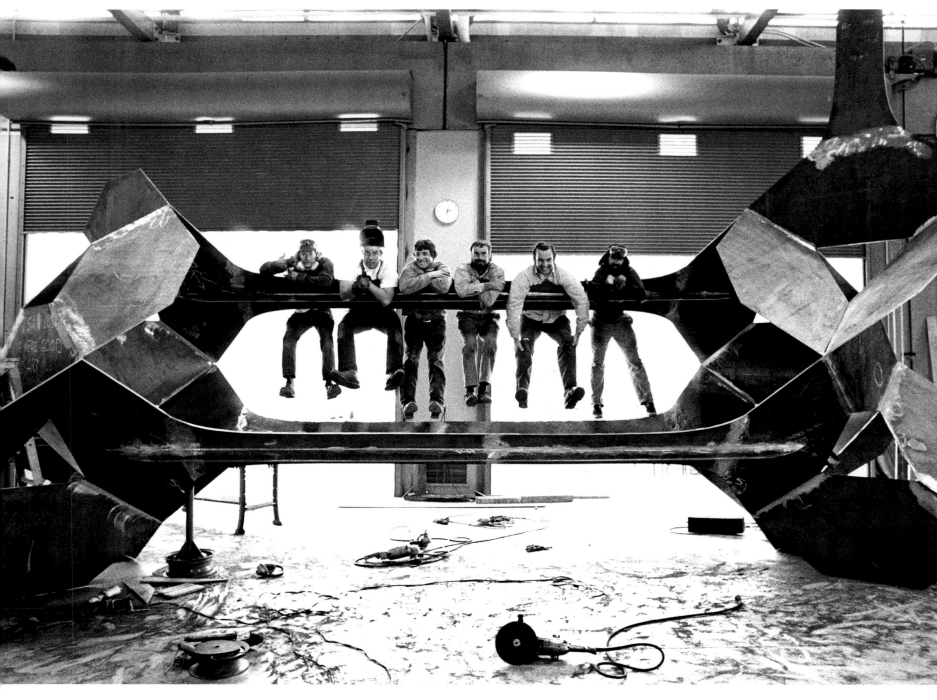

Bruce Beasley and his crew (Dan Dykes is on the far left) clowning on *Big Red*, Oregon International Sculpture Symposium, Eugene, 1974.

1974

Creates *Big Red*, a monumental forty-foot-long steel sculpture (plate 101). Awarded commission for a cast-acrylic sculpture by the federal government for the courthouse in San Diego. The National Museum of American Art in Washington acquires *Scalar Gyration* (plate 16).

1975

Builds a large new building at his studio complex with inside and outside cranes for large-scale metal fabrication. Young sculptor Dan Dykes becomes his chief studio assistant, beginning a long personal and professional relationship. Does a large commission (*Six Tonner*; plate 100) in painted steel for Lakeside Center in Illinois. Birth of Bruce and Laurence's first child, a son, Julien.

1976–77

Approached by leading oceanographers to cast an all-transparent bathysphere. A scuba diver since his teens, Beasley is intrigued by this use of his invention and agrees to take on the project. Problems turn out to be more difficult than anticipated, but the castings finally succeed, and he builds two submersibles with all-transparent crew compartments. The Exploratorium of San Francisco exhibits the bathysphere before it goes into subsea service. Daughter Celia is born.

1978

Does three large commissions in metal: the Miami International Airport (*Atea*; plate 102); state office building in San Bernardino, California (*The Gallup Flyer*; plate 105); and the San Francisco International Airport (*The Hesperides*; plate 103). Meets George Rickey at the International Sculpture Conference in Toronto and begins long friendship.

1980

Works informally with professor of crystallography at U.C. Berkeley, pursuing his interest in crystal structure. Lectures at the International Sculpture Conference in Washington, D.C., where he meets Isamu Noguchi.

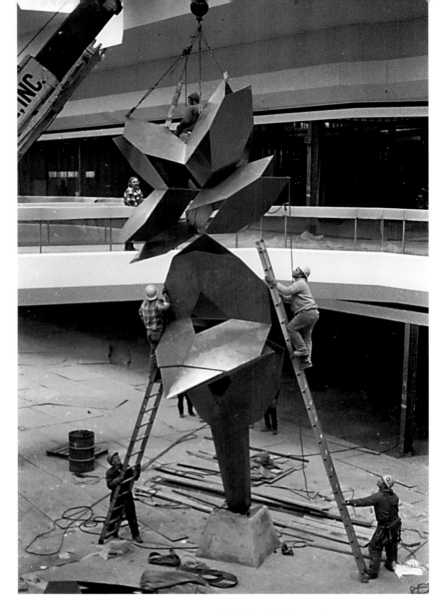

Installing *Six Tonner* at Lakeside Center, Illinois, 1975.

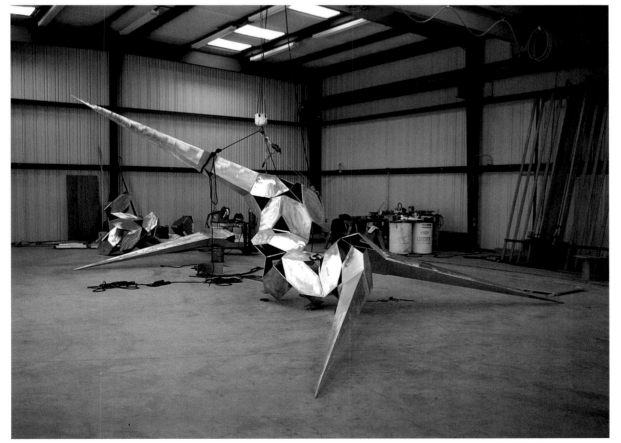

Sculptures in progress at the new five-thousand-square-foot Lewis Street studio addition, 1976.

Bruce Beasley with
two-year-old Julien, 1977.

Julien with model of a sculpture,
Lewis Street studio, 1977.

Bruce Beasley with Celia, Tacoigniers, France, summer 1977.

Atea being installed at
the Miami International
Airport, 1978.

Bruce Beasley with Celia and Julien, Lewis Street, 1980.

Bruce Beasley with George Rickey at Rickey's studio, East Chatham, New York, 1980.

1981

Again visits the prehistoric caves in France, including the cave of Lascaux.

1982

Visits Ed Kienholz and Nancy Reddin in Hope, Idaho. Exhibits in 100 Years of California Sculpture at The Oakland Museum.

1983

Stanford University purchases twenty-eight-foot stainless steel sculpture *Vanguard* (plate 107). He makes *Arristus* (plate 5), a large stainless steel sculpture, for the Djerassi Foundation in Woodside, California. Revisits the prehistoric caves in France and Spain, including Lascaux and Altamira. The American Association for the Advancement of Science publishes a major article on Beasley's contribution to science: his invention of the process for massive acrylic casting that is now used worldwide to make all transparent bathyspheres, windows for submersible vehicles, large aquarium windows, and other scientific uses.

Installing *Vanguard* at
Stanford University, 1983.

Bruce Beasley with Celia installing *Arristus* at the
Djerassi Foundation, Woodside, California, 1983.

1984

Makes *Artemon* (plate 108), a thirty-two-foot stainless steel sculpture, for the Los Angeles Olympic Games. *Artemon* is included in The California Sculpture Show, an exhibition of twelve monumental sculptures that travels to Bordeaux, France; Mannheim, Germany; and Yorkshire, England. Visits Eduardo Chillida, whom Beasley greatly admires, for the first time, in San Sebastián, Spain. Chillida takes Beasley to see *Wind Combs*, his series of great iron sculptures set into the rocks of Donostia Bay.

1985

Installs *Arctos* (plate 104), a thirty-three-foot stainless sculpture, for the city of Anchorage, Alaska.

1986

Struggles with models for a new style of work involving complex intersecting geometric forms. Publishes an article on prehistoric sculpture in *Bulletin de la Société Préhistorique*, a French journal of prehistory. Receives a commendation from the National Aeronautics and Space Administration (NASA) because the transparent submersible he built located and recovered the crew compartment after the tragic explosion of the space shuttle *Challenger*.

1987

Participates in the International Steel Sculpture Symposium in Krefeld, Germany, at the Kleinewefers factory. Creates a large Cor-Ten steel piece (*Titiopoli's Arch*; plate 114) in the new style of intersecting geometric forms. Begins friendship with German sculptor Ingo Ronkholz.

Bruce Beasley (right) getting ready to fly off France's Mount Blanc in a hang glider, 1986.

Potlatch given by Kwakiutl Chief Tony and attended by Bruce and Laurence Beasley, Alert Bay, British Columbia, 1987.

Bruce Beasley with a model of *Titiopoli's Arch* (plate 114) at the International Steel Sculpture Symposium, Krefeld, Germany, 1987.

1988

Vigorously pursues the new metalwork, beginning an investigation of computers to visualize complex geometric relationships prior to making them. Is assisted by Don Glaser at U.C. Berkeley.

1989

Learns and modifies a three-dimensional computer solid modeling system to allow spontaneous changes to and visualization of complex geometric models prior to physical construction. Lectures on contemporary American sculpture in Hong Kong and Japan. Receives Individual Artist Award from the City of Oakland. Visits Eduardo Chillida in San Sebastián, Spain. San Francisco Bay Area is struck by the Loma Prieta earthquake. Beasley's studio is only blocks from the Cypress Freeway structure that collapses, killing forty-one people. His studio is damaged but not destroyed. He and his son work in the rescue efforts.

Bruce Beasley with Eduardo Paolozzi jurying a competition at the Hong Kong Museum of Art, 1989.

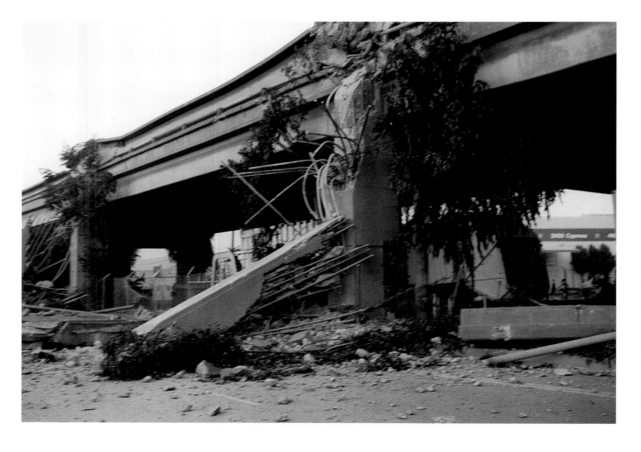

The Cypress Freeway that collapsed in the Loma Prieta earthquake just a few blocks from the Lewis Street studio. Shown here is the ruptured steel reinforcing that Beasley later used to cast *Pillars of Cypress*, now in the collection of the Oakland Museum of California, 1989.

The Lewis Street sculpture garden, 1991.

1990

Solves technical problems associated with the precision required by the new style. Makes *Pillars of Cypress* (plate 118), a sculpture cast from steel beams that failed in the freeway collapse, as a tribute to his neighbors' efforts to rescue those trapped in the fallen freeway. Studio requires extensive repair due to earthquake damage. Begins long collaboration doing patinas with artist Lex Lucius.

1991

The Smithsonian Institution produces a nationally aired TV program on Beasley's invention of the process for acrylic casting. Visits marble quarries in Pietrasanta and Carrara, Italy, to investigate stone carving facilities. Commissions his first stone piece, nine feet high.

1992

Installs *Guardian* (plate 145), an eighteen-foot-high bronze sculpture, at the Federal Home Loan Bank in San Francisco.

Bruce Beasley with Gio Pomodoro at the marble quarries, Carrara, Italy, 1994.

December 21, 1993

Dear Bruce,

I have seen your large stainless steel sculpture in the park of Andre Emmerich. It is the artwork that I was most impressed by among the many carefully placed sculptures all around the site. The site is a beautiful wild expanse of a landscape so markedly different from the Italian landscape, which so clearly displays the intervention of man. Your sculpture spoke to me in a language I could understand, while the majority of the other sculptures placed in that landscape were quite distant from my conception of sculpture. There is a great gap between the work of my American colleagues and what we do in Italy and Europe. Very roughly you could say that we are old style, and in the U.S. you are modern. But this brings us away on a tangential misconception, so such a statement is false. I am old-fashioned and archaic compared to these new sculptors, but my sculptural language is very sophisticated and knowledgeable, just as the language of the new American sculptors is confused and approximate. Many of them borrow their lexicon from the technological landscape. These U.S. sculptors are like naturalist painters of the urban scene. But the urban scene is by far richer and more powerful than their works. Compared to what the urban scene offers, their efforts appear in contrast to be very modest.

I do not doubt that when enclosed in a gallery or museum their works may gain more strength, but still this is a strength that, when placed in the context of a natural landscape, pales and brings failure. These works have all to lose and nothing to gain when next to and confronted with nature. A mere single tree in a forest becomes a threatening judge of a ridiculous and provoked uneven struggle.

Your sculpture seems to be born from the earth where silent and cold crystal formations multiply and develop to maturity. The trees in the forest do not hand down on your work a harsh judgment. The roots of the trees share the darkness of the ground with the crystal formations, and the leaves can detect the luminescence given off by the crystals below. Your work is in great harmony with the forest, but it should be engaged all by itself with the trees surrounding it. Your sculpture does not have the privacy it deserves, and that is a pity.

I wish you good work and hope to see you in Pietrasanta.

A dear, friendly farewell,

Gio

Bruce Beasley working on a patina, new Lewis Street studio, 1994.

1993

Exhibits at the Frankfurt and Chicago Art Fairs and installs *Artemon* (plate 108) at Andre Emmerich's Top Gallant Farm in New York. The Sheldon Memorial Art Gallery, University of Nebraska, acquires *Bateleur II* (plate 131). He is named to the Board of Directors of the International Sculpture Center, where he meets Gio Pomodoro and begins a friendship and correspondence.

1994

Solo exhibition at the Kunsthalle Mannheim in Mannheim, Germany. The museum purchases *Spokesman II* (plate 144), *Knight's Gambit II* (plate 126), and *Messenger II* (plate 154). Visits Gio Pomodoro in Pietrasanta, Italy.

1995

San Francisco Museum of Modern Art acquires *Breakout* (plate 123).

1996

Solo exhibitions in Dortmund and Bad Homberg, Germany. Group exhibitions in Europe and the United States. Young sculptor Albert Dicruttalo apprentices with Beasley for the summer.

1997

Begins construction of a long-dreamed-of sculpture garden adjacent to the studio. Artist Jennifer Craigie begins as Beasley's model maker.

1998

Beasley's work is included in the United States' representation at the Cairo Biennale, and he and Laurence visit Egypt. The Egyptian government purchases *Ally II* (plate 179) for its national collection. Lectures at International Conference on Prehistoric Art, Santander, Spain, and at the International Sculpture Conference in Chicago, where he presents the ISC Lifetime Achievement Award to Eduardo Chillida. Albert Dicruttalo becomes Beasley's chief assistant.

Bruce Beasley installing trees,
Lewis Street sculpture garden, 1997.

Bruce Beasley with Eduardo Chillida at the
Chillida Museum, San Sebastián, Spain, 1998.

Bruce Beasley with Ingo Ronkholz at
Ronkholz's studio, Krefeld, Germany, 1999.

Bruce Beasley (center) working on the mold
for a large iron casting, Krefeld, Germany, 1999.

Bruce Beasley with Gio Pomodoro,
Lewis Street sculpture garden, 2000.

Bruce Beasley looking at 33,000-year-old cave paintings in the recently discovered cave of Chauvet, France, 2000.

Bruce Beasley with Mark di Suvero, 2000.

1999

Travels to southern India to investigate possibilities for carving granite sculptures there. Grounds for Sculpture, a sculpture park in New Jersey, purchases the thirty-foot stainless steel sculpture *Dorion* (plate 113).

2000

Is one of two Americans on the team investigating the newly discovered prehistoric cave of Chauvet in France, then travels to Portugal to carve granite. Casts an eight-thousand-pound cast-iron sculpture at Siempelkamp GmbH, Germany's largest iron foundry. Completes commission for a large outdoor sculpture at the University of Texas, Houston. Gio and Etta Pomodoro visit Bruce and Laurence at their home in Oakland.

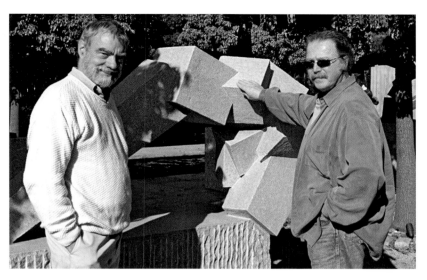

Bruce Beasley with Kenneth Snelson,
Lewis Street sculpture garden, 2001.

Bruce Beasley with Albert Paley, Lewis Street sculpture garden, 2001.

Wins competition for a monumental sculpture at Frank Ogawa Plaza
in front of Oakland City Hall. Travels to Portugal to work on sculp-
tures at Singranova granite quarry. Participates in International Sculp-
ture Symposium in Isla Mujeres, Mexico. The city of Bad Homberg,
Germany, purchases *Spokesman II* (plate 144). Lex Lucius trains Lau-
rence to do Bruce's patinas.

Bruce Beasley with *Vitality* before taking it to
be installed, new Lewis Street studio, 2001.

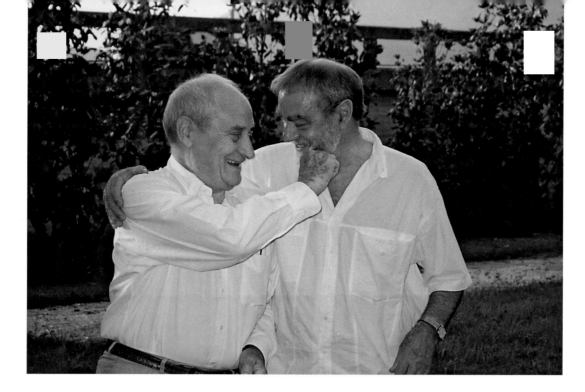

Bruce Beasley's last visit with Gio Pomodoro,
at Pomodoro's studio, Querceta, Italy, 2002.

2002

Wins competition for a large outdoor sculpture for the University
of Miami, Oxford, Ohio. Installs thirty-foot-high sculpture *Vitality*
(plate 173) in front of Oakland City Hall. Returns to Portugal to work
on sculptures at Singranova granite quarry. Travels to Thailand,
where his brother, Palmer Beasley, is awarded the King Midol Prize
in International Medicine. Visits the newly opened Isamu Noguchi's
Garden Museum on Kagawa-Ken Island, Japan. Presents the Inter-
national Sculpture Conference Lifetime Achievement Award to Gio
Pomodoro.

Bruce Beasley with Manuel Neri, 2002.

Bruce Beasley with Nathan Oliveira, 2002.

Bruce and Laurence Beasley at the
installation of *Vitality*, Oakland
City Hall Plaza, California, 2002.

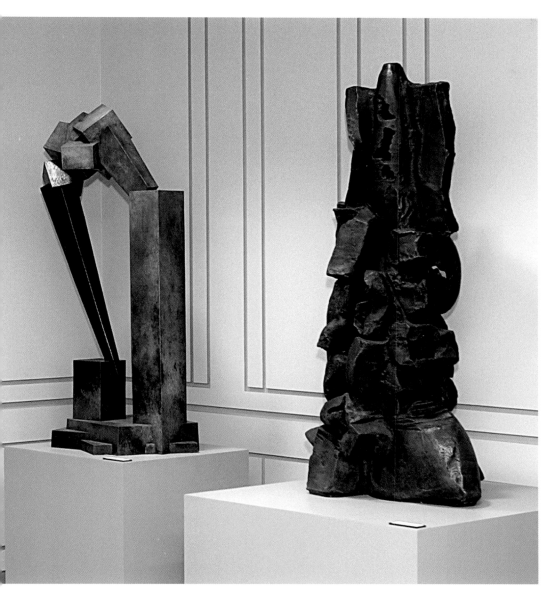

Part of the Voulkos–Beasley installation at the new Baker Library
at Dartmouth College, Hanover, New Hampshire, 2003.

2003

Dartmouth College makes a permanent installation of six sculptures
by Peter Voulkos and six by Bruce Beasley in the college's new Baker
Library in Hanover, New Hampshire. Installs *Ascender IV* (plate 166)
for City of Brea, California.

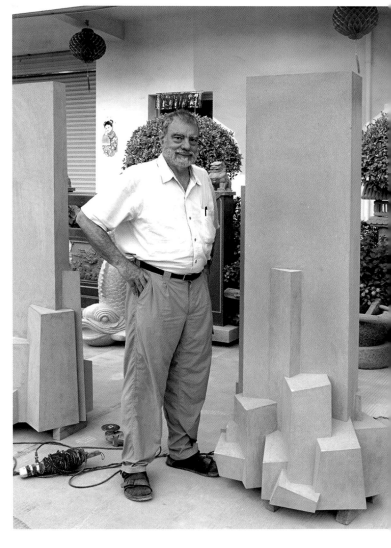

Bruce Beasley with granite sculptures,
Chongwu, China, 2003.

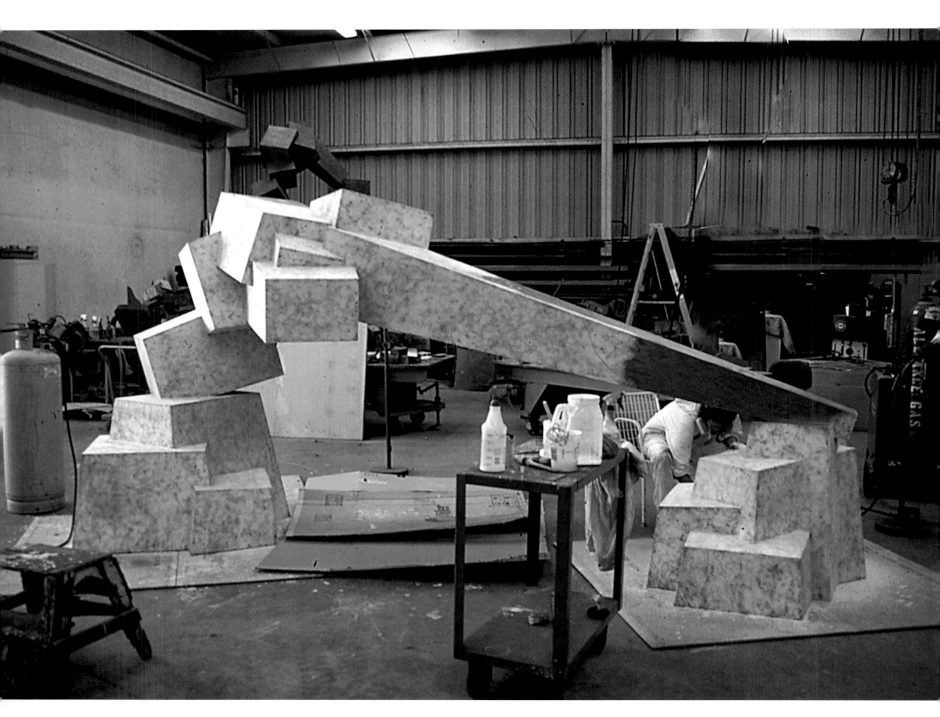

Encounter III getting the patina before being shipped off for installation at the University of Oregon Art Museum, 2003.

2004

Travels to Chongwu, China, to work on granite sculptures. Presents the ISC Lifetime Achievement Award to Christo.

2005

Beasley has his first major retrospective exhibition at the Oakland Museum of California.

Bruce Beasley with (from left) Bernar Venet, Jeanne-Claude, and Christo at Venet's studio, New York, 2004.

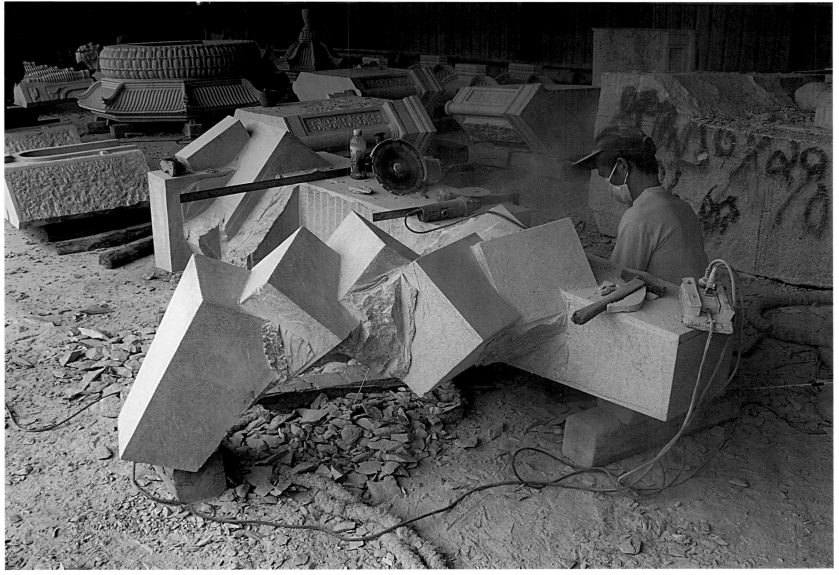

Granite carving in progress, Chongwu, China, 2004.

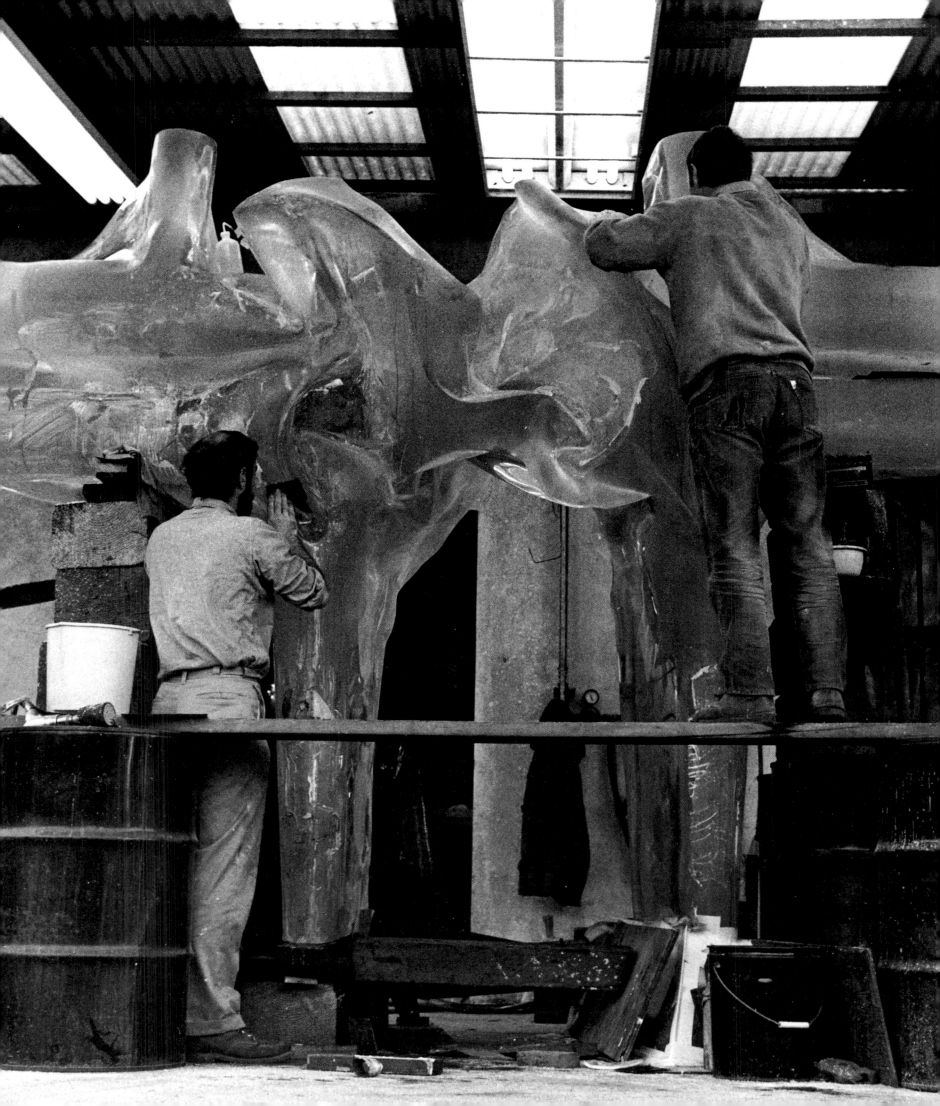

In 1967 Bruce Beasley took a break from his normal program of yearly exhibitions to explore the idea of transparent sculpture. He soon ruled out glass as a medium, finding that it was impractical for the large sizes he wanted to work in, and learned that he must use plastic. Over and over he was told that acrylic was the only plastic that remained truly transparent when made into objects more than a few inches thick, but that acrylic could not be cast into the immense, complex forms he wished to make without bubbling and cracking.

Despite secrecy in the plastics industry, Beasley managed to cast a few sculptures that were several inches thick—close to the maximum size that anybody in the industry could cast—and his eagerness to make large transparent sculptures grew steadily. Yet it seemed he would either have to abandon the idea or somehow invent a new way to cast acrylic. Just at this time the State of California initiated an invitational competition for the state's first large outdoor sculpture, and Beasley was selected as a semifinalist on the strength of his

Bruce Beasley and an assistant sanding *Apolymon* after its two weeks curing in the autoclave. [facing]

earlier cast-metal work. Thus it was a surprise to the jury when he submitted an acrylic sculpture for the competition, and he took quite a chance in doing so. He knew that his acrylic casting technique was far from perfect and that it would be hard to convince the jury that acrylic was an acceptable material for a monumental sculpture, but he was too excited about working with acrylic to return to metal sculpture should he win the competition. The jurors were intrigued by what they saw, and Beasley won.

The jury did not fully realize that the technique Beasley planned to use to scale up the model was still being developed and was entirely untested. He now had to make a cast-acrylic sculpture that was thirteen feet wide and four feet thick, but the largest casting he had managed so far was forty inches wide and four inches thick. In fact, the sculpture he was proposing would be the largest acrylic casting ever made as well as the largest transparent object in the world.

Beasley hoped that winning the commission would generate some help from the plastics industry. He met with DuPont, who manufactured the raw material, seeking technical and material support. DuPont was stunned that Beasley, an artist with no training in chemistry, had managed to cast such a complex and thick acrylic sculpture. The company agreed to supply the material for the sculpture but said candidly that since Beasley had already taken the technique beyond its own capabilities, DuPont could give no technical assistance. In learning how to cast four-foot-thick acrylic, Beasley was on his own.

Cast acrylic has to cure under high pressure in a heated chamber called an autoclave, so Beasley's first step was to acquire a massive autoclave. He had viewports installed in it, hoping that by observing the bubbles when they formed he would be able to invent a process for thicker castings. One night, through the viewport in the autoclave, Beasley observed the bubbles just as they formed, and he understood immediately how he could cast acrylic of any thickness. His next experiment was twenty-four inches thick with no bubbles and no cracks, proving that the new technique worked. The next casting was *Apolymon*, thirteen feet wide and four feet thick, and it was perfect.

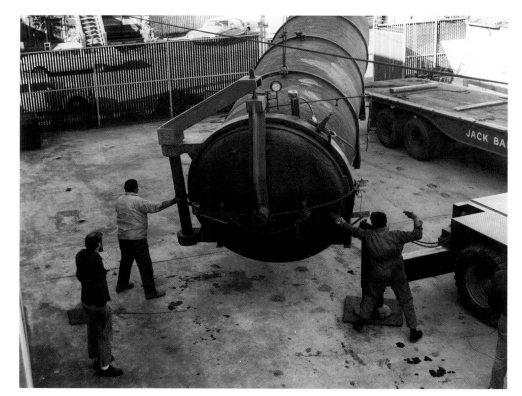

Installing the big autoclave
at the Lewis Street studio.

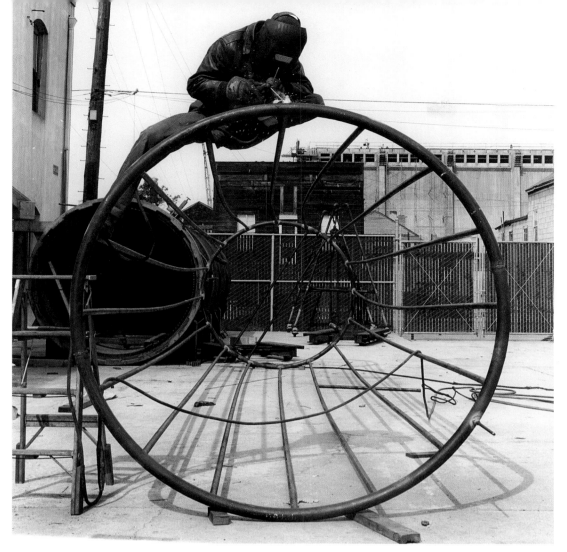

Welding the heating pipes for the autoclave.

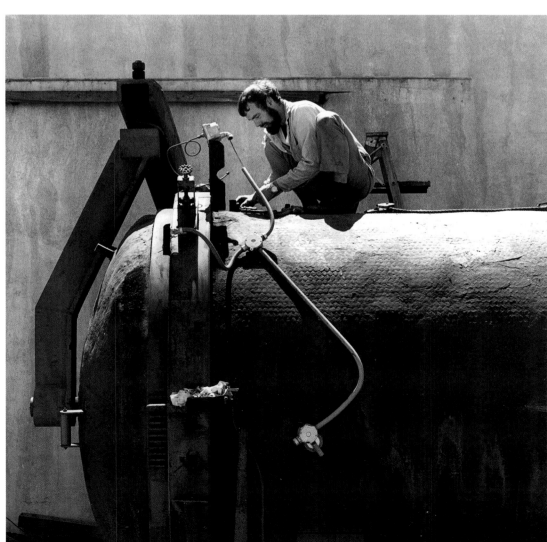

Bruce Beasley wiring the autoclave.

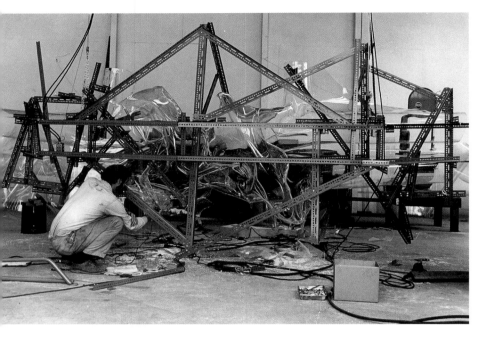

Starting to build the mold for *Apolymon*.

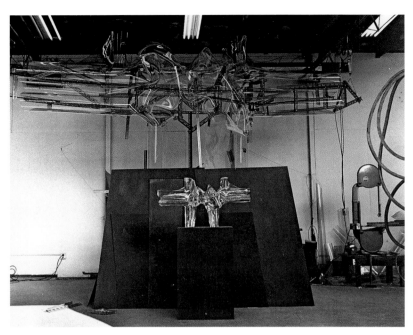

Comparing the model with the first section of the *Apolymon* mold.

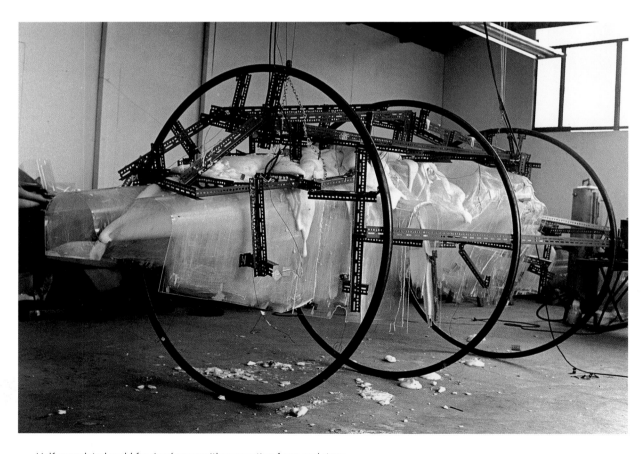

Half-completed mold for *Apolymon* with supporting foam and rings.

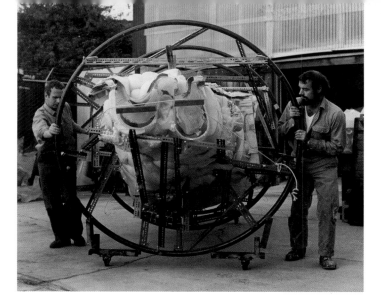

Beasley (right) and an assistant rolling the completed
mold to the autoclave before pouring in the acrylic.

Mixing chemicals to create liquid acrylic.

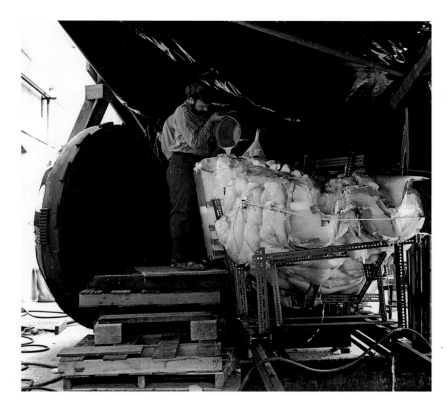

Pouring liquid acrylic into the *Apolymon* mold.

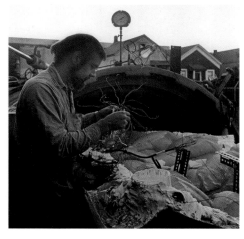

Wiring the sixty-four
temperature sensors to
allow monitoring of the
curing of the casting.

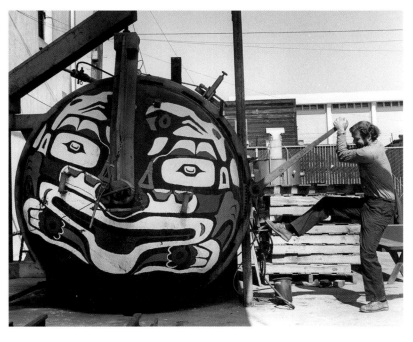

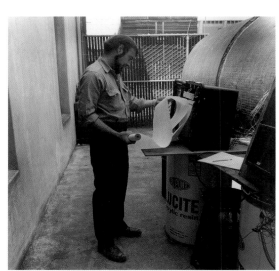

Checking the temperature
readouts from the sensors
inside the autoclave.

Opening the autoclave after two weeks of curing. Beasley had painted
a Northwest coast American Indian–inspired face on the autoclave.

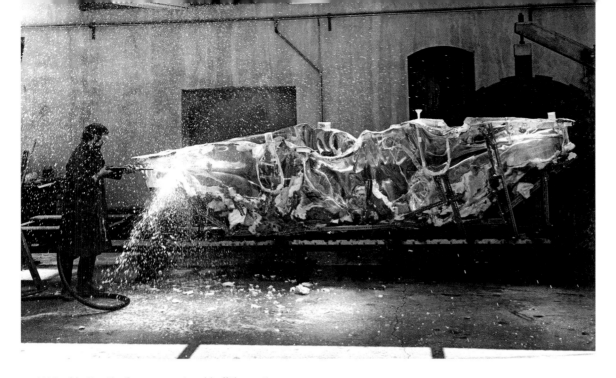

Water-blasting the foam support mold off the casting.

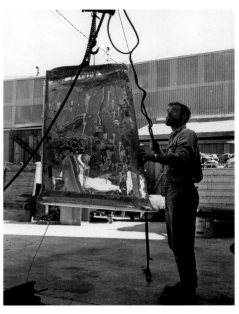

One of *Apolymon*'s legs, cast but
not yet joined to the main casting.

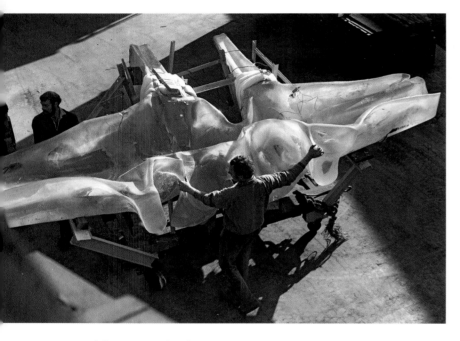

Both legs are joined to the main casting.

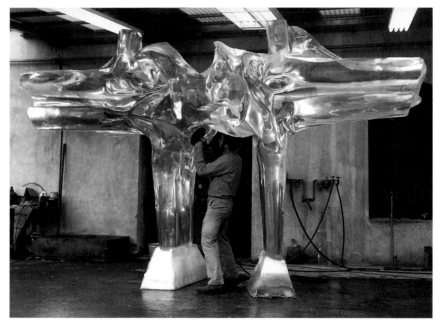

Polishing *Apolymon*, a process that took several months.

Beasley built an oven
around the sculpture
to anneal it by heating
and slowly cooling.

Installing *Apolymon* in Sacramento.

Apolymon's unveiling.

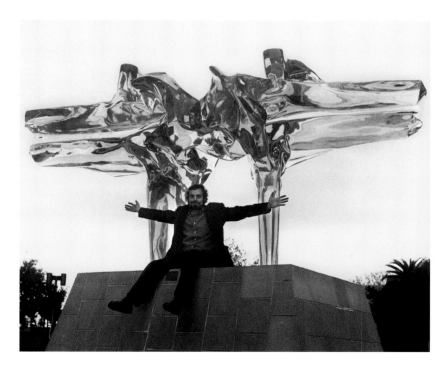

Beasley with *Apolymon*.

The Sacramento Girls' Fife and Drum Corps using *Apolymon* as a practice site before going to the Osaka World's Fair.

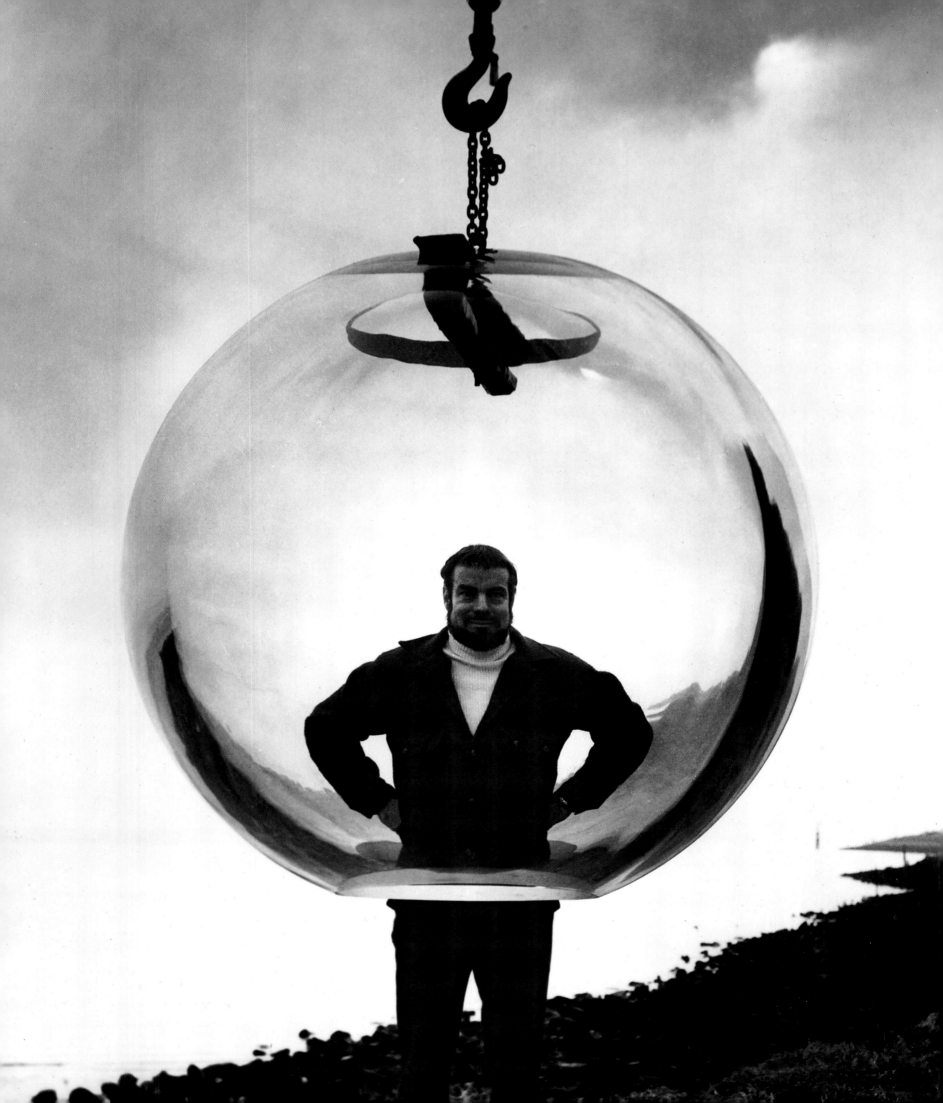

After Bruce Beasley installed the monumental transparent sculpture *Apolymon* at the California state capitol in 1970, he was approached by a group of oceanographic engineers who asked if he could cast an all-transparent bathysphere. Bathyspheres—hollow globes from within which scientists can see and explore the ocean floor—traditionally had been made of steel with small glass or quartz windows. However, when the windows were large enough for the scientists to see sufficiently at great depths, the glass penetrating the steel sphere weakened it. The ideal solution was to make the entire sphere transparent so that it was one large window. The oceanographic engineers wanted Beasley to make an all-transparent bathysphere using the process he had invented to cast acrylic sculpture. Beasley, a scuba diver since his teens, accepted the challenge to take man's eyes to the bottom of the sea.

After some difficulty, he succeeded in adapting the sculpture-casting technique to make the first cast transparent bathyspheres. These bathyspheres are now the manned

Bruce Beasley inside his cast-acrylic bathysphere. [facing]

compartments for the Johnson-Sea-Link submersibles operated by Harbor Branch Foundation, one of the world's leading oceanographic institutions. They can be used at a depth of three thousand feet, and in more than eight hundred dives they have made possible the discovery of hundreds of species of sea life. The bathyspheres have been used extensively for underwater photography, including for the award-winning BBC documentary series *The Blue Planet* and the Imax film *Galapagos 3-D*. Using Beasley's invention, scientists have discovered many compounds derived from marine organisms,

such as a potent anti-tumor agent that is currently on the way to obtaining FDA approval.

When the space shuttle *Challenger* exploded in 1986, the Johnson-Sea-Link submersibles with Beasley's cast-acrylic spheres were the only undersea vehicles with the capacity to search the miles of seabed needed to locate the wreckage. For his contribution to the recovery of the wreckage of the *Challenger*, Beasley received a commendation from the National Aeronautics and Space Administration.

Bruce Beasley with the
bathysphere's outside mold.

Assembling the inside and outside molds.

Bruce Beasley and Laurence
Leaute pulling a vacuum
on the liquid acrylic
to remove bubbles.

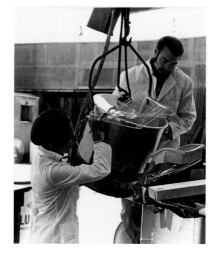

Preparing to pour
the liquid acrylic into
the assembled mold.

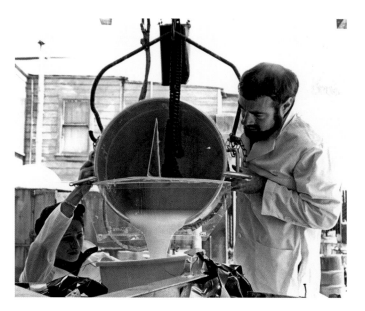

Pouring liquid acrylic into the mold.

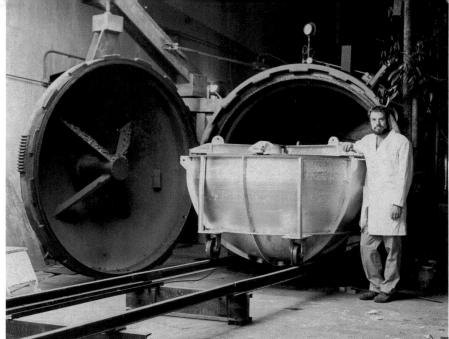

Beasley with the filled mold ready to roll into the autoclave to cure.

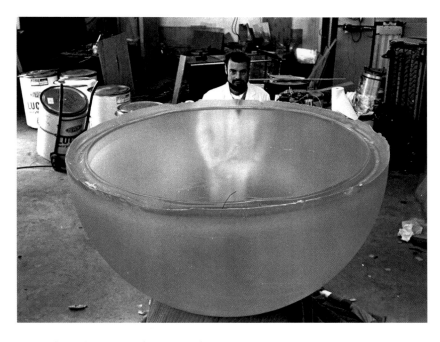

Beasley with a casting of one hemisphere.

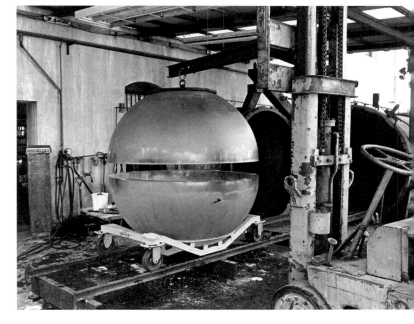

Positioning the two hemispheres prior to bonding.

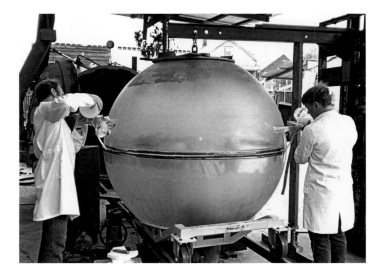

Pouring acrylic into the joint to bond the two hemispheres.

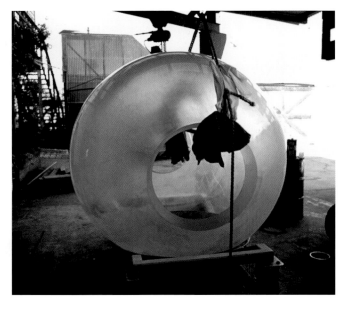

Starting to polish the bathysphere.

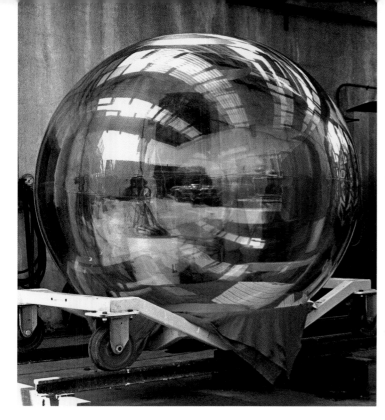

The polished bathysphere.

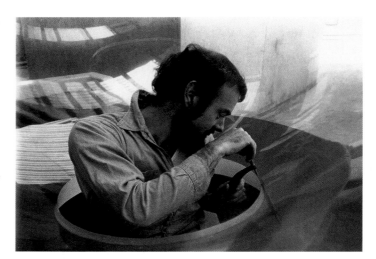

Beasley inside the bathysphere measuring its thickness.

Beasley with a Johnson-Sea-Link submersible on the deck of a mother ship. The bathysphere is mounted as the crew compartment of the submersible.

The Johnson-Sea-Link underwater. [facing]

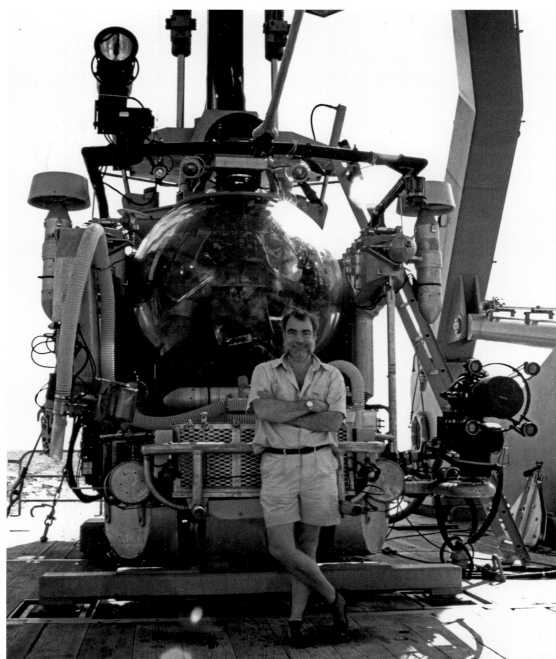

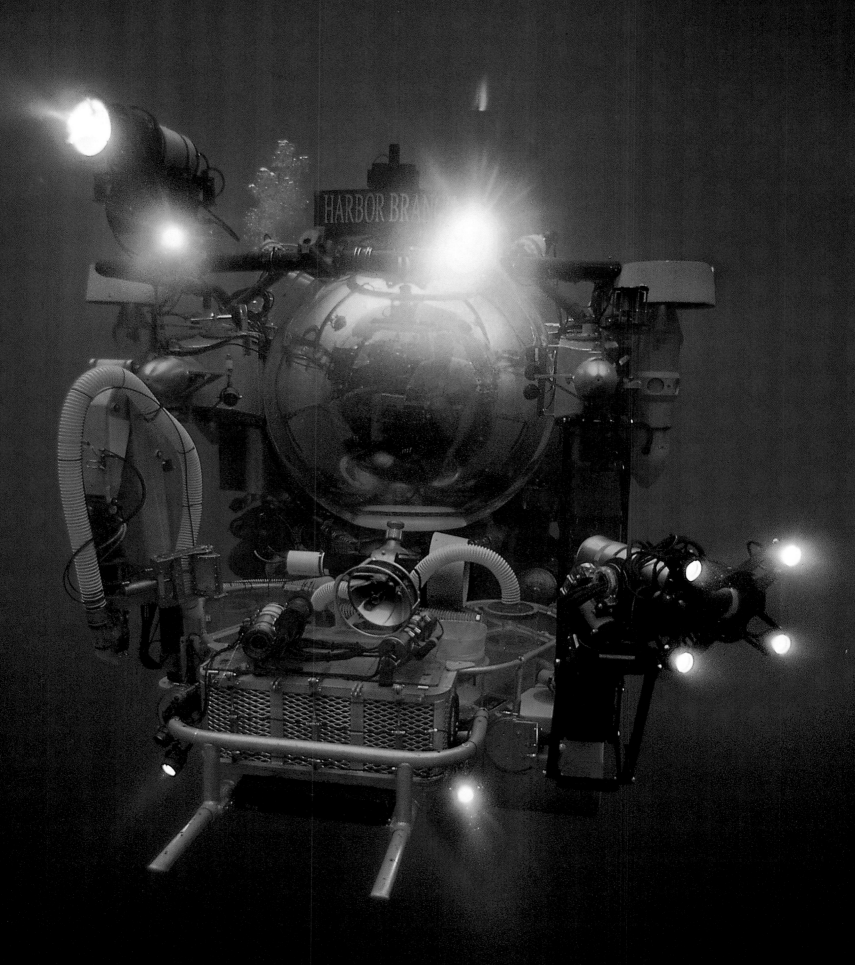

SELECTED EXHIBITIONS AND COLLECTIONS

SOLO EXHIBITIONS

2004 Atrium Gallery, St. Louis, Missouri

2002 Solomon/Dubnick Gallery, Sacramento, California

2001 Gail Severn Gallery, Ketchum, Idaho
 Silicon Valley Art Museum, Belmont, California

2000 Mathematical Sciences Research Institute,
 Berkeley, California

1999 Kouros Gallery, New York, New York

1998 Gwenda Jay Gallery, Chicago, Illinois
 Hooks-Epstein Gallery, Houston, Texas

1997 Atrium Gallery, St. Louis, Missouri
 Purdue University, West Lafayette, Indiana
 Solomon/Dubnick Gallery, Sacramento, California

1996 City Center, Dortmund, Germany
 Scheffel Gallery, Bad Homberg, Germany

1995 Atrium Gallery, St. Louis, Missouri
 Galerie Marie-Louise Wirth, Zurich, Switzerland
 Hooks-Epstein Gallery, Houston, Texas
 Mannheim City Hall, Mannheim, Germany
 Yorkshire Sculpture Park, West Bretton, Great Britain

1994 Harcourts Modern and Contemporary Art,
 San Francisco, California
 Rudolfinum Museum, Prague, Czech Republic
 Stadtische Kunsthalle Mannheim, Mannheim, Germany

1993 Hooks-Epstein Gallery, Houston, Texas
 Gallerie Scheffel, Bad Homberg, Germany
 Shidoni Gallery, Santa Fe, New Mexico
 Gallerie Utermann, Dortmund, Germany

1992 California State University, Turlock, California
 Fresno Art Museum, Fresno, California
 Jaffe Baker Gallery, Boca Raton, Florida
 John Natsoulas Gallery, Davis, California
 The Oakland Museum, Oakland, California

1991 California Polytechnic State University,
 San Luis Obispo, California
 Sonoma State University, Rohnert Park, California
 Southern Oregon State University, Ashland, Oregon

1990 Hooks-Epstein Gallery, Houston, Texas
 Loma Linda University Art Gallery, Riverside, California
 Pepperdine University Art Gallery, Malibu, California

1981 Fuller-Goldeen Gallery, San Francisco, California

1973 San Diego Museum of Art, San Diego, California
 Santa Barbara Museum of Art, Santa Barbara, California

1972 M. H. de Young Memorial Museum and the
 California Palace of the Legion of Honor,
 San Francisco, California

1971 Andre Emmerich Gallery, New York, New York

1966 David Stuart Gallery, Los Angeles, California

Plate 193 [facing]. Vascone II, 1967. Cast aluminum, 36 × 32 × 14 in. City and County of San Francisco, California. (See also plate 66.)

1965 Hansen Gallery, San Francisco, California

1964 Kornblee Gallery, New York, New York

1963 Everett Ellin Gallery, Los Angeles, California

1961 Richmond Art Center, Richmond, California

SELECTED GROUP EXHIBITIONS

2004 The Blair Collection, Galerie Dionisi, West Hollywood,
 California

2003 Eighth Annual Sculpture Show, The Art & Cultural Center,
 Fallbrook, California

 Eighth International Shoebox Sculpture Exhibition,
 University of Hawaii Art Gallery, Honolulu, Hawaii
 traveling internationally (2003–2005)

 Fifth Anniversary Show, The Art Foundry Gallery,
 Sacramento, California

 International Rapid Prototyping Sculpture Exhibition,
 Sarofim School of Fine Arts, Southwestern
 University, Georgetown, Texas

 Sterling Stuff, Sigurjon Olafsson Museum, Reykjavik,
 Iceland; traveled to Royal Academy of Arts, London,
 United Kingdom

2002 Second Saturday Reception, Solomon/Dubnick Gallery,
 Sacramento, California

2001 First International Sculpture Meeting, Isla Mujeres, Mexico

 Tenth Anniversary Celebration, Solomon/Dubnick Gallery,
 Sacramento, California

 Works from the International Sculpture Center Board,
 Grounds for Sculpture, Hamilton, New Jersey

2000 Autour du Cubisme, Galerie Michel Cachoux, Paris, France

 Celebrating Modern Art/The Anderson Collection,
 Museum of Modern Art, San Francisco, California

 Opening Show, Gail Severn Gallery, Ketchum, Idaho

 San Francisco International Art Exposition, San Francisco,
 California

 Spatial Expressions, Hooks-Epstein Gallery, Houston, Texas

1999 Art at the Summer Solstice, Ruth Bancroft Garden,
 Walnut Creek, California

 Blickachsen 2, Bad Homberg, Germany

 Form and Function, Atrium Gallery, St. Louis, Missouri

 Group Show, Art Foundry Gallery, Sacramento, California

Opening Show, Imago Galleries, Palm Desert, California

Pier Walk '99, Navy Pier, Chicago, Illinois

Seventh International Cairo Biennale, Cairo, Egypt

1998 Darmstadt Sculpture Biennale, Darmstadt, Germany

 Group Show, Del Mar Sculpture Gallery, Del Mar, California

 Group Show, I. Wolk Gallery, St. Helena, California

 Pier Walk '98, Navy Pier, Chicago, Illinois

 20/20, The Twentieth Anniversary Exhibition, Sonoma
 State University, Rohnert Park, California

1997 An Artist's Legacy, Kennedy Art Center Gallery, Holy
 Names College, Oakland, California

 Blickachsen—Skulpturen im Kurpark, Bad Homberg,
 Germany

 55 & Up, Art for a Lifetime, Bedford Gallery, Walnut Creek,
 California

 Nine Bay Area Avant-Garde Artists of the Sixties: Then &
 Now, J. J. Brookings Gallery, San Francisco, California

 Pier Walk '97, Navy Pier, Chicago, Illinois

 Sculpture Inaugural, T. Curtsnoc Gallery, Miami, Florida

 Skulpture Heute '97, Galerie Wirth, Zurich, Switzerland

1996 California Color, Sheldon Memorial Art Gallery, University
 of Nebraska, Lincoln, Nebraska

 Contemporary Sculpture, Galerie Gabriele von Loeper,
 Hamberg, Germany

 Generations: The Lineage of Influence in Bay Area Art,
 Richmond Art Center, Richmond, California

 Sculpture Invitational, Cerrillos Cultural Center, Cerrillos,
 New Mexico

 Sculpture Invitational, Grounds for Sculpture, Hamilton,
 New Jersey

1995 Art Chicago 1995, Navy Pier, Chicago, Illinois

 Art Cologne, Cologne, Germany

 A Bay Area Connection: Works from the Anderson Collec-
 tion, Triton Museum of Art, Santa Clara, California

 An Opening Exhibition, The Sculpture Gallery,
 San Francisco, California

 The Second Fujisankei International Biennale: Excellent
 Maquettes, Hakone Open-Air Museum, Hakone, Japan

 Skulpture Heute, Galerie Marie-Louise Wirth, Zurich,
 Switzerland

1994 Artists Shedding Light on Science, San Francisco State
University, San Francisco, California

Beasley, Dykes, Yates, Solomon/Dubnick Gallery,
Sacramento, California

Contemporary Cast-Iron Art, Visual Arts Gallery,
University of Alabama, Birmingham, Alabama

Directions in Contemporary Cast-Iron, Ramapo
College Art Galleries, Mahwah, New Jersey

Recent Acquisitions of Twentieth-Century American Art,
Fine Arts Museums, San Francisco, California

Sculpture Invitational, Hessische Landesgartenschau,
Fulda, Germany

Skulpture Heute, Galerie Marie-Louise Wirth, Zurich,
Switzerland

A Syntex Retrospective, Syntex Corporation Gallery,
Palo Alto, California

1993 Chicago International Art Exposition, Donnelley Interna-
tional Hall, Chicago, Illinois

Computer Art: An Ohio Perspective, Dayton Visual Arts
Center, Dayton, Ohio

Five Bay Area Sculptors, Harcourts Gallery, San Francisco,
California

The Fujisankei International Biennale: Excellent
Maquettes, Hakone Open-Air Museum,
Hakone, Japan

International Biennial of Graphic Arts, Xantus Janos
Museum, Gyor, Hungary

1992 Bay Area Greats, Syntex Corporation Gallery, Palo Alto,
California

New Works: Beasley, Albuquerque, Davis, Valerie Miller
Fine Art, Palm Desert, California

Seventh International Los Angeles Art Fair, Los Angeles,
California

1991 New California Sculpture, The Oakland Museum, Oakland,
California

Sculptural Perspectives for the Nineties, Muckenthaler
Cultural Center, Fullerton, California

Sculpture 1991, Fermilab National Accelerator Facility,
Batavia, Illinois

Vernissage, Galerie Utermann, Dortmund, Germany

1990 Beyond Fragments: After the Earthquake, Pro Arts Gallery,
Oakland, California

Oakland's Artists '90, The Oakland Museum, Oakland,
California

Sculpture, Novus Gallery, Atlanta, Georgia

1989 Bay Area Bronze, Civic Arts Gallery, Walnut Creek,
California

1988 State of California, Art in Public Buildings, 1978–88, Fresno
State University, Fresno, California; traveled statewide

1987 Budapest Triennial International Sculpture Exhibition,
Palace of Exhibitions, Budapest, Hungary

Monumenta, Nineteenth Sculpture Biennale, Middleheim
Sculpture Park, Antwerp, Belgium

Outdoor Sculpture Show, Shidoni Gallery, Tesuque,
New Mexico

Sculpture: Looking into Three Dimensions, Anchorage
Museum of History and Art, Anchorage, Alaska;
traveled to Alaska State Museum, Juneau, and
University of Fairbanks, Fairbanks, Alaska

Steel Sculpture, International Steel Sculpture Symposium at
Park der Berg, Krefeld, Germany; Wantipark, Dordrecht,
Netherlands; Yorkshire Sculpture Park, West Bretton,
Great Britain; Kunsthalle, Bremen, West Germany

1986 Brook House Sculpture Invitational, Kaiser Center, Oakland,
California

Casting across America, North Dakota Museum of Art,
Grand Forks, North Dakota

A Gift of Sculpture, San Francisco Civic Center Plaza,
sponsored by the San Francisco Arts Commission,
San Francisco, California

Selections from the Security Pacific Collection, San Fran-
cisco Arts Commission Gallery, San Francisco, California

1985 Art Collectors in and around Silicon Valley, Euphrat Gallery,
DeAnza College, Cupertino, California

The Art of the San Francisco Bay Area: 1945 to 1980,
The Oakland Museum, Oakland, California

Going Public: A Retrospective Exhibition, Walnut Creek
Civic Arts Gallery and Civic Park, Walnut Creek,
California

1984 California Sculpture Show, Twenty-second Olympic Arts

Festival and the Fisher Galleries, University of Southern California, Los Angeles, California; traveled to Musée d'Art Contemporain de Bordeaux, Bordeaux, France; Stadtische Kunsthalle Mannheim, Mannheim, West Germany; Yorkshire Sculpture Park, West Bretton, Great Britain; Sonja Henies Og Niels, Onstads, Norway (1984–85)

1983 Outdoor Sculpture Show, Shidoni Gallery, Tesuque, New Mexico

1982 First International Shoebox Sculpture Exhibition, University of Hawaii, Honolulu, Hawaii; traveled internationally (1982–84)

Forgotten Dimension . . . A Survey of Small Sculpture in California Now, two-year tour organized by the Fresno Art Museum, Fresno, California

Northern California Art of the Sixties, de Saisset Museum, Santa Clara University, Santa Clara, California

100 Years of California Sculpture, The Oakland Museum, Oakland, California

Sculpture '82, Shidoni Gallery, Tesuque, New Mexico

1980 Across the Nation: Fine Art for Federal Buildings, 1972–79, National Museum of American Art, Smithsonian Institution, Washington, D.C.

Forty American Sculptors, Twelfth International Sculpture Conference, Washington, D.C.

Sculpture in Public Spaces, San Mateo Arts Council, San Mateo, California

1979 Acquisitions, 1974–1978, Dartmouth College Museum and Galleries, Hanover, New Hampshire

Spaces, Walnut Creek Civic Arts Gallery, Walnut Creek, California

1976 Fine Art in New Federal Buildings, New Orleans Museum of Art, New Orleans, Louisiana

1974 Contemporary American Painting and Sculpture, Krannert Art Museum, University of Illinois, Urbana-Champaign, Illinois

Oregon International Sculpture Symposium, Eugene, Oregon

Public Sculpture/Urban Environment, The Oakland Museum, Oakland, California

1973 Refracted Images, DeCordova Museum, Worcester, Massachusetts

Le Salon de Mai Biennial Exhibition, The Luxembourg Gardens, Paris, France

Salon de la Jeune Sculpture, Musée d'Art Moderne de la Ville de Paris, Paris, France

The Small Format, St. Mary's College Art Gallery, Moraga, California

1972 Sculpture '72, Stanford University Museum of Art, Stanford, California

1971 Centennial Exhibition, San Francisco Art Institute, de Young Museum, San Francisco, California

A Decade in the West: Painting, Sculpture, and Graphics from the Anderson Collection, Stanford University Museum of Art, Stanford, California, and the Santa Barbara Museum of Art, Santa Barbara, California

Translucent and Transparent Art, Museum of Fine Arts, St. Petersburg, Florida

1970 American Sculpture in Perspective, Sheldon Memorial Art Gallery, University of Nebraska, Lincoln, Nebraska

Excellence, University of California Art Museum, Berkeley, California

Expo '70, San Francisco Pavilion, Osaka, Japan

Looking West, 1970, Joslyn Art Museum, Omaha, Nebraska

1970 Biennial Invitational: West Coast '70 Painters and Sculptors, Crocker Art Museum, Sacramento, California

Pierres de Fantaisie, The Oakland Museum, Oakland, California

A Plastic Presence, The Jewish Museum, New York, New York; Milwaukee Art Center, Milwaukee, Wisconsin; San Francisco Museum of Modern Art, San Francisco, California (1969–70)

Pollution Show, The Oakland Museum, Oakland, California

Sculpture Here and Now, Stanford University Art Museum, Stanford, California

1969 Contemporary American Painting and Sculpture, Krannert Art Museum, University of Illinois, Urbana-Champaign, Illinois

Plastics and New Art, Institute of Contemporary Art, University of Pennsylvania, Philadelphia, Pennsylvania

1968 Art from California, Janie C. Lee Gallery, Dallas, Texas

1967 California Artists in National Collections, Lytton Center of the Visual Arts, Los Angeles, California

Plastics, West Coast, Hansen-Fuller Gallery, San Francisco, California

Thirtieth Anniversary Exhibition, Richmond Art Center, Richmond, California

1966 Contemporary Art from the Lytton Collection, Lytton Center of the Visual Arts, Los Angeles, California

Sculptors Who Operate Their Own Foundries, Hansen Gallery, San Francisco, California

Selected Acquisitions, Solomon R. Guggenheim Museum, New York, New York

Twenty-ninth Annual Drawing, Print, and Sculpture Exhibition, San Francisco Museum of Modern Art, San Francisco, California

Twenty-two Sculptors, California State University, Northridge, California

1965 Group Show [Untitled], The Berkeley Gallery, Berkeley, California

Some Aspects of California Painting and Sculpture, La Jolla Museum of Art, La Jolla, California

Twenty-eighth Annual Drawing, Print, and Sculpture Exhibition, San Francisco Museum of Modern Art, San Francisco, California

Zellerbach Memorial Competition, Palace of the Legion of Honor, San Francisco, California

1964 Contemporary Sculpture, Albright Knox Gallery, Buffalo, New York

Eleven American Sculptors, University of California Art Museum, Berkeley, California

1963 Biennale de Paris, Musée d'Art Moderne de la Ville de Paris, Paris, France

Contemporary California Sculpture, The Oakland Museum, Oakland, California

International Contemporary Sculpture, Everett Ellin Gallery, Los Angeles, California

Twenty-sixth Annual Drawing, Print, and Sculpture Exhibition, San Francisco Museum of Modern Art, San Francisco, California

1962 Painting and Sculpture Acquisitions, Museum of Modern Art, New York, New York

Three Artists, Gallery 8, Santa Barbara, California

1961 The Art of Assemblage, Museum of Modern Art, New York, New York; traveled to the Dallas Museum for Contemporary Art, Dallas, Texas; and the San Francisco Museum of Modern Art, San Francisco, California (1961–62)

Contemporary Painting and Sculpture, Everett Ellin Gallery, Los Angeles, California

Twenty-fourth Annual Drawing, Print, and Sculpture Exhibition, San Francisco Museum of Modern Art, San Francisco, California

1960 Northern California Sculptors' Annual, The Oakland Museum, Oakland, California

Painting and Sculpture Annual, Richmond Art Center, Richmond, California

MUSEUM COLLECTIONS CONTAINING WORK BY BRUCE BEASLEY

The Crocker Art Museum, Sacramento, California

De Saisset Museum, Santa Clara, California

Fine Arts Museums, San Francisco, California

Franklin D. Murphy Sculpture Garden, University of California, Los Angeles, California

Fresno Art Museum, Fresno, California

Grounds for Sculpture, Hamilton, New Jersey

Hood Museum of Art, Dartmouth College, Hanover, New Hampshire

Islamic Museum, Cairo, Egypt

Laguna Art Museum, Laguna Beach, California

Los Angeles County Art Museum, Los Angeles, California

Musée d'Art Moderne de la Ville de Paris, Paris, France

The Museum of Fine Arts, Houston, Texas

Museum of Modern Art, New York, New York

Museum of Modern Art, San Francisco, California

National Museum of American Art, Washington, D.C.

Norton Museum of Art, West Palm Beach, Florida

The Oakland Museum of California, Oakland, California

Orange County Museum of Art, Newport Beach, California

San Jose Museum of Art, San Jose, California

Santa Barbara Museum of Art, Santa Barbara, California

Seattle Art Museum, Seattle, Washington

Sheldon Memorial Art Gallery, University of Nebraska,
 Lincoln, Nebraska

Solomon R. Guggenheim Museum, New York, New York

Stadtische Kunsthalle Mannheim, Mannheim, Germany

University of Kansas, Spencer Museum of Art, Lawrence, Kansas

University of Oregon Museum of Art, Eugene, Oregon

Utah State University, Nora Eccles Harrison Museum
 of Art, Logan, Utah

Wichita Art Museum, Wichita, Kansas

Xantus Janos Museum, Gyor, Hungary

CIVIC AND CORPORATE COLLECTIONS
CONTAINING WORK BY BRUCE BEASLEY

Arco Corporation, Los Angeles, California

Berkeley Repertory Theatre, Berkeley, California

Bishop Ranch, San Ramon, California

Capitol Group, Los Angeles, California

City of Anchorage, Alaska

City of Bad Homberg, Germany

City of Dortmund, Germany

City of Eugene, Oregon

City of Oakland, California

City of Salinas, California

Djerassi Foundation, Woodside, California

Federal Home Loan Bank, San Francisco, California

Federal Office Building, San Diego, California,
 GSA Art in Architecture Program

Gallaudet College, Washington, D.C.

Gateway Center, Walnut Creek, California

IBM Corporation, New York, New York

The Johnson Foundation, Racine, Wisconsin

Kleinewefers GmbH, Krefeld, Germany

La Jolla Crossroads, San Diego, California

Lakeside Mall, Sterling Heights, Michigan

Landeszentral Bank, Hessen, Germany

Mall at Short Hills, Short Hills, New Jersey

Miami International Airport, Miami, Florida

Miami University, Oxford, Ohio

San Francisco Arts Commission, San Francisco,
 California (three pieces)

San Francisco International Airport, San Francisco, California

Sculptural Park Punta Sur, Isla Mujeres, Mexico

Security Pacific Corporation, Los Angeles, California

Stanford University, Stanford, California (two pieces)

State of Alaska, Anchorage, Alaska

State of California, Capitol Office Building, Sacramento, California

State of California, State Office Building, San Bernardino, California

Times Mirror Corporation, Los Angeles, California

Tupperware, Inc., Orlando, Florida

University of Oregon, Eugene, Oregon

Village of Flossmoor, Illinois

Voit Brea Business Park, Brea, California

World Savings, Oakland, California

SELECTED BIBLIOGRAPHY

BOOKS AND CATALOGUES

Acquisitions, 1974–1978. Introduction by Jan van der Marck. Hanover, NH: Dartmouth College Museum and Galleries, 1979.

Across the Nation: Fine Art for Federal Buildings, 1972–79. Introduction by Joshua C. Taylor. Washington, D.C.: National Museum of American Art, Smithsonian Institution, 1980.

Albright, Thomas. *The Art of the San Francisco Bay Area: 1945 to 1980.* Berkeley: University of California Press, 1985.

American Sculpture in Perspective. Essay by Norman A. Geske. Sheldon Memorial Art Gallery. Lincoln: University of Nebraska, 1970.

Andrews, Oliver. *Living Materials.* Berkeley: University of California Press, 1983.

Art Collectors in and around Silicon Valley. Essay by Jan Rindfleisch. Euphrat Gallery. Cupertino, CA: De Anza College, 1985.

Art in Architecture Program. Washington, D.C.: United States General Service Administration, 1978–79.

Art Now Gallery Guide, New Jersey Special Edition. Clinton, NJ: Art Now, Inc., October 2003.

Art Today. New York: Faulkner-Ziegfield/Holt Rinehart Winston, 1969.

Ausstellungskatalog. Fulda, Germany: Hessische Landesgartenschau, 1994.

Barr, Alfred H., Jr. *Painting and Sculpture in The Museum of Modern Art, 1929–1967.* New York: The Museum of Modern Art, 1977.

Barrie, Brooke. *Contemporary Outdoor Sculpture.* Gloucester, MA: Rockport Publishers, Inc., 1999.

A Bay Area Connection: Works from the Anderson Collection. Essay by Katherine Church Holland. Santa Clara, CA: Triton Museum of Art, 1995.

Beyond Fragments: After the Earthquake. Introduction by R. Almaguer. Oakland: City of Oakland Public Art Program, 1990.

Beyond the Surface 2. Fallbrook, CA: The Art and Cultural Center at Fallbrook, October 2003.

Biennial Exhibition. Introduction by Denys Chevalier. Paris: Salon de la Jeune Sculpture XXV, 1973.

Blickachsen—Skulpturen im Kurpark. Bad Homberg, Germany: Magistrats der Stadt Bad Homberg, 1997.

Brook House Sculpture Invitational. Introduction by George Neubert. Oakland: Kaiser Center, 1986.

Bruce Beasley. Essay by Dr. Gottlieb Leinz. Dortmund, Germany: Galerie Utermann, September 1993.

Bruce Beasley. Essay by Dr. Manfred Fath. Bad Homberg, Germany: Galerie Scheffel, March 1993.

Bruce Beasley: An Exhibition of Acrylic Sculpture. Introduction by William H. Elsner. San Francisco: M.H. de Young Memorial

Museum and the California Palace of the Legion of Honor, 1972.

Bruce Beasley: An Exhibition of Bronze Sculpture. Essay by Albert Elsen. Rohnert Park, CA: Sonoma State University, 1990.

Budapest Triennial International Sculpture Exhibition. Essay by Janos Frank. Budapest, Hungary: Palace of Exhibitions, 1987.

Bush, Julia M. A Decade of Sculpture. Philadelphia: Associated University Presses, Inc., 1974.

California Artists in National Collections. Los Angeles: Lytton Center of the Visual Arts, 1967.

California Sculpture Show. Foreword by Henry Hopkins; essays by Jan Butterfield and Melinda Wortz. Los Angeles: International Arts Foundation Olympic Arts Festival, 1984.

California Sculpture Show. Introduction by Peter Murray. Yorkshire, England: Yorkshire Sculpture Park, 1985.

Caplin, Lee Evan. The Business of Art. Englewood Cliffs, NJ: Prentice-Hall, Inc., 1982.

A Captive Flow of Light. Nature-Science Annual. New York: Time-Life Books, 1970.

Catalog of the Collection. Franklin D. Murphy Sculpture Garden. Essay by Gerald Nordland. Los Angeles: University of California, 1984.

Catalog of the Collection. Franklin D. Murphy Sculpture Garden. Los Angeles: University of California, 1968.

Catalog of the Collection. Franklin D. Murphy Sculpture Garden. Los Angeles: University of California, 1976.

Catalogue. Frankfurt, Germany: The International Fair for Contemporary Art, 1993.

Catalogue of the Sculpture Collections. Introduction by Douglas Hyland. Spencer Museum of Art. Lawrence: University of Kansas, 1981.

Celebrating Modern Art/The Anderson Collection. Berkeley: San Francisco Museum of Modern Art/University of California Press, 2000.

Contemporary American Painting and Sculpture, 1969. Introduction by James R. Shipley and Allen S. Weller. Krannert Art Museum. Urbana-Champaign: University of Illinois, 1969.

Contemporary American Painting and Sculpture, 1974. Introduction by James R. Shipley and Allen S. Weller. Krannert Art Museum. Urbana-Champaign: University of Illinois, 1974.

Contemporary Art from the Lytton Collection. Los Angeles: Lytton Center of the Visual Arts, 1966.

Contemporary Cast-Iron Art. Birmingham: The University of Alabama, 1994.

Cummings, Paul. Dictionary of Contemporary American Artists. New York: St. Martin's Press, 1988.

A Decade in the West: Painting, Sculpture, and Graphics from the Anderson Collection. Introduction by Albert E. Elsen. Palo Alto: Stanford University Museum of Art and the Santa Barbara Museum of Art, 1971.

Eighth International Shoebox Sculpture Exhibition. Foreword by Tom Kolbe. Manoa: University of Hawaii Manoa Art Gallery, 2003–5.

First International Sculpture Assembly. Isla Mujeres, Mexico: The Quintana Roo Institute of Culture, 2001.

First International Shoebox Sculpture Exhibition. Introduction by Tom Kolbe. Honolulu: University of Hawaii, 1982.

Forgotten Dimension . . . A Survey of Small Sculpture in California Now. Introduction by George W. Neubert. Organized by Fresno Art Museum. Fresno, CA: Art Museum Association, 1982.

Forman, Will. The History of American Deep Submersible Operations, 1775–1995. Flagstaff, AZ: Best Publishing Co., 1999.

The Fujisankei International Biennale: Excellent Maquettes. Essay by Sam Hunter. Tokyo, Japan: The Hakone Open-Air Museum, 1993.

The Growing Edge of California Sculpture. San Rafael, CA: Marin Museum Association, 1965.

Hollander, Harry B. Plastics for Artists and Craftsmen. New York: Watson-Guptill Publications, 1972.

In Retrospect: The Oregon International Sculpture Symposium of 1974. Eugene: University of Oregon, 1985.

International Directory of Arts. 20th ed. Frankfurt, Germany: Verlag Muller, 1992.

International Rapid Prototyping Sculpture Exhibition. Georgetown, TX: The Sarofim School of Fine Arts, Southwestern University, 2003.

Ironworks: Directions in Contemporary Cast Iron. Mahwah, NJ: Ramapo College Art Galleries, 1994.

Kerlow, Isaac Victor. The Art of 3-D Computer Animation and Imaging. New York: Van Nostrand Reinhold, 1996.

Kerlow, Isaac Victor, and Judson Rosebush. *Computer Graphics for Designers and Artists*. New York: Van Nostrand Reinhold, 1994.

Kowal, Dennis, and Dona Z. Meilach. *Sculpture Casting*. New York: Crown Publishers, 1972.

Krantz, Les. *The California Art Review*. Chicago: American References, Inc., 1989.

Lawrence, Sidney. *Music in Stone: Great Sculpture Gardens of the World*. New York: Scala Publications, 1985.

Le Salon de Mai Biennial Exhibition. Introduction by Gaston Diehl. Paris: The Luxembourg Gardens, 1973.

Looking West, 1970. Introduction by LeRoy Butler. Omaha, NE: Joslyn Art Museum, 1970.

Lucie-Smith, E. *Late Modern, The Visual Arts Since 1945*. New York: Praeger Publishers, 1969.

Maquet, Jacques. *The Aesthetic Experience*. New Haven: Yale University Press, 1986.

Meikle, Jeffrey L. *In the American Mold: A Cultural History of Plastic*. New Brunswick, NJ: Rutgers University Press, 1995.

Meilach, Dona Z. *Direct Metal Sculpture*. Rev. ed. Atglen, PA: Schiffer Publishing, 2001.

Miller, Teressa R. *The Security Pacific Collection*. Los Angeles: Security Pacific Corp., 1985.

Nawrocki, Dennis A. *Art in Detroit Public Places*. Detroit: Wayne State University Press, 1980.

Newman, Thelma R. *Plastics as an Art Form*. New York: Chilton Book Company, 1969.

1970 Biennial Invitational: West Coast '70 Painters and Sculptors. Sacramento: Crocker Art Museum, 1970.

Northern California Art of the Sixties. Essays by Fred Martin and Georgianna Lagoria. Santa Clara, CA: De Saisset Museum, Santa Clara University, 1982.

Northern California Sculptors' Annual. Oakland: The Oakland Museum, 1960.

Oakland's Artists '90. Introduction by Harvey Jones. Oakland: The Oakland Museum, 1990.

100 Years of California Sculpture. Introductions by Christina Orr-Cahall, Paul Tomidy, and Terry St. John. Oakland: The Oakland Museum, 1982.

Onze Sculpteurs Americains. Biennale de Paris. Introduction by Herschel B. Chipp. Paris: Musée d'Art Moderne de la Ville de Paris, 1963.

Opitz, Glenn B. *Dictionary of American Sculptors*. New York: Apollo Book Co., 1984.

Orr-Cahall, Christina. *The Art of California*. Oakland: The Oakland Museum, 1984.

Painting and Sculpture Acquisitions. New York: The Museum of Modern Art, 1963.

Pickover, Clifford A. *Mazes for the Mind*. New York: St. Martin's Press, 1992.

Pierres de Fantaisie. Foreword by George Neubert. Oakland: The Oakland Museum, 1970.

Pier Walk '97. Chicago: 3-D Chicago, May 7–October 20, 1997.

Pier Walk '98. Chicago: 3-D Chicago, May 5–October 30, 1998.

Pier Walk '99. Chicago: 3-D Chicago, May 6–October 28, 1999.

Pier Walk 2001. Chicago: 3-D Chicago, May 7–October 18, 2001.

A Plastic Presence. Introduction by Tracy Atkinson. Milwaukee, WI: Milwaukee Art Center, 1969.

Plastics and New Art. Introduction by Stephen S. Prokopoff. Philadelphia: Institute of Contemporary Art, 1969.

Plastics, West Coast. San Francisco: Hansen-Fuller Gallery, 1967.

Preble, Duane, and Sarah Preble. *Artforms*. 5th ed. New York: HarperCollins Publishers, 1994.

Preble, Duane, Sarah Preble, and Patrick Frank. *Artforms*. 6th ed. New York: Addison Wesley Longman Publishers, 1999.

Public Sculpture/Urban Environment. Introduction by George Neubert. Oakland: The Oakland Museum, 1974.

Refracted Images. Worcester, MA: DeCordova Museum, 1973.

Sculptural Perspectives for the Nineties. Essay by John Natsoulas. Fullerton, CA: Muckenthaler Cultural Center, 1991.

Sculpture, Looking into Three Dimensions. Foreword by Patricia Wolf. Anchorage, AK: Anchorage Museum of History and Art, 1987.

The Second Fujisankei International Biennale: Excellent Maquettes. Introduction by Sam Hunter. Tokyo, Japan: The Hakone Open-Air Museum, 1995.

Seitz, William. *The Art of Assemblage*. New York: The Museum of Modern Art, 1961.

Selz, Peter, and Manfred Fath. *Bruce Beasley/Sculpture*. Mannheim, Germany: Stadtische Kunsthalle Mannheim, 1994.

Shipley, James R., and Allen S. Weller. *Contemporary American Painting and Sculpture*. Urbana-Champaign: University of Illinois Press, 1974.

The Small Format. Moraga, CA: St. Mary's College Art Gallery, 1973.

Some Aspects of California Painting and Sculpture. Introduction by Donald Brewer. La Jolla, CA: La Jolla Museum of Art, 1965.

Spaces. Introduction by Carl Worth. Walnut Creek, CA: Walnut Creek Civic Arts Gallery, 1979.

Spring Auction. San Francisco: San Francisco Museum of Modern Art, 1983.

Stachiw, Jerry D. *Handbook of Acrylics*. Flagstaff, AZ: Best Publishing Co., 2003.

Steel Sculpture. Essay by Siegfried Salzmann. Krefeld, Germany: International Steel Sculpture Symposium, 1987–88.

Sterling Stuff, Fifty Sculptors. Gloucestershire, England: Gallery Pangolin, 2002.

Taylor, Leighton. *Aquariums, Windows to Nature*. Foreword by Dr. Sylvia Earle. New York: Prentice Hall General Reference, 1993.

Thalacker, Donald. *The Place of Art in the World of Architecture*. Preface by Sam Hunter, Princeton University. New York: Chelsea House Publishers, 1980.

13,000 Pounds of Outdoor Art. Richmond, CA: Richmond Art Center, 1966.

Thirtieth Anniversary Exhibition. Richmond, CA: Richmond Art Center, 1967.

Twenty-fourth Annual Drawing, Print, and Sculpture Exhibition. Foreword by George D. Culler. San Francisco: San Francisco Museum of Modern Art, 1961.

Vernissage. Dortmund, Germany: Galerie Utermann, October 1991.

Williams, Arthur. *Sculpture: Technique-Form-Content*. Worcester, MA: Davis Publications, 1989.

Williams, Arthur. *The Sculpture Reference*. Gulfport, MS: Sculpture Books, 2004.

Wingspread: The Sculpture Collection. Racine, WI: The Johnson Foundation, 1983.

Works from the International Sculpture Center Board. Hamilton, NJ: Grounds for Sculpture, 2001.

Zelanski, Paul, and Mary Pat Fisher. *Shaping Space*. 2nd ed. Fort Worth, TX: Harcourt Brace College Publishing, 1995.

ARTICLES AND REVIEWS

Albrecht, Herbert. "Zwolf Bildhauer in der California Sculpture Show." *Die Welt*, February 18, 1985.

Albright, Thomas. "A Statue for the State." *San Francisco Sunday Examiner and Chronicle*, February 8, 1970.

Albright, Thomas. "An Impressive Look West." *San Francisco Chronicle*, November 29, 1970.

Albright, Thomas. "Bay Area Medicis." *San Francisco Chronicle*, June 12, 1971.

Albright, Thomas. Review. *Art Gallery Magazine* 14, no. 6 (March 1971).

Albright, Thomas. Review. *Art Gallery Magazine* 16, no. 3 (December 1972).

"All Things Californian." *Sheffield Morning Telegraph*, May 21, 1985.

"Apolymon—A Triumph of Sculpture." *The Sacramento Bee*, March 14, 1970.

"Artist Casts Own Creations." *The Milwaukee Journal*, February 19, 1967.

"Arts Festival Names Winners." *San Francisco Chronicle*, September 22, 1967.

Baker, Kenneth. "Peninsula Collectors' Bay Area Connection." *San Francisco Chronicle*, November 18, 1995.

Barnfather, Janet. "Bretton Display of Sculptures from California." *Wakefield Express*, May 10, 1985.

"Beasley Sculpture on View at N.Y. Museum of Modern Art." *Los Angeles Times*, December 16, 1962.

Bloomfield, Arthur. "Acrylic Makes Good Art." *San Francisco Examiner*, October 14, 1972.

Bloomfield, Arthur. "Gimmicks and Beauty in Art out of Plastics." *San Francisco Examiner*, November 3, 1967.

Blum, Walter. "A Foundry in His Own Back Yard." *San Francisco Sunday Examiner and Chronicle*, March 13, 1966.

Blum, Walter. "It's the Man, Not the Medium." *San Francisco Sunday Examiner and Chronicle*, April 19, 1970.

Blumfield, John. "The Olympics California Sculpture Show." *Artweek*, July 28, 1984.

Bolt, Greg. "Revamped Museum Coming Together." *The Register-Guard*, February 24, 2004.

Booth, Greg. "Bruce Beasley: Renaissance Man." *Grand Forks Herald*, March 31, 1988.

Boss-Stenner, Helga. "Skulpturen des US-Bildhaurets Bruce Beasley." *Frankfurter Rundschau*, July 12, 1996.

Boss-Stenner, Helga. "Stable but Nonetheless Animated: The Sculptor Bruce Beasley." *Artis*, February/March 1994.

"Beasley Sculpture on View at N.Y. Museum of Modern Art." *Los Angeles Times*, December 16, 1962.

"Bruce Beasley at the Mannheim Kunsthalle." *Artis*, August/ September 1994.

"Bruce Beasley, Sculpteur." *Recherché et Architecture: Année 1973*, 1973.

"Bruce Beasley's *Spokesman* in Bad Homberg," *Frankfurter Allgemeine Zeitung*, July 15, 1996.

Burt, Cecily. "Artist's Vitality." *Oakland Tribune*, August 13, 2002.

"California Creations . . ." *Huddersfield Daily Examiner*, May 17, 1985.

"California Sculpture Show." *Frankfurter Allgemeine Zeitung*, February 20, 1985.

"California Sculpture Show." *Rhein-Neckar-Main*, February 1, 1985.

"California Sculpture Show." *Yorkshire Post*, May 16, 1985.

"Capital Unveils Plastic Sculpture." *The San Diego Union*, March 15, 1970.

Chipp, Herschel B. "The 1963 Paris Biennale." *Artforum*, April 1963.

Chlumsky, Milan. "Works of American Bruce Beasley in the Mannheim Kunsthalle." *Rein-Neckar-Zeitung*, September 3, 1994.

Clapsaddle, Kelly. "Sculpture Walk to Enhance the Charm of Village." *The Star*, February 1, 2001.

Cline, Mary A. "Bruce Beasley Explores New Levels of Form." *The Press-Enterprise*, October 28, 1990.

Coffelt, Beth. "The Undersea World of Bruce Beasley's Bathysphere." *San Francisco Chronicle*, February 1, 1976.

Cooklis, Ray. "Newest Sculpture Brings Questions." *San Bernardino Sun*, June 20, 1980.

Cooklis, Ray. "Sculptor Expects Work to Outlast Criticism." *San Bernardino Sun*, June 27, 1980.

Coplans, John. "A Portfolio of California Sculptors." *Artforum*, April 1963.

Cross, Miriam D. "Beasley Exhibit Glitters and Glistens." *Oakland Tribune*, November 26, 1972.

Cross, Miriam D. "First Big Show by Marin Art Group." *Oakland Tribune*, May 16, 1965.

Cross, Miriam D. "Museum Installs Beasley Sculpture." *Oakland Tribune*, July 16, 1972.

Cross, Miriam D. "N.Y. Museum Gets Oakland Work." *Oakland Tribune*, December 16, 1962.

Cross, Miriam D. "Sparkling Show at the Oakland Museum." *Oakland Tribune*, November 15, 1970.

Cross, Miriam D. "U.C. Sculpture Returns from Paris Triumph." *Oakland Tribune*, February 16, 1964.

Cross, Miriam Duncan. "Oakland Sculptor Bruce Beasley in Capital." *Oakland Tribune*, March 22, 1970.

Davies, Lawrence E. "California Sculptors Enter Paris Show." *The New York Times*, September 11, 1963.

DeFao, Janine. "Oakland Art a Fount of Debate." *San Francisco Chronicle*, February 5, 2001.

Demoro, Harre W. "Sculptor Bruce Beasley." *San Francisco Business Journal*, March 23, 1981.

"Die Landgrafin Elisabeth hat einen neuen Nachkbarn." *Bad Homberger*, June 7, 1996.

Ditmar, Peter. "Am Liebsten mit Rost." *Die Welt*, September 17, 1987.

Donohue, Marlena. "Breaking Free of Artistic Labels." *The Christian Science Monitor*, July 27, 1992.

Donohue, Marlena. "Bruce Beasley." *Sculpture Magazine*, July–August 1992.

Drohojowska, Hunter. "California Sculpture for the World to See." *Los Angeles Herald Examiner*, June 8, 1984.

Fagan, Beth. "Sculptors, Public Involved in Art for Oregon." *The Oregonian*, July 18, 1974.

Feeser, Sigrid. "Works of the California Sculptor Bruce Beasley in the Mannheim Kunsthalle." *Die Rheinpfalz*, July 4, 1994.

Field, Michael. "From California to West Bretton." *The Star*, May 27, 1985.

Fish, Tim. "Eye Warms to Beasley." *Press Democrat*, April 12, 1991.

Fowler, Carol. "Beasley Sculpture Invites Closer Look." *Contra Costa Times*, May 4, 1986.

Frankenstein, Alfred. "American Sculpture in Perspective." *San Francisco Sunday Examiner and Chronicle*, September 27, 1970.

Frankenstein, Alfred. "Fascinating Sculpture Full of Invention." *San Francisco Sunday Examiner and Chronicle*, February 14, 1971.

Frankenstein, Alfred. "Plastics as Fine as Marble." *San Francisco Chronicle*, October 29, 1970.

Frankenstein, Alfred. "Sculptors Who Operate Their Own Foundries." *San Francisco Chronicle*, March 16, 1966.

Frankenstein, Alfred. "Some New Artistic Directions." *San Francisco Chronicle*, October 21, 1972.

"French Government Buys Sculpture by UC Artist." *Berkeley Daily Gazette*, February 3, 1964.

"A French Honor." *San Francisco Chronicle*, February 4, 1964.

French, Palmer D. "Plastics, West Coast." *Artforum*, January 1968.

Frese, Hans Martin. "Dokumente der Zeit in Stahl." *Reinische Post*, May 26, 1987.

"The Funkiest Show in Town." *San Francisco Chronicle*, May 3, 1970.

"Galerie Utermann zeigt Skulpturen von Bruce Beasley." *Westdeutsche Allgemeine*, September 1, 1993.

Gebhard, David. "Contemporary Painting and Sculpture: Everett Ellin Gallery." *Artforum*, April 1962.

Genauer, Emily. "Far-Out Sculpture Far Out West." *New York Herald Tribune*, August 11, 1963.

Glueck, Grace. "Building the Plastic Image." *The New York Times*, December 7, 1969.

Goldstein, Barbara. "California Sculpture Show." *Arts & Architecture*, December 1984.

Graves, Ralph. "The Crystal Clear Scene." *Time*, February 9, 1968.

Graves, Ralph. "Ars Gratic Amoris." *Time*, July 11, 1969.

Haggerty, Gerard. "New York Reviews." *ARTnews*, November 1999.

Hammond, Pamela. "Art from California's Sixties Stars." *Los Angeles Reader*, June 15, 1984.

Hartmann, Horst. "Avoiding Standard Symbols: Works of California Sculptor Bruce Beasley in the Mannheim Kunsthalle." *Allgemeine Zeitung*, July 13, 1994.

Hartmann, Horst. "Works of California Artist Bruce Beasley in the Mannheim Kunsthalle." *Mainzer Echo*, July 13, 1994.

Heimer, Dianne. "Sculptor Bruce Beasley." *Sacramento Magazine*, February 1992.

Heybrock, Christel. "Where Contradictions Stay in Balance: Sculpture from Bruce Beasley in the Mannheim Kunsthalle." *Mannheimer Morgen*, July 4, 1994.

Holst-Steppat, Susanne. "Ein Fursprecher fur die Kunst." *Taunus-Zeitung*, July 3, 1996.

Holst-Steppat, Susanne. "Bruce Beasley's Sculpture: Symbiosis of Nature and Technology." *Nike*, January/February 1993.

Holst-Steppat, Susanne. "Konstrukteur von Bewegung: Der Bildhauer Bruce Beasley." *Taunus-Zeitung*, March 11, 1993.

Homberg, Mird. "A Satirical, Brutal View of Pollution." *Oakland Tribune*, July 15, 1969.

Hotaling, Ed. "The Age of Lucite Dawns in Sacramento." *ARTnews*, May 1970.

Huber, Alfred. "Wenn die Linie einen Bogen kreuzt." *Mannheimer Morgen*, February 21, 1985.

Hurlburt, Roger. "Beasley Knows the Scale." *Fort Lauderdale Sun-Sentinel*, September 27, 1992.

Ingram, Jan. "Public Art." *Anchorage Daily News*, January 8, 1984.

"Jetzt steht der 'Spokesman.'" *Taunus-Zeitung*, June 1, 1997.

Johnson, Charles. "Apolymon—A Major Happening in City History." *The Sacramento Bee*, March 22, 1970.

Johnson, Charles. "Big Clear Sculpture . . ." *The Sacramento Bee*, December 12, 1969.

Johnson, Jill. "Bruce Beasley: Review." *ARTnews*, November 1964.

Johnson, Patricia. "Sculpture Exhibit." *Houston Chronicle*, November 25, 1990.

Jones, Susan. "The Shape of Things." *Horizon Magazine*, June 1984.

Kaimann, Frederick. "Grounds for Sculpture Offers Tranquil Setting to Enjoy Art." *Home News Tribune*, August 8, 1999.

Keefer, Bob. "Sculpting a Legacy." *The Register-Guard*, August 15, 2004.

Kornblum, Janet. "Out of the Rubble." *Alameda Times-Star*, May 2, 1990.

Krulak, Bob. "Bruce Beasley: Art and Technology." *Triptych, Magazine of the Fine Arts Museums of San Francisco*, July–August 1994.

"Kubische Anordnungen in korperhafter Durchdringung." *Taunus-Kurier*, March 13, 1993.

Kull, Petra. "Burgpark, Kunstpark, Spielpark." *Rheinische Post*, October 3, 1987.

"Landgafin Elisabeth im dialog mit *Spokesman II.*" *Taunusblick*, June 29, 1996.

Lando, Michal. "Vitality Takes Shape." *The Montclarion*, September 24, 2002.

Lett, Maggie. "All Things Californian." *Morning Telegraph*, May 21, 1985.

Lew, Julie. "In Oakland, Spaces for Art and Life." *The New York Times*, February 4, 1990.

Lewubsin, David. "Show Is Olympian in Size." *The San Diego Union*, July 8, 1984.

Lingnau, Frank. "Stahl Gibt der Natur elnen Starken Akzent." *Westdeutche Zeitung*, June 29, 1987.

Liu, Marian. "Three Sculptures Compete for Ogawa Plaza." *Oakland Tribune*, February 5, 2001.

"Lucite Sculpture by Beasley at Museum." *Santa Barbara News Press*, January 7, 1973.

Ludlow, Lynn. "Top Prize to Oakland Sculptor." *San Francisco Examiner*, May 2, 1965.

Mancewicz, Bernice. "Shoebox Sculptures." *The Grand Rapids Press*, July 25, 1982.

Marech, Rona. "Garden Latest Masterpiece for Sculptor." *San Francisco Chronicle*, January 28, 2000.

Marechal-Workman, Andree. "Bruce Beasley: New Work, New Medium." *Artweek*, June 20, 1981.

"Master Sculptor Shows Acrylics." *Palo Alto Times*, September 29, 1972.

McCann, Cecile N. "Bruce Beasley, Sculptor of Light." *Artweek*, August 26, 1972.

McCann, Cecile. "Bruce Beasley at De Young Museum." *Artweek*, October 21, 1972.

McCann, Cecile N. "Solidified Atmospheres." *Artweek*, November 7, 1970.

McClarin, Wanda. "Oakland Sculptor Wins $139,000 Commission." *Oakland Tribune*, November 9, 1979.

Meeker, James. "Young Artist's Work Exhibited in Dallas." *Fort Worth Star Telegram*, October 20, 1968.

Michel, Stefanie. "250 Kilogramm Kunst im foyer des theaters." *Taunus-Zeitung*, August 28, 1996.

Miller, Arthur. "Beasley's Textured Metal and Space." *Los Angeles Herald Examiner*, June 6, 1963.

Muchnic, Suzanne. "Sculpture on a Pedestal." *Los Angeles Times*, June 2, 1984.

Murphy, Jack. "Sculpture: The Age of Acrylic." *DuPont Magazine*, September–October 1970.

Neri, Kate. "Open to Question." *Oakland Museum Magazine*, Summer 1993.

"New Oakland Acquisition." *San Francisco Examiner*, July 17, 1972.

"News from the Board." International Sculpture Center, April 2003.

"Oakland Artist Bruce Beasley." *Valley Times*, December 14, 1990.

"Oakland Artists Exhibit Monumental Sculptures." *The Montclarion*, September 2, 1986.

Oakland Museum Magazine cover illustration, September/October 1989.

"Oakland Unveils Beasley Sculpture." *Artweek*, November 2002.

O'Brien, Mike. "Symposium Sculptors and Their Works." *Register-Guard*, July 21, 1974.

Olten, Carol. "Transparent Sculpture Here." *The San Diego Union*, March 4, 1973.

"One and a Half Tons of Lucite." *San Francisco Chronicle*, July 15, 1972.

O'Neill, David. "Collector Cultivation." *Décor, The Business Magazine of Fine Art*, October 1996.

Palm, Joan. "Bruce Beasley's Studio." *Oakland Tribune*, September 29, 1968.

"A Paris Accolade." *San Francisco Examiner*, February 3, 1964.

Peschken, Von Hans Dieter. "Krefeld ist in der ganzen Welt berühmt für Eisen und Stahl." *Rheinische Post*, October 11, 2000.

Polly, E. M. "Bruce Beasley's Acrylic Sculpture to Be Exhibited at De Young Museum." *Vallejo Times-Herald*, October 1, 1972.

Polly, E. M. "San Francisco Review." *Artforum*, December 1965.

Preston, Stuart. Review. *The New York Times*, October 3, 1964.

"Primer Encuentro Internacional de Escultura." *Cancunissimo*, January 2002.

Pugliese, Joseph. "Casting in the Bay Area." *Artforum*, April 1963.

Reinke, Klaus U. "Dokumente der Zeit." *Handelsblatt*, October 11, 1987.

Review. *New York Herald Tribune*, October 3, 1964.

Rico, Diana. "California Sculpture Show." *Los Angeles Life–Daily News*, June 2, 1984.

Robbeloth, DeWitt. "Apolymon Flies on Light." *Artweek*, March 15, 1970.

Rogers, Michael. "The Sculpture Transparent." *Science '83*, December 1983.

Rose, Barbara. Review. *Art International*, November 1964.

Scanlon, Tom. "The Hills Are Alive with Art." *Peninsula Times Tribune*, July 14, 1992.

Schmidt, Doris. "Kunst von der Olympiade." *Suddeutsche Zeitung*, March 5, 1985.

"Sculptor Bruce Beasley." *Elan Magazine*, November 1990.

"Sculptor Bruce Beasley in Utermann Gallery." *Ruhr Nachrichten*, September 1, 1993.

"Sculptor's Scientific Hit." *San Francisco Examiner*, February 26, 1976.

Seldis, Henry J. "Beasley Sculpture on View." *Los Angeles Times*, January 22, 1973.

Seldis, Henry J. "Beasley, Zammitt Shows Outstanding." *Los Angeles Times*, January 10, 1966.

Seldis, Henry J. "International Group of Sculptors on View." *Los Angeles Times*, June 28, 1963.

Seldis, Henry J. "Locals Get Chance in Lytton Exhibit." *Los Angeles Times*, 1965.

Seldis, Henry J. "Young Sculptor Displays Rare, Precocious Talent." *Los Angeles Times*, June 3, 1963.

Shere, Charles. "California Sculpture Goes to the Olympics." *Oakland Tribune*, May 27, 1984.

Shere, Charles. "Capital Exhibit for Oakland Artist." *Oakland Tribune*, June 21, 1980.

Simon, Richard. "Huge Sculpture Marks Advance for Art." *Sacramento Union*, March 14, 1970.

Simon, Richard. "Huge Sculpture Marks Advance for Art, State." *Sacramento Union*, March 27, 1970.

"Skulpturen aus dem Computer." *Hamberger Morgenpost*, November 29, 1996.

Snow, Shauna. "Art." *Los Angeles Times*, April 29, 1990.

"*Spokesman II* installed in City Park." *Taunus-Zeitung*, May 24, 1996.

"Stadt kauft kleinen, 'Spokesman.'" *Taunus-Zeitung*, November 6, 1996.

"Stahlskulptur aus Krefelder Gießerei." *Westdeutch Zeitung*, October 10, 2000.

Steigler, B. "Die Skulpturen Show aus Kalifornien." *Mannheimer Lokalnachrichten*, February 1, 1985.

Stiftel, Ralf. "Kristallreihen aus dem Computer." *Westfalischer Anzeiger*, September 1, 1993.

Stinnett, Peggy. "Plaza Sculpture Puts Beasley on Oakland Map." *Oakland Tribune*, September 18, 2002.

Stofflet, Mary. "A Trio in the Galleries." *Nob Hill Gazette*, July 1981.

"Storm, nannte Bruce Beasley." *Frankfurter Allgemeine Zeitung*, July 17, 1996.

Strini, Tom. "Sculpturally Speaking, L.A.'s in Great Shape." *The Milwaukee Journal*, July 8, 1984.

Stutzin, Leo. "Beasley's Artistic Vision." *The Modesto Bee*, September 20, 1992.

Tarshis, J. "San Francisco: Beasley Sculpture Between State Office Buildings." *Artforum*, Summer 1970.

Taylor, Robert. "DeCordova Trips the Light Fantastic." *Boston Sunday Globe*, February 18, 1973.

Temko, Allan. "The Multi-Faceted World of Sculptor Bruce Beasley." *San Francisco Chronicle*, June 20, 1981.

Thayer, Paul. "Sculpture in the Berkeley Mold." *California Monthly*, April 1964.

Tischler, Gary. "Dioptus Sculpture Adds Naked Poetry." *Hayward Daily Review*, July 26, 1972.

Tischler, Gary. "Sculptor Makes His Work an Integral Part of Life." *Hayward Daily Review*, August 2, 1972.

Van de Kamp, Mark. "Sculpture a 'Landmark.'" *Tri-Valley Herald*, December 14, 1990.

Van Neumann, Isabelle. "Olympischer Nachgeschmack." *Rhein-Neckar-Zeitung*, March 5, 1985.

Van Tongeren, Herk. "Beasley Turns from Acrylic to Aluminum." *Sculptor's News Exchange*, May 1978.

Ventura, A. "Prospect Over the Bay." *Arts*, May 1963.

Villani, John. "Beasley's Creations." *The Santa Fe New Mexican*, September 16, 1993.

"Vitality for Oakland." *San Francisco Chronicle*, September 10, 2002.

"Vital Venture." *Oakland Tribune*, September 10, 2002.

Waitz, Christiane. "Opening of the Bruce Beasley Exhibit in the Mannheim Kunsthalle." *Die Rheinpfalz*, July 4, 1994.

Wallace, Dean. "Beasley's Art Ennobles 'Junk.'" *San Francisco Chronicle*, October 19, 1965.

Walsh, Mike E. "Sculptures for Public Places." *Artweek*, September 7, 1974.

Wanzelius, Von Rainer. "Bruce Beasley—Skulptur aus einem GuB." *Westfalische Rundschau*, September 1, 1993.

Wasserman, Abby. "Bruce Beasley, Recent Sculpture." *Oakland Museum Magazine*, Summer 1992.

Wilson, William. "A Potpourri of California Sculpture." *Los Angeles Times*, June 17, 1984.

Wilson, William. "Bruce Beasley." *Artforum*, March 1966.

Wilson, William. "Sculptor Unveils 'Impossible' Feat." *Los Angeles Times*, March 15, 1970.

Winter, David. "Reviving Northern California Art of the Sixties." *Peninsula Times Tribune*, November 2, 1982.

Worthington, Robin. "Urban Aesthetics." *San Jose Mercury News*, June 16, 1991.

Wright, Sheila. "Bruce Beasley—Environmental Expressionism." *Daily Ledger–Post Dispatch*, August 5, 1990.

INDEX

Page numbers in italics indicate illustrations.